Signed for Kathleen
on the occasion of
RBS, Charlottesville,
1996
Michael Nyman

D1270839

EARLY LITHOGRAPHED BOOKS

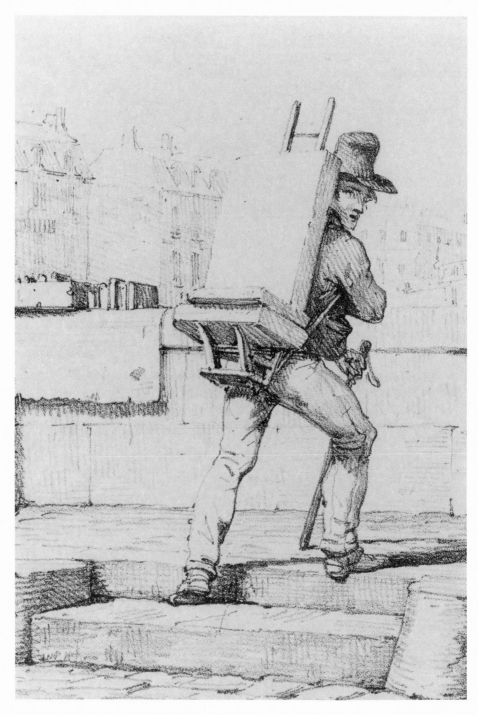

Detail of a lithograph by Horace Vernet, dated 1818, showing a boy carrying
lithographic stones on one of the quais in Paris. Approx. 145 × 103 mm.

EARLY LITHOGRAPHED BOOKS

a study of the design and production
of improper books
in the age of the hand press

WITH A CATALOGUE

by Michael Twyman

THE BOOK PRESS LTD
WILLIAMSBURG, VIRGINIA

FARRAND PRESS &
PRIVATE LIBRARIES ASSOCIATION
LONDON

Farrand Press
50 Ferry Street
Isle of Dogs
London, E14 9DT

Private Libraries Association
Ravelston, South View Road
Pinner
Middlesex, HA5 3YD

Distributed in the Western Hemisphere by the Book Press Ltd,
PO Box KP, Williamsburg, Virginia 23187

Set in Linotype CRTronic Trump Mediaeval.
Printed on Westcote acid free 135 g/m² paper from waterless
lithographic plates by Westerham Press Limited, Westerham,
Kent. Bound by Skyline Bookbinders, Dorking, Surrey.

Twyman, Michael
Early lithographed books: a study of the design and production
 of improper books in the age of the hand press
1. Lithography, history
I. Title 686.231509

ISBN 1-85083-017-7 (Farrand Press), 0-916271-05-6 (Book Press)

(The author and publishers wish to thank all who have helped in the
preparation of this book. In particular, they acknowledge the following for
granting permission to reproduce the illustrations shown in parentheses
after their names: Alecto Historical Editions (265); Alpine Club Library
(196, 197); Bath University Library (163–179); Bibliothèque Nationale,
Paris (140); Bodleian Library (72, 78, 228–236); British Library (27, 28, 82,
141, 192, 212, 222, 223, 237, 238, 257); David Chambers (71); Chatsworth
Settlement Trustees (187, 218–221); Glasgow University Library (153–
156); Höherere Graphische Bundes- Lehr- und Versuchsanstalt, Vienna
(279); Institute of Chartered Accountants in England and Wales (83–90);
Ordnance Survey (262); Reading University Library (6, 7, 12, 19, 21, 22,
101–131, 133–139, 203, 204); St Bride Printing Library (9, 44–46, 214, 226,
227, 241, 280–282); Peter Stockham of Images (205–208); Board of Trustees
of the Victoria & Albert Museum (29, 215, 216); Dr K. T. Winkler (30–40,
250). Illustrations 41–43, which are taken from an item in the Library of
the Ministry of Defence, are Crown Copyright and are reproduced by
permission of the Controller of Her Majesty's Stationery Office.

Contents

TO NIN

without whom
this book might never
have been written

Preface

This book is about books produced by lithography in Europe in the age of the hand press. The period it covers corresponds roughly with the first half of the nineteenth century, but since the hand press continued to be used for lithography long after this, even on a commercial basis, I have allowed myself some chronological licence. To my knowledge very little of any consequence has been published about such books by those who wrote on lithographic subjects at the time, and nothing at all since then. This book's main aim, therefore, is to introduce a little-known area of book design and production; but I hope that it will also contribute to our understanding of the overall picture of printing and publishing history.

Ever since I began working on aspects of the early history of lithography some thirty years ago I have made a note of those books produced by the process that have come my way, but over the last decade or so I have searched for such books more systematically. The items I have come across are listed in the Catalogue at Appendix B and run to just over 400 (the number will vary according to what is counted as an independent publication). I have deliberately excluded books in Arabic and other non-latin scripts that were produced by lithography outside Europe; I do not know enough about them to say anything more than that they were probably more common than their European counterparts. I have also excluded atlases, music scores, and writing manuals, mainly on the grounds that they pose special problems and do not usually include passages of text of any great length. Books which were printed throughout by colour lithography have been admirably covered by Ruari McLean in his *Victorian book design and colour printing* (2nd ed. London, 1972), and also fall outside this study.

Though I have pursued my search with some vague notion of where early lithographed books might be found, some have come my way quite by chance. I have no doubt that many more books of this kind will come to light, particularly outside this country, once people start looking for them.[1] At present it is

[1] In an article called 'Autographie' in *Le Lithographe*, vol.2, 1839, Desportes referred in very general terms (pp.82–83) to several works that would probably fall within the scope of this book. I suspect that I have traced some of them, though not, for example, 'quelques livres classiques' or 'les listes électorales du département de la Seine', the last of which he described as running to more than 500 pages.

1. R. C. Binkley, *Manual on methods of reproducing research materials* (Ann Arbor, 1936). A very early example of the use of typewriter composition and offset lithographic printing for book production. Printed by Edwards Brothers, Inc., Ann Arbor, Michigan. Page size 275 × 213 mm.

2. C. Tyler, *Organic chemistry for students of agriculture* (2nd impression, London: George Allen & Unwin, 1947). One of the earliest uses of typewriter composition and offset lithographic printing in a British book. The text composed on a large-image typewriter and justified at the second stage of typing. Printed by the Berkshire Printing Company, Reading. Page size 245 × 150 mm.

probably true to say that most of those interested in the history of book production are not even aware of this small, untrampled corner of their field. Even the standard works of Martin and Dobell, which between them cover privately printed books of the nineteenth century, list no more than a handful of the publications discussed here.[2] Though the total output of lithographed books produced in the age of the hand press may not be large, I believe the importance of such books far outweighs their number. Some of my reasons for this bold assertion are outlined in my introductory chapter, but I hope that they are implicit in every other chapter.

One good reason for drawing attention to these books is that we are experiencing a revival of similar approaches to book production today. I do not intend to discuss examples of alternative book production in the twentieth century – though this needs to be done by someone – but it is clear that the last decades have seen a considerable growth in the production of books that involve authors in the graphic origination of their own texts. The use of typewriters for the origination of text for books dates from at least as early as the mid 1930s in America [1],[3] and from the mid 1940s in Britain [2]. In recent years we have seen a significant trend towards authors capturing their initial key strokes using microcomputers with word-processing software. The do-it-yourself nature of this kind of activity was made explicit in 1984 with the coining of the term Desktop publishing to describe the production of documents using computers linked to laser printers.[4] But alongside such developments, which were dependent on technological advances, there also seems to have been a growth in the production of books with their texts written out by hand. Probably the most successful of these books are the guides to walks in the Lake District which were meticulously written out in his own hand by their author, Alfred Wainwright [3]. The first books in this series were published in 1955 and since then around a million copies have been sold all together. These guides were originally printed letterpress but, like other handwritten books of recent years that have been produced by photolithography, they have some of the characteristics of the books of the first half of the nineteenth century we are concerned with here. The similarities between the subject of this book and these recent developments in publishing seem to me to be striking. For example, publications

[2] J. Martin, *A bibliographical catalogue of books privately printed* (London, 1834; 2nd ed. London, 1854); B. Dobell, *Catalogue of books printed for private circulation* (London, 1906).

[3] In another typewritten book published in the same year as the one shown in illustration 1, Edwards Brothers Inc. indicate that they were working on the idea of typewritten publications as early as 1933. See Edwards Brothers Inc., *Manual of lithoprinting containing complete information on the publication of a preliminary textbook and samples illustrating the possibilities of this process* (Ann Arbor, Michigan, 1936), p.9.

[4] The term was first used by Paul Brainerd at a board meeting of the Aldus Corporation in the autumn of 1984. It was intended to cover the integration of text and graphic images using a desktop microcomputer and a laser writer. Within a couple of years the use of the term had spread throughout the world.

3. A. Wainwright, *A pictorial guide to the Lakeland fells, Book six: The North Western Fells* (Kendal, 1964). One of a series of popular guide books written out by hand and illustrated by Alfred Wainwright. Printed letterpress by Westmorland Gazette Ltd, Kendal. Page size 172 × 112 mm.

can be found from both the nineteenth and twentieth centuries in which economy of production, the need to combine pictures with words, a concern to control as many aspects of book production as possible, or simply the desire to be different, played a part in the decision to depart from traditional book production practices. The outcome of such publishing ventures, both in the nineteenth and twentieth centuries, has been the production of books that, in many cases, look very different from their more orthodox letter-press counterparts.

I have called such books of the first half of the nineteenth century 'improper' books, and have used this word in my title. The use of such a suggestive and provocative word in this context calls for a brief explanation. It is being used in the literal sense of the word: the opposite of proper. Its use here derives from discussions I had with the Design Director of a printing company in the late 1960s. Book production in Britain was then in a state of flux: traditional letterpress books were still being produced, but they were being strongly challenged by photocomposed and lithographically printed books. Our discussions were about a projected book on British printing from the industrial revolution onwards. In the course of our discussions about the design of the book, I was asked whether I would like it to be what was referred to as a 'proper' book. I knew exactly what was meant by this expression: it meant a book set on a 'Monotype' machine and printed letter-press, probably with letterpress half-tone plates on art paper gathered together at the back of the volume, or at least in separate sections. My book *Lithography 1800–1850*, which Oxford University Press were printing very handsomely at the time, was just

such a book; but I knew that I did not want this other book to look anything like it. I had in mind a publication that was different in flavour from most books on printing history and that could incorporate numerous small illustrations alongside the text. In effect, this meant that it had to be printed lithographically. But if *Lithography 1800–1850* was a 'proper' book, what then should this other kind of book be called? Needless to say, we did not bother to come up with a descriptive term for it at the time. Such books, which were by no means new even then, now tend to be called 'integrated' books (and in some fields have since become the new kind of 'proper' book). However, I remembered this discussion while working on lithographed books of the first half of the nineteenth century and decided that, in contrast to the 'proper' letterpress printed books of the period, it would be appropriate to call them 'improper' books. I am not proposing a more general use of this term, but it seemed a suitable one to use in the context of this publication to emphasize that the books I discuss break many of the hallowed 'rules' of book design and production.

Two personal and longstanding interests have contributed to my writing this book, and it may not be out of place for me to mention them briefly here since a book on a new topic is unlikely to emerge out of the blue. They stem from two apparently unrelated concerns: an interest in the history of lithography, and particularly its use as an alternative to traditional methods of printing, and an involvement as a teacher of typography with the design of information for economical production and effective use. It is particularly fortunate for me that these two interests converged in the subject of this book; that they have done so has encouraged me to believe that this obscure area of book production was worth writing about.

I also feel an attachment to the subject of this book for another reason. Though I did not remember the experience when I began writing it, one of my earliest excursions into practical lithography after graduating involved me in the production of a late example of an improper book. Around 1960 I was asked to complete the printing of the last of Ralph Chubb's hand-written, illustrated books. Chubb was one of the few people this century to have made a speciality of printing their own lithographed books on a hand press [4, 5].[5] His last book had already been written out by hand on transfer paper and transferred to stone at the time of his death in 1960.[6] All the printing was completed too, apart from a few sheets. I took on the routine task of completing the printing of this book and it represents both the beginning and, I suspect, the end of my own practical involvement with the subject of this study.

Few books can be written without the help of others, and this one is no exception. I am deeply indebted to Hermann Baron, who

[5] See A. Reid, 'Ralph Chubb, the unknown', *Private Library*, 3rd. series, vol.3, no.3, Autumn 1970, pp.141–156; vol.3, no.4, Winter 1970, pp.193–213.

[6] R. Chubb, *The Golden City, with idylls & allegories* (Fair Oak, Ashford Hill, Newbury, 1960); see Reid, 'Chubb', p.209.

4. Two of the lithographic stones used for printing R. N. Chubb's *Song's pastoral & paradisal* (Fair Oak, 1958). Each stone measures approx. 410 × 330 × 55 mm.

5. Detail of a stone used for printing the first page of the introduction of R. N. Chubb's *Songs pastoral & paradisal* (Fair Oak, 1958), showing Ralph Chubb's own notes recording an edition of 18 printed on 12 January.

allowed me to study at leisure in my own home his splendid collection of lithographed music, including most of the method books discussed in Chapter 6.[7] I am also grateful to David Chambers, who allowed me to inspect his collection of items printed for Sir Thomas Phillipps and was kind enough to put at my disposal his own considerable knowledge of Phillipps's excursions into printing. What I know of early German lithographed books derives principally from work I have been privileged to do on the splendid collection of lithographs of all kinds brought together by the late Dr R. Arnim Winkler of Munich. He was extremely generous in letting me see items in his collection, in answering queries, and in providing xeroxes and photographs; and in recent years his son, Dr K. T. Winkler, has been equally obliging. Michael Winship provided valuable guidance on bibliographical matters and helped me to come to terms with describing the eccentricities of my subject in the Catalogue, and Dr Claus Gerhardt was kind enough to take a look at the German-language entries for me.

Numerous librarians, many of whom I am unable to thank by name, have also been helpful. I am especially grateful to Mr J. H. Lamble, Librarian of Bath University Library, for his kindness in allowing me to work under rather special circumstances on the collection of Isaac Pitman's shorthand books in his care. Joan Friedman, Curator of Rare Books at the Yale Center for British Art, James Mosley, Librarian of the St Bride Printing Library, and the Librarians of the Alpine Club Library, the Carlton Shorthand

[7] This collection has subsequently been acquired by Reading University Library, where it is known as the H. Baron Collection.

Collection of the University of London Library, the Devonshire Collections at Chatsworth, the Institute of Chartered Accountants in England and Wales, and the Royal Engineer Corps Library have also been most helpful. The Rev. Malcolm Anker, Robin de Beaumont, Gavin Bridson, Dr Erik Dal, Bamber Gascoigne, Professor Peter Isaac, David Knott, Richard Kossow, Thomas Lange, Barrie Marks, Ian Mumford, the late Sir James Pitman, Dr Margaret O'Sullivan, Leonard B. Schlosser, the late Lieut-Colonel J. E. South, Dr Charles Warren, the late Dr Berthold Wolpe, and Johan de Zoete have all been kind enough to draw my attention to items of interest or to answer specific points I have put to them.

Gwen Averley of the Nineteenth Century Short Title Catalogue project (NSTC) has generously given me advance notice of lithographed items to be listed in forthcoming volumes of the publication. If the first few letters of the alphabet are representative of this whole union catalogue, I estimate that something in the region of 125 to 150 further items would need to be added to my catalogue. I make no claims, therefore, for the completeness of this publication. Had NSTC been projected before I started work on my catalogue, I might have been tempted to delay publication of this part of the book. As it is, I hope to be able to produce a supplementary catalogue at a later stage.

Given its subject matter and the facilities now available to help authors produce their own texts, there was no real option but for me to do as much work on this book as I could myself. This has included the keyboarding and initial coding of the text, in addition to the design and page make-up of the publication. All the same, I have benefited considerably from the contributions of other people. On the text-handling side, I should like to acknowledge the skills and patience of Mick Stocks, who converted my crudely coded discs into refined typographic form using a Linotronic 300 imagesetter. Anyone familiar with command-driven typesetting will appreciate the effort and judgement that went into his contribution. Throughout all stages of the production of this book I have received encouragement from Roger Farrand, the publisher, and David Chambers of the Private Libraries Association, both of whom have suggested improvements to the text and have helped me to avoid at least some errors and infelicities. Overall, the experience of working on this book has merely confirmed my belief – which it might not be out of place to refer to in a book dealing partly with do-it-yourself books – that authors who work entirely on their own do so at their peril.

Department of Typography & Graphic Communication
University of Reading
July 1989

Introduction

After some 500 years of almost total domination by letterpress printing, the production of books (other than unillustrated paper-backs) is, for the time being at least, firmly in the hands of the lithographic trade. The change from letterpress to lithographic methods of printing in the book trade has been a gradual one, with the rate of change depending on the kind of book produced. This change has echoed developments in the printing industry as a whole, but the rapid growth of photocomposition in the late 1960s and 1970s was probably the decisive factor in bringing about a fundamental shift in methods of book design and production. Letterpress printing, though to a large extent responsible for deter-mining the organization and structure of books, is now almost a thing of the past; even in the field of book design it has begun to lose its influence in favour of more flexible approaches made possible by lithography. It is all the more surprising, therefore, that historians of printing should have neglected to study the beginnings of lithographic book production.

It so happens that the lithographed book is almost as old as lithography itself, and that within a few years of Alois Senefelder's invention of the process in Munich in 1798 it was used for the production of books and book-like items. These are the incunables of lithographic book production and, like the incunables of letter-press printing, many of them are small-scale pamphlets which were printed in small editions. Over the next half century litho-graphed books continued to be produced on the hand press in most parts of Europe. Their impact on book production was negligible at the time, but their significance in relation to the overall pattern of book production should surely be re-assessed now that litho-graphy has become the dominant printing process in this field.

Quite apart from their significance as precursors of the litho-graphed book of today, lithographed books produced in the age of the hand press are important because they draw attention to several limitations of conventional book-production methods. Letterpress printing from movable type catered for most kinds of straightforward material very well; in particular it accommodated

the making of corrections easily and very cheaply. But in some areas of book design it imposed considerable constraints. It was these constraints that explain why early printed books began to move away from the more flexible conventions of manuscript production in terms of design; and also why the manuscript book lingered on for centuries in some areas of book production. Two particular limitations of letterpress printing may be referred to here by way of example since they demonstrate the advantages offered by lithography for certain kinds of work in the first half of the nineteenth century.

One of these was the limitation imposed by letterpress composition on the range of characters that could be printed. In straightforward work this rarely presented a problem since fonts of type were designed to cope with standard needs, but any printer working in a pioneering field of study in the age of metal composition must have been familiar with the problem of finding or inventing characters for special situations. In the fifteenth century, for example, printers faced with the problem of producing Greek and Hebrew words sometimes took the easy way out and left gaps for them to be filled in by hand. In later centuries, however many different fonts and characters a printer had, there was always an occasional need for something extra to fulfil a new requirement.

Another limitation of letterpress printing lay in the field of non-linear configurations of text, such as tables and trees. They could be coped with in letterpress printing, but were extremely time-consuming to set. It was for this reason that they were grouped together in a chapter called 'Difficult composition' by the American printer Theodore Lowe De Vinne[1] right at the beginning of this century and were referred to as something to be avoided where possible by one recent writer on typing for printing.[2]

In addition, some publications were needed in such small numbers that they scarcely justified the expense of setting text in movable type, and others required illustrations of various kinds that needed to be integrated with the text. For these reasons, and many more, other methods of book production have existed alongside printing from movable type from Gutenberg's time onwards. Such alternative books probably warrant a study on their own; I shall limit myself to a few examples by way of illustration.

Block books provided the earliest printed alternatives to Gutenberg's invention.[3] Whether they preceded the invention of printing from movable type or not is of no great consequence in this context, but the fact that they enabled text to be combined with illustrations on the same wood block gave them a decided advantage for certain kinds of didactic books. Origination costs were low, blocks could be transported easily, and sheets could be printed

[1] T. L. de Vinne, *Modern methods of book composition* (New York, 1904), pp.171–230.

[2] J. Westwood, *Typing for print: a manual for typists and authors* (London, 1976).

[3] See in particular A. M. Hind, *An introduction to the history of woodcut* (London, 1935), pp.207–264.

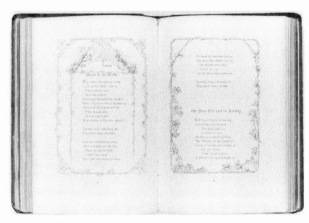

6. Horace, *Opera*, 2 vol. (London, 1733–37). Engraved throughout by John Pine and printed intaglio. Page size 227 × 140 mm.

7. T. Moore, *Irish melodies* (London, 1846). Illustrated by D. Maclise, engraved by F. P. Becker and printed intaglio. Page size 267 × 185 mm.

from them virtually on demand. For these reasons, block books continued to be manufactured and used long after the invention of printing from movable type. Another approach to the problem of combining text with pictures, particularly more refined pictures than could be achieved in woodcutting, involved intaglio engraving. In France, particularly in the second half of the eighteenth century, some illustrated books were published with their text and illustrations engraved throughout on metal.[4] Not only did this create a visual unity between verbal and pictorial elements, but it also meant that everything could be printed together on the rolling press, albeit rather slowly. A few books were printed by similar means in Britain in the eighteenth and nineteenth centuries, the best-known examples being Pine's edition of Horace's *Opera* (London, 1733–37) [6] and Thomas Moore's *Irish melodies* (1st ed., London, 1846) [7], which had its text engraved on steel by F. P. Becker. My search for lithographed books of the nineteenth century in particular subject areas suggests that similar kinds of books were printed in the eighteenth century by intaglio methods as were printed in the nineteenth century by lithography. For example, two areas of lithographic book production dealt with here, shorthand books and music method books, are known to have had substantial numbers of intaglio-printed precursors.[5]

The most personal, inventive, and creative books printed by alternative means in any period were the illuminated books of William Blake, which were produced by the method of relief etching on metal he developed at the end of the eighteenth century.[6] Blake wanted to find a means of combining text and pictures in such a way that they were graphically and technically inseparable, and that also gave him complete control over production, including the writing of the text. It could also be argued that Blake must have seen the conventional letterpress book as representing the forces of reason in book production, analogous to the cold academism of the paintings of Reynolds that he so despised.

[4] See C. L. de Peslouan, 'L'Art du livre illustré au XVIIIe siècle', *Arts et Métiers graphiques*, no. 24, July 1931, pp. 304–306.
[5] See J. J. Gold, 'The battle of the shorthand books, 1635–1800', *Publishing History*, no. 15, 1984, pp. 5–29.
[6] See in particular R. N. Essick, *William Blake printmaker* (Princeton, 1980), pp. 85–120.

In any event, Blake could not have afforded to produce his own poems using orthodox methods of book production. Whatever the principal reason for inventing his own printing methods, however, we see in Blake's books the supreme achievements of one who turned to an alternative method of book production in search of liberation.

Another person who sought to discover an alternative way of disseminating his own writings was Alois Senefelder, the inventor of lithography, though his main concern was to find a cheap way of printing so as to make a living from his plays.[7] It was Senefelder's search for such alternative methods of printing, at more or less the same time as Blake was producing his small illuminated volumes, that eventually led him to the discovery of lithography.[8] But by the time he had got this far, his excitement over the new process and his concern to improve it had deflected him from his writing. For the most part his new process of lithography was used in its early days not for the printing of books, but for music, maps, circulars, jobbing printing of all kinds, and the multiplication of artists' drawings.

The search for alternative ways of producing books did not stop with the invention of lithography. In 1839, soon after the discovery of photography, Fox Talbot hinted at some of the possibilities of the process for the reproduction of writing in a letter to Sir John Herschel. Not long afterwards a few experimental publications were printed using a photographic process called Cyanotype, the first and most important of these being Anna Atkins's *Photographs of British Algae: Cyanotype impressions* (1843–54).[9] The publication consisted mainly of plates of algae, but the text and captions were also produced photographically. Photographic negatives were produced by writing in opaque ink on paper and then oiling the paper to make it transparent. This approach had some similarities with the use of transfer paper in lithography, though the photographic process did not lend itself to the printing of such large editions as did lithography.

Later on in the nineteenth century some books were engraved throughout on wood, such as Richard Doyle's *Jack the giant killer* (London, 1851 and 1888). When photomechanical processes took over from the craft processes, they too began to be used for the production of books which had their texts written out by hand. Even stencil duplicating was tried for book production in the nineteenth century.[10] Yet none of these groups of alternatives to printing books from movable type provided anything to compare, either in terms of numbers or diversity of approach, with the lithographed publications discussed in this book. These lithographed productions represent the first serious alternatives to books printed from movable type since the block book and serve

[7] A. Senefelder, *A complete course of lithography* (London, 1819), pp.1–2.

[8] See M. Twyman, *Lithography 1800–1850* (London, 1970), pp.5–12.

[9] L. Scharf, 'Anna Atkins' Cyanotypes: an experiment in photographic publishing', *History of Photography*, vol.6, no.2, Apr. 1982, pp.151–172.

[10] A weekly magazine, *The Herald*, was produced by the file plate stencil process, starting in February 1885. See W.B. Proudfoot, *The origin of stencil duplicating* (London, 1972), pp.48–50.

to draw attention to some of the shortcomings of Gutenberg's invention.

It is important to consider the advantages and disadvantages of lithography for the production of books in the age of the hand press. On the composition side, lithography was clearly at a severe disadvantage when compared with the setting of movable type in so far as straightforward text matter was concerned. In the first place, there were no ready-made letterforms in lithography; secondly, whatever methods were adopted for composing long passages of text were bound to be inferior, and, taking correction into account, probably slower too than the hallowed methods of the letterpress printer. Nevertheless, handwriting did have some advantages over the setting of movable type. The letterpress compositor was limited by what was available both from the typefounder and in the printing works; it is necessary to make this distinction because what might have been available in the sense that it had been manufactured, may not have existed in a particular printing house. It was especially in the field of non-latin scripts that lithographic writers had the upper hand, but they also had advantages in technical works that involved the use of mathematical and chemical symbols, and in publications that included passages of music alongside text. By the middle of the nineteenth century the collective repertoires of the typefounders in such fields was huge, though only the largest printers or the most specialized ones could have been expected to hold more than a small proportion of what was available from the founders. And when it came to transcripts and facsimiles of manuscripts and inscriptions, lithography had further advantages over letterpress at the origination stage.

Lithography had advantages, too, when it came to handling complex configurations of text, what De Vinne called 'Difficult composition'. Movable type lends itself to the linear configurations of verbal messages that involve strings of characters set side by side in rows. But it is not nearly so easy for it to handle other configurations, such as tables and trees, or to deal with rule work and diagrammatic elements. Lithographers were not so constrained and were in a position to place words with more or less equal ease wherever they wanted them on a page, to combine text with horizontal and vertical rules without difficulty, and even to introduce diagrammatic or pictorial elements within a line of text. The whole system of printing with movable type, which is essentially based on the idea of re-usable ready-made elements, can only cater for pictures or decorations if they can be provided from existing stock blocks or decorative type units. Early letterpress printers often tried to bend the system and made ingenious attempts to produce geometrical diagrams and simple maps with

rules and type material, but, in general, they learned to accept the limitations of the system within which they worked. Lithographers had much greater freedom than letterpress printers when it came to relating pictures to a text, and a whole range of pictorial effects associated with lithography could be produced with text at one pass through the press. In short, lithography brought back to the book – at least in theory – some of the flexibility it lost when manuscript production was replaced by letterpress printing.

Though lithography had some advantages over traditional letterpress methods of book production with regard to flexibility, it also had the weight of tradition against it. As numerous typographic designers have found to their cost, readers are reluctant to change the habits of a lifetime. The most convenient method of getting passages of text on to lithographic stone was handwriting, and this produced pages of books that looked very different from those readers were used to. In all probability too, they were less efficient in terms of legibility than pages of typeset material. We have no reliable indicators of the relative legibility of good handwriting and typeset text even today, so there is no likelihood that we shall ever know how easy or otherwise it was for people in the nineteenth century to read handwritten lithographed books. But it may be worth referring here to the views of the author of an early twentieth-century publication who took a sideswipe at the idea of printing a work in an author's own handwriting:

> ... graphology ravers might draw the conclusion, that the best thing would be to print a work in the facsimile of the author's hand-writing. Heinrich Vogeler-Worpswede and Walter Harlan conceived the whimsical freak of having their poems reproduced in their own hand-writing; they have the effect upon the reader of private news clad in poetic form, and yet again, they have not that effect, for the writing is forcibly adapted to the purpose and thus lacks the most important feature, the characteristic of the moment which is, after all, the distinguishing feature of a hand-writing. An autogram of Goethe or Nietzsche is certainly a fine thing to have; but an autographed publication of a whole work influences its objective effect and mars the work.[11]

However, the overwhelming disadvantage of lithography for book production in the age of the hand press was not the origination of the text, but its slowness at the printing stage. Various estimates of the speed of lithographic printing have been provided by lithographers for the period under discussion. The speed of output varied greatly according to the size of the stone or sheet, the kind of image, and the quality of printing; but no more than 100 to 120 impressions an hour would have been printed from even a simple image on a small stone, and more complex work would have

[11] G. Kühl, *On the psychology of writing* (Offenbach, 1905), pp.8–9.

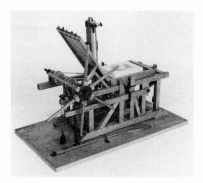

8. Model of a wooden star-wheel press used by Charles Hullmandel, based on a set of drawings published in the *Encyclopaedia Britannica*, vol.5, 1824. Department of Typography & Graphic Communication, University of Reading, reproduced by courtesy of Arthur Ackermann.

9. Lemercier's press room in Paris between about 1844 and 1848 showing over thirty wooden star-wheel presses and, in the foreground, one of the new iron presses introduced by Eugène Brisset. From an advertisement of the firm of Lemercier in *Le Figaro lithographe* (1895).

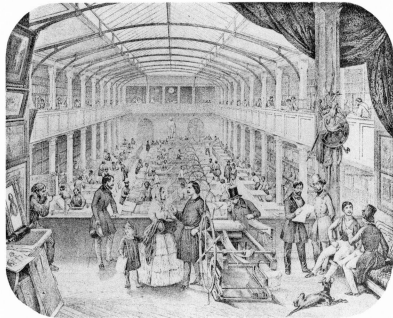

taken considerably longer.[12] Though information gleaned from contemporary sources varies greatly, the overriding fact that lithographic printing was much slower than letterpress printing is clearly established. This was the position even before the successful application of Koenig's powered cylinder machine to letterpress printing in 1814; the disparity between lithographic and letterpress printing speeds became even more marked when improved powered machines began to be taken up by letterpress printers in the second quarter of the nineteenth century. In this period, while letterpress machines were producing copies at hourly rates that could be numbered in the thousands, some of them printing on both sides of the sheet at one pass through the press, lithography was still in the era of the hand press [8,9]. Though numerous attempts had been made to speed up lithographic printing, including experiments with the application of steam power, no really successful powered press was in use in the first half of the nineteenth century.[13] The relatively slow speed of lithographic printing when compared with letterpress meant that it was unlikely to be used for book production, except where print runs were short or when other factors prevailed.

For these reasons, lithographed books of the first half of the nineteenth century fall into several fairly well-defined groups; some are subject related, others have to do with design and production requirements. First, though by no means most important, there are vanity books, which were produced on behalf of an author for private distribution to his or her friends in very limited

[12] M. Twyman, 'The lithographic hand press 1796–1850', *Journal of the Printing Historical Society*, no.3, 1967, pp.32, 41–44.

[13] M. Twyman, 'Lithographic hand press', pp.46–50.

numbers. The few examples of this kind that have come to light are all illustrated publications. Secondly, there are the precursors of what would today be called 'in-plant' or 'in-house' productions; that is, books printed by an institution for its own purposes using its own facilities for reasons of convenience, security, or economy. The best examples of this kind are sets of instructional manuals that were produced for military purposes. Thirdly, and forming by far the largest group, are books that would have been more difficult to produce using traditional letterpress methods. Included in this group are the following clearly defined sub-categories: works involving non-linear configurations of text and rule work, such as genealogies and account books; works requiring considerable use of non-latin characters that were not available from letterpress printers, such as books on Egyptology and shorthand; works that involved the printing of passages of music along with text, such as song books and method books; and facsimiles of early printed books and collections of facsimiles of manuscript material. Lastly, some lithographed books, mainly those that date from the early years of the nineteenth century, must have made use of lithography simply because of the excitement engendered by the new process.

There is, of course, considerable overlap between these five groups. For example, it is difficult to know whether Sir Thomas Phillipps set up his own lithographic press at Middle Hill because he was excited by the possibilities of the process or, like many in-plant printers, because of the convenience and economy it seemed to offer him. But regardless of the group they fall into most neatly, most of the publications discussed in the following chapters have in common the fact that they appealed to a limited audience and could be produced economically by lithography only because they were needed in very small numbers. Under such circumstances the speed and convenience of lithography at the origination stage must have far outweighed its slowness at the machining stage when compared with traditional letterpress printing. The only books discussed in the following chapters that are known to have been produced in relatively large numbers are the early shorthand publications of Isaac Pitman, and in such cases the problems of originating the text were clearly paramount.

The methods used for lithographic book production in the age of the hand press were essentially the same as those used in other fields of commercial lithography at the time. As far as the casual present-day viewer of such books is concerned they probably appear to fall into two categories: handwritten books, and others – not so many of them – that look as though they were printed from type. Though this book aims to avoid printing technicalities as much as possible,[14] some brief account is probably needed of

[14] I have discussed the principal methods of lithography in *Lithography 1800–1850* (London, 1970), and the means of identifying those used in lithographed music in *Lithographed music: the first fifty years* (in preparation). Two articles of mine in the *Journal of the Printing Historical Society* deal extensively with presses and stones: 'The lithographic hand press 1796–1850', no.3, 1967, pp.3–50; and 'Lithographic stone and the printing trade in the nineteenth century', no.8, 1972, pp.1–41.

the ways in which text and other lettering could be produced for lithographic printing. Some of these techniques will be referred to again in greater detail when discussing particular books. At this stage, all that needs to be said is that there were six main ways in which the texts of new improper books were originated: three of them involved handwriting and hand lettering, and another three made use of prefabricated letters (either types or punches). In addition, two photolithographic methods were used to reproduce existing handwritten or printed texts.

These methods can be summarized as follows:

1. Writing in reverse on to the stone using lithographic ink and, in most cases, a steel pen.

2. Writing in the normal way on to specially prepared paper, known as transfer paper, using lithographic transfer ink and an appropriate quill or steel pen. The writing was then transferred by a relatively simple operation so that it appeared on the stone in reverse, and therefore the correct way round for printing.

3. Writing in reverse on the stone with a steel point through a coating of gum arabic (which was usually coloured so that the writer could see the work in progress). The gum arabic protected the stone from grease and, on completion of the writing, greasy lithographic ink was rubbed into the lines. The coating of gum arabic was then washed away and thicker strokes added where necessary as in 1.

4. Setting type in the traditional manner and proofing it on transfer paper using lithographic transfer ink of a different kind from that referred to in 2. The proof was then transferred to the stone. A later version of this approach involved the transfer of ink from right-reading type direct to the stone.

5. Another method, used only in music publications, involved striking right-reading letter punches one by one into a metal plate, as for intaglio music printing. A proof of the plate was then taken with lithographic transfer ink and transferred to the stone.

6. A further method, used only for the production of facsimiles of old printed books, involved damping the original sheet of printed matter and then inking it up with lithographic transfer ink. The damp repelled the greasy ink in the blank areas, while the greasy parts remained dry and attracted the transfer ink. All that remained to be done was for the image on the inked-up sheet to be transferred to stone.

7. Taking a photographic negative of a printed or handwritten document and exposing light through it on to photographically sensitive transfer paper. This was treated so as to make its image receptive to grease; the image was then inked up and transferred to stone or a metal plate.

8. Taking a photographic negative of a printed or handwritten

document and exposing light through it on to a stone or metal plate coated with an appropriate photosensitive substance.

In addition, there were modifications to some of these methods, which will be discussed at appropriate points in this book.

The foregoing descriptions, brief though they are, probably make the subject rather more complex than it actually was. In practice, two of these methods, writing directly on the stone (1) and writing on transfer paper (2), accounted for the vast majority of the books to be discussed. It might therefore be worth saying something about the main advantages and disadvantages of both of these methods.[15] The transfer method was quicker for the writer, but less certain in its quality. Part of the problem lay in the difficulty of writing carefully on rather insensitive paper, and part in the loss of definition that resulted from transferring the image to stone. In 1824 Hullmandel held that it was very difficult to write on transfer paper and advised his clients to make a clean copy in ordinary ink of whatever document they wanted printed and to get a lithographer to do the writing and printing for them.[16] More than a decade later, Engelmann pointed out that transferring was so much less certain than writing directly on to the stone that it was best to go to the latter when anything was needed in a hurry.[17] But despite such reservations, writing on transfer paper was widely practised by professionals and amateurs alike and was described in most nineteenth-century manuals on lithography. Nevertheless, the best quality work was nearly always done by writing in reverse directly on to stone. Surprisingly, once the technique was mastered, this was not as slow an operation as one might suppose, and there are still people alive today who can testify to the skills they developed in writing backwards on Ordnance Survey maps. And long before this, Engelmann revealed that while in Berlin he had seen eight folio pages of a work being written backwards on to stone in a single day.[18]

Though the best quality work was certainly written directly on stone, some writing done on transfer paper was very well executed. Two separate specimens of careful lithographic writing on paper from *Every man his own printer; or, lithography made easy* (1st

[15] This account of lithographic writing draws on numerous sources, including: W. Abraham, *Lithography in India: being a few practical hints for the Indian amateur* (Bombay, 1864), pp.5–10; L.J.D.B., *Coup-d'œil sur la lithographie* (Brussels, 1818), pp.12–17; L.-R. Brégeaut, *Nouveau manuel complet de l'imprimeur lithographe*, augmented by Knecht and Desportes (Paris, 1850), pp.198–199; J. Desportes, 'Autographie', in *Le Lithographe*, vol.2, 1839, pp.56, 94; J. Desportes, *Manuel*

pratique du lithographe (Paris, 1834 and 1840), pp.51–58, 87–96, 107; G. Engelmann, *Traité théorique et pratique de lithographie* (Mulhouse, 1835–40), pp.256, 260–262, 267–268, 286, 311–324, 333–339, 397, 412; L. Houbloup, *Théorie lithographique* (Paris, 1825), pp.30, 65–68; Knecht, *Nouveau manuel complet du dessinateur et de l'imprimeur lithographe* (Paris, 1867), pp.69–71, 131–168; L. M....r, 'Dessins et écritures sur pierre', in *Le Lithographe*, vol.3, 1842, pp.18–27;

E. Tudot, *Description de tous les moyens de dessiner sur pierre* (Paris, 1833), pp.125–130; W. D. Richmond, *The grammar of lithography* (London, 1878), pp.40–43, 47, 51–54; [Waterlow & Sons], *Every man his own printer; or, lithography made easy* (London, 2nd ed. 1859), pp.10–13.

[16] C. J. Hullmandel, *The art of drawing on stone* (London, 1824), p.78.

[17] Engelmann, *Traité*, p.262.

[18] Engelmann, *Traité*, p.262.

ed., London 1854), which was published by the firm of Waterlow, demonstrate this point. A specimen of 'studied writing' [10] is described as having been written very slowly by outlining the whole work and then thickening the down strokes of the letters.[19] A further specimen of ornamental writing [11] was done on transfer paper in a similar way by outlining and then reworking the heavy parts.

It has to be said that it is often extremely difficult to distinguish between work done on transfer paper and work done on stone when equal care was taken. However, careful examination of a long text may reveal occasional awkward junctions between letters, which usually means that the writing was done in reverse,

10. Detail of specimen of studied writing on transfer paper from plate 1 of [Waterlow & Sons], *Every man his own printer* (London, 2nd ed. 1859). 105 × 78 mm.

11. Specimen of ornamental writing on transfer paper from [Waterlow & Sons], *Every man his own printer* (London, 2nd ed. 1859). Page size 272 × 183 mm.

19 [Waterlow & Sons], *Every man his own printer*, pp. 13–14.

12. Detail of text written in reverse on stone showing awkward junctions between letters. From M. Clementi, *Méthode pour le piano forte* (Offenbach, c. 1809). 24 × 36 mm. [Cat. 1.69].

13. Detail from the introduction to *Monument, van het driehonderdjarig bestaan der onveranderde Augsburgsche Geloofsbelydenis* (Haarlem, 1830), described in the text as having been written the normal way round on transfer paper. 55 × 82 mm. [Cat. 1.156].

14. Detail from the Confession in *Monument, van het driehonderdjarig bestaan den onveranderde Augsburgsche Geloofsbelydenis* (Haarlem, 1830), described in the text as having been written in reverse on the stone. 58 × 86 mm. [Cat. 1.156].

and therefore directly on to stone [12]. One unusual Dutch publication, *Monument, van het driehonderdjarig bestaan der onveranderde Augsburgsche Geloofsbelydenis* (Haarlem, 1830) [13, 14], provides us with an opportunity to compare the two methods and was published by the lithographic firm of Sander & Compie partly as a means of demonstrating their skills. The book reproduces the Augsburg Confession of 1530 and was ostensibly published to commemorate the three-hundredth anniversary of the Diet of Augsburg. Nevertheless, it must also have been seen as a technical exercise because the introduction explains that the Confession itself was written directly on to stone whereas the foreword was written on transfer paper and then transferred to stone.

Fig. 15.

Fig. 16.

Fig. 17.

15. Illustrations relating to the making of pens for lithography. From plate III of L.-R. Brégeaut, *Nouveau manuel complet de l'imprimeur lithographe*, new edition enlarged by Knecht and J. Desportes (Paris, 1850).

Lithography began to be used for multiplying documents just as the steel pen began to replace the quill in everyday writing, and the practices of the lithographic writer changed with this gradual shift from one tool to the other. The general position as expressed by early writers on lithography was that goose or crow quills were good for writing on transfer paper, but not at all satisfactory for writing on stone because they could not be cut fine enough and were easily blunted by the stone and by contact with alkali in the lithographic ink. On the other hand, the steel pen worked well on stone, though it may not have been so satisfactory for writing on transfer paper because it ran the risk of digging into it. Understandably, later writers seem to have changed with the times and to have accepted that the steel 'lithographic pen' could be used on paper too, but there was general agreement that writers should never use a pen that had already been used with ordinary ink. Initially lithographers made their own pens from watch springs and, even after special lithographic pens were available, some writers on lithography felt that it was best for a professional lithographer to make his own [15].

The third of the methods described above, often called rather misleadingly engraving on stone, was mainly used for the production of display lettering on title-pages and in headings. It allowed for finer lines than could be produced by working with a pen, whether on stone or on paper. It was especially suited to the production of flourishes and the finely hatched tones that are often found in the thick strokes of display letters of the period. The method was also used on occasions for the fine strokes of lettering in continuous text. The way this was done is not described anywhere so far as I know. But, judging by actual examples, it seems that the whole of the writing was initially mapped out using an etching needle or similar tool through a coating of gum arabic. These marks must then have been inked up and the coating washed away before the thick strokes were added with lithographic writing ink.

Methods 4, 5, and 6 all involved the use of prefabricated letters and produced images that look a little like traditional printing, but they were very rarely used. Transferring from ordinary letterpress types [16] seems to have had considerable potential; it offered the attraction of combining the versatility of lithography in the production of pictures with a method of composing text material that would not offend the sensibilities of the ordinary reader used to traditional printing. An alternative solution to this problem was proposed by Firmin Didot *père et fils* in conjunction with the lithographic printer Motte. In 1827 they took out a joint patent for a process which involved printing from letterpress types and type-high lithographic stones at the same time.[20] An additional

20 French patent no.2211, 10 November 1827, for 'Litho-typographie'.

16. Detail of text transferred from
type and printed lithographically,
from J.-F. Champollion, *Grammaire
égyptienne* (Paris, 1836–41),
37 × 51 mm. [Cat. 1.66].

workman was needed to damp the stone, but the printing itself
was done in a single operation. I do not know whether this
approach, which strictly speaking falls outside the subject of this
book, was ever practised, but it is interesting because it too
demonstrated the need for a method of printing that combined the
advantages of letterpress and lithography. Transferring type matter
to stone offered many advantages over letterpress in fields where
types were not available, since additional matter could be inked
in by hand on the stone. It was tried in the early 1820s, but was
rarely used for book production thereafter; the most important
publication to make use of it, Champollion's *Grammaire égyp-
tienne* (Paris, 1836–41), must have caused all sorts of problems for
its printers because they reverted to letterpress half way through
its production.

The remaining transfer methods (5 and 6) were used even more
rarely. Unlike the other methods discussed above, they were
specific to particular kinds of work: books containing passages of
music and facsimiles of early printed books. Further discussion of
them will therefore be left to the appropriate chapters. The last
two methods involved photography and were considerably later
than the others. Method 7 was the more important of the two in
the nineteenth century and was first used for book production in
1859. But in the first instance this method, which might seem to
have been the immediate precursor of modern photolithographic
book production, was used exclusively for the reproduction of old
documents, both manuscript and printed.

The most commonly used methods of lithographic book produc-
tion, particularly in the early years of our period, all used hand-

writing to produce passages of text. The prevailing style of writing was the English round hand, more commonly known as copper-plate, and in France as *anglaise*. By the beginning of the nineteenth century it had become the standard commercial hand throughout Europe. There were national differences in writing, the most marked of which was the German cursive hand which was used in some, though not all, the German books discussed here. French language books often made use of less formal styles of writing, such as *bâtarde* and *coulée*, and of the slightly bolder *ronde* for headings and where emphasis was needed in text matter. Some music books in parallel languages took advantage of the differences between these national styles of writing to help the reader distinguish one language version of a text from another.

When working directly on to stone, guide lines for writing were drawn either with a very hard pencil or a copper or brass point. There was a special device for ruling double lines which had a pair of points set into an adjustable arm. Sometimes, guide lines were added to control the slope of the writing. Complicated letters would normally have been treated as drawings and mapped out carefully in pencil with a point, or may have been traced through paper coated with red chalk. Cursive writing – even though done in reverse – would have been written freehand on ruled lines without any form of tracing so as to keep a feeling of flow. When working on transfer paper, guide lines were either ruled in lightly with a pencil or made by using a blunt metal point on the reverse of the paper. By the last quarter of the nineteenth century at the latest, pre-ruled sheets of transfer paper could be bought from law stationers.[21] It was especially important that transfer paper was kept free of grease, and writers were instructed to avoid handling it, except at the edges, and to place a clean piece of paper under the hand when writing.

Corrections to written texts were made differently according to whether the work was done directly on stone or on transfer paper. Corrections were comparatively easy to make on the stone. If the writer recognized a mistake immediately it was simply a matter of wiping the wet ink from the stone. But if the work was dry, the offending parts could be lightly scraped away so that the surface of the stone was freed from any trace of grease and could be written on again. It was much easier to make corrections before the stone was prepared for printing, which led Engelmann to point out that it was important to check each stone carefully before this stage was reached.[22] After preparation of the stone, the part to be corrected needed to be scraped away or, if it was large enough, ground down with pumice stone.

The making of corrections to writing done on transfer paper was a little more complicated and several writers on lithography made

[21] Richmond, *Grammar*, p.41.
[22] Engelmann, *Traité*, p.268.

the somewhat unhelpful comment that it was best to avoid them. The techniques adopted for making corrections did not seem to have changed much from the 1830s to the end of the century. Three different methods were described in the treatises, and they accord closely with the instructions written out by Sir Thomas Phillipps which are quoted in Chapter 4 (pp.85–86). If the part to be changed was large enough, the marks that needed to be deleted were washed clean with spirits of turpentine applied with a piece of linen, a camel-hair brush, or the feather end of a quill. Smaller areas could be deleted with an India rubber, though a paper mask was needed to protect the surrounding areas from being erased too. The third method, which was recommended for the smallest of all corrections, involved cutting out the offending marks and pasting down a new piece of transfer paper from behind. Though no writer mentioned this, it seems likely that extensive alterations (such as the re-writing of whole paragraphs) would have been best made by replacing large sections of the transfer paper. Small corrections or imperfections to the writing could also be made on the stone after the work had been transferred.

17. Trade card of the Bristol lithographic printer T. Bedford, from the 1830s, showing a range of jobbing work that includes lettering and writing. Image 150 × 199 mm.

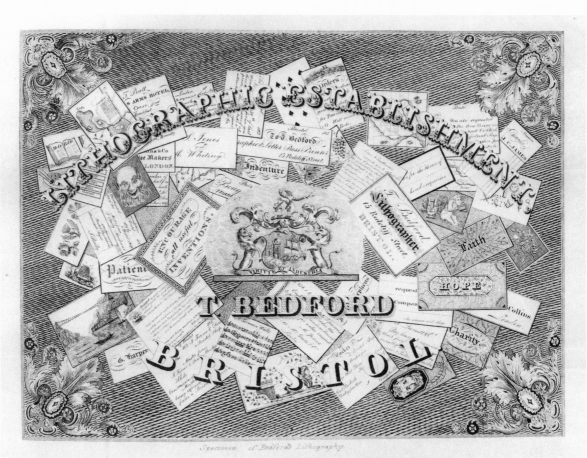

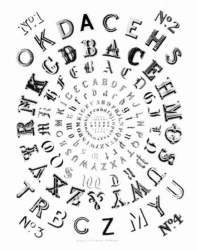

Pl. IV.

18. Alphabets in reverse for lithographic writers. From plate IV of L.-R. Brégeaut, *Nouveau manuel complet de l'imprimeur lithographe*, new edition enlarged by Knecht and J. Desportes (Paris, 1850). Image 110 × 425 mm.

19. A range of ornamented and other letterforms suitable for display purposes. Designed and written by B. P. Wilme for his *A manual of writing and printing characters* (London, 1845). Lithographed. Page size 276 × 215 mm.

[23] Other books that deserve mention are P. Dupont, *Essais pratiques d'imprimerie* (Paris, 1849) and J. E. Mettenleiter, *Schriften-Magazin für Freunde der Kalligraphie* (Leipzig, 1860).

Lithographic writing was frequently referred to and illustrated on contemporary trade cards [17] and, as we have seen, was discussed in some of the many lithographic treatises of the nineteenth century. It is clear from such sources that it was regarded as an important branch of the lithographic trade. The treatises give clear advice about the methods to be adopted when writing on stone or transfer paper and also describe how to make pens and prepare transfer paper and ink. Unfortunately, they tell us virtually nothing about when one method should be used rather than another, or about the procedures to be adopted when, for example, organizing information on the page. Styles of writing are rarely discussed either, though many treatises provided examples of writing and lettering. Some examples take the form of complete alphabets, and a few of these were drawn in reverse so that they could be used as models when working directly on the stone [18]. Such specimens give us some idea of the prevailing styles of writing and lettering. In addition, several other kinds of publications appeared in the middle of the century that provided examples of ways of arranging displayed lettering [19].[23]

The lithographic writer is a particularly elusive figure in historical terms. Anyone who could write was also capable of doing so on lithographic transfer paper, and some of the books discussed here look as though they were written by people with no great experience of this kind of work. Writing long passages of text in a neat and regular manner was quite a different matter, and so too, of course, was writing in reverse on the stone. There must have been specialists in such work, and it is possible that craftsmen skilled at engraving backwards on intaglio plates were initially recruited for the writing that had to be done in reverse on stone. Before long, however, the lithographic writer had emerged as a specialist within the lithographic trade. The evidence for this assertion is somewhat tenuous; it rests partly on the quality of surviving work and partly on references to lithographic writers in printed sources and on the imprints of lithographed items. In Germany, J. E. Mettenleiter was renowned for his lithographic

writing and calligraphy, and in Britain Robert Martin was working as a lithographic writer as early as 1819. But apart from Isaac Pitman, who had a prodigious output as a writer of shorthand on transfer paper, it has to be admitted that we know the names of few other people who devoted a lot of their time to lithographic writing. Lithographic writers rarely signed their work, and though I have kept a note of the signatures of every lithographic writer or letterer I have come across, whatever their field of lithography, I have recorded barely fifty names, monograms, or initials from the whole of Europe. Slight though this information is, I have thought it worth including at Appendix A so that others can add to it in the course of time. Very few of the books listed at Appendix B reveal the name of their lithographic writer, and in some of these cases, since the name appears only on the title-page, it is not at all clear how much of the book he or she was responsible for.

The quality and range of formality of lithographic writing in the books under discussion is extremely variable. It seems clear that some presses, among them Sir Thomas Phillipps's and the military press at Chatham, were not aiming at high-quality productions; but some publications, most notably a few of the music method books, must have been produced to stand comparison with books produced by more orthodox means. Nevertheless, however carefully a handwritten book was produced, it was bound to lack something of the visual authority of a letterpress production. It was presumably for this reason that a few of the books discussed here were given letterpress introductions and title-pages. Alternatively, some books which were printed throughout by lithography managed to achieve formality by having their title-pages and other features carefully lettered, or by transferring them from type matter. The range of formality of lithographed work varies considerably from the most casual, in which lines of copy are fairly arbitrarily placed and written informally in the style of writing used for the text pages, to well-executed pages with important words picked out in different kinds of decorated letterforms [20].

It must be evident from what has already been written that it would be grossly misleading to think in terms of there having been anything like a lithographic book trade during the first half of the nineteenth century. The links between lithographic book production and recognized publishing houses seem to have been negligible, and most of the books discussed in the following chapters were either privately distributed or were published by the institutions that produced them. The major exceptions to this were the phonetic publications of Isaac Pitman which, at the outset, were published by the London Bible publisher Samuel Bagster & Sons, and some of the music method books, which were published by well-known names in music publishing. Furthermore, no major

20. Title-page of J.-F. Français, *Précis des leçons du cours de topographie militaire* (Metz, 1824), showing a range of different styles of lettering. Signed Pierron. Page size 335 × 210 mm. [Cat. 3.18].

21. Examples of signatures in (top) A.M. Strobel, *Kleine für Kirche und Schule bestimmte Musikstücke* (Strasbourg, 1829); (middle) C.-S. Catel, *Trattato di armonia* (Rome, 1840); (bottom) Pitman's *Phonographic Correspondent* (London and Bath, April, 1871). [Cat. 1.200, 1.61, 5.37].

printer of lithographed books emerges from this study. All this seems to suggest that book production should not be considered an important branch of the lithographic trade in the first half of the nineteenth century. Though some leading lithographic printers, among them Ackermann, Clouet, Day & Son, the Duponts, Hullmandel & Walton, Lasteyrie, Robert Martin, Nethercliff, Senefelder, and Thierry *frères* produced lithographed books, not one of them appears to have specialized in this kind of work. What is more, the vast majority of the many treatises on lithography that appeared in the first half of the nineteenth century ignored book production entirely. The few that did not either had very little to say on the subject or merely showed by example that long passages of text could be printed lithographically. A small group of lithographic treatises that were written out by hand and printed lithographically is discussed in Chapter 13. For the most part, those books that were produced by lithography in the age of the hand press seem to have been treated as large-scale items of jobbing printing (just as, in recent years, in-plant printing houses have moved imperceptibly into book production having begun by taking on jobbing work).

It is hardly surprising therefore that lithographed books lack some of the features that have become part and parcel of letterpress book production over the ages. The most notable of these are signatures, which were taken over by printers from manuscript production as a means of identifying sheets and ensuring that they were brought together correctly into gatherings for binding.[24] Signatures are very rare in early lithographic book production, other than in the publications of Isaac Pitman (where they are nearly always present) and those of leading music publishers [21].[25] The only reference to signatures I know in contemporary lithographic literature appears in an article by Jules Desportes in the trade journal *Le Lithographe*.[26] Allied to the question of signatures is that of imposition schemes, the placing of pages on a sheet so that they appear in the right sequence when the sheet is folded and trimmed. It is clear that many improper books were printed four or more pages to view because, in addition to those examples with signatures, some others show printed fold marks in their back margins and, occasionally, similar marks for folding and trimming at their head margins. Many of these are music books, and the question of fold and trim marks is discussed in greater detail in Chapter 6. A few such items with untrimmed and unsewn pages allow us to see more or less intact a single sheet showing four pages to view [22]. It seems likely that many lithographed books would have incorporated such fold and trim lines to guide the binder, though in most cases they would no longer be visible. Imposition schemes in lithography would have been no

[24] For manuscript signatures, see G.S. Ivy, 'The bibliography of the manuscript-book' in F. Wormald and C.E. Wright (Eds), *The English library before 1700* (London, 1958), p.47–48. For signatures in letterpress books, see R.A. Sayce, 'Compositorial practices and the localisation of printed books, 1530–1800', *Library*, vol.21, March, 1966, pp.1–45.
[25] Signatures are to be found in the following items in the Catalogue at Appendix B: 1.13, 1.19, 1.48–1.50, 1.61, 1.65, 1.66, 1.77, 1.81, 1.83, 1.84, 1.99, 1.103, 1.171, 1.183, 1.184, 1.199, 1.200, 1.235–1.237; 2.2; 3.18; 3.21; and in most of the shorthand books of Isaac Pitman (5.1–5.66).
[26] J. Desportes, 'Autographie', *Le Lithographe*, vol.2, 1839, p.37.

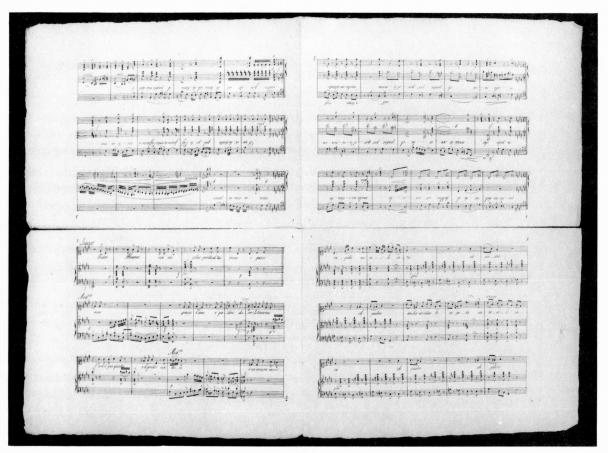

22. D. Capranica, 'Scena e duetto "Che dicesti? Il figlio?" nell'oratorio Isacco', shown here with pages 2, 3, 8, & 9 to view. Fold marks are just visible at the head of p.2. Pressure marks from the stone lie about 25 mm beyond the printed image, though they are not visible in this reproduction. Printed by the Litografia delle Belle Arti, Rome, c.1855. Sheet size 536 × 744 mm.

[27] Desportes, 'Autographie', pp.113–115. Knecht also referred to imposition schemes in his *Nouveau manuel complet du dessinateur et de l'imprimeur lithographe* (Paris, 1867), though this book was based on an earlier publication by Brégeaut and Desportes; the section on imposition in both these books relates closely to Desportes's earlier account of it.

different from those used in letterpress book production, and would therefore have been understood by those lithographers who worked in both areas. The French lithographic printer Jules Desportes appears to have been the only person to have written about lithographic imposition schemes in the first half of the nineteenth century, though, significantly, he noted that lithographers were not often called upon to print books.[27]

Very little precise information has come to light about the edition sizes of improper books, though it is certain that some were very small. For example, Georgiana Spencer's *Passage du Mont saint-Gothard* (Paris, c.1817) is reported as having been printed in just fifty copies and Hunt's *Specimens of lithography* (London, 1819) in sixty copies. The *Catalogue of books in the Library of the Military Dèpot* (London, 1813) may well have been printed in several copies only. It seems very unlikely that many of the privately published books listed at Appendix B would have been printed in more than a couple of hundred copies. It is worth noting that the majority of the edition sizes listed by Martin for privately printed books of the first half of the nineteenth century (most of which were letterpress productions) lie between twenty-

23. *Statement of general average and special charges on cargo: case of the steamer 'Westford'* (New York, 1923). A late example of a workaday handwritten lithographed book. It presents the findings of the loss adjusters Johnson & Higgins, and runs to 463 pages, many of them consisting of tables. Page size 340 × 245 mm.

24. R. N. Chubb, *The heavenly cupid* (Fair Oak, 1934). The second of Ralph Chubb's lithographed books, written on transfer paper and printed from stone. Page size 390 × 285 mm.

28 Martin, *Bibliographical catalogue*, 1854.

five and one hundred, with fifty being the most typical figure.[28] There is no reason to believe that lithographically printed books that were privately published would have been substantially different in their edition sizes. The exceptions were probably the music method books of leading publishing houses, which must have been printed in larger editions than this, and some of Pitman's shorthand publications, which certainly ran into four figures.

Though straightforward line images on stone were capable of standing up to runs of tens of thousands, lithographic printing was, as has been mentioned already, slow at the machining stage when compared with letterpress printing. For this reason, and because some of those who decided to use lithography for book production in the age of the hand press were not primarily interested in commercial aspects of publishing, the total output of lithographed books in our period must have been minute when compared with letterpress production. It is hardly surprising therefore that such books are now extremely difficult to find. While I have seen as many as seven of the fifty copies of Georgiana Spencer's *Passage du Mont saint-Gothard*, and though many copies of Champollion's *Grammaire égyptienne* (Paris, 1836–41) and *Dictionnaire égyptien* (Paris, 1841–43) must survive in the major libraries of the world because of the importance of their texts, I have been unable to trace more than single copies of many of the publications listed in the Catalogue at Appendix B. It follows that others must have disappeared without trace and that the subject of this book has not developed to a stage that will allow variants to be studied in a systematic way.

It is no part of the argument of this book that lithographed books produced in the age of the hand press led inexorably to the lithographed book of today. Indeed, I do not believe this to have been the case. Even the photolithographed facsimiles of the 1860s discussed in Chapter 12 relate only distantly to present-day issues in book production. What is more, books of the kind I have described continued to be produced as alternatives to traditional letterpress books for a long time after the close of our period [23]. And in the field of Egyptology scholarly books that incorporated hieroglyphs continued to be written out by hand and printed lithographically even after photocomposition was available.

In the Preface, I refer to a book lithographed throughout by Ralph Chubb which was published in 1960. This was the last of a series of his illustrated books which he wrote out by hand on transfer paper and printed on his own lithographic press [24]. Had these books been produced a century earlier they would have fallen neatly into Chapter 9 on books with pictures. Many French *éditions de luxe* of this century with illustrations by noted artists

25. F. Hölderlin, *Hymne an die Freiheit* (Berlin, 1919), designed and written by Jan Tschichold when seventeen years old. Printed lithographically, hand-coloured initials. Page size 330 × 260 mm.

26. Catalogue issued by the firm Bever Zwerfsport, The Hague, Summer 1980. Written out by hand and printed lithographically. Page size 210 × 149 mm.

29 See E. J. Simmons, *Introduction to Tolstoy's writings* (Chicago & London, 1968), p.157. In his earlier book, *Leo Tolstoy* (London, 1949), Simmons refers to these versions of *The Kreutzer Sonata* as 'hectograph copies' (p.490).

have also been lithographed throughout. In addition, some notable calligraphers, including Monica Bridges, Graily Hewitt, Jan Tschichold, and, in recent years, Gerrit Noordzij, have used lithography as a means of multiplying books written out in their own accomplished hands [25]. Lithography has also been used as a means of circumventing censorship. Perhaps the best example of this concerned Tolstoy's *The Kreutzer Sonata* (completed in 1889). The novel was censored in Russia because of its sexual nature, but it circulated in manuscript copies and in a lithographed version, thereby commanding a high price as contraband literature.[29] More recently, writers with no great literary pretensions have used the opportunities offered by instant-print houses to produce low-cost publications, such as alternative cookery books and catalogues [26]. All these publications are in the tradition of improper books of the first half of the nineteenth century in that they are alternatives to the proper books of the period.

Today there are several ways in which an author, illustrator, or calligrapher can produce an alternative book, but in the first half of the nineteenth century the position was very different. In fact, the only thing that makes the extremely varied groups of texts discussed in the following chapters to some extent homogeneous is that they made use of the only serious alternative to letterpress printing available at the time. The producers of these books turned to lithography rather than to other processes because no other method met their needs nearly so well.

What these early lithographed books contributed to book design and production at the time was probably negligible: there were not many of them and, with a few notable exceptions, they would not have been widely read. Moreover, they vary considerably in their size, extent, degree of formality, and design, and therefore do not form a very recognizable group in terms of their physical appearance. The most casually produced of them do not look as though any attempt could have been made to organize their material in a way that would be helpful to the user, whereas some of the finest made an excellent job of translating conventions of letterpress books into lithographic terms. A few – perhaps out of ignorance of book conventions – even made innovations in design, the most remarkable of these being the use of asymmetric facing pages. To my knowledge this method of organizing pages was used for the first time in the history of printed book production in early lithographed books; and it was used consistently in the course units produced by the School of Military Engineering at Metz, which are discussed in Chapter 3.

Nevertheless, it has to be pointed out that few works of great elegance and no masterpieces of book design and production are described in this book. Anyone who turns to the following pages

with such things in mind will be disappointed. The essential contribution of these lithographed books was to make it possible, both technically and economically, to publish certain kinds of texts in a period of great intellectual, technical, and social change. Among other things, lithography facilitated the production of major works on Egyptology, such as Champollion's *Grammaire* and *Dictionnaire*; it gave Isaac Pitman the opportunity to promote his system of shorthand; it made possible the production of facsimiles of documents of historic importance, including *Domesday Book* and Shakespeare's first folio; it gave us Edward Lear's *Book of nonsense* and the precursors of the comic strip; and it opened the way to the multiplication of cheap instructional texts. Any process that did all this has to warrant a place in the history of the book.

Lithographic incunables

It seems likely that our understanding of the earliest book production by lithography, that is, of books which have their text matter printed mainly or entirely by the process, is very fragmentary indeed. Books of this kind were usually published in small editions, many of them on an informal basis, and there can be little doubt that some have disappeared without trace. All the same, we can be fairly confident in stating that the first serious attempts to produce whole books by lithography were made in Germany. Most of the earliest recorded examples of lithographic book production stem from there, and specifically from Munich, which was the birthplace of lithography and remained the centre for the commercial development of the process long after Paris, London, and other centres became important for the production of pictorial lithographs.

What evidence there is suggests that the writing of passages of text on stone and the invention of lithography went more or less hand in hand, and that lithography began as a process for printing words rather than pictures. Senefelder made it clear in his treatise that he experimented with different methods of printing because he wanted to publish his own plays more cheaply than traditional letterpress methods would allow; and it was these experiments that led him to use what we now call lithographic stone as a printing surface and, ultimately, to the discovery of the planographic process of lithography.[1] It is not known what Senefelder produced in this developmental period that could be classed as a lithographed book, but in his treatise he refers to two undertakings that warrant our attention.[2] The earlier of the two is a small copybook for young girls which he undertook for J. M. Steiner, then Director of the Royal Establishment for Schoolbooks. He described it as having been written in a German script and admitted that it turned out to be of only average quality – a surprising admission for Senefelder – because he had not practised this style of writing sufficiently. No copy of this work appears to have survived, but we can be fairly sure that it must have been produced by relief etching on stone, because Senefelder refers to it in his

[1] See Twyman, *Lithography*, pp.3–12.
[2] A. Senefelder, *A complete course of lithography* (London, 1819), pp.28–29; A. Senefelder, *The invention of lithography*, translated from the Munich edition of 1821 by J. W. Muller (New York, 1911), pp.22–23.

treatise before he considers the invention of lithography proper in 1798–99. The second of the two books was referred to by Senefelder in the context of the development of the planographic branch of lithography. He explained that he was faced with the problem of writing a prayer book on stone for Steiner's institution, which was to be done in a cursive hand and, of course, in reverse. The prospect of this task seems to have alarmed Senefelder to such a degree that he tried to find an easy way out of the problem. In doing so he developed the idea of transfer lithography, which allowed him to write the normal way round with greasy ink on specially prepared paper and then transfer the image to stone. As it happens, this idea opened up the way for the discovery of the planographic branch of lithography, which is his real claim to fame. Senefelder made no further mention of this prayer book in his treatise, and it is completely in line with what we know about the character of the inventor of lithography that he should have become so excited by his experiments that he may not have finished the work. But if he did manage to do so, no copies appear to have survived.

The earliest surviving lithographed book that I know of is the important catalogue of Mozart's work edited by A. André: *Thematisches Verzeichniss sämmtlicher Kompositionen von W. A. Mozart* (Offenbach, c. 1805) [27, 28]. This work was printed and published by the well-known music-publishing house of Johann André, and two copies of it are preserved in the British Library.[3] It is an octavo book and consists for the most part of verbal descriptions of the entries on versos and their opening bars on rectos. It is by no means an ordinary book in terms of content and has much in common with the music method books which are discussed in Chapter 6. André's press in Offenbach was one of the earliest to practise lithography in Germany. Johann André had bought the rights to Senefelder's new process in 1799,[4] and used it regularly for his music publications from the following year onwards.[5] This catalogue of Mozart's works would therefore have presented André with few production problems, though it appears to have been printed four pages to view whereas most of his early lithographed music was printed one page at a time.[6] It has no signatures, but the method of working can be deduced by comparing the slightly varying positions of the printing on the pages of the two copies in the British Library.

Mozart's *Thematisches Verzeichniss* has parallel title-pages,

[3] Hirsch iv 1062; M.e.l.(2).

[4] See Twyman, *Lithography*, pp. 12–13.

[5] See O. E. Deutsch, *Musikverlags Nummern* (Berlin, 1961), p.6, and *Die Andrés*, exhibition catalogue (Stadtmuseum Offenbach, 1974), p.33. Deutsch gives 1801 as the year in which André first used lithography for his music printing, but the first items of lithographed music to come from his press were published in 1800 and have the plate numbers 1480 and 1502. For a discussion of André's early lithographed music see M. Twyman, *Lithographed music: the first fifty years* (in preparation).

[6] The methods used for printing music by lithography are discussed in Twyman, *Lithographed music*.

27, 28. A. André, *Thematisches Verzeichniss sämmtlicher Kompositionen von W. A. Mozart* (Offenbach, c. 1805). Printed and published by J. André. The German-language title-page and a typical double-spread. Page size 244 × 155 mm. [Cat. 1.4].

one in German the other in French. Both include some features of displayed typography: in the German version Mozart's name is picked out in decorated capital letters of the kind commonly found on music titles of the period; in the French version it is in a much larger size of the hand used for the rest of the book, known in France as *anglaise* and in Britain as copperplate or round hand.[7] There are also separate forewords for the two languages and, though they run to just a single page each, they are the only pages in the book that might be described as straightforward text pages. In both cases the right-hand margins are ragged, though some attempt must have been made to keep the irregularity within bounds because there are many word breaks at the ends of lines (seven on the German page and six on the French one). The texts of these two forewords are in a cursive *anglaise* hand, whereas the catalogue entries which form the bulk of the work are slightly more formal and have, for the most part, unjoined letters. The whole production is accomplished in terms of both origination and printing: its writing is elegant and regular, its margins are fairly constant, it has page numbers and, in general, it has the feel of a real book.

André published a further lithographed edition of the same work with the title *W. A. Mozart's thematischer Catalog* in 1828. It takes a very similar form, but is much more elegant; it has a fine displayed title-page and the catalogue entries, which include upright, bold, and italic letterforms, were made to look as much like traditional printing as possible. At first sight the letterforms appear to have been transferred from type, but on closer inspection it is obvious that they were not.

Mention should also be made here of two other André publications: M. Clementi, *Méthode pour le piano forte* (Offenbach, nd)

[7] The term 'round hand' was used by the writing masters of the seventeenth and eighteenth centuries; 'copperplate' is the more popular term and is used here partly for this reason and partly because the forms of such letters, particularly in the nineteenth century, were condensed and distinctly unround.

29. J. C. F. von Aretin, *Über die frühes-
ten universalhistorischen Folgen der
Erfindung der Buchdruckerkunst*
(Munich, 1808). Letterpress title-page.
Page size 255 × 200 mm. [Cat. 1.9].

and J.-L. Duport, *Essai sur le doigté du violoncelle* (Offenbach, nd).
Although they are undated, their publication numbers (2738 and
2599) indicate that they must have appeared around 1809.[8]
Duport's work is a major item which runs to 165 pages, whereas
Clementi's is a single-section work of only thirty-one printed
pages. Both combine continuous text with short passages of music
and are discussed in greater detail in Chapter 6 on music method
books. With the Mozart catalogue of 1805, they suggest that
Offenbach played an important part in the early development of
lithographic book production.

We must now return to Munich to consider the first litho-
graphed books that have survived from the birthplace of litho-
graphy. The earliest of them provide a foretaste of an important
category of work which is discussed in more detail in later chap-
ters, the production of facsimiles of old documents. It is sufficient
to refer here to J. C. F. von Aretin's *Über die frühesten univer-
salhistorischen Folgen der Erfindung der Buchdruckerkunst*
(Munich, 1808) [29, 215, 216],[9] which contains a nine-page fac-
simile of a piece of very early printing, and to the first facsimile
edition of Dürer's marginal drawings for the Emperor Maximi-
lian's prayer book: *Albrecht Dürers Christlich-Mythologische
Handzeichnungen* (Munich, 1808) [217]. Neither of these publica-
tions involved the origination of material in terms of writing new
text, other than for preliminary matter. Aretin's book is a
thoroughly convincing facsimile of an existing printed text; the
Dürer facsimile merely reproduces the artist's original drawings
and does not even include the text around which they were made.

The first dated example of book production by lithography
involving the origination of pages of straightforward text matter
that I have come across is a pamphlet on the refinement of grain
by Heinrich Seel: *Abhandlung staatswirtschäftliche über die
Getraid-Reinigung* (Munich, 1809) [30, 31]. The page size of the
one recorded copy in the Winkler Collection is 190 × 115 mm.[10] In
addition to its sixteen text pages, it has a fine folding plate with
two crayon-drawn views of a grain-refining machine. The text is
evenly written in a German cursive hand and is placed on the page
so that the margins are similar to those normally associated with
letterpress book production of the period. The title-page is dis-
played in a centred arrangement using different sizes of a formal
copperplate hand (apart from the first line, which is in black-
letter), and some of its lettering reveals the kind of hesitation that
results from writing backwards on the stone. The text passages are
much more cursive and must therefore have been written the right
way round on transfer paper. The line increments of the text pages
vary from page to page and full pages contain between eighteen
and nineteen lines of text, though all appear to be of similar depth.

[8] Deutsch, *Musikverlags Nummern*, p.6.
[9] L. Dussler, *Die Incunabeln der
deutschen Lithographie* (Berlin, 1925),
Alois Senefelder, 46.
[10] R. A. Winkler, *Die Frühzeit der
deutschen Lithographie* (Munich, 1975),
871:8.

30, 31. H. Seel, *Abhandlung staats-wirtschäftliche über die Getraid-Reinigung* (Munich, 1809). Page size approx. 190 × 115 mm. [Cat. 1.189].

The lines are fairly even in length and, in order to achieve this, words were broken at the ends of many lines. No obvious reason can be advanced for the use of lithography for this book, other than economy in short-run publishing; the text is absolutely straightforward and contains no tables or diagrams that might have suggested the use of lithography, and its one set of illustrations is included as a separately printed plate.

In the next decade several small books, mainly of *Taschenbuch* size, are known to have been produced by lithography in Germany. Some of them were printed anonymously, but one whose printer can be identified is *Mercur: ein Taschenbuch zum Vergnügen und Unterricht mit Bemerkungen auf das Jahr 1816* [32, 33], which carries the imprint of the Königl Armen-Beschäftigungs-Anstalt am Anger in Munich. The main body of the book consists of ruled pages for every month, each one having a different pictorial heading of putti, delightfully drawn by J. F. Weber. The title-page is an accomplished design of antiqua and black-letter words, and is executed in a manner that suggests the writer already had considerable experience as a copperplate letterer before turning to lithography. The book also includes a frontispiece of Mercury drawn by Weber and a title-page vignette, which is assumed to be by the same artist. Another work from the same press, though of a routine kind by comparison, is an eight-page *Preis Courant* of the productions of the Königl Armen-Beschäftigungs-Anstalt. It is undated, but is probably of the same period as a single sheet prospectus of the same press which has been dated 1813 or 1814.[11] The pages of this *Preis Courant* are surrounded by double rules;

11 Winkler, *Lithographie*, 023.

32, 33. *Mercur: ein Taschenbuch zum Vergnügen und Unterricht mit Bemerkungen auf das Jahr 1816* (Munich, *c.* 1816). Lithographed at the Königl Armen-Beschäftigungs-Anstalt am Anger in Munich. The title-page (right) and a typical page from a hand-coloured disbound copy (below). Page size approx. 155 × 95 mm. [Cat. 1.153].

its text is written in a cursive German hand and its headings in copperplate.

A rather more ambitious piece of book production in the Winkler Collection stems from an anonymous Munich press. This is a selection of prayers, *Auswahl katholischer Gebete*, which was published by J. B. Oettl in Munich in 1819 [34, 35]. Its text runs to over one hundred pages of cursive German handwriting and is

34, 35. *Auswahl katholischer Gebete* (Munich, 1819). The text lithographed from handwriting. Page size approx. 165 × 100 mm. [Cat. 1.11].

placed within multiple borders of thin/thick/thin lines. The book has a frontispiece by Anton Falger, and its title-page is confidently displayed in a variety of decorated letters which are surrounded by calligraphic flourishes of the kind made popular by the writing masters of earlier centuries.

Other works produced in Munich in this early period that should be mentioned are a *Berechnung* compiled by Kolb senior

36. Kolb (senior), *Berechnung*
(Munich, 1815). Lithographed from
handwriting. Page size approx.
160 × 100 mm. [Cat. 1.130].

and published in 1815 [36], which takes full advantage of the
convenience of lithography for tabular work and includes hierar-
chies of rules, both horizontal and vertical; two sets of writing
models printed by Joseph Sidler dating from 1815;[12] and a series
of memorandum books published by J. G. Zeller the first of which,
Allgemeines Erinnerungs-Buch für das Jahr 181[?] [37, 38], was
written on stone by Clemens Senefelder (who may also have been
responsible for later issues too).

Munich and Offenbach were not the only places in Germany
where books were produced by lithography in the early days of the
process. Johann Baptist Lachmüller, the first lithographic printer
in Bamberg,[13] produced a book there: *Exerzier Reglement für die
Koeniglich baierische Landwehr* (Bamberg, 1817) [39, 40]. It was
issued in a quarto format (the only recorded copy is in the Winkler
Collection[14]) and consists of seventy-four pages of lithographed
text and two plates of military formations, one of them a folding
plate. It has no independent title-page, but the first page of the text
has a decorative and pictorial opening that displays the title. The
text is written in a cursive German hand and follows a stationery,
rather than a book, convention in having a wide margin to the left
of each page regardless of whether it is a recto or verso. These
margins are used on occasions for headings.

Berlin seems to have been involved with lithographic book
production at much the same time as Bamberg. The evidence for
this statement comes from the *Morgenblatt für gebildete Stände*
of 23 March 1819. It is reported there that Dr Friedrich Förster, a
teacher at the school of artillery and engineering in Berlin, had
written on stone in his own hand *Einleitung in die allgemeine
Erdkunde mit einer Vorschule der Feldkunde* (Berlin, 1818).[15] The
experiment was described some years later in *Le Lithographe* as a

37, 38. *Allgemeines Erinnerungs-
Buch für das Jahr 181[?]* (Munich:
J. G. Zeller). Page size approx.
180 × 90 mm. [Cat. 1.2].

[12] Winkler, *Lithographie*, 722:3,5.
[13] See F. Friedrich, *Bamberg und die frühe
Lithographie* (Bamberg, 1978).
[14] Winkler, *Lithographie*, 455.5.
[15] See also the *Bulletin de la Société
d'Encouragement pour l'Industrie
nationale*, vol. 18, p. 269, and the *Literary
Gazette*, no. 124, 5 June 1819, p. 360.
Förster's book is discussed in the *Literary
Gazette* under the heading 'Lithography.
The first Book printed by Lithographic
Writing'. Though no copy has been traced,
the book is listed as Cat. 1.101.

39, 40. *Exerzier Reglement für die Koeniglich baierische Landwehr* (Bamberg, 1817). Opening page and double-spread. The text lithographed from handwriting, the illustration drawn in pen and ink. Printed by J.B. Lachmüller, Bamberg. Page size approx. 210 × 175 mm. [Cat. 1.95].

success, and it was pointed out that lithography had considerable advantages over letterpress printing for mathematical works 'where it is more acceptable to find the figure drawn alongside the text than to look for it on a separate plate at the back of the book'.[16] This argument for what we would now call the 'integrated book' is surely among the earliest recorded pleas for bringing text and illustrations together in book production. Unfortunately, we are not able to see how well the book handled the problem since no copy has been traced. Like Lachmüller's book, however, it anticipates the more ambitious military publications lithographed at Chatham and Metz which are discussed in Chapter 3.

These early German publications, most of which must be considered fairly ephemeral, demonstrated that by 1820 lithography had come to terms with some of the basic problems associated with book production. All the same, they look just like manuscript books and, as far as their text material goes, their producers made few concessions to traditional book design, either in the style of the writing or its organization. Traditional cursive hands were used for all long passages of text and copperplate or other formal hands for headings and sub-headings. It is true that ragged righthand margins were made more regular than they would otherwise have been by copious use of word breaks, but the general impression these early German lithographed books give is very different from that given by letterpress books of the time. Their most characteristic feature, apart from looking like manuscripts, is the profusion of rules – not only in publications such as memorandum and read-reckoner books, where they are functional features, but also in the *Auswahl katholischer Gebete* where borders surround every page of text and even impinge on the beginnings and ends of lines. In an attempt to counteract their informal flavour, carefully lettered and well-organized title-pages were sometimes introduced. This was most obviously the case with the *Auswahl katholischer Gebete*, which has a title-page that compares quite favourably with some of the best copper-engraved examples of the period.

Before 1820, very little use appears to have been made of lithography for the production of entire books other than in Germany. No French examples have been traced, with the possible exception of Georgiana Spencer's *Passage du Mont saint-Gothard*, which may perhaps fall into this period, but is discussed in Chapter 9 together with other illustrated books. Lithography was hardly practised at all in France until after the *cent jours*, and it took a little time to get established thereafter.[17] When it did get off the ground, French lithographic printers seem to have been so concerned with satisfying the demands of those who wanted pictorial prints that they had little time for book work. Or perhaps

16 *Le Lithographe*, vol.2, 1839, p.238.
17 See Twyman, *Lithography*, pp.41–57.

it was that the high standard of French letterpress printing at the time had the effect of discouraging the use of lithography for the making of books.

In Britain the position was a little different, though in this country too lithography suffered a setback after an initial period of euphoria and did not pick up again until after 1817.[18] Rudolph Ackermann, one of those responsible for the revival of lithography in Britain, printed two facsimile works at his lithographic press in the Strand in 1817 and 1818. The earlier of the two was a further edition of Dürer's marginal drawings for the Prayer Book of the Emperor Maximilian, and the other a Roxburghe Club edition of a book originally printed by Pynson. These books were very much influenced by early German publications and broke no new ground, other than that they were produced in Britain. They are therefore discussed in Chapter 10 with other facsimile work in lithography. However, two other examples of British lithographed book production from before 1820 that have come to light can be regarded as special cases.

The earlier of the two is a *Catalogue of books in the Library of the Military Dèpot. Q.M. Gens. Office*, which was printed in 1813 [41–43]. It is a very odd production and is now to be found in a single copy in the Library of the Ministry of Defence in London. It is a folio volume and runs to 118 pages when 'Miscellaneous addenda' between parts are included.

The catalogue itself is classified into sections and each of its pages has five columns, which are separated by rules. Entries for books and some other details were printed lithographically, but plenty of space was left for additional items and comments to be put in afterwards by hand. It seems likely, therefore, that no more than a handful of copies were printed. Capital letters appear at intervals on the pages as guides to the user when entering items and looking them up. In terms of paper consumption per copy, this is by far the largest piece of lithographic book production from before 1820 that has been traced, but it cannot begin to be compared in quality or complexity with many of the early German works discussed above. Its writing is rather more cautiously executed than the cursive hands used for most of the German books that have been discussed; each letter is separate from its neighbour, and the writing is stilted, uneven, and totally lacking in style. Its title-page makes a brave attempt at display typography. It presents a variety of letterforms, including an outline letter with bracketed slab serifs, all of which are organized within a geometrically patterned border. Beneath the main lettering, but within the border, the title-page proudly declares: 'Printed from Stone in the Year 1813. Written with Chymical Ink, by J. Wyld, Draftsman.'.

41. Title-page of the *Catalogue of books in the Library of the Military Dèpot. Q.M. Gens. Office* (1813). Written on transfer paper by James Wyld and printed by the press at the Quarter-Master-General's Office in Whitehall. The outer border on the title-page is pasted down from a separate working. The first book printed by lithography in Britain. Page size 382 × 240mm. [Cat. 1.60].

[18] See Twyman, *Lithography*, pp.26–40.

ENGLISH WORKS.

History, Chronicles, Memoirs &c.

Remarks	Book Case		No of Vol	Size
		Q		
		R		
	21	Rapin's History of England continued by Tindal, see History	5	Fol.
	17	Reign of Charlemagne, by Card Longman London 1807	1	8vo
Black Letter	16	Roberts of Gloucesters Chronicle, by Hearne at the Theatre Oxford 1724	2	8vo
	21	Robertson's History of Scotland during the Reigns of Q Mary and King James VI 9th Edition Millar London 1761	2	4to
together 8 Vol. 4to	21 of the Reign of Charles V Wm Strahan Do 1769	3	4to
	21 Do of America and India 1777 - 1791	3	4to
	26	Rushworth's Historical Collections, see Historical	8	Fol.
	20	Ricauts Ottoman Empire in the present State Starkey London 1670	1	Fol.
	20 History of the Turkish Empire, 1623 &c. Do Do 1680	1	Fol.
	20	Ripperda, Duke, his Memoirs, with Bings Expedition to Sicily	1	8vo
		S		
	22	Scotts Ferishta's History of the Dekkan see History	2	4to
Plans &c	21	Siege of Breda, translated from the Latin of Hugo 1627	1	4to
Plans, Views	21 of Gibraltar, History of the, by Drinkwater Spilsbury London 1785	1	4to
	22	Sketch of a Political History of India, by Malcolm see Observations	1	8vo
V		Speeds, John History of Great Britain 2d Edition G. Humble London 16--	1	Fol.
	20	Stafford's Pacata Hibernia, see Pacata	1	Fol.
	21	Stevens's History of Spain, see History	2	Fol.
Recd from the Author	21	Slotherts Narrative of the Campaign in Portugal 1809 10 and 11 Martin London 1812	1	8vo
	17	Stutterheims Battle of Austerlitz, by Col Coffin	1	8vo
Map, Views &c	21	Shetland Islands, History of the, by Hibbert London 1822	1	4to
		T		
	22	Tarleton's Lt Col History of the Campaigns 1781 N America Cadell London 1787	1	4to
	14	Transactions (Military) of the British Empire from 1803 to 1807, by Col Gordon 1808	1	4to
	17	Trial of Lord George Sackville Owen London 1760	1	8vo
Views	7	Tracts relative to the Island of St Helena by Dr Beatson London 1816	1	4to
		Treaty of the Congress at Vienna 9th June 1815	1	Fol.

42. Catalogue page of the book shown in 41. Lithographed; some entries added in ordinary writing ink.

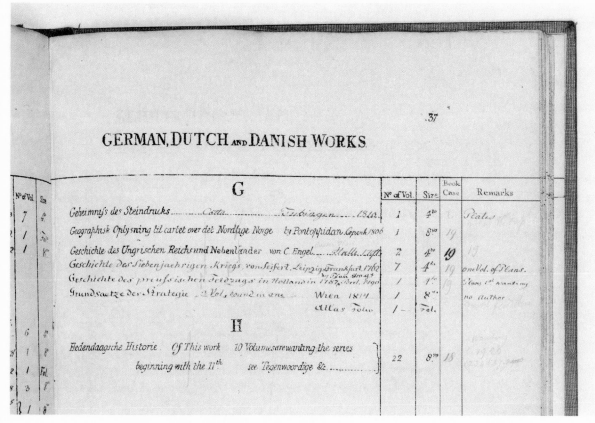

43. Detail of a catalogue page of the book shown in 41. The particular part shown records the library's copy of H. Rapp's *Das Geheimniss des Steindrucks* (Tübingen, 1810), which was the first monograph published on lithography anywhere. Lithographed; with considerable additions in ordinary writing ink. Approx. 180 × 240 mm.

James Wyld, who later set up as a lithographic printer and became well known as a geographer, was the father of the more famous cartographic publisher of the same name. At the time, he was employed as a draughtsman at the Quarter-Master-General's Office in Whitehall.[19] A lithographic press had been established there by May 1808 when its first production, a Plan of Bantry Bay, was printed. Subsequently the press was kept busy printing maps, plans, and circulars for several government departments.[20] The catalogue of the library of the Military Depot appears to have been its only piece of real book production to have survived, though an eight-page folio leaflet was printed there in 1818 [see Cat. 1.238], and other work of this kind may have been produced too. The press of the Quarter-Master-General's Office was the first in Britain to make use of transfer paper.[21] It began to do so in July 1813 and the printing of this catalogue of the Military Depot Library must have been one of the first major applications of the process in Britain.

The second of the two early examples of British lithographed book production to be discussed here is equally odd, but rather more significant for the future development of lithography than the catalogue of the Military Depot Library. It is especially important in relation to the use of lithography for the multiplica-

[19] The *Royal Kalendar* for 1820 lists him as an assistant to G. Pawley (Military Draughtsman), p.176.

[20] See Twyman, *Lithography*, pp.33–34.

[21] *Foreign Review and Continental Miscellany*, vol.4, no.7, 1829, p.49.

44. G. Hunt, *Specimens of litho-graphy* (London, 1819). Written on transfer paper and printed by C. Marcuard, Chelsea, in 1818. The principal title-page. Page size 200 × 157 mm. [Cat. 1.118].

tion of non-latin scripts, and was produced in order to allow those concerned with oriental languages to judge for themselves how suitable the process was for this purpose. The book was compiled by the Rev. George Hunt and was given the title *Specimens of lithography* on its principal title-page [44] and 'Specimens of stone printing' on what might be called its second or subsidiary title-page [45]. It consists of passages of Hebrew, Syriac, Arabic, Persian, Ethiopic, Chinese, Bengali, and other languages [46], all printed in lithography by C. Marcuard of the Kings Road, Chelsea. The main title-page is dated 1819, though surviving records show that the printing of the book must have been completed by 26 December 1818.[22] The book is a severely trimmed foolscap quarto and opens from right to left in the following sequence: title, blank, blank, foreword, second title, pages 2–32. Evidence gleaned from an inspection of several copies of the book, together with information from surviving documents, tell us something about its production. The texts were written on transfer paper, eight sheets having been used for the entire production. The pages were probably printed four to view and the edition was sixty copies only. There is good reason to believe that not everything went well with the printing, as the copy that Hunt presented to the Society of Antiquaries on 29 April 1819 carries the signed and seemingly despairing inscription 'This copy is one of the *best* impressions though some of the pages have changed their places in printing'. Other copies that have been inspected have their pages in the correct sequence, so it seems likely that it was the gathering of the sheets of the copy sent to the Society of Antiquaries that was wrong rather than the imposition.

The copies of *Specimens of lithography* that have been studied are tolerably even and regular in colour and are cleanly printed (apart from indications of scumming up where edges of the stones show in the margins). However, some parts of some pages have failed to print properly, particularly on pages 11 and 14, and all the copies I have seen have some manuscript retouching on page 14. In terms of design the book is organized fairly conventionally – given that its content is far from conventional. Each page of information is organized within a traditionally placed 'type area', which accords broadly with the borders of the title-page. The English text is written in a neat, but not particularly distinguished, copperplate hand, possibly by Hunt himself. Slab-serif letters have been used for the title on the main title-page, and an outline version of similar letterform appears on the subsidiary title-page: both these examples of lettering suggest that they were produced by a not particularly gifted amateur.

Little is known about C. Marcuard,[23] the printer of this volume, and he does not appear to have stayed in business long. Neverthe-

[22] MS account of C. Marcuard, dated 26 December 1818, in the St Bride Printing Library, London. A second account with the same date gives slightly different figures.

[23] He may have been related to Robert Samuel Marcuard, 1751–c. 1792, who was one of Bartolozzi's best pupils and made engravings after many well-known contemporary painters.

45. G. Hunt, *Specimens of lithography*. Second title-page, with Hunt's introduction.

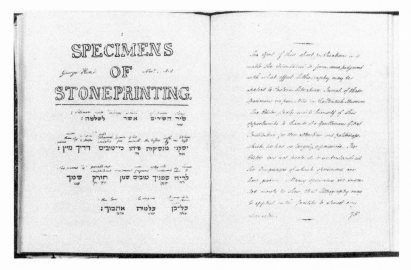

46. G. Hunt, *Specimens of lithography*. Double-spread showing several non-latin alphabets.

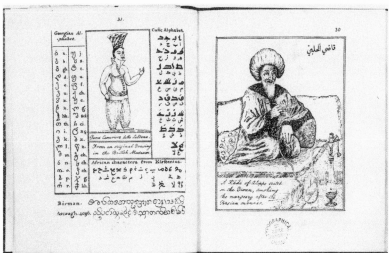

less, he provides us with a tenuous link with the press at the Quarter-Master-General's Office, because the copy of the first German treatise on lithography listed in the lithographed catalogue of the Library of the Military Depot has pasted into it a chalk drawing of a female head with the note 'Printed from Stone at the Military Depot, drawn by Mr Marcuard, H. gds. 23d. Jany. 1815.'[24] Marcuard's name also appears on one of the many lithographed maps printed at the Quarter-Master-General's Office (dated Feb. 1815) and now in the British Library's map collection. This connection between Marcuard and the press of the Quarter-Master-General's Office may help to explain the use of similar kinds of display lettering on the title-pages of the two publications discussed here, since slab-serif letters were by no means common, even among letterpress printers, in this period.

[24] Twyman, *Lithography*, p. 34, n. 6.

47. The *Parthenon*, no. 1, 11 June 1825. Printed by Ross and Co. at the Typolithographic Press, London. This number has its text matter transferred from type. Page size 235 × 157 mm. [Cat. 1.171].

Hunt's *Specimens of lithography* is a landmark in British lithography; it is also of wider significance in terms of the reproduction of non-latin texts. But whether it was 'The first Work printed in England by Lithography', as Hunt claimed in a manuscript note accompanying one copy of the book,[25] is very much a matter of interpretation.

Finally in this chapter on lithographic incunables, we should consider another unusual early British work, the *Parthenon* (1825), which was the first journal to be produced anywhere entirely by lithography [47–49]. Though it appeared much later than the other works discussed in this chapter, it seems appropriate to mention it with the incunables of lithographic book production because of its priority in periodical publishing and because of the particular techniques employed in its production. In its prospectus the *Parthenon* describes itself as a magazine of literature and art. It was published weekly in London by Black, Young, and Young of Tavistock Street, Covent Garden, and ran from 11 June 1825 to January 1826 (sixteen issues in all). It was printed from stone by Ross and Co. at the Typolithographic Press, White Lion-court, Wych-street, London, using their own special process which they called Typolithography.[26]

This new process was described in a short note at the end of the first number of the journal, which explained that it was called typolithography '... because it produces the effect of typographic printing, through the medium of stone.'. The note goes on to give the following brief technical description: '... the types of Mr. M'Millan, of Bow-street, which we have employed for this purpose, are impressed upon stone, after being composed in the usual manner.'. There is no mention of the use of transfer paper in this context; if we are to take this description literally the types of M'Millan were impressed directly on to the stone and must therefore have been right-reading.[27] On the other hand, transfer paper appears to have been used for at least some of the illustrative material of the journal, and this is hinted at in the following passage from the prospectus:

[25] St Bride Printing Library, London, 25789.

[26] For David and William Ross, both of whom seem to have been connected with typolithography, see W. B. Todd, *A directory of printers and others in allied trades London and vicinity 1800–1840* (London, 1972), and M. Twyman, *A directory of London lithographic printers 1800–1850* (London, 1976).

[27] Right reading types (called reversed types) were referred to by L. A. Legros and J. C. Grant in *Typographical printing-surfaces* (London, 1916), p.108. A patent was taken out for them in Britain by M. Guthrie in 1864 ('Type cut in reverse for reverse printing', no.970), but there was no real demand for such types until the development of offset printing.

[28] There is a copy of this prospectus in the John Johnson Collection, Bodleian Library. In the passage from the prospectus printed here, ellipses replace actual examples of the kind of work discussed. In the original the words 'Facsimile' and 'Curious Manuscripts' were put in by hand in an appropriate style of lettering.

The Ornamental and Illustrative Prints of this Journal will be executed in various styles; but Pen and Ink Sketches, in the following manner, will be the kind most frequently introduced The pieces of Music thought worthy of insertion, will sometimes be printed from Musical Types transferred to Stone, as . . . And at other times from written characters – in this manner: . . . Besides the advantage of being thus enabled to enrich the pages of a Periodical Paper with Transcripts of the finest Specimens which the arts of Painting and Music can supply, Facsimile Representations of Curious Manuscripts may be given, and, if desirable, incorporated in the same page with the typographic matter.[28]

The *Parthenon* was issued as a super-royal octavo of sixteen pages stitched in a cover, price one shilling each number. Because some people had not realized that its prospectus was produced from stone – even though this had been made abundantly clear – the note about typolithography referred to above emphasized the novelty of the methods used for the production of the journal. And it was stated in the journal that the *Parthenon* and its prospectus demonstrated the first use of the method in any publication in Britain and, it was believed, in any other country.

The first few numbers of the *Parthenon* amply demonstrate the advantages of typolithography and include facsimiles of autographs, line sketches of works of art illustrating an outline history of Italian painting, and passages of music (some of which run to more than one page). The whole journal has the flavour of a letterpress production and, unusually for a lithographed publication, even carries signatures; it is hardly surprising therefore that

48. The *Parthenon*, nos. 4 and 5, 2 and 9 July 1825. These numbers have their text matter transferred from type.

scades, the waters

aspects in their fal

1 one side by steep

e distant villages,

ere and there am

some contemporaries failed to note that its prospectus was printed by a method other than normal letterpress printing. The type matter is mostly Brevier in size, but even goes down to Nonpareil in places, and at its best is sharp and evenly transferred [49]. The quality of the printing is surprisingly high considering the experimental nature of the methods used [50, 51]. All the same, there must have been production problems because, without a word of explanation to the reader, the numbers from 6 onwards had their text matter printed letterpress to much the same design [52, 53] with the non-text matter overprinted by lithography, sometimes using a second colour. In the bound volume of the journal issued on completion of publication, or at least in those copies that contain its preliminary matter, the publishers explained that '... the Title-Page, this Preface, the whole of the first five numbers, and various parts of the remainder ...' were produced by typo-lithography. But no explanation was provided for the change in production methods.

Despite this rather sheepish return to orthodox methods and its very short life, the *Parthenon* is remarkable for its ambitious and technically daring foray into typolithography. Perhaps the technique was just that bit too complex to withstand the pressures associated with getting a weekly journal out on time. No publication seems to have used printing types again for the text of a lithographed book until the experiments of the Didot *frères* in the second half of the 1830s (see pp.135–139), and no journal was printed throughout by lithography again until Isaac Pitman began issuing his *Phonographic Journal* in 1842 (see pp.150–151).[29]

[29] I am excluding two mainly pictorial journals, the *Glasgow Looking Glass (Northern Looking Glass)*, 1825–26, which began by being lithographed, and the *Looking Glass; or, Caricature Annual*, which was produced entirely by lithography from no.8, 1 Aug. 1830 [see Cat. 1.110, 1.143].

50, 51. Details from the *Parthenon*, no.4, 2 July 1825, printed lithographically from transferred type. 65 × 115 mm and 10 × 35 mm.

52, 53. Details from the *Parthenon*, no.6, 16 July 1825, printed letterpress. 65 × 115 mm and 10 × 35 mm.

By considering some of the earliest examples of lithographed books together in one chapter it has been possible to highlight some of their general characteristics. Subsequent chapters explore specific categories of work that seem to have been regarded as appropriate for lithographic book production. It will become clear in the course of these chapters that most of the kinds of books discussed had their precursors in these incunables. Taken together, these early works provide evidence of the usefulness of lithography in just those areas of book production which letterpress printers found difficult, time consuming, and expensive to cater for. Although we have precise details about print runs in only one case, it seems clear that many of the lithographic incunables discussed above were printed in very small editions, which put lithography at an advantage over letterpress because of its low origination costs. Some of them, such as the ready-reckoners, year books, and the library catalogue, involved the use of rules which, particularly if they had to appear to cross one another, were troublesome to letterpress printers. Others included passages of music, which brought their own very special problems of origination, or, as in Hunt's book, required non-latin characters for which no letterpress types were available. Facsimiles of old documents, both manuscript and printed, figure among the books discussed in this chapter, and so too do military publications. Both these categories were to loom large in lithographic book production in later years. It seems clear, therefore, that lithographic printers quickly identified weaknesses in the letterpress printer's armoury and soon set out to explore some of their own strengths.

The term 'incunables', which I have used for the title of this chapter, is borrowed from the study of early letterpress printing. Among other things, the study of letterpress incunables has taught us that it is dangerous to apply a simple chronological categorization to early printed books, particularly in relation to such features as formats, title-pages, and foliation and pagination. Similar dangers lurk for the student of lithographic incunables, and for this reason no precise dates have been ascribed to the incunabulum of lithographic book production. What would have been run-of-the-mill work in Munich around 1815 would have been considered unusual in other parts of Germany at the time, daringly experimental in Britain, France, and Italy, and would not have been possible in some other countries simply because lithography had not yet reached them. The term 'lithographic incunables' is used here, therefore, only in the sense that those books covered by it belong to the developmental stage of the process in their respective countries or centres.

As it happens, a few early lithographed books, and some later ones too, are rarer than many letterpress incunables. Only after

years of searching have some come to light. This chapter might appropriately end therefore with the frank but obvious admission that similar books to those discussed here might well have been produced in other parts of the world, and even in Britain, France, Germany, and Italy, without my knowing about them.

CHAPTER 3

Military manuals: the presses at Chatham and Metz

Lithography was taken up by several military establishments[1] because of its convenience for the production of maps and diagrams when compared with engraving, and its cheapness for continuous text in short-run work when compared with hand composition and letterpress printing. Two early examples of books associated with military needs which were produced entirely by lithography, a drill book published in Bamberg in 1817 and a book on geodesy published in Berlin around 1819, have been discussed in the previous chapter. In this chapter, two military establishments that made regular use of lithography for the production of their own internal texts will be considered: The Royal Engineer Department at Chatham and the École d'Application de l'Artillerie et du Génie at Metz.

The Royal Engineer Establishment at Chatham (later to become the Royal School of Military Engineering) was set up by Royal Warrant on 23 April 1812 as a school of military engineering under the control of the Royal Engineer Department. It was established as a consequence of the considerable losses suffered by the Corps of Royal Engineers, an exclusively officer corps, and the Royal Military Artificers (redesignated Royal Sappers and Miners in 1813) when attacking fortresses during the Peninsular War. Its initial brief was to produce trained military engineers at the earliest possible date so that they could be sent out to the Peninsula. At first the Establishment was solely concerned with fortresses, but as it developed it began to cater for other areas as well, such as construction and estimating, electrical and mechanical engineering, and surveying, and it also began teaching such subjects as telegraphy, signalling, chemistry, and printing (including lithography). The first Director, Major C. W. Pasley, played a seminal role in the development of the Establishment. Hero of the Napoleonic Wars, educational innovator and prolific writer on military matters, he grew in stature during his twenty years at Chatham, eventually leaving it as Major-General in 1841 to become Inspector General of Railways.

The headquarters of the Royal Engineer Department was in

[1] Others were the Royal Staff Corps, the Ordnance Department at the Tower of London, and the Quarter-Master-General's Office in Dublin. See *Foreign Review*, vol.4, no.7, 1829, p.49, and note 9 below.

London, at 84 Pall Mall, and it had its design team at the Horse Guards in Whitehall. This was the building where the press of the Quarter-Master-General's Office was housed. It seems probable that there was some link between the two lithographic ventures since it is recorded that G. Pawley, the draughtsman at the Quarter-Master-General's Office at the time, instructed a number of other bodies in lithography, including the Corps of Sappers and Miners.[2] Precisely when and under what circumstances the press of the Royal Engineer Establishment was set up at Chatham is not clear, but the first of its products that have been traced date from 1822 [Cat. 2.7, 2.14]. Severe economic measures were imposed on the armed forces after the Napoleonic Wars, principally in the period 1819–25, and the use of lithography instead of letterpress for the Establishment's own internal communications may perhaps have been a consequence of them.

Whatever the circumstances, however, it is hard to imagine that Pasley took a back seat. He had already proved himself to be an innovator and energetic organizer, and some of the very first productions of the Chatham press were written by him. Unfortunately, very little is known of the Chatham press itself, beyond the fact that it continued to operate for the production of instructional material until as late as 1948.[3] An account of what was called the 'Printing School' at Chatham, written by Sir Francis Head and published in 1869, indicates that by this time lithography was practised alongside letterpress and copperplate printing, and that there were three lithographic presses compared with one press each for the other processes.[4] At this time classes took place in one large hall under the instruction of a Serjeant-Instructor, and Head took special pride in the fact that the students all wore military uniforms. He stressed the educational side of the activities and, though referring to the savings to the country resulting from the printing of documents within the Establishment, pointed out that the primary objective was 'to enable it to render assistance to an army in the field.'[5]

We cannot be sure that these same conditions and objectives applied equally in the 1820s, but it can well be imagined that lithographic workers were required to wear military uniforms under the stern discipline of Wellington's army. The educational role of the printing activities at Chatham must have grown as the Establishment broadened its objectives over the years, and it seems likely that in its early days the lithographic press there worked more as a service department, providing circulars and plans for internal use.

The productions of the press that are of most interest in the present context are a series of small instructional manuals produced during the 1820s and early 1830s, several of which were

[2] *Foreign Review*, 1829, p.49.

[3] I am much indebted to the late Lieut-Colonel J. E. South who, when he was Librarian of the Royal Engineer Corps Library, Chatham, was extremely helpful in providing me with information about the work of the press.

[4] F. Head, *The Royal Engineer* (London, 1869), pp.171–178. Head served in the Royal Engineers between 1811 and 1825 and wrote at least one of the items lithographed at Chatham [Cat. 2.10].

[5] Head, *The Royal Engineer*, p.175.

54. *Rules for making fascines and gabions* (Chatham, 1823). Lithographed at the Royal Engineer Establishment for its own internal use. The footnotes are keyed to the text by means of conventional typographic symbols. Page size 212 × 130 mm. [Cat. 2.34].

written by Pasley.[6] Thirty-nine of these early instructional manuals are listed [Cat. 2.1–2.39] and some of them ran into further editions. The double-page spread shown here from *Rules for making fascines and gabions* (Chatham, 1823) [54] is fairly typical of these manuals. Most of them are around demy octavo in size, though the precise format cannot be established as the majority of those that have been seen are bound up in sets that may have been heavily trimmed. They range in extent from eight pages to more than a hundred, and many of them are illustrated. The word 'published' has been carefully avoided in this account of the work of the press since most of the manuals it produced carry the following note (or a very similar one) on the reverse of the title-page: 'Papers and Plans lithographed at the Establishment for the use of the Corps are not to be published or used as materials for publication'. The use of the word published here, rather than re-published, seems to suggest that these manuals were not considered to have been published in the ordinary sense of the word.

The writing out of the texts of these manuals is fairly free and must have been done on transfer paper [55, 56], and several different copperplate hands, all neat and regular, can be distinguished. Lines are ragged to the right, and normally no more than three or four word breaks appear on each page. The overall organization of the text pages is more like that to be found in letterpress books than in the early German lithographed books discussed in the previous chapter. Running heads, which were not used in the German books, are included in standard positions alongside folios; usually the title of the book appears on the verso and the topic

[6] The Royal Engineer Corps Library, Chatham, has copies of most of these manuals, and several copies of some of them.

under discussion on the recto. Some pages include footnotes, which are in a smaller size of writing and are keyed into the text by conventional typographic symbols [54]. Headings in the text appear in a larger size of writing than the main text and are sometimes underlined. Paragraphs are indented a regular amount of space. There is every reason to believe that the operation of producing books by lithography at Chatham was approached with a good deal of common sense. Some kind of 'house style' must have existed, and in this and other respects the press probably gained from being in touch with people with experience in letterpress methods. The major limitation of the lithographic methods being used is most glaringly evident in the title-pages, which are

55. *The exercise of military bridges of casks* (Chatham, 1822). Lithographed at the Royal Engineer Establishment for its own internal use. Page size 212 × 130 mm. [Cat. 2.7].

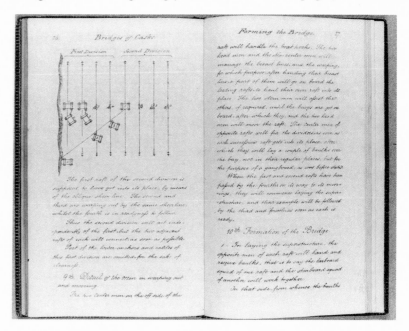

56. Detail of 55 showing an informal copperplate hand typical of writing done on transfer paper. 66 × 110 mm.

very simply displayed on a central axis in a mixture of unpretentious copperplate and blackletter hands [57, 58]. They could not have been given the degree of attention accorded to some of the early German title-pages and, as a result, some of the items have lines which are noticeably off-centre. Whereas lines of copy could be centred very easily when setting type, it required a considerable amount of pre-planning to produce well-centred lines of handwriting for lithography.

Most of the Chatham manuals include simple line drawings and diagrams. These mainly appear along with the text exactly where they are needed in terms of sense, and on occasions the text even runs around the illustrations [54, 59]. The anonymous reviewer who, a few years earlier, praised Dr Förster's book on geodesy because it brought text and illustrations together,[7] would surely have approved of such a design feature. Where tables occur, they are boxed, and lines are used to separate headings from the body of the table and to help define its columns. One manual, *Detail of the exercise of Light Infantry and the bugle sounds of the Royal Sappers & Miners* (2nd ed., Chatham, 1823), is notable in the context of British lithography of the period for its inclusion of four pages of lithographed music for the bugle calls. It cannot be said that the illustrative material in these manuals is particularly high in quality, but it has the merit of relating to the verbal instructions in a sensible way.

Signatures are visible on only one of these manuals [Cat. 2.2], but combined evidence from the pressure marks of stones and the variation in inking suggest that the normal practice at Chatham was to print four pages to view. Such an approach is consistent with the sizes of presses available at the time.[8] When pressure marks from the edges of stones are visible they appear very close to the written text, frequently as close as 5 mm and sometimes closer. It can be seen that the printer tried to get the pages to back one another up line by line, but only occasionally was this done with complete success. The quality of inking is also variable, even within one manual. Although these Chatham manuals fall short of the highest standards of lithography of the period, and are far from elegant, they provide excellent examples of utilitarian work designed for a purpose and within the capabilities of a production system. In this respect they are important precursors of more ambitious undertakings in this field.

The press at Chatham continued to function in the field of book production beyond the 1820s; a few examples of its work have been traced from the middle of the century, and one from 1877 [Cat. 2.36]. Nevertheless, the manuals printed there in the 1820s seem to have stemmed from an early enthusiasm for lithography that may not have been sustained. In the second quarter of the

[7] See above, pp. 46, 48, and also Cat. 1.101.
[8] M. Twyman, 'The lithographic hand press 1796–1850', *Journal of the Printing Historical Society*, no. 3, 1967, pp. 1–50.

57. Title-page of *A simple practical treatise on field fortification* (Chatham, 1823). Lithographed at the Royal Engineer Establishment for its own internal use. Page size 212 × 130 mm. [Cat. 2.37].

58. Title-page of C. W. Pasley, *Exercise of the new decked pontoons* (Chatham, 1823). Lithographed at the Royal Engineer Establishment for its own internal use. Page size 212 × 130 mm. [Cat. 2.19].

59. C. W. Pasley, *Exercise of the new decked pontoons* (Chatham, 1823). One of several productions of the Royal Engineer Establishment that integrate illustrations and text. Page size 212 × 130 mm. [Cat. 2.19].

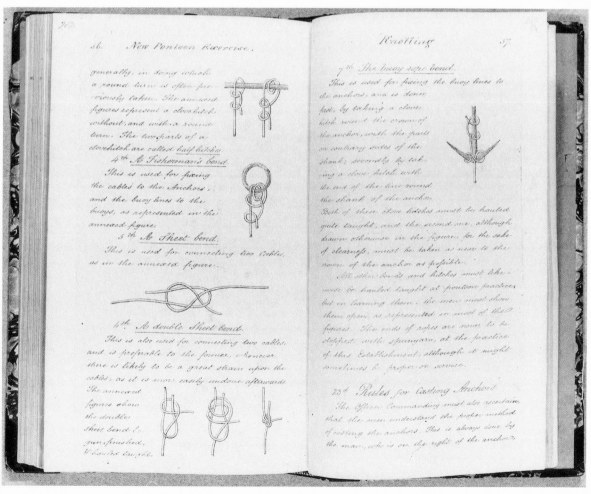

60. A set of publications of the École d'Application d'Artillerie et du Génie (Metz, 1830–41), bound in nine volumes.

century, however, the famous military academy at Metz, the École d'Application de l'Artillerie et du Génie, took lithography a stage further for the production of military instructional material.[9] The Academy, the leading one in France for the training of engineers and artillery, had established its own lithographic press by at least 1824. Its principal productions were texts of complete courses and summaries of course programmes. These items were distributed free of charge to staff and students of the Academy and could also be obtained on request by any French army officer for the cost of the printing.[10] The press remained at Metz until the Franco-Prussian War, but shortly afterwards moved to Fontainebleau; it continued to produce lithographed publications regularly through to the First World War and occasionally thereafter.

What has survived of the output of the Academy's press while it was at Metz represents by far the largest homogeneous group of lithographed books and pamphlets of the first half of the nineteenth century that has been traced [Cat. 3.1–3.45]. Several items have been seen from the 1820s, but the discussion that follows rests mainly on a study of a single set of thirty-seven separately paginated items which are now bound up in nine volumes [60]. These items, which are a mine of information on military matters, range in date from 1830 to 1841 and amount to over 3500 pages of lithographed material. The principal series of courses, not all of which can be credited to an author or be precisely dated, are as follows: P.-J. Ardant, *Cours de constructions* (1840); J.-F. Français, *Cours d'art militaire* [c. 1835–41]; T. Gosselin, *Cours de géodèsie* (1834); G. Piobert, *Cours d'artillerie* (1841]; J.-V. Poncelet, *Cours de mécanique* [c. 1839]; *Cours de topographie* [c. 1835–41]. Some individual items make substantial volumes and run into hundreds of pages; others are mere pamphlets of a few pages. The longest course, Ardant's *Cours de constructions*, was produced in four parts and amounts to well over 1300 pages [Cat. 3.1–3.4].

Ordinances of the Academy dated 5 June 1831 specified that it should include 'Une lithographie complète'.[11] This was to be under the control of a staff officer, who had the services of an artist lithographer and an assistant librarian.[12] The term 'artist lithographer' is a literal translation from the French, which has no real equivalent in English. But whatever term is used to describe this person, the implication is that he should be competent to supervise all aspects of lithography. He was to be responsible for the equipment in the lithographic workshop, which appears to have had facilities for copperplate engraving and printing too. Lithographic workmen were not part of the permanent establishment; they were employed on an annual basis and paid by the day.[13] They worked a seven-hour day, which was very short for the time, and

61. Three publications of the École d'Application d'Artillerie et du Génie, Metz, of the mid 1820s. Shown as published in their blue-stained wrappers. Page size of each item approx. 335 × 210 mm. [Cat. 3.18, 3.21, 3.25].

considerably shorter than that of other workers at the Academy. The assistant librarian stored the productions of the press, kept a record of stocks, and issued items to students.[14] Three surviving examples from the mid 1820s (one dated 1824 and the others of a similar date) are still in the plain blue-stained wrappers in which they must have been issued [61]. Judging by fragments of paper that remain in some of the bound volumes of later course units, they continued to be issued in a similar form in the 1830s and 1840s, though the paper used at this stage would be described as grey-blue rather than blue.

The lithographic productions of the Metz press that have been traced are all printed in one of two sizes and have a page size of either 328 × 210 mm or 214 × 175 mm (when bound). (The largest of the items in their original wrappers measures 345 × 212 mm). These sizes are almost certainly Tellière folio and quarto. Tellière folio was the paper size specified in regulations for use by students

14 *Ordonnance*, pp.153–156.

62. T. Gosselin, *Cours de géodèsie*
(Metz, 1834). One of the few displayed
title-pages among the productions of
the École d'Application de l'Artillerie
et du Génie that have been traced.
Page size 327 × 205 mm. [Cat. 3.20].

15 W. D. Richmond, *The grammar of
lithography* (London, 1878), p.41, refers to
transfer paper being provided ready-ruled
for law writers. In any case, some station-
ery papers are known to have had their
lines and margins defined at the manu-
facturing stage by the same method as
was used for making watermarks.

of the Academy when writing their notes and was the closest
equivalent to the English size foolscap.

The earliest books from the Metz press that have been traced
are all folios, and were produced in a formal and considered way.
Those dating from the mid 1820s are printed on a variety of papers,
both laid and wove; the paper came from different manufacturers,
though most of it has a watermark device consisting of two back
to back, c-shaped curves in outline, sometimes interlocking. The
same device is found on paper in some of the later publications.
All the items have their texts written in a neat copperplate hand,
which the French call *anglaise*; their marginal headings are in a
slightly smaller *ronde* or a copperplate. Transfer paper seems to
have been used for most, if not all, of the writing and lettering.

Text pages of the folio items, whether rectos or versos, have
larger margins to the left and very small ones to the right. In the
publications of the 1820s the left-hand margins measure some-
thing in the order of 50 mm, but in the later folio publications the
margins became established at 65 mm to the left and rather less
than 10 mm to the right. However, the treatment of text pages in
these folio items appears to have been remarkably consistent over
a period of twenty years. It always has a ragged edge to the right,
though the raggedness is kept within limits by frequent word
breaks. The lines of writing are at approximately 8 mm incre-
ments, and standard modules of 8 mm space appear between
sections. One unit from the 1820s that has been seen has 37 or 38
lines to the page; but most units have 40 lines to a full page, though
this number varies on occasions to avoid widows and also to cater
for new sections or tables that had to be taken over to the next
page. This consistency over a large number of folio documents
suggests that a standard grid must have existed notionally, and
perhaps actually in the form of pre-ruled sheets of transfer paper.[15]

Display features do not figure prominently in these publica-
tions. Only a few of those seen have what might be called displayed
title-pages, and these were probably drawn directly on to the stone
[20, 62]. Most of these course units have no separate title-pages,
and it is possible that some of the original wrappers carried
publication details. The opening page of each unit identifies the
course, and its lettering is normally displayed in several sizes
along with a variety of rules of the kinds used in letterpress
printing (monoline, double-line, thick and thin, and swelled) [63].
Running heads were not used regularly and appear only in the
Cours de mécanique, and even then not in all of its eight sections.

Many of the course units have illustrations, which range from
highly technical drawings of instruments or constructions to
rather more pictorial subjects, such as elevations of buildings. The
quality of the illustrative material reflects the importance

Ecole d'Application de l'Art.^e et du Génie.

Cours de Mécanique appliquée aux Machines.

3^{ème} Section.

Calcul des Résistances passives dans les pièces à mouvement constant et soumises à des actions sensiblement invariables.

Considérations préliminaires.

Décomposition des machines complexes en machines simples.

1) En parlant de l'établissement des machines en général (444)★ nous avons donné une idée succinte de la manière dont on procède au calcul de la force motrice qui doit vaincre toutes les résistances réunies : cela consiste à considérer séparement chaque pièce distincte et mobile du système, comme une machine simple, soumise elle-même à une puissance et à des résistances qui se font équilibre à tous les instants, ou dont la somme des quantités de travail instantanées est constamment égale à zéro (15). La force motrice et la Résistance utile ou active appliquées à chacune d'elles n'étant autre chose, en effet, que les efforts de réaction qu'elle éprouve de la part de celle qui la précède immédiatement, du côté du moteur, ou qui la suit immédiatement du côté de l'opérateur, on conçoit comment, à l'aide des règles ordinaires de la statique, on peut parvenir à calculer, de proche en proche, en partant de l'une quelconque des pièces extrêmes de la machine, la valeur des différentes forces, passives ou actives, qui la sollicitent à un instant donné, en fonction, soit de la pression motrice du récepteur, soit de la résistance utile de l'opérateur; et par suite, comment on peut aussi calculer (N^{os} 8 et suivans) pour chacune de ces forces, la quantité de travail positive ou négative (19), qu'elle livre à la machine dans chaque élément du temps, ou entre deux positions quelconques données.

Objet spécial de cette section.

2). Ces calculs présentent généralement de très-grandes difficultés toutes les fois que les vitesses et les forces varient, en intensité et en direction, suivant des lois quelconques dans les diverses positions des pièces

★ Tous les renvois de ces préliminaires sont relatifs à la section 1.

63. Opening page of the third part of J.-V. Poncelet, *Cours de mécanique appliquée aux machines* (Metz, c. 1839), showing the use of a variety of rules: thick and thin, swelled, double, and single. Page size 325 × 210 mm. [Cat. 3.30].

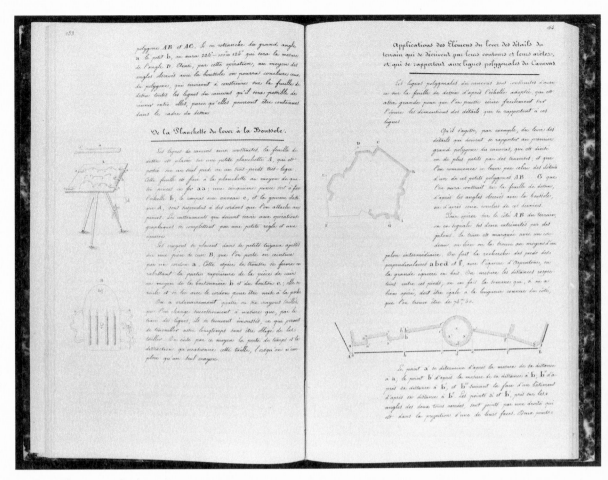

64. *Cours de topographie* (Metz, c. 1835–41). Double-spread showing the placing of illustrations in the large margin to the left of each page and across the entire page. Page size 330 × 207 mm. [Cat. 3.7].

attached to drawing at the Academy. It formed part of the training of students and some of the lithographed courses in topography dealt with it. Even official regulations touched on the subject, and rules were laid down on such matters as the drawing of scales and borders, the use of colours, and the styles of lettering to be used on drawings.[16] Some course units have full-page illustrations which are presented on fold-out pages at the back of the volume. This was the method employed in the three units from the mid 1820s that have been seen. It was continued in the later units but, in addition, many smaller illustrations and diagrams were included in the margins to the left of the page [64]. It was presumably for this reason that the size of these margins was increased from around 50mm in the 1820s to 65mm in the 1830s. When an illustration was a little too large for the margin, the text was often written to run partially around it. Tables also appear along with the text and occupy either the width of the whole page, the width of the text area, or, occasionally, appear in the left-hand margin. Some course units include complex and extensive tables that run

16 *Ordonnance*, pp.77–82.

into many pages. Most tables are boxed and make consistent use of two thicknesses of lines to organize information into sub-categories and of calligraphic braces to link items.

The quarto works tend to be more extensive and later in date (1840, 1841) than the folio ones. They are also more variable in terms of the formality of their presentation. Some are written in a neat copperplate hand, similar to that used for the folio volumes [65]; others are written in what can only be described as an everyday cursive hand and display all those characteristics associated with hasty writing [66]. On occasions, the change from formal to informal occurs in the middle of a course unit, even half-way through a section of it. In the informal parts, traces of a *ronde* style are to be found in marginal headings and other passages needing emphasis. Where the text is hastily written the tables are roughly presented too; but most of the illustrations are drawn with care and it is odd to find, as one does from time to time, a

65. Text written in a neat copperplate hand, from P.-J. Ardant, *Cours de constructions*, part 1 (Metz, c. 1840). Probably written in reverse on the stone. 73 × 125 mm. [Cat. 3.1].

66. Text written in an everyday cursive hand, from P.-J. Ardant, *Cours de constructions*, part 1 (Metz, c. 1840). Written the right way round on transfer paper. 77 × 125 mm. [Cat. 3.1].

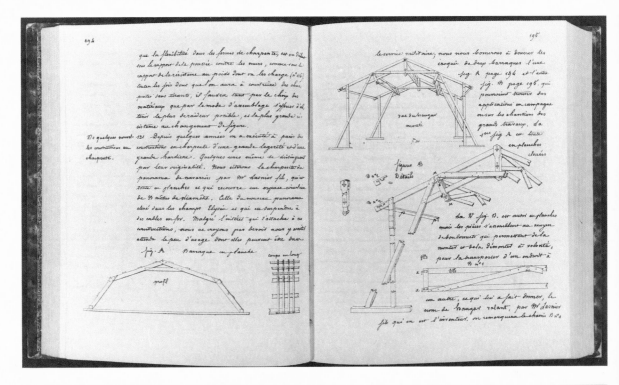

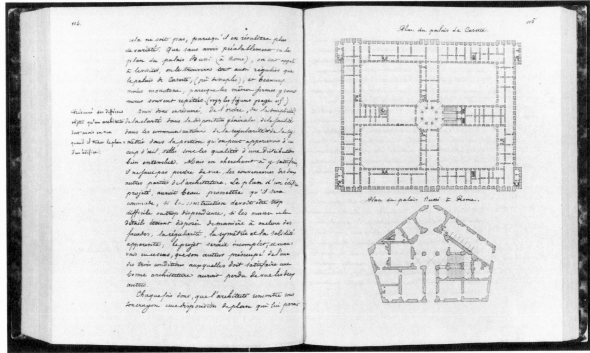

67. Double-spread from P.-J. Ardant,
Cours de constructions, part 1 (Metz,
1840). Page size 213 × 175 mm.
[Cat. 3.1].

68. Double-spread from P.-J. Ardant,
Cours de constructions, part 2 (Metz,
c. 1840). Page size 213 × 175 mm.
[Cat. 3.2].

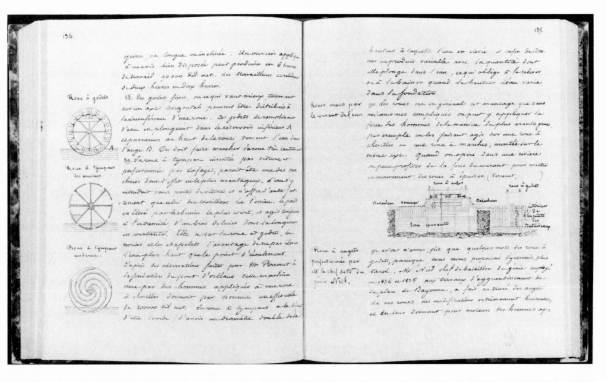

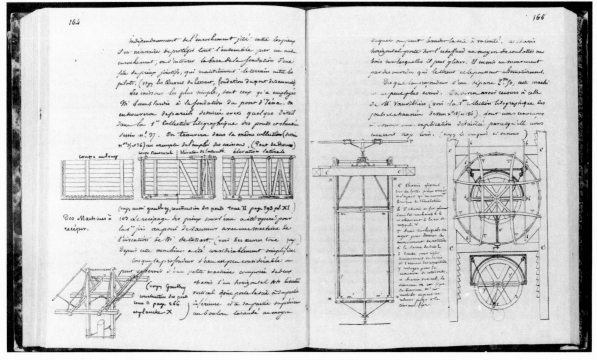

69, 70. Double-spreads from
P.-J. Ardant, *Cours de constructions*,
part 3 (Metz, 1840). Page size
213 × 175 mm. [Cat. 3.3].

careless piece of writing running around a meticulous technical drawing. Despite their roughness, and even illegibility on occasions, there is a refreshing spontaneity about these informally written items that gives them something of the feeling of immediacy associated with authors' manuscripts [67–70]. It is even possible, of course, that this is exactly what they are, and that course teachers had to resort to doing their own writing on transfer paper when a professional writer was not available, or in order to cut costs.

Whether written formally or informally, the texts of the quarto items normally fall within a standard grid of twenty-six lines to a page, with their lines placed at just over 6 mm increments. As with the folio items, there is a large margin to the left of each page, though this measures 50 mm (rather than the 65 mm adopted in the later folio ones) because of the smaller page size. The quarto items are also similar to the later folio ones in the manner in which illustrations and tables are combined with text, though they make much greater use of illustrations that run the full width of the page or the text area.

The printing of these Metz productions is much more assured than that of the Chatham ones; it is blacker, crisper and, in general, more consistent. To some extent this reflects the general improvement in lithography over the decade or so between the productions of the two establishments. The printing of the illustrations, many of which appear to have been drawn directly on to stone rather than transferred to it, is particularly good and compares well with work done by commercial printers of the period.

The scrupulous care with which it is known armies usually prescribe practices and define responsibilities, coupled with evidence provided by the published regulations of the Academy, lead one to suppose that the lithographic workshop at Metz had its own clearly-defined rules. Details of these are not known, but the regulations relating to the making of students' own notes even went so far as to specify that there should be margins of five centimetres to the left, one centimetre to the right, and two centimetres at the head and foot of each page.[17] These margins are broadly in line with those to be found in the lithographed productions described above and particularly the folio publications of the mid 1820s. It seems likely therefore that similar regulations were merely carried over from the one area of work to the other. Consequently, practices worked out with writing and stationery paper in mind were adopted for printing and book production. Both the folio and quarto items lithographed at Metz were made from stationery paper sizes and are unconventional in size in so far as books go. The practice of having a large margin to the left of each

[17] *Ordonnance*, pp.81–82.

page appears to have no real precedent in book production, and certainly not among letterpress printed books;[18] it resulted in an asymmetric arrangement of a double spread instead of the traditional practice of placing pages as mirror images of one another in terms of their margins. In the folio volumes of the mid 1820s the left-hand margins were used for subheadings and for references to the plates, but by 1830 these margins were increased in size, presumably to cater for illustrations. Though the initial use of large left-hand margins was merely a survival of stationery conventions and, perhaps, an unthinking use of them, it seems clear that the decision to increase the size of these margins marks a conscious recognition of the design advantages offered by this kind of page organization.

Notwithstanding their unconventionality – or possibly because of it – these Metz productions appear to work well in terms of design. The underlying grid allowed illustrations to be handled with great flexibility and, in particular, the generous left-hand margins made it possible for illustrations and headings to be included without interrupting the main body of the text. Probably by accident in the first place, and certainly because they were uninhibited by the rigid conventions and actual constraints of letterpress printing, whoever designed these Metz productions came up with a new solution to the age-old problem of book design. The solution appears to have passed unnoticed at the time, but it was taken up again quite independently almost a century later with the increasing use of A4 formats, new methods of composition, offset printing, and a more open-minded approach to the design of books. It so happens that this mid-nineteenth century solution has become, over the last few decades, one of the orthodox forms of illustrated book design.

[18] Earlier examples of it in lithographic book production are to be found in Cat. 1.46, 1.95.

CHAPTER 4

The lithographic publications of Sir Thomas Phillipps

MIDDLE HILL.

Nº

71. Book-plate of Sir Thomas Phillipps showing a view of Broadway Tower on his estate at Middle Hill. Pen and ink lithograph, dated 1854. Image 54 × 54 mm.

[1] A.N.L.Munby, *Phillipps studies*, 5 vol. (Cambridge, 1951–60).

[2] G. Wakeman, 'Anastatic printing for Sir Thomas Phillipps', *Journal of the Printing Historical Society*, no.5, 1969, pp.24–40.

[3] D.Chambers, 'Sir Thomas Phillipps and the Middle Hill Press', *Private Library*, 3rd series, vol.1:1, Spring 1978, pp.3–38. I am greatly indebted to David Chambers, who has been most generous in sharing with me the fruits of his work on Phillipps.

[4] Munby, *Phillipps studies*, vol.3, p.71.

[5] M. Twyman, 'The lithographic hand press 1796–1850', *Journal of the Printing Historical Society*, no.3, 1967, p.35.

The work of the lithographic presses used by Sir Thomas Phillipps in furtherance of his antiquarian and bibliographical interests is the one area of lithographic book production that has attracted the attention of scholars. Several people have worked in the field, most notably A. N. L. Munby, whose *Phillipps studies* must be the starting point for any serious student of the subject.[1] This chapter draws heavily on his work and on the more specific contributions of Wakeman[2] and Chambers;[3] but it also attempts to see Phillipps's lithographic publications in the context of other lithographed books of the period.

Sir Thomas Phillipps, the greatest collector of manuscript books the world has ever known, set up a letterpress workshop on his estate at Middle Hill, Broadway, in 1822, the products of which continue to fascinate and exasperate bibliographers and historians of printing. This letterpress workshop was initially housed in the inhospitable but attractively situated Tower, within the grounds of his estate on Broadway Hill [71]. Later, it was moved into the house itself. It was kept busy over a long period printing catalogues, transcriptions of documents, and genealogies, as well as all kinds of everyday ephemeral printing. These works are not our concern here beyond noting that by far the greater part of Phillipps's considerable output of publications was printed letterpress, and much of it very badly indeed.

Not much is known about Phillipps's excursion into lithographic printing, and very little has been written about the lithographed books he published [Cat. 4.1–4.14]. However, we know that in 1831 he bought one of the newly patented lithographic presses of William Day and some stones for £21.14s.[4] An advertisement for Day's presses of precisely this period lists five sizes, only the smallest three of which cost less than the sum Phillipps paid for the press and stones together [72].[5] If he had bought a reasonable quantity of stones at Day's advertised price of 4 pence a pound, it seems likely that the press referred to would have been one of the smallest – either a 10 × 15 inch version costing £9 or a 15 × 20 inch one costing £15. However, only the

72. Day's patent lithographic press. Detail of an advertisement of the firm of Day & Haghe which was printed on the rear wrappers of *Day's lithographic drawing book* of the mid 1830s.

larger of these presses would have allowed him to print a full crown sheet for his largest format book, *Visitations of Berkshire*, or the full foolscap sheet he favoured at a later stage. Pressure marks from the stones on some pages of the *Visitations* show that the stones he used for this publication would have measured approximately 12½ × 18 inches. There can be little doubt, therefore, that Phillipps bought a 15 × 20 inch press from Day.

It seems most unlikely that Phillipps would have set up his lithographic press in Broadway Tower; it had no water supply[6] and would therefore have been even more unsuitable for lithographic printing than it was for his letterpress work, which had been transferred to the main house by 1826.[7] It is almost impossible to establish what lithographic work Phillipps produced in the 1830s and 1840s, and we have no information at all about the lithographers who worked for him in this period. The only lithographic publication of his that must have been produced before 1850 is the *Visitations of Berkshire*, which is dated 'circa 1840'. All his other lithographic books were produced in the 1850s and, though some of them were probably printed at Middle Hill, most were printed by Appel in London and one by Cowell in Ipswich. But in addition to books, Phillipps produced various bits and pieces of undatable lithographic printing, such as drawings and jobbing work. His press was certainly still around in July 1853,[8] and in the following year we find him negotiating with Rudolph Appel to instruct a young man (probably James Brumbley) in the methods of anastatic printing.[9]

Though Phillipps's lithographic press at Middle Hill may not have been very productive, there is every reason to consider it

[6] See Munby, *Phillipps studies*, vol.3, p.17.

[7] David Chambers has referred me to a change in Phillipps's imprints in Nov. 1825 from 'Typis Medio-Montanis in Turre Lativiensi', to 'Typis Medio-Montanis'.

[8] Wakeman, 'Anastatic printing', pp.31–32.

[9] Wakeman, 'Anastatic printing', p.34.

with the 'in-plant' presses discussed in the previous chapter. Like these, it aimed to serve a particular purpose: it was set up at Phillipps's own expense and on his own premises with the intention of running off small editions of material that he himself had compiled or transcribed. But whereas it was one thing for a large military establishment that employed people with a variety of skills to undertake such a venture, it was quite a different matter for a private individual to do so, particularly one surrounded by medieval manuscripts and in such an isolated spot. How was it that this indefatigable collector of valuable manuscripts came to take the bold step of setting up his own lithographic press in the heart of the Cotswolds in the 1830s? And how did he come to learn about lithography in the first place?

Munby has shown that Phillipps was a man of singular drive and persistence and that, though his prime concern was to gather together treasures from the past, he was open to innovations of a technical kind. He was, for example, one of the first to use photography for the recording of documents[10] and incredibly – bearing in mind the nature and quality of his letterpress printing – he tried to buy a typesetting machine as early as 1840.[11] All this merely indicates that he was unlikely to have closed his mind to a process such as lithography. There is no evidence as to how he came to be interested in it; but in the 1830s he corresponded with Thomas Crofton Croker and Michael Faraday, both of whom had longstanding connections with lithography. Crofton Croker was closely associated with the firm of Engelmann, Graf, Coindet & Co, and was the author of an anonymous article on lithography which appeared in the *Foreign Review* in 1829.[12] He was also a founder member of the Camden Society and, later on, wrote enthusiastically about the use of lithography for the reproduction of historical documents (see pp.238–239). Michael Faraday was a friend and near neighbour of the lithographer Charles Hullmandel and was associated with some of his lithographic activities. Faraday's interest in lithography was a longstanding one and he gave lectures on the subject to the Royal Institution in 1826, 1831, 1842, and 1845. On the earliest of these occasions his lecture was accompanied by a demonstration of various aspects of lithography by Hullmandel. Faraday's notes for his 1826 and 1831 lectures show that he touched on the use of the transfer method for making facsimiles; in his 1845 lecture, however, he dealt specifically with anastatic printing.[13]

In one of his letters to Appel of around 1853–54 in which he haggles over the price of instruction in the anastatic process, Phillipps refers somewhat disingenuously to '... not being a regular Printer but only printing for my own amusement.'.[14] And at the outset this may have been true. It may simply have been that

[10] Munby, *Phillipps studies*, vol.4, pp.39–41.

[11] Munby, *Phillipps studies*, vol.4, p.46.

[12] *Foreign Review and Continental Miscellany*, vol.4, no.7, 1829, pp.41–58.

[13] F. W. Stoyle, 'Michael Faraday and Anastatic Printing', *British Ink Maker*, Nov. 1965, pp.46–51. Stoyle refers to lectures on aspects of lithography that Faraday delivered to the Royal Institution in 1826, 1831, and 1845. Faraday gave a further lecture on lithography on 10 June 1842 entitled 'Principles and Practice of Hullmandel's Litho-Tint'. I am grateful to Mrs I. M. McCabe, Librarian and Information Officer at the Royal Institution for supplying me with information about these lectures.

[14] Wakeman, 'Anastatic printing', pp.34–35.

Phillipps was fascinated by the new process of lithography – as he was later to be fascinated by photography and typesetting machines – and wanted to learn more about it. But at a later stage he cannot have been blind to the practical advantages the process offered for the kinds of publications he had in mind. Like many others who turned to lithography, he would have been attracted by its economic advantages for short-run book production. Anyone who might doubt whether such a comparatively wealthy man would have bothered to look for minor savings will find ample evidence that he did from his correspondence, which reveals his extreme niggardliness over paying bills. It is reasonable to suppose that Phillipps would have been looking for economies at the origination stage of production, since writing on transfer paper in a running hand offered the prospect of being considerably quicker and cheaper than setting type. But the greatest advantage of lithography as far as he was concerned may well have been that it allowed his transcribers to write directly on to transfer paper, thereby reducing both the chance of making errors and correction costs. In addition, Phillipps may have been fascinated by the ease with which lithography could be used for making facsimiles of old documents and for producing genealogical trees, though the latter appear only in his first lithographed book, *Visitations of Berkshire*.

Though it seems that Phillipps's lithographic press was not very active in the 1830s and 1840s, he must have retained a fascination for the process throughout this period. In the 1850s, however, he made greater use of it, particularly for book production. In this period he turned increasingly to outside lithographic printers, first to Rudolph Appel in London, and later to S. H. Cowell in Ipswich. At one stage he was even printing 'in-house' by lithography at the same time that he was employing an outside lithographer. The signs are that he was not entirely happy with the productions of his own press, but was not prepared to close it down hastily. Phillipps's involvement with lithography in the 1850s, at least the part of it that was done by others, is fairly well documented through correspondence with his printers and through other items that have survived among the Phillipps papers. In his survey of these papers with regard to anastatic printing, Wakeman draws attention to documents which suggest that Phillipps was comparing the cost of employing his own lithographer, James Brumbley, on a regular weekly wage with the cost of paying Appel to do the transferring and printing as required.[15]

The two outside lithographic printers to whom Phillipps turned, Appel and Cowell, both used the anastatic printing process. This is said to have been developed in Germany and was patented in England by Joseph Woods in 1844.[16] The process created a good deal of excitement in the 1840s and 1850s, but there was really

[15] Wakeman, 'Anastatic printing', p.39.
[16] For the introduction of anastatic printing to this country, see below pp.222–225 and Wakeman, 'Anastatic printing', pp.24–28.

73. Letterpress title-page of Thomas Phillipps, *Chronicon Abbatiae S. Nicholai* (c. 1853–54), which has the unusual imprint 'Ex Lithographia Medio-Montana'. Page size 328 × 205 mm. [Cat. 4.2].

74. Lithographed pages of Thomas Phillipps, *Chronicon Abbatiae S. Nicholai* (c. 1853–54), written on transfer paper and printed on blue paper. Page size 325 × 205 mm. [Cat. 4.2].

nothing very new about it. Like so many technical developments, it depended on the bringing together of several known ingredients. It involved transferring images from paper to zinc plates, and allowed for the possibility of printing them on powered lithographic machines. By 1840 transfer lithography and printing from metal plates had been thoroughly explored by many printers, and powered lithographic machines had also been developed.[17] Even the idea of taking transfers from old images, which gave the anastatic process its name, had been explored by Senefelder and several lithographers in France (see pp.211–222), though this part of the process proved to be so unreliable as to be impracticable. Nevertheless, anastatic printing attracted considerable attention, and was already being used in Ipswich by both Appel and Cowell in the late 1840s. Wakeman has suggested that Appel, who claims to have introduced the process from Germany and to have taught Cowell how to use it, was allowed to use Cowell's equipment in return for teaching him about it.

Phillipps may have become aware of anastatic printing when he visited the Great Exhibition in May 1851,[18] since both Appel and Cowell exhibited there. By this time Appel had moved to London, where he advertised his services as an anastatic printer from 43 Gerrard Street, Soho.[19] Appel worked for Phillipps from 1851 (the earliest surviving letter from Appel to Phillipps is dated 10 January 1852 and refers to printing that was already underway) and continued to do so until he was declared bankrupt in 1857. In a circular letter dated 11 October 1858, Appel informed his former clients that his anastatic printing business had been taken over by

[17] See Twyman, 'Lithographic hand press', pp.41–50.

[18] Munby, *Phillipps studies*, vol.2, p.61; Wakeman, 'Anastatic printing', p.29.

[19] Wakeman, 'Anastatic printing', p.28.

75. Detail from p.13 of Thomas Phillipps, *Chronicon Abbatiae S. Nicholai*, showing traces of the inky edge of the stone. 175 × 115 mm.

Mr S. H. Cowell of Ipswich, who had 'successfully carried on the Anastatic Printing for the last ten years'.[20] Thereafter, Cowell continued to print for Phillipps probably until the latter's death in 1872. When Phillipps's lithographic press at Middle Hill fell into disuse is not known; his attempt to get Appel to teach Brumley the methods of anastatic printing in 1854 seems to have come unstuck, and thereafter we hear no more of the matter.

As yet there is no comprehensive bibliography of the productions of Phillipps's press.[21] His lithographed items are not conveniently gathered together anywhere, but are to be found along with other Phillipps material in the Bodleian Library, the British Library, the Yale Center for British Art, and in several private collections. It would be unwise, therefore, to be too specific about the number of lithographic books Phillipps produced; fourteen have been traced [see Cat. 4.1–4.14], and it is just possible, though unlikely, that one or two others have escaped notice.

It is difficult to say with certainty whether some lithographically printed items issued by Phillipps were printed at Middle Hill or by one of his outside printers. Not all his publications carry an imprint and many are undated. The imprint 'Ex Zincographia Appelana' is found on some items produced in the 1850s,[22] and 'Ex Lithographia Medio-Montana' on others.[23] The second of these imprints follows the style of Phillipps's better-known imprint 'Typis Medio-Montanis', which he used regularly for his letterpress productions from the mid 1820s, and for his earliest surviving lithographed book, *Visitations of Berkshire* , which is dated 'circa 1840'. It seems likely that nost of the items with the 'Ex Lithographia Medio-Montana' imprint mean just what they say and were printed by Phillipps at Middle Hill. All the other books with this imprint date from the first half of the 1850s. They bear no printer's name, though one of them, *Index Pedum Finium pro Com. Glouc.*, is known through documentary evidence to have been printed by Appel. However, one of the others with this imprint, *Chronicon Abbatiae S. Nicholai* [73–75], has some impression marks which look as though they were made from the edges of a stone rather than a plate, which suggests that the book was printed on Phillipps's own press. This book is printed on the

20 See Wakeman, 'Anastatic printing', p.36.

21 A complete catalogue is currently being prepared by David Chambers. For more or less complete listings of Phillipps's printed productions, see T. F. Fenwick, *The Middle Hill Press* (London, 1886); H. P. Kraus, *A catalogue of publications printed at the Middle Hill Press, 1819–1972* (New York, 1972); T. Lowndes, *The bibliographer's manual* (London, 1864),

vol.iv, appendix, pp.225–237; J. Martin, *Bibliographical catalogue of books privately printed* (London, 1834; 2nd ed.1854); Sotheby & Co. (Hodgson's Rooms), *Catalogue of printed books comprising publications of the Middle Hill Press* (London, 1969).

22 *Index to the Pedes Finium for Wiltshire* (1853); *Index to the Pedes Finium for Worcestershire* (1853); *Wiltshire pipe rolls temp. Henrici 2* (1853); *Heralds visitation*

disclaimers (1854); Ferrers, Countess of, *Assignatio dotis Elizabethæ Comitissæ de Ferrers* (1855).

23 *Chronicon Abbatiae S. Nicholai* (c. 1853–54); *Index Pedum Finium pro com. Glouc.* (c. 1854); *Excerpta ex registris parochialibus, in Com. Gloucester, &c.* (1854); *Cartularium Monasterii de Winchcombe* (1854); *The Wallop Latch* (c. 1854).

same blue paper, watermarked 'Kent 1853', as two other books with the 'Ex Lithographia Medio-Montana' imprint [Cat. 4.4, 4.5], whereas the books printed for Phillipps by Appel made no use of this paper.

As with Phillipps's letterpress publications, the lithographic ones vary considerably in extent. One consists of no more than seven printed pages [Cat. 4.6], whereas the two most extensive, the *Index to the Pedes Finium for Worcestershire*, which was printed by Appel in London in 1853, runs to 436 pages, and the *Cartularium Monasterii de Winchcombe* (1854) to 229 pages. Most of Phillipps's lithographed books were printed on a blue, laid stationery paper, and a few of his letterpress publications were printed on the same stock. Not every copy of the same item was printed on the same paper, however, and some copies even mix papers. It was not at all uncommon, for example, for him to provide a letterpress title-page printed on white paper to go with a set of text pages printed on blue paper. Where his lithographed books have come down to us in bound form, they are in the 'Middle Hill boards' familiar to collectors of his letterpress productions. Judging by surviving documents, fifty was the usual print run when Appel and Cowell were doing the printing, though occasionally a hundred copies were printed.[24] There is no reason to believe that the print runs of his own lithographic press were very different from these, though they may well have been smaller.[25] All but two of Phillipps's lithographic books, whether printed at Middle Hill or elsewhere, are foolscap folio in format; the exceptions are post quarto and crown folio [Cat. 4.3, 4.11]. Those from Phillipps's own press would almost certainly have been printed two to view, but accounts and letters in the Phillipps papers reveal that sheets of some of his books were printed by Appel four to view.[26]

Though Phillipps issued more lithographed books than most producers of improper books, it has to be admitted that in terms of quality they compare very unfavourably with most lithographed books of the period. The presswork was usually quite capable, particularly when Appel was the printer; the major faults lay at the origination stage, and principally in a failure to organize the material within a grid so that there was some consistent underlying structure to the pages. The lack of such a structure means that many of Phillipps's lithographed books fail to hang together from a visual point of view. They certainly depart considerably from established book conventions in many respects, most notably in having very small margins, though attempts appear to have been made to achieve even right-hand margins by splitting words, and some of his books have running heads and catchwords. The style of the writing varies from what might be described as a neat

24 See Wakeman, 'Anastatic printing', pp. 30–38.

25 See Munby, *Phillipps studies*, vol. 4, pp. 47–48.

26 Wakeman, 'Anastatic printing', pp. 31, 34, 35.

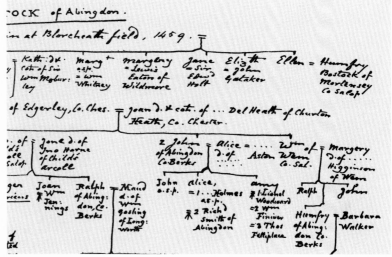

76. Thomas Phillipps, *Visitations of Berkshire* (c. 1840). Written on transfer paper by Phillipps. Page size 380 × 255 mm. [Cat. 4.11].

77. Detail of 76. 115 × 180 mm.

cursive (of the kind used for ordinary correspondence in the period) to sheer scribble. What is more, the size of the writing often varies within an item for no apparent reason. All this suggests a lack of control at the origination stage, which contrasts markedly with the approach of the military press at Metz; though it is absolutely in line with Phillipps's chaotic approach to letterpress printing.

None of the copies of Phillipps's lithographed books that I have seen has a lithographed title-page. Those with title-pages have letterpress ones, sometimes printed at a later stage [73].[27] Some of these title-pages have a view of Broadway Tower printed intaglio, others have one or more lines printed in red; and there are variants of several title-pages. Even though these title-pages were in the main badly printed, they must be seen as an attempt to make these unorthodox-looking productions accord more with people's expectations of books. The imprints used by Phillipps that have been referred to above are all to be found on these letterpress title-pages, and not on lithographed pages.

Most of Phillipps's lithographed books follow his overriding design principle which, broadly speaking, involved cramming as much into a given space as possible. Only his *Visitations of Berkshire* [76, 77] is markedly different. Its unusual imprint, which reads 'Typis Medio-Montana circa 1840', suggests that the title-page was printed some time after the rest of the publication. The book is crown folio, which would have been the largest format Phillipps would have been able to print two pages to view on a 15 × 20 inch press. It is the only book Phillipps printed in this format, and is also unusual in having been printed on white paper throughout.

27 Wakeman, 'Anastatic printing', p.39.

The body of the book consists of hastily scribbled genealogies, organized one to a page so that the pages have to be turned ninety degrees to be read (the pages are numbered to 42, but 37 and 38 do not seem to have been printed and are missing from all recorded copies). Lithography had already been used for genealogical trees by William Berry in his *County genealogies* (see pp.100–102), and it is hard to accept that Phillipps did not know of them, and particularly Berry's volume on Berkshire which was published in 1837. The wording on Phillipps's title-page, 'Thomae Phillipps, Bart. Autographa', tells us that he did the writing on transfer paper himself, though it was done with no more care than if he had been making notes for himself. Though less competently produced than most of Appel's books, it is important because it demonstrates the convenience of lithography for the presentation of non-linear configurations of graphic language, which is a theme which will be taken up again in the following chapter.

Though Phillipps's lithographed publications are as ill-considered in terms of design as his letterpress ones, they are of particular interest when considering the making of corrections to lithographic writing. Anyone at all familiar with Phillipps's letterpress printing will be aware that extensively corrected proof sheets for his publications abound. Why is it then that no one seems to have come across similar proof sheets for his lithographic work?

The textual problems presented by lithographic and letterpress books were similar, and it might be supposed that a similar proportion of errors would be made in both, though perhaps somewhat fewer in lithographic writing than in typeset material. However, the relative ease and accuracy with which scribes could have transcribed documents by writing them out on transfer paper may have been the major reason why Phillipps persevered with lithography over such a long period. He appears to have been very accurate in the two books he wrote in his own hand, *Visitations of Berkshire* and *Heralds visitation disclaimers*. But whether he did the writing himself or not, a lithographic writer was likely to make fewer errors than a compositor, partly because of the nature of the task, and partly because such a person was likely to have had some knowledge of the material being copied. In this respect it is worth noting that Phillipps's more professionally written books [see for example Cat. 4.13, 4.14] appear to be comparatively error free when compared with the more roughly written ones [see for example Cat. 4.1, 4.2, 4.6]. This latter group reveals that plenty of mistakes were made and corrected at the writing stage. The reason that no corrected proofs of Phillipps's lithographed books survive is simply that corrections were made either on the transfer paper itself or on the stone or plate before it was prepared for

printing. In either case, corrections and alterations would have been made before any proofs had been taken.

The making of corrections to lithographic writing is considered in Chapter 1. It is picked up again here because most of Phillipps's publications were so carelessly produced that they reveal traces of the methods of correction that were used. What is more, Phillipps has left a brief account of his procedure for making corrections in a more general set of instructions about transfer lithography. These instructions appear on two foolscap lithographed sheets written in Phillipps's own hand and organized with parts of the text reading in different orientations around their edges [78].[28] Whether Phillipps was responsible for drafting these instructions is not clear, but their tone of voice is consistent with the way in which he would have addressed one of his lithographic writers or printers. They are unsigned and undated, and begin with the address 'Sir':

You are requested to use a very sharp knife to make pens to write on transfer paper, & to use fresh ink daily

Take care to have the old writing perfectly effaced from the stone with the sand

After being effaced, the Stone to be polished with Pumice stone. Great care must be taken to prevent grease or soap touching the stone whether wet or dry, although grease will not soil the stone when wet but soap will

Rub the ink dry in the saucer, & drop two or three or more drops of boiled water & rub it up with the end of the finger untill it is of the fluidity of milk or rather thicker

The hand must never touch the prepared paper where the writing is to be Having written the transfer, examine it carefully, & if there is any error dip the feather end of the pen into some turpentine & with it wash out the mistake. You must wash out the whole word, & be cautious that the turpentine does not touch any other word. Then wipe the erasure with a piece of soft rag or silk wrapt round the end of the finger Then as soon as the erasure is dry it may [be] re-written. Errors may also be rubbed out with common India rubber. Warm the Stone, obtain proper pressure, damp the back of the transfer carefully with a sponge damped with cold water untill it will lie flat, then place it on the centre of the stone & pass it quickly under the press

Damp the transfer again & pass it again thro' the press once or twice. The transfer paper may now be carefully removed from the Stone, & the Stone laid by untill it is quite cold. Prepare a solution of gum water of the consistence of treacle, & cover the whole face of the stone with it. As soon as the stone is quite cold wash off the gum and charge the

78. One of two lithographed sheets, written in Phillipps's own hand, giving instructions for transfer lithography. Sheet size approx. 340 × 215 mm.

[28] Bodleian Library, Phillipps-Robinson, b.197, fols. 51–52. David Chambers was kind enough to draw my attention to this important document, which has hitherto passed unnoticed.

> writing with the printing ink. The roller shd always be
> scraped clean before it is put away & also the ink stone.
> When the transfer is charged with ink, examine it. If quite
> perfect & free from spots, pass some diluted nitric acid over
> it with a soft sponge. The strength of the acid shd be of the
> strength of lemon juice or not quite so strong. The writing
> should be again charged with ink & an impression may then
> be taken. Shd there be any imperfections in the writing on
> the stone, it must be allowed to dry & the corrections writ-
> ten backwards with a fine pen & with Lithographic Ink. This
> must be done before any acid is passed over the stone. Spots
> & dirt in the writing must be removed with a penknife
> before the acid is applied, & the margin must be cleaned
> with pumice stone

There follows a further paragraph on the grinding of stones.

The emphasis put on the use of stone in these instructions makes it clear that they relate to his own lithographic activities rather than to those of Appel or Cowell, both of whom used metal plates. The instructions seem fairly rudimentary and are likely therefore to relate to the period soon after he bought his press from Day, though there is no reason to rule out a date in the early 1850s when he tried to interest Brumley in lithographic printing. But whenever it may have been written, it provides valuable corroboration of the practices discussed in lithographic treatises. First, it suggests that Phillipps and his associates followed the normal practice of the time and used a quill for writing on transfer paper. Secondly, it underlines the importance of handling the paper with care. Thirdly, it confirms the two stages at which corrections could be made: immediately after writing on the transfer paper (by washing with turpentine or erasing with India rubber), and on the stone before preparing it for printing.

It may be dangerous to read too much into those corrections that are visible in Phillipps's publications, since others may have been made that cannot be detected. Nevertheless, it seems that some of his writers made their corrections as one might do when writing on ordinary paper by inserting, deleting, or going over the error a little more strongly and thus to a large degree obliterating it [79]. The last mentioned is very common in some of his publications and often takes the form of changes from small letters to capitals [80]. It seems most unlikely that a scribe would make the same error repeatedly if he were correcting as he went along, so it looks as though a proof-reading stage was written into the production process, as recommended by Engelmann (see above p.29), before transferring the writing to the stone or plate. Needless to say, this would have become even more necessary when Phillipps's printing was done by outside firms. The corrections that are more

79, 80. Corrections to p.6 and p.20 of Phillipps, *Chronicon Abbatiae S. Nicholai* (*c.* 1853–54), showing a deletion, an insertion, and overwriting of errors. Approx. 35 × 50mm.

81. Corrections to p.22 of Phillipps, *Chronicon Abbatiae S. Nicholai* (*c.* 1853–54), made on the transfer paper. The original text can just be made out as a ghostly image. Approx. 35 × 50 mm.

difficult to see are those that involved removing a word or two from the transfer paper by one of the methods he described in the passage quoted above. However, numerous examples of such practices can be discovered because some of the offending parts can just be made out as ghostly images [81]. It often happened that the re-written parts thickened up a little when done on paper that had been treated with turpentine or India rubber.

In addition to the lithographed books and pamphlets which Phillipps produced in small editions, several other kinds of lithographed items have survived which relate to his antiquarian pursuits. They are briefly mentioned here because they indicate that he also used lithography for pictorial purposes, though only once in his books. Among them are an undated and untitled collection of coats of arms,[29] some execrable pen and ink drawings of churches and other buildings,[30] and sheets of vignettes of Broadway Tower printed twelve-up and presumably intended for book plates (or, possibly, for pasting on to title-pages).[31] But in many ways the most interesting of these surviving oddments is an impressive four-page facsimile of a medieval manuscript, probably the eighth-century Collectio Conciliorum Galliae from the Meerman collection,[32] printed in red and black. It was produced two pages to view on a sheet measuring approximately 12½ × 20 inches, and pressure marks around the image reveal that it must have been printed from stone. It is to be found in many collections of Phillipps material and, though there is nothing to link it directly with Middle Hill, it seems to have been printed for him (perhaps by Cowell). All we can say with certainty is that the idea of making facsimiles of old documents was one which attracted him.[33]

[29] See Wakeman, 'Anastatic printing', p.37, for an account dated 25 May 1859 which may relate to it.

[30] See Wakeman, 'Anastatic printing', p.38.

[31] See Wakeman, 'Anastatic printing', p.30.

[32] Munby, *Phillipps studies*, vol.5, p.25.

[33] Munby, *Phillipps studies*, vol.4, pp.39–40.

Books on accounting and other 'difficult composition'

The books discussed in this chapter are less homogeneous than the productions of Chatham, Metz, and Middle Hill; they span a longer period of time and a wider range of subjects than these presses and, in addition, were produced in several different countries. Many of them have to do with accounting. Taken as a group these accounting books help to substantiate the common-sense view that similar kinds of publications must have been printed by lithography in many parts of Europe, though not necessarily in precisely the same period. Music methods books, which are discussed in Chapter 6, provide a further example of the same thing, though in this field there appear to have been greater national variations.

The features that unite books on accounting and the few other books included in this chapter are the display of information in tabular and other non-linear forms, and the use of what in letterpress printing would be called rules. In this respect this group of books has something in common with many of the earliest lithographed books produced in Germany, such as memorandum and ready-reckoner books, and with the military manuals printed at Metz, which also have numerous tables. Though letterpress printing could accommodate rule work, it was troublesome and time-consuming to fit pieces of brass rule together, particularly in situations where lines had to look as though they crossed one another at right angles. In lithography, however, rules of whatever kind presented very few problems, and the convenience of the process for tabular work was very briefly referred to by X. Mettenleiter as early as 1818 in one of the earliest treatises on lithography.[1]

An early application of lithography to tabular work before its regular use in books on accounting can be seen in a series of publications by César Moreau, French Vice-Consul in London. These books were all published in London in the period 1825–28 and consist mainly of statistical information on matters relating to trade and commerce, much of it in the form of boxed tables. Moreau compiled at least five substantial works of this kind that

[1] X. Mettenleiter, *Gründzuge der Lithographie* (Mainz, 1818), pp.11–12.

were produced entirely by lithography. Some of them have titles
that appear verbose even in the context of nineteenth-century
publishing. In much abbreviated form, and in sequence of publica-
tion, they are: *East India Company's records* (1825), *Rise and
progress of the silk trade* (1826), *Chronological records of the
British Royal and Commercial Navy* (1827) [82], *The past and
present statistical state of Ireland* (1827), *Chronological records
of British finance* (1828).

Apart from *The past and present statistical state of Ireland*, all
these publications were produced in the same large landscape
format. This format lent itself to the handling of large tables, but
it meant that the copy had to be organized into columns (some in
three, others in four or more). Smaller tables were usually made
to fit into column widths, though large ones frequently took up
whole pages. All these Moreau books appear to have been written
in the same copperplate hand; it is very neat, but so small in some
tables and notes as to be extremely difficult to read. What is more,
the reader is not helped by the way the information is densely
packed into the pages, with little space between items and remark-
ably small margins. Whatever effect all this may have had on
nineteenth-century readers, it must certainly have stretched the
techniques of transfer lithography to its limits. But uninviting and
eccentric though Moreau's books may look today, he managed to
cram a staggering amount of information into his pages.

The imprints of two printers appear on Moreau's title pages:
those of Joseph Netherclift and J. M. Hill, both of London. The
earliest book, *East India Company's records* (1825) has no imprint,
but the next two were printed by Netherclift and the remainder
by Hill, which suggests that Moreau switched from one to another.
All five publications referred to above are so similar that it looks
as though Moreau had the major say in their design. It even seems
likely that he wrote them out on transfer paper himself, because
his signature appears on the last page of most of them, together
with the date of completion and his address, 21 Soho Square. A
review of *Chronological records of British finance*, which appeared
in *The Times* of 3 February 1827, seems to support this interpreta-
tion:

> Mr Moreau, the French Vice-Consul in London, has just
> published a work which is remarkable on account of the
> manner in which it is executed, as well as the matter it
> contains.... The labour of collecting the materials, digesting
> them, and transferring them to stone, must have been
> immense. There are in the work 85 folio pages, closely
> written, in a character as small as the limits of legibility
> can permit, and almost every page is interspersed with
> intricate tables.

82. C. Moreau, *Chronological records of the British Royal and Commercial Navy* (London, 1827). Lithographed by Joseph Netherclift, London. Page size 280 × 440 mm. [Cat. 1.251].

In addition to the fairly substantial books referred to above, Moreau produced a few smaller-scale publications with tables (consisting of four or eight pages) and at least one broadsheet. Broadsheets that presented statistical material, some of them lithographed, seem to have been popular after the Napoleonic Wars, and in several respects Moreau's publications relate rather more to this category of material than they do to books. Nevertheless, Moreau succeeded in demonstrating in a convincing way the convenience and economy of lithography for tabular work, whether for books or not.

The need for vertical and horizontal rules in books on accounting was undoubtedly one of the reasons why some of them were produced by lithography in the nineteenth century. But another reason was the need to demonstrate a system of book-keeping by means of examples of accounting that looked convincing visually. From the sixteenth century onwards there had been a close link between book-keeping and certain styles of writing, and it was important that a book on accounting should include examples in an appropriate style of writing. Lithography emerged as the ideal process for this purpose in the nineteenth century and continued to be used to produce handwritten books on accounting long after it was abandoned for other kinds of books, and in Italy as late as the beginning of the twentieth century.

83. Feigneaux, *Cours théorique et pratique de tenue de livres en parties doubles* (Brussels, 1827). Detail of page showing the use of an *anglaise* hand and a *ronde* for emphasis. Printed by Auguste Macaire, Brussels. Approx. 175 × 205 mm. [Cat. 1.97].

84. Feigneaux, *Cours théorique et pratique de tenue de livres en parties doubles* (Brussels, 1827). Specimen page of calligraphic display, written by P. Lacroix and printed by Delfosse in Brussels. The plate is dated 1828. Image 283 × 225 mm. [Cat. 1.97].

The number of books on accounting produced by lithography in the nineteenth century was probably not large. A thorough search through the extensive Library of the Institute of Chartered Accountants in England and Wales has revealed fourteen such books. They come from seven different European countries: Austria-Hungary, Belgium, Denmark, England, France, Germany, and Italy.[2] The earliest of them was produced in the late 1820s and the latest just fall into the twentieth century.

The first of the group in terms of date and quality is Feigneaux, *Cours théorique et pratique de tenue de livres en parties doubles, démontrée dans ses différentes applications à toutes les branches de commerce* (Brussels, 1827) [83–86]. The book is a handsome folio and contains numerous lithographed pages of examples of accounts, all written and printed with great assurance. The title-page describes the book as having been 'Lithographié chez Delfosse jeune', though the majority of its pages were printed by another Brussels printer, Auguste Macaire. The names of two lithographic writers, P. Lacroix (working for Delfosse) and H. Kreins (working for Macaire), appear on a few pages. Bearing in mind the rarity of productions in which the lithographic writer is acknowledged, this seems to indicate that the publication was considered rather special. Moreover, the precision and complexity of the work suggests that the writing was done directly on the stone and not on transfer paper.

The samples of account book pages which are included in

2 See Institute of Chartered Accountants in England and Wales, *Historical accounting literature: a catalogue of the collection of early works on book-keeping and accounting in the Library of the Institute of Chartered Accountants in England and Wales* (London, 1975), pp.245–248. One of the items listed (E. Mondini, *La Regioneria generale*, 1890) is not a lithographed book.

85. Feigneaux, *Cours théorique et pratique de tenue de livres en parties doubles* (Brussels, 1827). Double-spread showing carefully written entries with headings in a variety of letterforms. Printed by Auguste Macaire, Brussels. Page size 365 × 265 mm. [Cat. 1.97].

Feigneaux's book must have been intended not just as illustrations of accounting methods, but also as examples of elegant book-keeping to be emulated. The basic style of writing used was the normal commercial hand of the day, the *anglaise*; this was combined in the usual French-language manner of the time with a *ronde* where emphasis was needed [83]. The writers of these specimen pages went out of their way to introduce variety and made use of numerous styles of lettering as though to demonstrate the satisfaction that could be obtained from this aspect of book-keeping by turning it into an art form [84, 85]. The book appeared at a turning point in lithographic lettering, between the period when the styles popularized by eighteenth-century writing masters prevailed, and a later period which saw the flowering of new kinds of display lettering which were more closely associated with advertising. It provides an admirable blend of the old and the new: every page is elegantly laid out, and great play is made with thick and thin rules on pages of accounts and of calligraphic flourishes on specimen title-pages. One large folding plate, a 'Tableau synoptique' compiled by Feigneaux and signed 'Lithographié à la plume par H. Kreins (1828)', deserves special mention for its ambitious and varied display of lithographed writing [86].

Tableau Synoptique,

présentant la Balance générale de tous les Comptes d'un Grand Livre

A PARTIES DOUBLES,

Par FEIGNEAUX.

87. E. Jones, *The science of book-keeping* (London, 1831). Lithographed by Dean & Munday, London. Page size 322 × 250 mm. [Cat. 1.124].

88. C. Ferrand, *Comptabilité* (Grenoble, c. 1888). Page size 285 × 190 mm. [Cat. 1.100].

86 (opposite). Feigneaux, *Cours théorique et pratique de tenue de livres en parties doubles* (Brussels, 1827). 'Tableau synoptique', a large folding plate, written by H. Kreins, 1828, and printed by Auguste Macaire, Brussels. 740 × 520 mm. [Cat. 1.97].

The next items in terms of date are two editions of Edward Thomas Jones's book, *The Science of book-keeping, exemplified in Jones's English systems of single and double entry and balancing books* (London, 1831). The preface of the first edition is dated 21 February 1831, that of the second 31 May 1831, which seems to suggest that the book had an immediate success. It is less impressive than Feigneaux's book lithographically [87], but rather more influential from an accounting standpoint. Jones's earlier book of 1796, *Jones's English system of book-keeping by single or double entry*, had attacked the longstanding system of double entry book-keeping and gave rise to a passionate international controversy. He failed to change the system, but these lithographed publications must have done something to keep the debate alive in the accounting world. In both editions some of the specimen plates at the beginning were printed from copper plates, but the others, which form the majority, were printed lithographically by Dean & Munday of Threadneedle Street, right in the heart of the financial centre of London. Some of the plates of the second edition differ from those of the first: folios and a few rules, which were drawn in by hand after the printing of the first edition was completed, must have been applied to the stone before printing the second (see, for example, page 251 of the book). Both editions have lithographed part titles, which are organized in a capable way and in a style associated with copper-engraving. Jones's specimens of book-keeping are equally accomplished and make use of a formal copperplate hand in several sizes and monoline rules. But though neatly written and well organized, the pages of Jones's books lack the style and sparkle of those in Feigneaux's.

Later books on accounting display little of the formal penmanship and quality of printing to be found in the books discussed above. Of the other works in the Library of the Institute of Chartered Accountants, only C. Ferrand, *Comptabilité* (Grenoble, c. 1888) [88], and A. Mlčzoch, *Návod Účetní* (Prague, 1872), seem to have been produced with any real concern for the quality of their writing and overall design. The main text of Ferrand's book is in a regular upright hand that looks a little like a *ronde*, but without its characteristic thick and thin strokes, and an *anglaise* is used for headings and for emphasis within a line. Its title-page and section headings are organized in a reasonably formal way and its samples of accounts are well presented. Mlčzoch's book is also formal in its organization and its title-page is planned on the lines of a traditional letterpress design; but it is printed on very thin paper, which results in a disturbing degree of show-through.

The other books on accounting in the collection must be seen as examples of the use of lithography primarily for the sake of economy, and may even have been printed on powered machines.

89. F.Besta, *Computisteria mercantile* (Venice, *c.* 1902). Written in an everyday cursive hand, but with more or less even line endings. Printed by Luigi Kirchmäyr. 265 × 195 mm. [Cat. 1.25].

90. G.Brambilla, *Lezioni di computisteria* (Milan, 1901). Written very informally. Printed by C.Tamburini, Milan. Page size 184 × 135 mm. [Cat. 1.40].

Two books by Fabio Besta, which were published in Italy around the turn of the nineteenth and twentieth centuries, *Computisteria mercantile* (Venice, *c.* 1902) and *Lezioni di contabilità di stato* (Venice, nd), are both substantial productions in terms of extent, the latter running to 1064 pages. Both publications include sample accounts within their texts, but these and the texts are written in a hand that looks no more formal than cursive writing used for ordinary correspondence [89]. They have small margins, and about the only concession they make in the direction of traditional book design is an attempt to achieve more or less even line endings (which they do by breaking words frequently and by extensions to terminal letters). The least formally written of all these books on accounting are three by another Italian author, Giuseppe Brambilla: *La Contabilita del capomastro* (Milan, 1900), *L'Azienda commerciale e industriale* (Milan, 1900), and *Lezioni di computisteria* (Milan, 1901) [90]. They are all octavo volumes, printed at the Tipo-Litografia C. Tamburini in Milan, but are singularly lacking in distinction.

Along with these books on accounting, which contain a lot of non-linear material, we should also consider an extraordinary publication consisting primarily of tables drawn up for the use of engineers and surveyors: *Ryde's hydraulic tables giving at sight the discharge & velocity of water & sewage flowing through pipes* (London, 1851) [91–93, 95]. It was compiled by Edward Ryde, a practising engineer and surveyor of 14 Upper Belgrave Place, Eaton Square, London, and was jointly published by J. Weale, Hullmandel & Walton, and the author. Other books of tables by Ryde announced in it were *Agricultural tables*, *Tables for setting out curves*, *Tables for setting out slopes*, and *Tables of land measure and the value of estates*. None of these items has been traced, and it seems doubtful whether any of them appeared.

The full title of *Ryde's hydraulic tables* reveals its purpose, which clearly has a bearing on improvements to sanitation in nineteenth-century Britain. The bulk of the volume consists of ninety tables giving, in four columns, the diameter of pipes, the discharge per minute in gallons, the discharge per minute in feet, and the velocity per minute [92]. Each table gives information for a different inclination. The information carried by the tables is in handwritten sanserif characters; every third line is picked out in bold and followed by extra space for ease of horizontal reading. The actual information is embedded in, and adorned by, a pictorial framework which, whether deliberately or not, derives from the way in which canonical tables were presented in medieval manuscripts [94]. But instead of the information in the tables being separated by means of architectural columns, which was the medieval practice, the columns of information in Ryde's tables are

91, 92. E. Ryde, *Ryde's hydraulic tables* (London, 1851). Drawn on zinc in the Office of Edward Ryde and printed by Hullmandel & Walton, London. The design of the tables follows the pattern established for canonical tables in medieval manuscripts. Page size 240 × 150 mm. [Cat. 1.184].

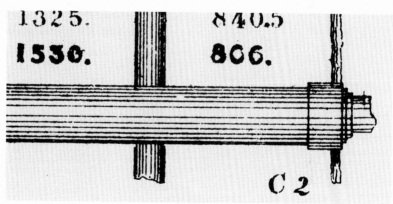

93. Detail of 92 showing a signature. Approx. 25 × 53 mm.

94. Canonical tables from the Golden Gospels of Henry III, *c.* 1043–46.

ingeniously and wittily separated by drain pipes. Only lithography could have accommodated such a delightful combination of pictorial and numerical language in mid-nineteenth century book production.

The book was described as having been 'Drawn upon zinc in the Office of Mr. Edward Ryde'. It includes a pictorial half-title, a title, and advertisement pages, all signed J. M'Nevin, and a preface written in an elegant copperplate hand. Every part of the book is lithographed and, though unconventional in almost every respect, it reveals a thorough understanding of the conventions of book production. For the first time to my knowledge in a British lithographed book [93], signatures were included in the traditional letterpress manner. The book is royal octavo in size and was printed from zinc by Hullmandel & Walton. There was nothing

95. E. Ryde, *Ryde's hydraulic tables* (London, 1851). Cased in green cloth, with blind and gold blocking. [Cat. 1.184].

3 F. Boase, *Modern English biography* (1921, 2nd imp. 1965), vol.6, pp.730–731. Boase lists several other publications by Vale.

particularly new about the use of zinc plates in lithography by this time, but *Ryde's hydraulic tables* may be the first book in which the use of zinc was explicitly acknowledged. Its pages were printed four to view on a heavy paper and gathered in eights. The same pictorial surround is found on all the tables, which means that a master image must have been transferred to the plates and then altered up to include the correct heading and the main body of numerical information. The book is not particularly well printed, and the use of the transfer technique may have been partly responsible for the variation in print quality from page to page. But even on the preliminary pages, which would not have suffered by being transferred from a master image, there is plenty of scumming, and this has probably to be put down to Hullmandel & Walton's relative inexperience of printing from zinc plates. Despite its technical imperfections and undoubted eccentricity, *Ryde's hydraulic tables* stands as one of the first lithographed books to have the feel of a real book, and the single copy I have seen is cased in green cloth with a gold-blocked device on its cover [95].

Another publication that might be appropriately discussed in this chapter is the Rev. Benjamin Vale's *Philological lectures* [96, 97], which was published privately by its author in Longton, Staffordshire. The book is not dated, but Dr Vale was Rector of St James's, Longton, from 1839 until his death in 1863. This does not narrow the date down much, but on grounds of both content and style the book appears to date from the middle of the nineteenth century; there is no reason therefore to doubt the date of 1854 ascribed to it by one source.[3] The book contains lectures on the twelves signs of the zodiac, the transition from speaking to writing, cabalism, mythology, and the evidence of antediluvian history in the alphabets of languages. Most of these contributions involved the use of ingredients that would have been difficult to cope with in letterpress printing. The ones on the transition from speaking to writing and cabalism needed Egyptian hieroglyphs, and the book could therefore have been discussed equally well in Chapter 7 along with books involving the use of non-latin scripts. The lecture on the twelve signs of the zodiac is the one that leads the book to be discussed in this chapter, because it includes a series of astrological charts. Each sign of the zodiac is dealt with on a pair of facing pages, the verso carrying a chart of a constellation and the recto a verbal commentary on it.

Few would hold that Vale's slim octavo is an elegant production. It is printed on a light-weight machine-made paper and many of its pages have very narrow margins; overall it has something of the quality of utility books which were made in Britain under special restrictions during the Second World War. In general, the lines of the writing are very close – far too close for comfortable

96, 97. B. Vale, *Philological lectures* (Longton, Staffs, *c.* 1854). Printed by J. McGahey, Chester. Page size 220 × 140 mm. [Cat. 1.231].

reading. They also vary in number from page to page. The likelihood is that the Rev. Benjamin Vale did most of the writing himself. The reason for making such a claim is that the major part of the book was written on transfer paper in a deliberately archaic hand with a long ſ. This character was quickly abandoned in printing after first being dropped in the late eighteenth century, and by about 1820 it was rarely used – except as a piece of conscious archaism – either in printing or in writing. In contrast to the majority of its pages, two pages of the text (those relating to the first two signs of the zodiac) do not use the long ſ. These two pages, along with the title-page and another page with display letters, also differ from the others stylistically. There is good reason to believe, therefore, that they were written by a different hand, and probably directly on the stone. It is possible that the original plan was for the whole book to be written out by a professional lithographic writer and that, soon after starting, there was a change of plan and Vale took over the writing himself.

A consistent feature of Vale's *Philological lectures* is the use of headings lettered in sanserif capitals. Though somewhat naively drawn and poorly centred, they provide a useful contrast to the passages of informally handwritten text. In style they relate to some of the sanserif types introduced by leading British typefounders in the 1840s.

The printer of Vale's *Philological lectures* was J. McGahey, who was then at Bold Square, Chester. He was a draughtsman and water-colour painter, and worked as a lithographic printer in Liverpool and Tranmere before setting up as a lithographic printer

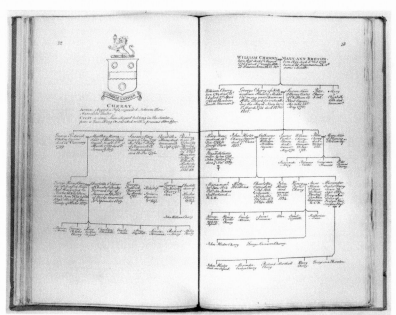

98, 99. W. Berry, *County genealogies: Pedigrees of Berkshire families* (London, 1837). Written on transfer paper by Berry and printed by Edward Barwick, London. Page size 345 × 215 mm. [Cat. 1.20].

and photographic artist in Chester in the 1850s. He is regarded as the first commercial photographer in Chester. Shortly after completing Vale's book, he gave up lithography to concentrate on photography, though he was back in Liverpool working as a lithographer by 1864.[4] It cannot be said that he made a particularly good job of pulling together Dr Vale's disparate-looking lectures into a coherent visual whole. In terms of lithographic book production, the publication is rather less advanced than the military manuals issued by the Royal Engineer Department at Chatham in the 1820s. It is certainly less elegant than most of the Chatham productions, and also lacks some of those features that are commonly associated with book design. Though it has a carefully displayed title-page and folios, it has no running heads or visible signatures, and its presswork is uneven in quality.

The lithographic process was also found to be useful for publications containing genealogies and, as has been noted, was used by Sir Thomas Phillipps for this purpose, albeit very crudely, in his *Visitations of Berkshire* (c. 1840). The most ambitious, and possibly the first of such lithographed works, was a series of *County genealogies* edited by William Berry, formerly of the College of Heralds in London. Eight folio volumes were published in this

[4] McGahey is not referred to in D. Nuttall, *A history of printing in Chester* (Chester, 1969). For a brief discussion of him, see D. Napper, 'Looking for an artist', *Deesider*, no.84, Oct. 1971, pp.24–25. The firm of J. M'Gahey & Son, of Bold Place, Chester, is listed under 'Printers-lithographic' and also under 'Artists' (photographic) in *Slater's (late Pigot & Co's) royal national commercial directory and topography of the counties of Cheshire, Lancashire, Shropshire, and North Wales* (Manchester & London, 1856); John McGahey is listed under 'Photographic artists', at City Wall, Eastgate, in Kelly's *Post Office Directory of Cheshire* (London, 1857), and as a photographer under 'Artists', at Northgate St., City Walls, in Francis White and Co.'s *History, Gazetteer, and Directory of Cheshire* (Sheffield, 1860).

100. Detail of 99. 100 × 130mm.

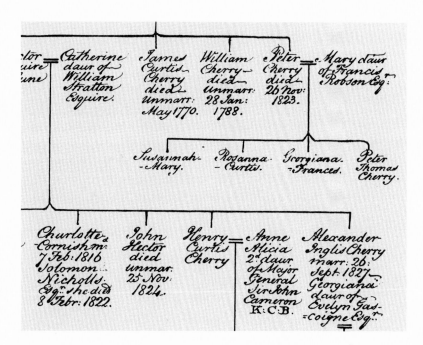

series between 1830 and 1842, each covering a different county. The first three volumes of the series were all printed letterpress, but the later ones for Berkshire, Buckinghamshire, Surrey, Essex, and Hertfordshire were lithographed throughout. The volumes for Berkshire, Buckinghamshire, and Surrey were issued together with a common half-title; each carries the same decorative title-page, dated 1837 [98], which was altered up successively on the stone to cater for the different county names and coats of arms. The Essex and Hertfordshire volumes have very different decorative title-pages from the other three, and also differ from one another on points of detail.

The five lithographed volumes in Berry's series of *County genealogies* are of special interest because their title-pages state that the writing was done on transfer paper by William Berry himself. The printing of the first four lithographed volumes was undertaken by Edward Barwick, that of the last by Frederick Alvey. Berry was specially qualified to do the writing of these books himself, and certainly more qualified than the typical genealogist or author, because he had been employed for fifteen years as the Registering Clerk at the College of Heralds and had acquired an accomplished hand. The preface to the lithographed volumes of the series draws attention to the novelty of the publication in the following terms:

> The printing of these Pedigrees in Lithography from the hand-writing of the Editor, will not only be a novelty, being the first Work published in the manner, but it will have the appearance of a Manuscript, and may be considered as such;

and some little interest may attach to it from the hand-
writing being so well known – all the Entries in the Heralds
College being made in it, during a period of fifteen years.

All together, the five lithographed volumes of Berry's *County
genealogies* run to almost 1000 pages. The main body of each
volume consists of family trees, organized with branching lines in
the traditional manner to indicate relationships both horizontally
and vertically [99, 100]. In lithography such lines could be drawn
very conveniently by hand along with the words, though this can
not have been the major reason for the use of the process since
family trees had been printed from type material for centuries and
the first three volumes of the series were produced this way. It
seems likely that the economic advantages stemming from the
use of lithography for a work of this kind figured prominently in
the decision to move away from letterpress methods, particularly
as the editor was able to undertake the 'composition' of the books
himself.

It is tempting to look for some connection between the litho-
graphed productions of William Berry and Sir Thomas Phillipps.
The two men's paths must surely have crossed from time to time,
if only because Phillipps would have been in contact with the
College of Heralds in connection with his genealogical work.
Berry's series of lithographed genealogies was well underway by
the time Phillipps published his first lithographed publication,
Visitations of Berkshire, around 1840. But if Berry did know of
Phillipps's rather miserable excursions into lithography at Middle
Hill, he must have been determined to apply altogether different
standards of production to his own publications, which are among
the most authoritative looking lithographed books of the period.

Music method books

As we have seen in Chapter 2 on lithographic incunables, the earliest recorded lithographed book, André's *Thematisches Verzeichniss sämmtlicher Kompositionen von W. A. Mozart* (Offenbach, *c.* 1805), included passages of music. This should come as no great surprise to anyone familiar with the beginnings of lithography, because the first commercially successful application of the process was in the field of music publishing, and in many ways this Mozart catalogue was no more than an extension of music printing. From this time onwards music publishers played an important part in the development of lithographic book production; and though they may not have understood very much about book design and production, they demonstrated that lithography had a role to play in this field.

The production of editions of music has always presented problems: letterpress methods were tedious and expensive at the composition stage, but were fast when it came to the actual printing; intaglio methods were relatively quick at the origination stage, and also offered great flexibility, but were extremely slow by comparison with letterpress at the printing stage and, most limiting of all, could not be used for long runs. Senefelder's new process offered several possibilities to the music publisher. It allowed music to be written backwards on the stone, in which case it may not have been much quicker than intaglio engraving; or it could be done the right way round on transfer paper and then transferred to stone. Other methods of printing music by lithography were used in the first half of the nineteenth century, but these were the main ones.[1] The use of transfer paper often led to a loss of quality, largely because it encouraged hasty writing, but there was no reason why working directly on to the stone should not produce results as satisfactory as those obtained from intaglio engraving. However, because the skills of music writing were tied up with the craft of engraving, it took some time for the lithographic music writer to match the quality of the best music engravers. On the machining side, lithography offered immediate advantages over intaglio printing; it was substantially faster, and

[1] For a more detailed discussion of music printing by lithography see M. Twyman, *Lithographed music: the first fifty years* (in preparation).

many more prints could be taken from stone than from intaglio plates. There was also the possiblity of taking advantage of the strong points of both processes by engraving the music in the normal manner and transferring a proof of the image to lithographic stone. But whatever techniques were used – and many different ones were tried – lithographers and music publishers alike were not slow to recognize the opportunities available to them.

Senefelder's own music printing goes back to his experiments in relief printing from stone at the close of the eighteenth century, and a good range of his early music printing is preserved in the music collection of the Staatsbibliothek in Munich. In the early days of his music printing Senefelder worked in partnership with Franz Gleissner, a local composer of some note, but now forgotten by the music world. In 1799 they sold the right to use lithography to Johann Anton André, the owner of the flourishing firm of music publishers of that name in Offenbach.[2] André began using lithography for the printing of music in 1800 and soon produced some very fine lithographed editions. He also had grandiose plans for establishing lithographic presses in various parts of Europe, and sent his brothers Frédéric and Philipp to Paris and London, and Gleissner's wife to Vienna, in order to take out patents for it. Not all these ventures succeeded as planned. For a short time after 1802 Frédéric André printed music lithographically at Charenton, then just outside Paris, but in London Philipp André's attention was diverted to the production of pictorial prints. Johann André's plans for Vienna were thwarted by Senefelder, who learned about them and sent his own two brothers there to protect his interests, and later on went there himself to print music. By the time Senefelder had obtained an exclusive privilege to print lithographically in Lower Austria in 1803, he had already begun printing music in Vienna. He soon tired of this venture, however, and returned to Munich in 1806. A few years later he sold his interests in the firm to S. A. Steiner, who published lithographed music under the style 'Chemische Druckerey' or 'Imprimerie chimique'.[3] Meanwhile, two of Senefelder's workmen in Vienna left in 1804 to set up a lithographic workshop for the well-known music publishers Breitkopf & Härtel in Leipzig.[4] Within a few years of the successful development of the process, lithography had been taken up by some of the leading music publishers; and by 1820 it was being used by music publishers in most countries of Europe – though not, oddly enough, in Britain. All the same, lithography was still very much the alternative process and the traditional method of intaglio engraving continued to be the principal means of producing music for many years to come.

The subject of this chapter is not the printing of music by

[2] For further discussion of this and other developments touched on in this paragraph, see Twyman, *Lithography*, pp.12–14, 26–29, 41–45.

[3] See Twyman, *Lithographed music, Austria: Chemische Druckerey*.

[4] Twyman, *Lithographed music, Germany: Breitkopf & Härtel*. On Breitkopf & Härtel in general see the entry on the firm by H.-M. Plesske in *The New Grove dictionary of music and musicians*, (London, 1980), vol.3, pp.251–252.

lithography, which is an enormous field of study that warrants a book on its own, but the production of music instructional manuals, called method books by musicologists. Of necessity, such books include passages of music. Sometimes these passages are quite long, but method books differ from music scores in that they depend quite as much on their text matter as on their music. Some of them are general works that introduce a particular approach or method, others relate to specific instruments or to singing; but most include music illustrations and carefully graded exercises. Numerous books of this kind were published in the nineteenth century, only a few of which were produced by lithography. Nevertheless, those that were form an interesting and fairly homogeneous category, and some of the most ambitious and complex early lithographed books are music method books. In common with the books on accounting discussed in the previous chapter, they were published in several countries in Europe. Some twenty or so lithographed method books have come to light,[5] though I suspect that many more were produced, particularly in central and eastern Europe. Most of the books discussed have come from Germany, France, and Italy; only one minor British example has been traced, which reflects a neglect of lithography by British music publishers in the first half of the nineteenth century that has not yet been satisfactorily explained.

The main concern of music publishers in the period under discussion – and probably at other times – was the production of sheet music, ranging from popular songs of ephemeral interest only to orchestral parts for major compositions. But even in such examples of music printing, the problem of combining music notation with words had to be faced. Conventional music notation makes considerable use of words for additional instructions, such as indications of tempo, dynamics, and expression marks; in addition, all kinds of music that has to be sung needs words to accompany the notation. The problem of combining words with music notation was not limited therefore to the production of method books. If the music was typeset, there was obviously no difficulty whatsoever; but if it was printed intaglio it presented much more of a problem, and the two main techniques that were used were engraving the lettering by hand and punching manufactured letters into metal (in the same way that noteheads were produced).

It is by no means easy to draw a precise line between books and non-books in the field of music publishing. Are bound volumes of music with no text to be considered books because of their codex form and extent? And are smaller unbound items, such as songs, to be counted along with books because they include some text? The difficulty of resolving such issues accounts for my concentra-

[5] This chapter is largely based on a study of the method books in the fine collection of lithographed music brought together by Hermann Baron. I am greatly indebted to him for so generously making them available for me to study and for having had the foresight to collect lithographed music long before it attracted other people's attention. At a late stage in the production of this book the H. Baron Collection was acquired by Reading University Library.

101, 102. A.M. Strobel, *Kleine für Kirche und Schule bestimmte Musikstücke* (Strasbourg, 1829). Page size 197 × 122 cm. [Cat. 1.200].

tion here on method books, all of which include text matter and most of which are sewn in sections and bound. However, I shall begin by referring to a couple of song books as representative of another sizeable category of lithographic publication with some text matter.

The books illustrated here are A.M. Strobel, *Kleine für Kirche und Schule bestimmte Musikstücke* (Strasbourg, 1829) [101, 102], and two volumes with the same title by W. Wedemann, *100 auserlesene deutsche Volkslieder mit Begleitung des Claviers* (Ilmenau, 1833; Weimar, 1836–38) [103, 104]. In these publications the first verse is written out along with the music, but all other verses appear separate from it, either on the opposite page or on the same page beneath the music. The formula adopted for these books is no different from that used for the production of popular songs in sheet form, such as those in octavo format published by Schott in Mainz and Williaume in Brussels around the 1820s, which occupy no more than a single folded sheet.[6] The difference is simply that the material has been bound in codex form and is extensive (Strobel's book runs to 84 pages and Wedemann's two books to over 200 pages each). As it happens, these books all have signatures (in the form of numbers), which the purist might take as a means of distinguishing between book production proper and bound up jobbing work. There is nothing in production terms, therefore, to separate them from many music method books. They are mentioned as examples of another kind of music book with extended passages of text, and also because they compare very favourably in terms of quality with what was being produced at

[6] See Twyman, *Lithographed music*, Belgium. Germany: Schott.

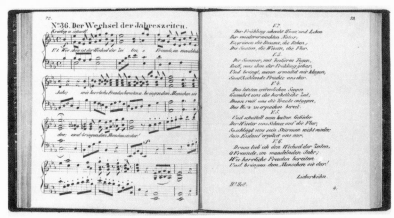

103, 104. W. Wedemann, *100 auserlesene deutsche Volkslieder mit Begleitung des Claviers* (Ilmenau, 1833). Printed by B. F. Voigt, Ilmenau. Page size 137 × 130 mm. [Cat. 1.235].

the time in other areas of lithographic book production.

One characteristic that relates the music method books that are discussed in this chapter is that they were mostly issued by music publishers rather than book publishers. Of the major European music publishers, the following were among those responsible for issuing the books discussed below: André (Offenbach), Cipriani (Florence and Bologna), Falter (Munich), Meissonnier (Paris), Ratti & Cencetti (Rome), Schlesinger (Berlin & Bonn), and Schott (Mainz). The consequence of the dominance of music publishers in this area of publishing is that method books usually follow the conventions of music publishing rather than book publishing. Among other things, this accounts for the fact that many lithographed method books are undated. Sometimes, and particularly in Germany, the practice was for publishers to provide a method book with a number in their normal sequence of publication numbers (called plate numbers by musicologists). These numbers often appear on the title-page and at the foot of every text page, just as they do on pages of sheet music. It is these publication or plate numbers that make it possible to date the books of some publishing houses to within a year or so.[7]

The earliest lithographed method books to be traced so far were published by André in Offenbach and have been referred to briefly in the chapter on lithographic incunables. They are J.-L. Duport, *Essai sur le doigté du violoncelle* and M. Clementi, *Méthode pour le piano forte*. Neither is dated, though their plate numbers (2599 & 2738 respectively) suggest that both were published around 1809.

Duport's *Essai sur le doigté du violoncelle* [105–109] is much the more ambitious of the two, and is a quarto volume that runs to 165 pages. The particular copy that has been studied has blue-paper wrappers with a small lithographed label pasted on the front. It has an accomplished title-page in French, and this is followed directly by parallel texts in French and German. Each page is

[7] See particularly O. E. Deutsch, *Musikverlags Nummern* (Berlin, 1961).

105–107. J.-L. Duport, *Essai sur le doigté du violoncelle* (Offenbach, c. 1809). Printed and published by J. André. Page size 340 × 275 mm. [Cat. 1.89].

8 See Twyman, *Lithographed music*, Germany: André.

divided into two columns, separated by a vertical rule, the French version on the left and the German translation of it on the right. Different styles of writing are used for the two languages: the French is written in an italic [108], whereas the German appears in a less cursive, sloped hand and has unjoined letters [109]. In general, the French writing has less contrast in stroke thickness than the German. Within these major differences the style of writing varies throughout the book, which suggests that more than one writer was involved. In the introductory pages [106] the German text has lines some 5 mm longer than the lines of the French text, which means that the two languages keep more or less in tandem with one another, but this practice was not followed thereafter in the book. The writing was clearly intended to look formal and appears to have been done directly on the stone, and therefore in reverse. The headings for the French text are in a large *anglaise* minuscule, whereas those for the German text are in sloped capital letters [107]. Passages of music included with the text usually span both columns, though in some instances very short musical phrases appear within each language version of the text. In common with André's lithographed music published before 1809, the solid noteheads are round rather than oval.[8]

Duport's *Essai* is a well-considered publication in book production terms and may well have served as a model for other bilingual works of a similar kind. Its text and music are positioned on the page so as to give well-proportioned margins and, in general, they are consistently printed. Folios are placed at the head and to the outer margins, plate numbers are at the foot and always to the right, and there are no signatures. Such features suggest that André approached this book in no way differently from any fairly large-scale musical score that he was responsible for. Evidence gleaned

108. Detail of 107 showing part of the French text, written in reverse on the stone in an italic hand. 24 × 36 mm.

ne l'ai jamais les matériaux, notes sur ce q eprenois un jour

109. Detail of 107 showing part of the German text, written in reverse on the stone in a sloped roman hand. 24 × 36 mm.

Zweck nicht au die Materialien gen welche mir abe dieſes Werks

from the impression marks of stones and from the variation in inking of pages suggests that, in common with André's music printing of the period,[9] Duport's *Essai* was printed one page at a time.

Clementi's *Méthode pour le piano forte* [110–113] is also a bilingual book, but is more modest in scale than Duport's *Essai*. It is a landscape format book and its thirty-one printed pages are sewn in a single section. In these respects, and in its title-page too, it is reminiscent of a musical score of the period. What distinguishes it from such publications is its instructional text in French and German, which is organized in much the same way as similar text in Duport's *Essai*. The styles of writing used for the two

[9] See Twyman, *Lithographed music, Germany: André.*

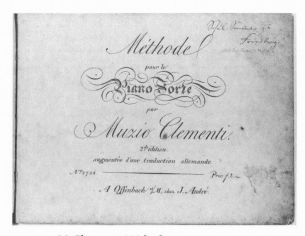

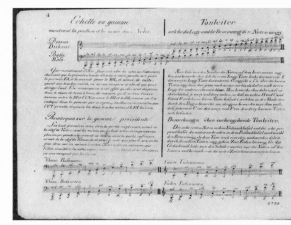

110, 111. M. Clementi, *Méthode pour le piano forte* (Offenbach, c. 1809). Printed and published by J. André. Page size 242 × 327 mm. [Cat. 1.69].

112. Detail of 111 showing part of the French text, written in reverse on the stone in an italic hand. 24 × 36 mm.

113. Detail of 111 showing part of the German text, written in reverse on the stone in a sloped roman hand. 24 × 36 mm.

languages [112, 113] are similar to those found in Duport's book, but the two columns of text are separated by a much stronger vertical rule. Clementi's *Méthode* also makes greater use of the practice of printing short passages of music within both French and German texts.

Shortly after André published Duport's *Essai* and Clementi's *Méthode* Simrock published a similar bilingual (French and German) method book in Bonn. This was a *Méthode de violon*, edited by Baillot and based on the methods of Rode, Kreuzer and Baillot himself. It is a quarto volume measuring 330 × 255 mm and, according to its plate number (35), it was published around 1812. Its two languages run in parallel columns, as in the Duport and Clementi works, but unlike them it makes no distinction in the style of the writing between French and German texts, and all its music illustrations are centred over two columns and serve both of them. The book runs to sixty pages and in terms of scale stands between the two earlier publications, though it is not as distinguished as either of them in graphic terms. Whereas its text and music are regular and neat, it lacks a sense of style overall. In particular, the music writing is stilted and the title-page lacks distinction. All the writing seems to have been done direct to the stone and the book was printed on good wove paper bearing the watermark of 'Van der Mu....len & Comp'. In general the pages back one another up well, and some of the pages of text even do so line by line. They were printed two pages to view under considerable pressure and in places show very clear impression marks. These reveal that most of the stones used were not much larger than the images of the two pages printed from them, and that, on occasions, the edges of the stones were no more than 5 mm away from the printed image. Nearly all the pages carry Simrock's plate number in the centre of the foot margin, but it is by no means certain that Simrock was responsible for the printing.

114, 115. J. J. F. Dotzauer, *Méthode de violoncelle* (Mainz, c. 1824). Printed and published by B. Schott. Page size 319 × 247 mm. [Cat. 1.87].

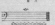

116. Details of display letters
from 114 drawn in pen and ink. All
24 × 36 mm.

10 Deutsch, *Musikverlags Nummern*,
p.23. For Schott in general, see the entry
by H.-C. Muller and F. Daunton in *New
Grove*, vol.15, pp.734–735; for the firm's
lithographed music, see Twyman, *Litho-
graphed music*, Germany: Schott.

11 P. Dupont, *Essais pratiques
d'imprimerie* (Paris, 1849), p.10.

In the 1820s and 1830s lithography was used for several method
books. The finest of these is another bilingual work in French
and German, J. J. F. Dotzauer, *Méthode de violoncelle / Violonzell-
Schule* (Mainz, c. 1824) [114–116]. Dotzauer was a composer and
teacher, and at the time he wrote his *Méthode* he was holding the
post of royal musician at Dresden. His book was published by
Schott and carries the publication or plate number 2014 on its
early pages and, somewhat strangely, 2114 from page 29 onwards.
These numbers mean that the book must have been published
about 1824.[10] No printer is referred to in the book, and the
assumption must be that it was printed by the firm of Schott,
whose own watermarked wove paper was used throughout. It is
an upright format book, measuring 319 × 247 mm, which is more
or less the same size as most upright music scores of the period,
and it runs to 110 numbered pages, plus preliminary material. It
opens with a fine bilingual title-page, with the main words of the
two titles picked out in display letters with strongly contrasting
features [116]. Though lettered in pen and ink, it looks as if it had
been engraved on copper and stands comparison with the older
process in every respect. There follow two pages of pen and ink
illustrations of the violoncello showing bowing and fingering
techniques. Thereafter, up to and including page 62, the book is
divided into two columns to accommodate the French and
German language versions of the text [115]. But whereas the
Clementi, Duport, and Baillot books had the French first, here the
German is on the left and the French translation of it on the right.
The pattern adopted for these other bilingual manuals is followed
in other respects: its double columns of text are separated by rules
(thick and thin ones), and a different style of writing is used for the
two languages. The German text is written in a style almost
identical to that called *italique* by Dupont,[11] but the French text,
though superficially looking the same, has different forms for the
small letters 'a', 'g', and 's'. These differences are consistent and
do not seem to arise from the use of different writers, because
other letters look very similar in both texts. The headings of the
two texts are more obviously different from one another: the
German language ones are lettered in modern-face capitals,
whereas the French ones are in the characteristic French *ronde*. In
his treatment of those passages of music that are printed with the
text Dotzauer follows the approach of Baillot, and is absolutely
consistent in centring them over the two columns so that repeti-
tion is avoided. The second part of the book consists of graded
exercises; it has no text and looks just like any ordinary music
score.

Dotzauer's *Méthode du violoncelle* is a most handsome publica-
tion and in this respect is comparable to Feigneaux's *Cours*

117, 118. F. Fenaroli, *Partimenti ossia basso numerato* (Rome, *c.* 1823). Page size 335 × 245 mm. [Cat. 1.99].

théorique et pratique in the field of accounting. By the mid 1820s Schott's production staff would have come to terms with lithographic music writing and printing through their experience with straightforward music scores, but it is to their credit that they managed to master the business of organizing text material in book form so well since this would have fallen outside their normal range of work. Not only is the writing of Dotzauer's book regular in slope and even in tone, but the text is organized to make constant page depths and is placed so as to give regular margins. Its pages were printed two to view, and short lines in the back margins indicate where they were to be folded. Though pages do not back one another up line for line, the printed areas as a whole back up well, and on some pages the vertical rules that separate the columns of text back up perfectly. In production terms generally, Dotzauer's *Méthode du violoncelle* must be seen as an outstanding lithographed book.

F. Fenaroli's *Partimenti ossia basso numerato* (Rome, *c.* 1823) [117, 118] belongs to the same period as Dotzauer's manual and is much the same in scale. However, its visual organization, machining, and paper are altogether inferior, which reflects the general difference in standard between lithographic work produced in Germany and Italy at the time. Its publishers were Ratti & Cencetti, whose lithographed music is better remembered for its quantity than its quality,[12] and its publication number is 104. Fenaroli was a music teacher in Naples and his 'Partimenti' remained the standard method of counterpoint in Italy for more than half a century. The book is divided into two, separately paginated parts; the first consists of explanatory text illustrated with examples of music, the second of graded exercises. In its

[12] See E. Zanetti, 'L'Editoria musicale a Roma nel secolo XIX: avvio di una ricerca', *Nuova Rivista Musicale*, vol.18, 1984, pp.191–199; the entry by R. Macnutt in *New Grove*, vol.15, p.600; Twyman, *Lithographed music*, Italy: Ratti & Cencetti.

119, 120. S. Mattei, *Pratica d'accompagnamento sopra bassi numerati e contrappunti a piu voci* (Bologna, Florence, Livorno, nd). Page size 330 × 240 mm. [Cat 1.149].

overall treatment it is similar to Dotzauer's book, but the essential difference is that its text is in Italian only and is not organized into two columns. It is written in an unusually large *coulée* hand, with key words picked out in a *ronde*. The rather indifferent quality of the printing makes it difficult to tell how the text was written, but the freedom of some of the flourishes suggests that it was done on transfer paper. The text areas are well positioned on the page and their right-hand edges are almost even; there are also footnotes and catchwords. Despite these traditional ingredients of book design, one oddity suggests that the publishers were not well versed in the conventions of book production. Every page carries the publisher's plate number, together with a signature in roman numerals; but since these signatures were printed on every page, instead of once on each sheet, they appear out of sequence when pages were gathered in sections (so that, for example, signature XI appears on p.40 and signature X on p.41 in illustration 118).

S. Mattei, *Pratica d'accompagnamento sopra bassi numerati e contrappunti a piu voci* (Bologna, Florence, Livorno, nd) [119, 120] is more like a straightforward music publication than Fenaroli's *Partimenti*. It was printed and published by Cipriani, one of the best-known Italian publishers to have issued lithographed music, and probably dates from the late 1820s.[13] Of its 132 pages, all but the preliminary ones, a six-page theoretical introduction, and some brief notes, consist of musical exercises. What text there is was capably enough written, though its title-page (which has an indecipherable signature) presents a graceless and overcrowded array of display letterforms. The initials 'T' and 'B' appear at the foot of many of the pages; these letters are found on other music published by Cipriani and it is assumed that they are the initials

13 According to C. Schmidl, *Dizionario universale dei musicisti* (Milan, 1937), p.63, it dates from the period 1825–30.

121. D.F.Grechi, *Regole del canto fermo* (Bologna, nd). Title-page carefully lettered to look like type. Page size 285 × 220mm. [Cat. 1.111].

of one of his music writers.[14] Two other Italian publications should just be mentioned, though they consist mainly of pages of music and are therefore even less like books than Fenaroli's *Partimenti*. They are G.Crescentini's *Raccolta di esercizj per il canto* and *Raccolta completa di esercizj di musica*, both of which were published in Rome by Ratti & Cencetti in the 1820s.

Two smaller manuals should also be referred to in passing. One of them, D.F.Grechi's *Regole del canto fermo* (Bologna, nd), was published by Cipriani, probably in the 1830s [121]. It carries the plate number 887 and runs to just eighteen pages (only sixteen of which were printed). Its writing is somewhat laboured and each character is separated from its neighbour as though imitating printing type. Though it is a very modest publication from the point of view of its lithography, its title-page is unusual for the period in that it is lettered to look something like a letterpress production. The title itself is convincingly rendered in a fat-face and the name of the author in a shaded Tuscan; even the word 'Bologna' in the imprint is picked out as though in a small ornamented display face.

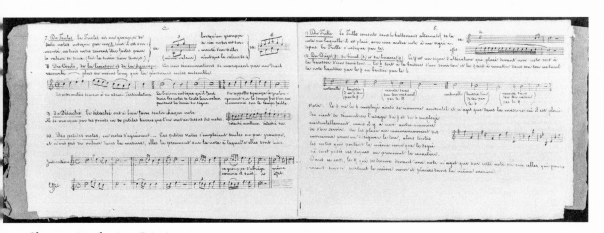

122. *Chant national suisse. Principes élémentaires de musique* (Geneva, 1833). Page size 155 × 235 mm. [Cat. 1.67].

The other small manual, *Chant national suisse. Principes élémentaires de musique* (Geneva, 1833), is even more modest than Grechi's [122]. It consists of just twelve landscape pages (eleven of which were printed), sewn in blue letterpress-printed wrappers. It is organized in a very flexible way and the words and music are written so freely – scribbled might be a better word to use – that they must have been done on transfer paper. It is among the crudest and slightest of all lithographed books that I have come across. Nevertheless, it has a special claim to be discussed here since the copy in the H.Baron Collection that I have studied is uncut on some of its pages and has printed fold lines about 20mm long on its back and head margins. It is clear therefore that it was printed four pages to view.

[14] See Twyman, *Lithographed music*, Italy: Cipriani.

123. H. Berlioz, *Die moderne
Instrumentation und Orchestration*
(Berlin, *c.* 1843–44). Printed by
F. Silber, Berlin. Page size
335 × 260 mm. [Cat. 1.19].

124. Detail of 123. The writing was
first done with a fine monoline tool
(possibly by engraving on stone) and
then thickened with a pen. There
is a correction on the third line.
24 × 36 mm.

15 Deutsch, *Musikverlags Nummern*,
p.21. See also C. Hopkinson, *A biblio-
graphy of the musical and literary works
of Hector Berlioz* (2nd ed., Tunbridge
Wells, 1980), p.61.

Judging by the number of examples that have survived from the
1840s and 1850s, there was a greater use of lithography for music
method books in this period than in earlier decades. The majority
of these later books continued to use the techniques already
discussed; that is, text and music were either written backwards
on the stone or the right way round on transfer paper and then
transferred to stone. A few music method books were produced
differently, and they will be discussed at the end of this chapter.

Among the largest in scale of the later method books, and one
of the most ambitious of all lithographed books produced in the
age of the hand press, is H. Berlioz, *Die moderne Instrumentation
und Orchestration* (Berlin, nd) [123, 124]. According to its plate
number, it was published by Schlesinger in 1843 or 1844.[15] It is
another bilingual book and its original German text has a French
translation running parallel with it; the German occupies the left
and the French the right column, and the two are separated by a
fine double rule. It measures 335 × 260 mm and has 332 litho-
graphed pages and a copper-engraved title-page. The imprint
informs us that it was printed by F. Silber in Berlin. The text of the
book is in a regular copperplate hand, an identical style being used
for both languages. It was written with great care and must have
been done backwards on the stone. When looked at through a
glass, it becomes clear that the writing was done first of all with
a thin, monoline tool, and then reworked with a broader, flexible
instrument to produce the thick strokes [124]. The text has many
word breaks and end of line flourishes which, together, give it the
appearance of having almost straight right-hand edges. Line incre-
ments and the size of the writing are not constant throughout the
book and several different writers seem to have been employed on
it. Headings were picked out either in modern-face or sanserif
capitals, and a larger size of copperplate writing was used to
emphasize words within the text.

There is a fairly even balance of text and music throughout
Berlioz's book, which means that it contains a substantial body of
text material. Very short music illustrations are embedded in the
columns of text and therefore have to appear twice to satisfy the
needs of readers in both languages, but, in general, the music is
centred across the two columns of text. The whole book creates
the impression that the printers knew precisely what they were
doing and that they were well versed in lithographic book produc-
tion. The words 'Berlioz Instrumentation' and signatures (in arabic
numerals) appear on each printed sheet, and there are fold marks
in the back margins. These fold marks take the usual form of lines
running parallel to the spine, though they depart from the norm
by being very short at the head and long at the foot. Taken along
with the signatures, they seem to indicate that the pages of

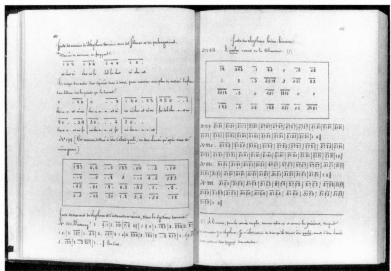

125, 126. A. Paris, *Guide pratique des cours d'enfans* (Ghent, 1842). Letterpress title-page and lithographed double-spread produced from handwriting on transfer paper. Page size 338 × 257 mm. [Cat. 1.168].

Berlioz's book were printed four to view, and probably by the work and turn method.

Another substantial manual, but very different in all other respects from Berlioz's, is A. Paris, *Guide pratique des cours d'enfans* (Ghent, 1842) [125, 126]. This seems to have been privately published by Aimé Paris, who was responsible for developing a system of music notation by numbers called 'Mnemotechnie', which had the distinction of being banned for a time in France in the 1820s. The book has 326 lithographed pages, plus a letterpress title-page and seven pages of a letterpress contents list. It makes use of Paris's system of notation and has very few pages of straightforward text. Both its words and music are freely written, and there can be very little doubt therefore that transfer paper was used. Though Paris's book is very informal in its presentation – even to the point of scribbled deletions being made on some pages (for example, on pages 200, 239, 252) – its presswork is quite good. It is by no means clear who printed the book: one page of illustrations has the imprint 'Lith de G. Jacqmain, rue basse, à Gand', but the illustrations on this page were certainly not drawn on transfer paper, which means that it cannot be assumed that this printer was responsible for the whole production. Paris's book has reasonably generous margins and features such as footnotes, but it is loosely organized and, despite the authority bestowed by its letterpress title-page, falls short of looking anything like a traditional letterpress book.

C.-S. Catel's *Trattato di armonia* (Rome, 1840) [127–129] goes even further than Paris's *Guide pratique* in using letterpress additions to make a lithographed production look more like a traditional book. As it happens, it is a much more accomplished

127, 128. C.-S. Catel, *Trattato di armonia* (Rome, 1840). Letterpress title-page and lithographed double-spread. The lithographic printing by Luigi Polisiero, Rome. Page size 354 × 235 mm. [Cat. 1.61].

129. Detail from p.9 of Catel's *Trattato di armonia*, written in reverse on the stone. 24 × 36 mm.

production all together and scarcely needs the help it gets from having its title-page, dedication, and preface printed from type. The major part of the book (pages 9–83) was produced with some assurance by means of lithography. Somewhat ironically, it is the letterpress title-page that informs us that the book was printed at the 'Stamperia litografica di Luigi Polisiero'. Its text is in Italian throughout (though translated from the French), and is written in a hand that might be described as a cross between a *bâtarde* and a *coulée* [129]. Both the music, which appears with the text on most pages, and the text itself, appear a little on the large size to present-day eyes. But for all this, the book has some interesting design features, the most unusual being the way the text relates to the music illustrations. Apart from a defined text area, no underlying grid can have existed for the design of the pages and the lengths of the text lines have been determined by the require-ments of the music. Headings are in letterforms based on modern-face types, and the notes to the text are separated from it by double rules and are written in a smaller hand. The book also has signa-tures (in the form of letters). Overall, there is a rather artless generosity about the whole production, which is reinforced by its large margins and heavy wove paper.

Other music method books of the same period which were produced by similar methods should be mentioned here since they might otherwise go unrecorded. They are A. de Garaudé, *Metodo completo di canto* (c. 1840), published in Rome by Pittarelli; M. Mühlauer, *Grosse Zither-Schule*, published by Falter in Munich in 1853; an anonymous and undated *Principes de musique vocale*; and the only Portuguese improper book I have come across, M. N. Aguedo, *Methodo geral para a viola franceza* (1840).

In technical terms the method books discussed so far merely took advantage of the possibilities offered by well-tried methods of lithography for combining text and music. The only snag with such methods was that the texts were handwritten, which prevented most of them from looking much like traditional books. The same could be said, of course, of all the books discussed so far, apart from the *Parthenon* (see pp.54–56); but it has to be remembered that the books produced at Chatham and Metz and for Sir Thomas Phillipps were not intended for public consumption, and that the use of handwriting for the texts of books on accounting and genealogy could be justified on other grounds. In the case of method books, which were published in the ordinary sense of the word, the use of handwriting for long passages of text must have been seen as a severe drawback. The last group of books to be discussed in this chapter highlights some attempts that were made to solve the problem of making the text matter of lithographed books look more like that of proper books.

Three different approaches were adopted in method books in an attempt to solve this problem, and they span a period of several decades. The most obvious approach was, of course, to print the text from movable type and the music by lithography; though such a book would hardly qualify as a lithographed book. The second was to use the traditional letter punches of the music engraver to produce text matter on intaglio plates, which could then be printed in lithographic transfer ink and transferred to stone. The third was the process of typolithography, which involved setting text with movable type in the normal manner, taking a proof of it in transfer ink, and transferring this to lithographic stone.

The first of these need not detain us long since it relates only marginally to the subject of this book. It was used with considerable success by Philippe de Geslin for his two books *Cours analytiques de musique, ou méthode developpée du méloplaste* (Paris, 1825) and *Cours d'harmonie* (Paris, 1826), both of which he published himself. Both books are octavos and have numerous lithographed plates, some of them folding ones, which are guarded into the book opposite the relevant letterpress page. More innovatory from a technical standpoint is S.Daniel, *Grammaire philharmonique, ou cours complet de musique* (2 vol. Bourges, 1836–37) [130, 131]. This is a substantial quarto publication and its title-pages have the unusual printer's imprint: 'Imprimerie en caractères et en lithographie de P.-A.Manceron'. It consists of a series of graded lessons, the general pattern being for a page of letterpress explanation to appear on the verso and the accompanying example of music on the opposite recto. The two processes were printed on the same sheets, and the lithographic printing was

130, 131. S.Daniel, *Grammaire philharmonique, ou cours complet de musique* (Bourges, 1836–37). Letterpress title-page and a typical doublespread showing a letterpress verso and a lithographed recto. All pages printed by P.-A.Manceron, Bourges. Page size 255 × 196 mm. [Cat. 1.81].

probably done before the letterpress. There are two reasons for believing this to have been so. First, the lithographic workings carry most of the signatures, which would have been helpful for identification purposes during the next working; secondly, the impression marks from the letterpress working show through strongly, and they would have been reduced or obliterated entirely had the paper been subjected to the considerable pressure of a lithographic press subsequently. The two printing processes are artfully integrated and the folios, for example, which were sometimes printed letterpress from types and sometimes lithographically from hand lettering, are made to match perfectly. Daniel's *Grammaire* is a most unusual production, yet it works remarkably well both visually and technically. It is surprising, therefore, that it does not appear to have had any imitators among later method books.[16]

The second approach to the problem of making text matter look more like what people were used to in traditional letterpress books belongs specifically to music publishing. What could be more natural for publishers who had been using letter punches for centuries for words accompanying music to try extending their use to the composition of long passages of text. Many method books, such as A. Panseron, *ABC musical* (Paris and Brussels, c. 1840), included long passages of text which were punched letter by letter into metal plates and then printed intaglio [132]. In this particular book very faint horizontal guidelines for the engraver who punched the letters can just be made out on some of the pages. It was a simple development to transfer the images from such plates to lithographic stones and so take advantage of the longer runs and quicker printing offered by lithography.

One major method book that used this technique was F. Stœpel, *Méthode théorique et pratique de chant* (Paris, 1836) [133–135], which was authorized by the French Minister of Education for use in schools. It measures 340 × 258 mm and runs to 124 pages, plus a title-page, all of which were lithographically printed on good quality laid paper. When open at its text pages the book might be taken for a letterpress production, because it follows most of the conventions of letterpress book design. Though it has many music illustrations, some of which run to a few pages each, over half its pages contain substantial amounts of text and some consist of text only. Its text is composed of letterforms that look like types, and they are organized in such a way as to produce even right-hand margins. What is more, its text areas are carefully disposed on the pages with generous margins around them and with occasional footnotes in a smaller size. Since the book has all the characteristics of letterpress printing, it is natural to assume that its text must have been transferred from letterpress types.

132. Detail showing the use of letter punches for text in an intaglio-printed music book. From A. Panseron, *ABC musical* (Paris and Brussels, c. 1840). The technique can be identified by the close spacing and poor alignment of the letters. 24 × 36 mm.

16 Though the *Encyclopedie pittoresque de la musique* (vol. 1, Paris, 1835), was produced by similar means.

133, 134. F. Stœpel, *Méthode
théorique et pratique de chant* (Paris,
1836). Title-page written on stone,
the double-spread transferred to stone
from punched and engraved intaglio
plates and printed lithographically.
Page size 340 × 258 mm. [Cat. 1.199].

135. Two details from p.37 of Stœpel's *Méthode* showing the uneven spacing and poor alignment of text produced from letter punches, and several strange characters. Lithographed. 24 × 36 mm.

However, a few small clues soon reveal that this was not so. First, the folios and some other matter fall outside what might be called the type area, which would have been most unusual in letterpress printing on grounds of economy. Secondly, the measure of the text varies from page to page. Thirdly, the characters are rather unevenly spaced along the line and – to use a conventional printing term loosely – the lines are badly justified. And fourthly, the characters do not line perfectly on a baseline. It seems clear therefore that the characters were produced one by one along the line [135]. The only reasonable way of doing this at the time would have been to use the technique employed in Panseron's *ABC musical* and similar intaglio printed method books; that is, the familiar music engraver's technique of punching letters into metal. That this was the technique used in Stœpel's *Méthode* is confirmed by a close inspection of the characters themselves. They are unlike those of any fount of printing type that has ever been produced. In the first place they have no ligatured characters, which is unusual for the period. In addition there are some very strange individual characters among them: some of the hyphens line with the base-line of the letters, the small 'i' with a circumflex retains its dot, the small 'g' is most idiosyncratic, and, most extraordinary of all, some of the 'y's seem to have been produced by combining a 'v' with a smaller size 'j' and some small 'j's by combining an 'i' with part of an inverted 'f' or long 's'.[17] Many other oddities can be found which would be too tedious to read about. Since the text must have been produced by punching letters into metal plates, it is obvious that the music would have been produced in a similar fashion. Visual evidence supports this view, because inky marks from unwiped edges of metal plates must have been picked up in the transferring and are just visible on some of the pages that consist of music only (see, for example, pages 73, 81, 83).

The same punches were not used throughout the publication, and by the time the second half came to be produced a small 'y'

[17] The custom of using two punches for the small 'y' and 'j' was common in intaglio music printing and presumably stems from the lack of these characters in early sets of punches. The fact that such customs should have lasted well into the nineteenth century says something about the innate conservatism of crafts, and particularly music printing. The set of punches used in Stœpel's *Méthode* appears to be the same as the one used by the music engraver of Henry Blanchard's 'Ronde provençale', which was published in Paris by Frère in the 1820s. As it happens, Frère operated from the Passage des Panoramas in Paris where numerous lithographers worked.

punch must have been found, which would have simplified the engraver's task considerably. The measure of the text also changes at much the same point in the book: in the first part it varies from 140 to 145mm and in the later parts (where there are longer passages of music) from 170 to 180mm. Generally speaking the work deteriorates as it progresses, and towards the end a few rogue pages creep in, including page 101 which has a ragged right-hand edge to it. We do not know who published Stœpel's *Méthode* or who was responsible for its production; the imprint on its title-page is unhelpful and merely reads 'Rue de Hanovre, No.8, au Bureau des Méthodes de Musique.'. But the use made of letter punches means that the book's production must have been firmly in the hands of those who specialized in music publishing.

136. F. Kalkbrenner, *Méthode pour apprendre le piano* (Paris, *c.* 1846). Transferred to stone from punched and engraved intaglio plates and printed lithographically by Thierry *frères*, Paris. Page size 350 × 268 mm. [Cat 1.128].

137. Detail from 136 showing uneven spacing and poor alignment. 24 × 36 mm.

A similar technique was used around ten years later in a more workaday production: F. Kalkbrenner, *Méthode pour apprendre le piano à l'aide du guide-mains* (Paris, *c.* 1846) [136, 137].[18] This book takes much the same form as Stœpel's, but has rather more music relative to the text and all but its first third is given over to exercises. All the same, it contains some long passages of continuous text. The punches used were not nearly so idiosyncratic as the ones used in Stœpel's *Méthode*: they relate to modern-face types of the period, but betray their method of production by the absence of ligatures, and by failing to line properly or be perfectly upright [137]. Considering the techniques that were used, the quality of the text matter is remarkably good. The lines are very long (something in the order of 125 characters to a line) and the text is moderately ragged to the right; but even so there are plenty of word breaks at the ends of lines. This alone would provide ample proof – if additional evidence were needed – that the setting was not

done with types in the traditional manner. Instructions on the music pages appear in similar characters to those in the text and for a variety of reasons there can be little doubt that these pages were also transferred from intaglio plates. We know the names of both the publisher and printer of Kalkbrenner's *Méthode*: the publisher was Meissonnier, whose plate number (3294) appears on every page, and the printer was the firm of Thierry *frères*, which was probably the leading lithographic house in France at the time.

The third approach to be adopted in music method books was used in other lithographed books too and involved the transfer of prints from type to stone by means of transfer paper. The process attracted a good deal of attention in the late 1830s and 1840s, particularly in France where it was known as *typolithographie* or *lithotypographie*. It cannot be said that it made any great inroads into the production of method books produced in the age of the hand press, but it was used for part of at least one such work: A. le Carpentier, *Petit solfège avec accompagt. de piano* (Mainz, *c.* 1844) [138, 139]. This landscape work of eighty-one pages was published by Schott, and its plate number (7325) indicates a date of either 1843 or 1844.[19] It is entirely lithographed, and trim and fold marks show that it was printed four pages to view. In terms of quality it cannot be compared with Dotzauer's *Méthode*, which Schott had published some twenty years earlier. It has a ten-page introduction, the text of which was set in ordinary printing type and then transferred to stone. A comparison of such typeset material [139] with examples of text produced by punching letters into a metal plate [135, 137] highlights the more even spacing and regular alignment of traditional letterpress methods. In among the text of *Petit solfège* are illustrations of music which look as though they were transferred from intaglio plates. The rest of the book consists of exercises in which music predominates, and these parts too were produced by transferring from intaglio plates. Though Carpentier's *Petit solfège* is a modest work on a number of accounts, it highlights some production issues facing publishers of method books and demonstrates the value of lithography as a means of utilizing the strengths of letterpress composition for text and intaglio engraving for music.

Why, then, were the techniques used in Carpentier's *Petit solfège* not used more often for method books? And why did the producers of the books of Stœpel and Kalkbrenner go to such lengths as to punch individual characters into metal to produce pages of continuous text when they could have made use of metal types more easily and probably produced a better-looking job as well? The answer to such questions must surely lie in the traditions of the craft of music engraving. Music engravers had always seen themselves as responsible for both the words and the music

[19] Deutsch, *Musikverlags Nummern*, p.23.

138. A. le Carpentier, *Petit solfège avec accompagt. de piano* (Mainz, c. 1844). Transferred from type and printed lithographically. Page size 231 × 285 mm. [Cat. 1.58].

139. Detail from the book reproduced in 138. 24 × 36 mm.

of their publications and, for the most part, they did not have letterpress facilities in their workshops. Music engravers had opened up their craft to embrace the new process of lithography, at least to some degree, because of the considerable advantages it offered in terms of quicker printing and longer runs, but they saw little need to open it up still further to take in letterpress methods of composition.

The earlier lithographed method books, which were written out by hand on stone or transfer paper, could have been produced without difficulty within the workshops of most music publishers of the second quarter of the nineteenth century, and by a few others long before this. When handwriting failed to meet the requirements of the market, which seems to have been the case, music publishers turned to the only means of producing text that looked something like type that lay within their control. In more senses than one, therefore, they left their stamp on the lithographed book of the nineteenth century.

Non-latin scripts

Nowadays we tend to forget how much letterpress printers used to be governed by the availability of types. In the fifteenth century, printers with no Greek or Hebrew types were quite prepared to leave gaps for words to be put in by hand; but what did nineteenth-century printers do when asked to print something in a language for which they had no characters? In theory, printers were much better equipped to deal with the problem by this time, and Edmund Fry's *Pantographia* of 1799 presents a staggering collection of examples of all the known scripts of the world, many of which were illustrated with movable types. Even so, non-latin types – somewhat arrogantly called 'exotics' in the typographic literature of the western world – were usually held only by the major scholarly presses and those which catered for the missionary market. And even such presses could not easily handle the many languages that had just been discovered or were in the throes of being deciphered. In many ways, therefore, the letterpress printer's problems were quite as great in the nineteenth century as they had been in the fifteenth. On the other hand, the possibilities offered by lithography for the multiplication of languages in non-latin scripts were limitless: any script could be reproduced by the process if there was someone capable of writing in it.

It is hardly surprising therefore that the international group of scholars and amateurs concerned with oriental and African languages in the early nineteenth century quickly saw the possibilities of lithography for the dissemination of their findings. Probably the first serious consideration of lithography for such purposes arose in connection with the official French Government publication *Description de l'Egypte*, which had to include plates of Egyptian hieroglyphs. According to Jomard, who was one of the commissioners responsible for it, Frédéric André proposed using lithography for its plates. Jomard already knew something about the process because he had seen it being practised by Senefelder in Regensburg in 1803, but he must have decided that it was too risky to use it for such a prestigious publication. Nevertheless, years later, he mused over the historical curiosity he might have been

140. Guyot-Desmarais, advertisement for his lithographic press in Paris, c. 1809, showing examples of Greek, Cyrillic, Arabic, and Farsi. Drawn by C. Johannot. Image 485 × 310 mm.

[1] Letter from Jomard to *Le Lithographe*, vol. 1, 1838, pp. 203–204; see also *Le Lithographe*, vol. 3, 1842, 'Notice historique', p. 28.

[2] Tab. 597.a.1 (55).

[3] For Vollweiler and Fisher, see Twyman, *Lithography*, pp. 28–32.

[4] *Annales encyclopédiques*, vol. 1, 1817, p. 93, n. 2.

[5] Letter from Jomard to *Le Lithographe*, vol. 1, 1838, pp. 203–204 n.

[6] Bibliothèque Nationale, Cabinet des Estampes, Ad. 64a.t.I; see Twyman, *Lithography*, p. 46.

responsible for had he gone ahead with lithography.[1]

What may well have been the first use of lithography for the purpose of reproducing a non-latin script is a broadsheet of Babylonian characters produced by Thomas Fisher in 1807. The item is to be found in the British Library, and its verbose, but accurate, heading conjurs up something of the spirit that led to its production: 'A Collection of all the Characters Simple and Compound with their Modifications, which appear in the Inscription on a stone found among the Ruins of Ancient Babylon sent, in the Year 1801, as a Present to Sir Hugh Inglis Bart. by Harford Iones Esqr. then the Honorable the East India Company's Resident at Baghdad; and now deposited in the Company's Library in Leadenhall Street, London.'[2] Thomas Fisher, an antiquary and early promoter of lithography in Britain, was connected with this venture through his employment at the India Office. He joined it as a clerk in 1786 and rose to become searcher of records in 1816. His organization of the 287 Babylonian characters of the above-mentioned inscription into rows of ten helps to explain the rather strange wording of its imprint: 'Collected, Etched and Published June the 1st: 1807 by Thos: Fisher'. No mention is made of its printer, but the only lithographic press known to have been operating in Britain at the time was that of Vollweiler, who returned to Germany shortly afterwards in August 1807.[3]

Rather more influential than this Fisher broadsheet was an Arabic inscription Frédéric André printed in Paris at much the same time for the atlas volume of A. L. Millin, *Voyage dans les Départemens du Midi de la France* (Paris, 1807–11). The plate in question (no. 49) has no imprint, but in some copies it is signed by Millin. Ten years later Millin declared in a footnote to an article in his own *Annales encyclopédiques* that he had used André's services for the printing of this and other plates in the publication.[4] André is also recorded as having printed some plates of 'inscriptions persépolitaines' in 1808 and 1809.[5]

The opportunities lithography offered for the reproduction of non-latin scripts were displayed visually in the advertisements of two early lithographic printers. The earlier of the two advertises the press of Guyot-Desmarais [140], who is known to have been working in Paris around 1809.[6] At the foot of his advertisement, beneath an account of the capabilities of the process, are seven small examples of lithographic work. In the centre, and occupying dominant positions, are two drawings and a map; but to either side are examples of non-latin scripts, Greek and Cyrillic to the left, Arabic and Persian to the right. A decade or so later Nathaniel Whittock, who styled himself 'Lithographic Engraver and Printer to the University of Oxford', issued an advertisement, no doubt with an eye to his university clientele, which contained small

examples of Coptic, Arabic, Greek, and Burmese.[7] But as far as the early literature of lithography goes, the strongest case to be made out for the use of lithography for non-latin scripts appears, somewhat uncharacteristically, in the second edition of Henry Bankes's *Lithography* (London, 1816). Bankes showed himself to be not at all sympathetic to the commercial use of lithography for the production of maps and circulars at the Quarter-Master-General's Office in Whitehall, but he seized on its use for reproducing oriental languages with surprising enthusiasm:

> I should not do justice to the art, however, if I omitted to suggest its capacity to multiply the hand-writing, and particularly the writing of those characters for which types are scarcely adequate, or at least much more expensively obtained – I mean, the characters of the oriental languages. The writer of these languages may, with the chemical ink, on a paper varnished with size or strong gum, complete his manuscript, which he may then transfer to the stone, and proceed with the printing from it, as if done at first on the stone, avoiding by this process all the difficulties of writing backwards, &c.[8]

It might not be too fanciful to imagine that the Reverend George Hunt, whose *Specimens of lithography* (London, 1819) has been referred to in Chapter 2 on the incunables of lithographic book production, came across Bankes's little treatise and that this passage, which related to his own interests, prompted him to experiment with the new process.[9] In any event, Hunt's *Specimens of lithography* has all the ingredients of a response to it and a vindication of Bankes's ideas: 'The object of this short publication', wrote Hunt, 'is to enable the Orientalist to form some judgment with what effect Lithography may be applied to Eastern Literature.' He went on to say that he did not pretend to understand all the languages for which specimens were included, and that many were inserted 'merely to shew, that Lithography may be applied with facility to almost any character.' The book has already been considered from the point of view of its production (see pp.52–54). It would take an expert in numerous languages to assess its merits from the point of view of Hunt's objectives, but some indication of its scope is provided by the languages it includes. They are given here in the sequence in which they appear

[7] John Johnson Collection, Bodleian Library.

[8] [H. Bankes], *Lithography; or, the art of taking impressions from drawings and writing made on stone* (London, 1816), p.14.

[9] A manuscript note with the St Bride Library copy of Hunt's *Specimens of lithography*, signed GH, reads: 'The first work printed in England by lithography. – Mr. Baber's Psalms was the next.' Hunt seems to have been wrong on this second point, unless the publication he refers to by the then Keeper of Printed Books at the British Museum failed to find its way on to the shelves of the library that employed him. H. H. Baber's *Psalterium Graecum* of 1812 was a letterpress production and, in any case, preceded Hunt's book; his better known and more lavish *Vetus Testamentum Graecum e Codice MS. Alexandrino* (London, 1816–28) had its specimens of manuscripts engraved by James Basire.

and using Hunt's names and spelling: Hebrew, Samaritan, Rabbinic, Syriac, Arabic, Cufic, African, Persian, Aethiopic, Pehlevi, Tatar, Armenian, Georgian, Sanscrita, Bengalee, Chinese, Pegu, Malabar. Beyond this, it need only be added that the scripts were all produced with no more expense at the composition stage than the cost of writing them, and the eight sheets of transfer paper listed in Marcuard's invoice (see p.52).

Another work of much the same period that included a wide variety of non-latin scripts was an edition of Dürer's marginal drawings for the Prayer-book of the Emperor Maximilian, published in Munich in 1820.[10] In earlier editions of this work the text areas around which the drawings were originally made were left blank, but in this edition each was filled with a prayer written in a different language, some of which involved the use of non-latin scripts. Also worth mentioning in this context is the second edition of J.A.Barth's curious, but rather magnificent, corpus of specimens of the principal languages of the world, which was issued in celebration of the establishment of peace on the continent of Europe following the defeat of Napoleon: *Pacis Annis MDCCCXIV et MDCCCXV* (Breslau, 1818).[11] It made use of lithography for several of those non-latin scripts for which, presumably, types were not available. The first editon of Barth's book was produced wholly by letterpress methods in 1816, but this second and more ambitious edition made considerable use of lithography for coloured borders and background tints; in its way it is a landmark in colour printing comparable in importance to Savage's *Practical hints on decorative printing* (London, 1822), work on which began just a few years later.

The real test of lithography's capabilities in the field of non-latin scripts, however, was whether it satisfied those making serious contributions to the study of oriental and African languages. The testing ground in this respect was the field of scholarship opened up by the discovery of the Rosetta Stone in July 1799 on Napoleon's ill-fated campaign in Egypt. The stone carries an inscription in three scripts: Egyptian in both hieroglyphic and demotic characters, and Greek. These texts were to provide the key to an understanding of the Egyptian language, which had eluded scholars for centuries. When the nineteenth century opened, as Diringer pointed out, 'not a word of hieroglyphic writing could be read',[12] but within a quarter of a century the essence of what is now known to be a phonetic system of writing was understood. The first decades of the nineteenth century were ones of intense activity in the decipherment of the Egyptian language, and the questions posed by the Rosetta Stone occupied the minds of specialists in oriental languages, and gifted amateurs as well, all over Europe. Eventually, as is well known, the problem was cracked by the

[10] Winkler, *Lithographie*, 831:14.
[11] See R.M.Burch, *Colour printing and colour printers* (2nd ed., London, 1910), p.176; J.M.Friedman, *Colour printing in England 1486–1870* (New Haven, 1978), 117; Winkler, *Lithographie*, 044.
[12] D.Diringer, *The alphabet* (3rd ed., London, 1968), vol.1, p.36.

French Egyptologist Jean-François Champollion in the early 1820s.

One of those who tried his hand at deciphering the Rosetta Stone inscriptions was the British polymath Thomas Young, who engaged in his Egyptian pursuits as a part-time activity and made his main attack on the Rosetta Stone during a summer holiday at Worthing in 1814. Young sowed some seeds that may well have led Champollion to his discoveries, and he and his supporters engaged in a long and acrimonious debate over who had priority on certain issues relating to the decipherment of the stone. In recent years Young's contribution in this regard has suffered something of an eclipse;[13] but as a promoter of lithography for the reproduction of Egyptian hieroglyphs he has no serious challenger. His *Hieroglyphics, collected by the Egyptian Society* (London, 1823–28), which had as its ambitious and unfulfilled goal the reproduction of all hieroglyphic inscriptions and manuscripts in existence, stands as a landmark in the history of the use of lithography in works on Egyptology.

The work was published in parts over a period of nearly a decade. It was described as being Royal folio in size and runs to almost a hundred plates, and in scale and quality of production is altogether different from Hunt's rather ineptly produced publication. Young must have known enough about lithography himself, or was sufficiently well advised, to obtain the services of the best lithographic printers in the country. All fifteen plates of his first fascicle, which was issued in 1819, were handsomely produced by Ackermann [141], one of the few firms capable of doing the work well at the time. Later fascicles involved other leading lithographic printers. Rowney & Forster, Joseph Netherclift, and N. Chater & Co. (who printed one plate only) were the printers of the second facsicle, which was not published until June 1823; thereafter Netherclift shared the printing with Hullmandel. In the important article on Egypt which Young contributed to the *Encyclopaedia Britannica* in 1819, he expressed his pleasure over Ackermann's printing of the plates of the first fascicle and over the 'extreme neatness and accuracy of the draughtsman who had been employed on them'.[14] No lithographic draughtsman is acknowledged on the plates of the first fascicle, but all those of the second were drawn on stone by Joseph Netherclift, regardless of who printed them. Later plates were drawn by Netherclift when he was responsible for the printing, and by George Scharf when the printer was Hullmandel.

Young's reasons for going to lithography for the reproduction of images of the kind that had traditionally been engraved, must have been mainly economic ones. He explained in his introduction that the process of lithography had an advantage in that it '... affords a ready mode of obtaining a moderate number of copies of a

[13] See especially M. Pope, *The story of decipherment* (London, 1975), Chapter 3.
[14] Supplement, vol.4, 1819.

141. T. Young, *Hieroglyphics, collected by the Egyptian Society* (London, 1823–28).
Lithographed plate, printed by Rudolph Ackermann, London, *c.* 1819.
Page size 525 × 350 mm. [Cat. 1.240].

drawing at a cheap rate.'.[15] It was never Young's intention to publish the collection widely and only 200 copies of the plates of the first fascicle were printed. The Egyptian Society appears to have been founded with the express intention of publishing Young's book; subscribers were secured in the hope of covering costs, and copies were presented to several public libraries in Europe. But Young's costs were not covered, and financial responsibility for the venture passed to the Royal Society of Literature from the second fascicle onwards. And at some stage the publication price was reduced from ten guineas to five.[16]

Young's draughtsmen and printers served him well. The plates of his *Hieroglyphics* are fine examples of lithographic craftsmanship. The collection reached those people and institutions likely to have some influence on Egyptology, and this must have helped to secure a place for lithography in this field of study. Young was the Foreign Secretary to the Royal Society over a long period and letters to and from him relating to hieroglyphics reveal that lithography was a household word among oriental scholars at the time. Familiarity with the noun lithography even seems to have led him and his fellow amateur orientalist Sir William Ged, then resident in Italy, to use – and perhaps even to coin – the ugly verb 'lithographize'.[17] It appears in correspondence between the two men in the 1820s (sometimes spelled 'ise') but, though it was used by others at the time, it does not appear to have caught on and failed to find its way into what might be described as the professional literature of lithography.[18]

Naturally enough, Young's *Hieroglyphics* includes several examples taken from the Rosetta Stone, which had been brought to England in 1802. However, this was not the first time that it had been 'lithographized'. A set of seven plates of its inscriptions was issued in wrappers in Munich in 1817, based on a publication of the Society of Antiquaries of London of 1810, to accompany a paper by Friedrich von Schlichtegroll entitled *Über die bei Rosette in Ägypten gefundene dreifache Inschrift*.[19] And a lithographed reproduction of the hieroglyphic part of the inscription appeared in *Morgenblatt für gebildete Stände* for 1819[20] at much the same time that Young's *Hieroglyphics* began to appear.

Though his book failed in commercial terms, Young had demonstrated that the emergent process of lithography could be used successfully in an important scholarly publication in the field of Egyptology. Other Egyptologists soon followed his example and used lithography in their publications. Some turned to the process for the plates alone: J.-F. Champollion made use of it in this way for the forty-eight plates in his seminal *Précis du système hiéroglyphique des anciens egyptiens* (Paris, 1824); G. Seyffarth included thirty-six lithographed plates, printed by J. A. Barth, fou

[15] p.i.

[16] See W. T. Lowndes, *The bibliographer's manual of English literature* (2nd ed., London, 1864), p.3022 and Appendix, p.150.

[17] See J. Leitch (Ed.), *Miscellaneous works of the late Thomas Young*, 3 vol. (London, 1855), vol.3, pp.216–217, 374, 377, 383.

[18] The word is recorded in the Oxford English Dictionary as obsolete. I have not seen it used in any published accounts of lithography.

[19] Dussler, *Lithographie*, p.254; Winkler, *Lithographie*, 712: 11–18. It was Schlichtegroll who, a little later, wrote the preface to Senefelder's treatise on lithography.

[20] Winkler, *Lithographie*, 961: 3.

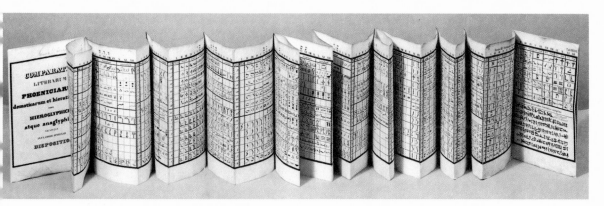

142. G. Seyffarth, *Rudimenta hiero-glyphices* (Leipzig, 1826). Folding lithographed plate, printed by J. A. Barth, Leipzig. 255 × 4170 mm.

of them ambitious folding ones, in his *Rudimenta hieroglyphices* (Leipzig, 1826) [142]; and the Marquis Spineto had the services of his local lithographic printer, Metcalfe of Cambridge, for the eleven plates in his *Lectures on the elements of hieroglyphics* (London, 1829). Others went a little further in lithographic terms. H. Tattam's *A compendious grammar of the Egyptian language* (London, 1830) has a few lithographed plates, one of which is acknowledged to have been printed by Willich; but more significantly, it includes as an appendix a dictionary of enchorial characters, compiled by Thomas Young, which runs to 110 pages and was lithographed throughout. Even more in the spirit of Young's *Hieroglyphics*, though neither so large nor so impressive, is J. Burton, *Excerpta hieroglyphica* (1823–28). Burton's book is in a landscape format; it has no text at all, apart from an author's note and four part-titles, and was printed throughout by lithography. Its plates are of hieroglyphs on wall paintings, inscriptions, and tablets. Most of them carry Burton's name or initials and it is possible therefore that he put them on stone himself. The place of publication of the book is not given, though several of the plates carry the initials CH. These happen to be the initials of the lithographic printer Charles Hullmandel, but the poor quality of the printing and the fact that Hullmandel is not known to have signed his printing in this way suggest that he was not responsible for them. The likelihood is that the book was printed in Egypt, because it includes a single-page lithographed note from Qahirah [Cairo], dated 1 January 1828, in which Burton apologized for the delay of the letterpress which was to accompany the plates '... owing to the state of the printing establishments in this country where the only one which has competent means of printing a work belongs exclusively to the Government'.

Mention should also be made in this context of E. Hawkins (Ed.), *Select papyri in the hieratic character from the collections of the British Museum* (London, 1844), largely because of its impressive use of lithography. This folio publication is not an improper book

in the strict sense of the term as it is a collection of plates with letterpress explanations, but its plates broke new ground in Egyptology and are remarkably faithful in their rendering of the hieratic characters. It has some 200 plates (the numbering runs to 168, but many additional, unnumbered plates were also included). They are the work of Joseph Netherclift, whose first excursion into Egyptian work took place some twenty years earlier in Thomas Young's *Hieroglyphics*. Most of them are lettered 'J Netherclift Lithog. fac-sim:' and a note at the end of the letterpress text reveals that the originals were 'traced on transfer lithographic paper' [*sic*].[21] All the plates have a rich brown solid tint, which defines the limits of the papyrus substrate; the writing is printed in black, often with an additional red working. The effect of the use of such a dark background tint in conjunction with these profusely worm-eaten and otherwise damaged papyri is to give the white paper a life of its own. Though this may well distract from the reading of the items depicted, it results in some striking graphic effects.

The most novel and ambitious use of lithography in the services of Egyptology was reserved, appropriately enough, for Champollion's two great works: *Grammaire égyptienne* (Paris, 1836–41) and *Dictionnaire égyptien* (Paris, 1841–43). Jean-François Champollion died in 1832; both of these publications were based on surviving manuscripts and were seen through the press with great loyalty by his elder brother, J.-J. Champollion-Figeac. Quite apart from their significance as pioneering works in Egyptology, these two books deserve to be remembered as among the most ambitious of all lithographed books produced in the age of the hand press. Both are substantial folio volumes and were published by the notable firm of French printers, Firmin Didot *frères* of Paris. The similarities between the two publications is most noticeable when copies are seen in their original wrappers, as they can be in the local museum in Champollion's home town of Figeac. The same dusky-pink paper wrappers are found on both publications, and both sets of wrappers are printed letterpress to similar designs. There, however, the similarity ends. Though both books made use of lithography for their texts, they were produced by very different methods.

The problem facing Champollion-Figeac and Didot *frères* when considering the production of these two books was how to print the numerous hieroglyphs, which were embedded in the text of the one book and formed a substantial part of it in the other. In the case of the *Grammaire égyptienne*, Champollion-Figeac estimated that more than 2000 different characters would have had to be cast (taking into account the need for different sizes of them) if traditional letterpress methods had been used.[22] No full founts of hieroglyphic types existed at the time and it would have been out

21 p.12.
22 Préface de l'éditeur, p.v.

143. J.-F. Champollion, *Grammaire égyptienne* (Paris, 1836–41). The text for this part of the book was transferred from type, the hieroglyphs were added later; the whole lithographed. Page size 330 × 215 mm. [Cat. 1.66].

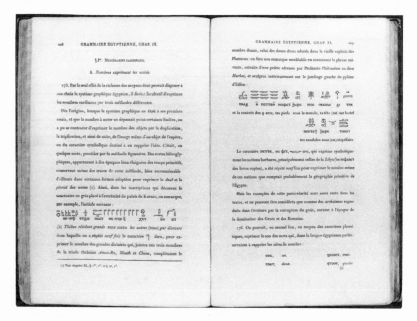

of the question to produce types specially for the publication on grounds of both cost and time. Hieroglyphic types made their first appearance in 1829, and in the second half of the 1830s two further hieroglyphic founts were designed; but no sufficiently complete founts of hieroglyphic types were cast until the early 1850s when a fount commissioned by the Imprimerie royale in 1842 neared completion.[23] There was therefore no question of hieroglyphic types being used for either the *Grammaire* or the *Dictionnaire*, so alternatives to the use of movable type and letterpress printing had to be tried. Together, these two important publications show three different ways in which lithography could be used to solve the problem of reproducing hieroglyphs along with text consisting mainly of letters of the latin alphabet.

The *Grammaire égyptienne* was published in three parts, each part costing twenty-five francs.[24] The first part appeared in 1836, and this is the date that appears on its title-page, but at the end of the volume there appear the words 'Achevé d'imprimer au mois de mars 1841'. The preface and analysis of content at the rear of the book created no special production problems and were therefore printed letterpress in ordinary type material in the usual way, but sandwiched between them were almost 550 pages that had to include hieroglyphs along with explanatory text. These pages form the bulk of the book and represent one of the Didot firm's innovations in book production. The methods used for the major part of it [143] were explained by Champollion-Figeac in his preface. All languages in the book for which movable type was available, French, Latin, Greek, Coptic, and others, were set up in the normal way, but with spaces left for the insertion of hieroglyphs

[23] For a discussion of the development of hieroglyphic types, see Rijk Smitskamp, 'Typographia hieroglyphica', *Quaerendo*, vol.9, no.4, Autumn 1979, pp.309–336.

[24] This information is taken from the wrappers of the publication. Smitskamp (op.cit. pp.310–311) states that the book was published in four instalments, that it went to press as early as 1833, and had already appeared in December 1835.

144. J.-F. Champollion, *Grammaire
égyptienne* (Paris, 1836–41). The text
for p.376 produced the same way as
the pages shown in 143. The text for
p.377 printed letterpress from type,
the hieroglyphs printed separately by
lithography. Page size 330 × 215 mm.
[Cat. 1.66].

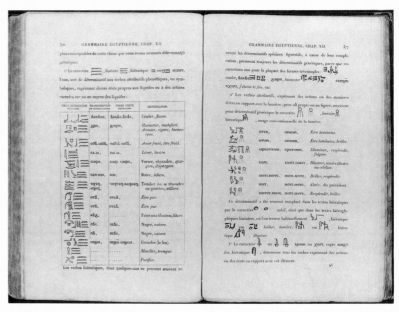

at a later stage. After proof corrections had been made, a proof of
each page was taken in lithographic ink and transferred to stone.
The hieroglyphs were then traced on the stone from Champol-
lion's manuscript and drawn by Salvador Cherubini, who had
accompanied Champollion on his voyage to Egypt and Nubia and
was an expert in transcribing hieroglyphs. After further proofing,
the edition was run off. Another contemporary account of the
method used for the production of the book stated that the hiero-
glyphs were inserted on the proofs before they were transferred to
stone.[25] This would have presented problems because the ink
would still have been tacky, but the account was written in the
early days of the book's production (probably as early as February
1836) and it is possible that both methods were tried initially.
Whatever the sequence of events may have been, Champollion's
Grammaire égyptienne was a brave attempt to combine the advan-
tages of the prefabricated letters of letterpress printing with the
flexibility for producing new characters offered by lithography.
Champollion-Figeac claimed in his preface that the French public
had before it the first fruits 'of that new and fertile marriage of
letterpress printing and lithography.'[26] The book was also unusual

[25] Paper read by Berger de Xivrey to the
Académie de Rouen, 20 May 1836, a sum-
mary of which appears in *Le Lithographe*,
vol.2, 1839, pp. 185–191. Information
about lithographic book production in the
nineteenth century is so hard to come by
that it may be useful to record here a note
in a British publication of the same period,
which confirms that the method Berger de

Xivrey described was practised in Britain.
The note appears in F. Saunders, *The
author's printing and publishing assistant*
(2nd ed., London, 1839; 3rd ed. 1840),
which includes a lithographed plate show-
ing a passage of printed text marked up
to illustrate the conventional proof-
correction marks, together with a footnote
which reads: 'This page is a specimen of

Lithographic Printing. The impression
from the Type being first taken on Paper,
in Lithographic Ink, the Corrections then
added with the Pen, and the whole trans-
ferred to the Stone from which the Page is
printed.'

[26] Préface de l'éditeur, p.v.

145. Detail of 144 (bottom of p.376) showing text transferred from type and printed by lithography. Approx. 20 × 50 mm.

146. Detail of 144 (top of p.377) showing text printed letterpress. Approx. 20 × 50 mm.

in that it included some pages with additional hieroglyphs printed in a second colour, a rather dull and pale red, and a few hand-coloured pages.[27] Similar, but not identical, techniques of transfer lithography had been tried out in Britain a decade earlier for the journal the *Parthenon* (1825–26) (see pp.54–56), and were also being used in France for music manuals at almost exactly the same time that Champollion's book was being produced (see p.124).

The description of the methods used for the production of the *Grammaire égyptienne* which appears in the book's preface was no doubt written in good faith, but it applies only to the first two-thirds of the book (strictly speaking up to and including pages 1–376, that is, signatures 1–94). Thereafter, where text was combined with hieroglyphs, as they were on pages 377–535 (signatures 95–134), two separate workings were used: the text was printed by traditional letterpress means and the hieroglyphs were printed by lithography. The change in techniques was not planned to relate to any textual break and, as it happens, occurs in the middle of the word 'recevoir' ('re-' appears on page 376 and was printed lithographically, 'cevoir' on page 377 and was printed letterpress [144–146]). The distinction between those parts of the book produced by the two different methods is quite clear, even I suspect to the non-specialist, and it has to be admitted that the all-lithographed pages of the first two-thirds of the book are not entirely satisfactory. The original letterpress setting must have fattened up considerably in the process of being transferred to stone and, if

[27] Most pages between 72 and 156 inclusive were printed in two colours. Pages 7–11 and 47 were hand-coloured in imitation of Champollion's original manuscript.

147. Detail of letterpress-printed text from Champollion's *Grammaire égyptienne* (p.509). 38 × 52 mm.

étition obligée d'une ph

erra dans l'exemple suiva

le chanson ou d'exhorta

ou dépiquant le grain, l

148. Detail of lithographically-printed text from Champollion's *Grammaire égyptienne* (p.28) showing characters that have transferred well. 38 × 52 mm.

er une même voix ou u

s différents de forme c

scribe égyptien, usant

nétique, pouvait, à son

149. Detail of lithographically-printed text from Champollion's *Grammaire égyptienne* (p.144) showing characters that have fattened up in the transferring. 38 × 52 mm.

vera des exemples de l'e

part des coudées ou ét

de l'Égypte; on y a exp

isions du doigt. On ren

anything, the quality got worse rather than better as the publication progressed [147–149]. But at its best, the quality of the transfer lithography was very high [150, 151]. In those parts of the book that were produced by a double working of letterpress and lithography, one of the workings usually appears rather grey compared with the other. Clearly the printers found it difficult to match their inking across the two processes, just as – judging by the number of workings that are out of register – they found it difficult to register the two workings [152].

The publication is unusual among lithographed books of the period in having signatures throughout (π^3 A–B^2 a–f^2 1–137^2 x136–137^2); even more surprising is that the signatures on those workings that combined letterpress and lithography (95–134) were all printed lithographically. The signatures on the purely letterpress workings (π^3 A–B^2 a–f^2 and x136–137^2) were printed from type, and this accounts for the repeating of 136 and 137 in the numeration of the signatures. The use of lithographed signatures for the main body of the book, even when the text was printed letterpress, suggests that the lithographic printing may have been done first. If this were the case, it might go some way to explain the poor registration of the two workings on many pages. Variation in the positioning of damp sheets of paper when using a lithographic hand press would have been greater than the variation arising from the feeding of sheets into a letterpress machine, and any such variation would not have been very easy to detect until the letterpress working was added, by which time it was, of course, too late to do much about it.

GRAMMAIRE

GRAMMAIRE

150 (top). Detail of letterpress printing from Champollion's *Grammaire égyptienne* (Introduction, p.i). Height of 'Grammaire' 9 mm.

151 (bottom). Detail transferred from type and printed lithographically from Champollion's *Grammaire égyptienne* (Chapter I, p.1). Height of 'Grammaire' 9 mm.

GRAMMAIRE ÉGYPTIENNE, CHAP. XII. 379

ϭⲁⲧ.ⲥⲱ, ⲥⲱ.ϭⲁⲧ,　　　*Boire.*

ϭⲁⲧ.ⲥⲱ, ⲥⲱ. ϭⲁⲧ,　　　*Boire.*

ⲥⲧⲙ,　　ⲥⲱⲧⲙ,　　　*Écouter, entendre.*

Les verbes hiératiques correspondants prennent plus fréquemment la deuxième forme du déterminatif　　　que la première

Exemples :　　ϭⲁⲧ, ⲥⲱ, *boire*,　　　　ⲥϩⲁⲓ, *écrire.*

Nous ferons remarquer aussi que les verbes *aimer* et *chérir* reçoivent parfois le déterminatif　　　sans qu'il nous soit possible d'en bien préciser le motif :　　　ⲙⲁⲓ, *aimer*, hiératique

ou　　　ⲙⲉⲣⲉ, ⲙⲉⲣⲓ *chérir*, hiératique

On conçoit beaucoup mieux, par exemple, pourquoi le mot *nom*, ordinairement déterminé par l'image du cartouche, prend aussi quelquefois le déterminatif　　　comme dans ce passage :

ⲛⲙⲁⲛⲅⲉⲙⲅⲓⲛⲧⲙⲉ　ⲙ̄　ⲙⲟⲧⲛ　ⲛⲁⲣⲁⲛ　ⲥⲛ-†

le tribunal-de-justice dans être stable mon-nom accordent (que les dieux)

« Puissent les dieux accorder que mon nom subsiste devant le tribunal « de justice ! »

5° Le caractère　　　ou　　　hiératique　　　, représentant un homme portant un boisseau ou un vase sur sa tête, sert de déterminatif aux verbes exprimant des actions qui exigent le transport d'objets quelconques. Tels sont par exemple :

ϥⲁ.ϥⲓ,　　ϥⲁⲓ.ϥⲓ.ϩⲓ,　　　*Porter, ferre.*

ⲉⲧϥ.ⲉⲧϥ, ⲉⲧϥⲱ.ⲱⲡⲧ,　　　*Charger, transporter un*
ⲟⲧϥ,　　ⲱⲧⲡ,　　　　　*fardeau.*

152. Page from the second half of Champollion's *Grammaire égyptienne*, printed by letterpress and lithography with the two workings badly out of register. Page size 330 × 215 mm.

DICTIONNAIRE

ÉGYPTIEN

EN ÉCRITURE HIÉROGLYPHIQUE.

PAR J. F. CHAMPOLLION LE JEUNE;

PUBLIÉ

D'APRÈS LES MANUSCRITS AUTOGRAPHES,

ET SOUS LES AUSPICES DE M. VILLEMAIN

MINISTRE DE L'INSTRUCTION PUBLIQUE.

PAR M. CHAMPOLLION FIGEAC.

PARIS,

CHEZ FIRMIN DIDOT FRÈRES, LIBRAIRES-ÉDITEURS,

IMPRIMEURS DE L'INSTITUT DE FRANCE,

RUE JACOB, Nº 56.

M DCCC XLI.

153. J.-F. Champollion, *Dictionnaire égyptien* (Paris, 1841–43). Letterpress title-page. Page size 334 × 215 mm. [Cat. 1.65].

That the methods used for the *Grammaire égyptienne* were not entirely successful was made clear with the publication of Champollion's other major work, his *Dictionnaire égyptien* (Paris, 1841–43). This book was based on two manuscripts which Champollion had begun before his great break-through in the decipherment of Egyptian hieroglyphs, though he had updated them regularly. After his death, parts of the two manuscript versions were lost, but when they were found in 1840 his elder brother, Champollion-Figeac, began preparing them for publication. In his introduction, Champollion-Figeac referred to the difficulties presented by letter-press printing and to the success of the method employed for the production of the *Grammaire égyptienne*. He had hoped that hieroglyphic types would have satisfied all requirements but, he explained, such types were not available and so it was decided that the book would be produced by lithography. If we are to take the words of Champollion-Figeac's introduction literally, the book was written directly on to stone and not transferred from paper ('transcrit sur la pierre et imprimé par la presse lithographique.').[28]

Champollion's *Dictionnaire égyptien* is similar in extent and size to his *Grammaire égyptienne* and, likewise, was published by Didot *frères*. Its title-page and preface were printed letterpress from movable type [153], but the remaining 487 pages were litho-graphed throughout [154–156]. It seems likely that Didot *frères* printed the letterpress, but the main body of the book is described as having been 'Dessiné et écrit par Jules Feuquières' (the word 'Dessiné' refers, presumably, to the rendering of the hieroglyphs),[29]

154. J.-F. Champollion, *Dictionnaire égyptien* (Paris, 1841–43). Written by Jules Feuquières and printed litho-graphically by J.-A. Clouet, Paris. Page size 334 × 215 mm. [Cat. 1.65].

28 p.xxxi.

29 Feuquières lithographed some, if not all, the tail pieces to the chapters in the *Grammaire*.

155, 156. J.-F. Champollion, *Dictionnaire égyptien* (Paris, 1841–43). Written by Jules Feuquières and printed lithographically by J.-A. Clouet, Paris. Page size 334 × 215 mm. [Cat. 1.65].

30 P. Gaskell, *A new introduction to bibliography* (Oxford, 1974), p.196.
31 I am particularly grateful to Mr T. G. H. James, former Keeper of Egyptian Antiquities in the British Museum, for generously sparing his time to answer innumerable questions and for drawing my attention to the continuing tradition of improper books in the field of Egyptology.

and then printed lithographically by J.-A. Clouet, rue Furstemberg, Paris. The printing was completed on 1 November 1843. The text was written in a backward-sloping cursive hand that retains its regularity reasonably well throughout the extensive book, and the printing was quite well executed on a wove paper. Nevertheless, the book is not as much like a traditional book as the *Dictionnaire* and was not nearly so audacious technically.

Whatever Didot's involvement in the production of the lithographic parts of the *Grammaire* and *Dictionnaire* may have been, it is clear that the firm must have exercised some influence on the way in which the volumes were designed and printed. Both have traditional book margins, folios, and running heads, and are unusual among lithographed books of the time in having their gatherings identified with signatures. In the preliminary parts of both books, which were printed letterpress, the gatherings are signed with letters; but the lithographed parts follow the growing nineteenth-century custom of using arabic numerals.[30]

These posthumously printed works of Champollion established a highwater mark for the lithographed production of scholarly books, and his *Dictionnaire* set a pattern for the design and production of subsequent works on Egyptology. Because of the difficulty and cost of printing books which combined European languages with hieroglyphs, numerous books on Egyptology have since been written out by hand by their authors for reproduction by lithography. Indeed, this can be said to have been the normal way of producing such scholarly works for a century or more.[31] Handwriting allowed for greater subtlety in the spacing of hiero-

glyphs than did typesetting and, so long as the author had the requisite skills, hieroglyphs could also be made to harmonize with one another in both size and weight. In his *Egyptian grammar* (Oxford, 1927), the distinguished Egyptologist A.H.Gardiner went so far as to state that type was not sufficiently adaptable to do justice to hieroglyphs and that '... there is only one wholly satisfactory method of publishing hieroglyphic texts, namely reproduction in facsimile.'[32] Most such facsimile publications of the twentieth century were reproduced by photolithography, so that all the author had to do was to produce camera-ready copy. Two late works of this kind are A.H.Gardiner, *Ancient Egyptian Onomastica* (Oxford, 1947) and R.O.Faulkner, *A concise dictionary of Middle Egyptian* (Oxford, 1962, reprinted 1972, 1976, 1981) [157]. The introductory pages of these publications were typeset, but the main texts of both were written out by hand by R.O.Faulkner for production at Oxford University Press. Gardiner refers in his preface to Faulkner's contribution and to the advice he received from the University Printer, John Johnson, in helping him to settle on 'autographic reproduction' as 'far the speediest, cheapest, and most satisfactory' means of production.[33] Though the techniques used for the reproduction of such handwritten texts were different from those used in the first half of the nineteenth century, the design of their pages owes a great deal to that of their precursors. Much the most obvious similarity is the use of simple line borders to surround the pages and to define the areas occupied by running heads. This convention goes back to some of the earliest books produced by lithography in Germany (see pp.43–45, 48) and echoes the treatment of the pages of the 'Tableau' in Champollion's *Dictionnaire* [156].

Though this book is about books published in Europe, it must not be forgotten that in the world as a whole those languages that use the latin alphabet are outnumbered by those that do not. By the middle of the nineteenth century movable type had been produced for many languages of the world; but even in the case of languages for which movable type existed, handwriting multiplied by lithography often offered considerable advantages over letterpress methods. Unfortunately, the early days of lithographic printing outside Europe and North America are very poorly documented and have scarcely been considered at all by historians. All the same, there is every reason to believe that the occasional small book would have been produced wherever a lithographic press was established. This seems to have been the case in India. Khan records that Dr J.N.Rind set up a lithographic press for the Bengal government in Calcutta in 1823 which produced various kinds of short-run administrative printing, some of it in oriental languages.[34] A lithographic press is reported as having existed in

157. R.O.Faulkner, *A concise dictionary of Middle Egyptian* (Oxford, 1962, reprinted 1981), written out in Faulkner's own hand and reproduced by photolithography. Page size 245 × 165 mm.

[32] p.432.
[33] p.x.
[34] M.Khan, 'History of printing in Bengali characters up to 1866', Ph.D. thesis, School of Oriental and African Studies, University of London, 1976, pp.191–193.

158. Rifat, efendi, *Mecellei Nefisei Mergubeyi Makbule*. A religious text written in Farsi and lithographed throughout. Printed in the Middle East, probably in the second half of the nineteenth century. Page size 260 × 180mm.

Tehran even before movable type and letterpress printing came to the town, and a note in *Le Lithographe* for 1838 records that an official gazette had been published there regularly since the beginning of the year.[35] Unfortunately, a proper consideration of books produced by lithography in the vernacular languages of the Middle and Far East must wait until further work has been done on the history of lithography world wide. But judging by the number of such books that have survived [158], lithography was more widely used for book production in the East than in the West in the nineteenth century.

In Europe, the increasing interest in non-latin languages aroused by travel to far off lands, and the discovery of 'interesting and curious' inscriptions, led to a widespread use of lithography for the reproduction of plates of oriental languages. The Royal Asiatic Society seems to have done much to promote the use of lithography for such purposes. The *Transactions of the Royal Asiatic Society* (1827–35) made good use of lithography for the reproduction of scripts and included examples of Chinese, Cufic, Tamil, Sanscrit, Devanagari and other languages, which were printed by

35 Vol.1, 1838, p.351.

159. Specimens of non-latin scripts from plate II of L.-R. Brégeaut, *Nouveau manuel complet de l'imprimeur lithographe*, new edition enlarged by Knecht and J. Desportes (Paris, 1850).

Joseph Netherclift. Later, the *Journal of the Royal Asiatic Society* included lithographic plates of non-latin scripts, though not on such a regular basis. The Royal Asiatic Society was also responsible for publishing Captain Henry Harkness's book, *Ancient and modern alphabets, of the popular Hindu languages* (London, 1837), which dealt with various languages of southern India and was printed throughout in lithography by L. Schönberg.

It would be pointless to enumerate more publications that made use of lithography for the printing of non-latin languages. It may be necessary however to point out that the process was by no means limited to eastern languages. By way of contrast, therefore, we may point to the inclusion of a lithographed plate in the newly developed Cherokee characters, printed by H. Selves, lithographer to the University of Paris, which was published in the *Bulletin de la Société de Géographie* in 1828.[36]

Lithographers must have been well aware of their strengths in the field of languages that are not based on the latin alphabet. Some early references to the usefulness of lithography for this kind of work have already been discussed, but later writers on lithography continued to promote it for such purposes. De la Motte included examples of what he called Arabic, Chaldean, and Turkish hands in his treatise of 1849,[37] and Brégeaut in 1850, and Knecht in his revision of Brégeaut in 1867, printed examples of Chinese, Arabic, Sanscrit, and Persian writing [159].[38] There is good reason therefore to see the printing of non-latin texts as one of the longstanding specialities of lithographic printing in the age of the hand press.

[36] Nos. 64–65, Aug.–Sept., 1828.

[37] P. H. De la Motte, *On the various applications of anastatic printing and papyrography* (London, 1849), pl.7.

[38] L.-R. Brégeaut, *Nouveau manuel complet de l'imprimeur lithographe* (Paris, 1850), pl.II; Knecht, *Nouveau manuel complet du dessinateur et de l'imprimeur lithographe* (new ed., Paris, 1867), atlas vol., pl.II.

Lithography and phonography: the books of Isaac Pitman

The history of shorthand goes back to ancient times, and books printed in shorthand began to appear as early as the sixteenth century. It has been estimated that more than one hundred shorthand books were published in Britain alone in the period from 1635 to 1800; many of them included engraved pages to illustrate the system being proposed and some were even engraved throughout on intaglio plates.[1] The problems facing producers of shorthand books were very similar to those facing printers of material written in some non-latin scripts, and shorthand books that were printed by lithography might therefore have been considered in Chapter 7 along with books on Egyptology that involved the use of hieroglyphs. But shorthand is so different in other respects from languages which were described in the nineteenth century as 'exotic', that it seemed appropriate to consider it separately. A further reason for doing so was that the use of lithography for the multiplication of shorthand writing was closely bound up with the endeavours of one man, Isaac Pitman.[2]

Pitman was not the first to see the advantage of bringing together lithography and shorthand. Credit for this should probably go to Conen de Prépéan, who included two lithographed examples of his own system of shorthand among the ten plates in the third edition of his *Sténographie exacte* (Paris, 1817) [160].[3] These lithographed plates were printed by Lasteyrie and are of no great consequence in themselves, although 1817 was early for any kind of lithographed book illustration outside Germany. Of much greater significance are some references in the preface of Conen de Prépéan's book to two forthcoming books which were to be produced in their entirety by a combination of stenography and lithography: 'The ease with which lithography could be applied to stenographic writing', he wrote, 'has determined me to use this process, and to print in abbreviated characters perhaps the two most interesting novels that have appeared in any language, *Atala*, of M. de Châteaubriant, and *Paul et Virginie*, of *Bernadin de St. Pierre*.'.[4] An announcement at the back of the book states that one of these best-sellers, *Atala*, was already available from the 'Dépôt général

[1] See J. J. Gold, 'The battle of the shorthand books, 1635–1800', *Publishing History*, no.15, 1984, pp.5–29.

[2] Many other shorthand manuals were produced by lithography, a few of which are listed in the Catalogue (1.8, 1.48–1.54, 1.102, 1.103, 1.175). The most comprehensive catalogues of shorthand books are K. Brown and D. C. Haskell, *The Shorthand collection in the New York Public Library* (New York, 1935), and J. Westby-Gibson, *The Bibliography of shorthand* (London and Bath, 1877).

[3] The sixth edition, *Sténographie, ou l'art d'écrire* (Paris, 1833), has three lithographed plates, which were printed by Mantoux.

[4] Conen de Prépéan, *Sténographie exacte* (3rd ed., Paris, 1817), p.9.

160. Conen de Prépéan, *Sténographie exacte* (3rd. ed., Paris, 1817). One of two lithographed folding plates, printed by Lasteyrie, Paris. 210 × 260 mm.

de *Lithographie*, chez M. *De Kymli*, rue Jacob, no.14, à Paris'.[5] Though this announcement implies that at least one of these two books was published, I have been unable to locate a copy of either of them.

Despite this very early connection between lithography and shorthand in France, no one seems to have taken real advantage of it until twenty years later when Isaac Pitman (1813–97) began to promote the system that has dominated the shorthand world ever since.[6] Pitman's system, which he called phonography, was developed in the second half of the 1830s, though his interest in shorthand went back to about 1829 when he was little more than a boy. At first, he based his approach on the shorthand method developed by Samuel Taylor towards the end of the eighteenth century; but in 1837, shortly after taking up a teaching post at Wotton-under-Edge in Gloucestershire, he took the first steps towards making public his own system of phonography.

Phonography was one of two important innovations that Pitman made in the field of written language, both of which were the products of the same reforming zeal that led to his advocating – and actually using for himself – the duodecimal system of numeration.[7] Pitman called the second of his innovations in written language 'phonotypy'. It is not nearly as well known as phonography, but in its general approach it too has had many followers. It was – to use today's terminology – a form of simplified spelling. Like many others concerned with the reform of writing systems, Pitman was disturbed by the poor correlation in the English

[5] Conen de Prépéan, *Sténographie*, p.221.
[6] For biographies of Isaac Pitman, see C. A. Reed, *A biography of Isaac Pitman* (London, 1890), and A. Baker, *The life of Sir Isaac Pitman* (London, 1908; 2nd ed. 1913).
[7] Reed, *Pitman*, pp.77–78.

language between grapheme and phoneme. He therefore proposed
dropping three of the existing characters of the latin alphabet
(k,q,x) and adding many new ones in order to represent about forty
phonemes. At a later stage he reduced the number of characters
substantially to thirty-two.

In terms of its objectives, phonography was quite different from
phonotypy. It was an attempt to find a graphic method of recording
speech in a phonemically consistent manner and at something
like the speed at which it could be spoken. Like other shorthand
systems, Pitman's phonography abandoned the traditional forms
of letters, and in order to speed up production, abbreviations for
common words and parts of words were written as single marks.
As the difference between the two names implied, phonography
was essentially a hand-written form of spoken language, whereas
phonotypy related more to printed language and was concerned
equally with reading and writing. Both, however, were integral
parts of what Pitman referred to as the reform of writing and
printing.

The differences between phonography and phonotypy referred
to above highlight some of the issues that led Pitman to use
different means of production for the two systems when promot-
ing them through the medium of printing. Phonotypy, with its
limited number of characters, lent itself to being produced by
means of movable types and letterpress printing. It was not dif-
ficult to have punches cut and types cast for the additional charac-
ters that were needed, and there were some benefits at the compos-
ition stage since, in its initial stages, the phonotypic alphabet was
used in capitals only. Phonography was much more difficult to
reproduce by letterpress printing because, like some oriental lan-
guages, it involved the use of a very large number of different
characters. There was no great difficulty in producing such charac-
ters – and in the middle of the century founts of simple shorthand
characters were manufactured – but they did not provide the
answer to Pitman's problems. There were several reasons for this.
First, the capital needed for such a venture would have been
considerable, and would certainly not have been available when
Pitman began promoting phonography. Secondly, the number of
different characters needed would have made composition and
distribution slow and expensive: as those who used logography in
the late eighteenth century had already discovered, there was a
point beyond which increasing the number of characters to cope
with common words, suffixes, and prefixes led to slower rather
than faster composition – and phonography would have required
many more characters than logography. Thirdly, quite apart from
the difficulty of printing phonography by means of movable type,
Pitman needed to demonstrate how his system would look when

written out by hand because he had developed it as a form of handwriting.

The methods used by Pitman for the production of his phonographic publications were quite different therefore from those he used for his phonotypic ones. For his phonotypic works he used movable type and letterpress printing almost exclusively; for his phonographic ones his principal means of production involved a combination of writing and lithography (later on, though probably not in Isaac Pitman's lifetime, a relief process called typographical etching was used).[8]

It was phonography that first brought Pitman into contact with lithography, and it is arguable that his system of shorthand would not have got off the ground as successfully as it did without it. Pitman was a great publicist of his own ideas and undertook their promotion with a happy combination of imagination, idealism, diligence, and hard work. He toured the country giving lectures and was constantly writing letters, but his principal means of promoting phonography were the various journals he published at prices which were low enough for ordinary people to afford. In this respect lithography, and particularly transfer lithography, provided the answer to Pitman's promotional requirements because it kept the cost of origination – that is, the making of the image to be printed – to a minimum. Pitman was also quick to take advantage of the opportunities offered by the Penny Post for the distribution of his material. The outcome of Pitman's marriage of lithography and phonography was a programme of publications unparalleled in the history of shorthand, which left his system virtually unchallenged in the English-speaking world by the end of the century.

How Pitman came into contact with lithography in the first place is unclear. In the biography of Pitman written by a fellow enthusiast and co-worker, Thomas Allen Reed, and read in proof by Pitman himself, it is claimed that Pitman 'made his first acquaintance with the art of lithography' while on a short lecture tour in Manchester in the winter of 1841.[9] But this cannot be strictly true since Pitman's first publication, *Stenographic soundhand*, had made use of lithography a few years earlier. It was

[8] The process was referred to by this name in L. A. Legros and J. C. Grant, *Typographical printing-surfaces* (London, 1916), p.487. It was patented in 1872 by A. and H. T. Dawson (British Patent no.1626) who referred to it as 'Improvements in typographic etching and engraving ...'. It involved coating a metal plate with a film of wax, removing this where positive marks were needed, and then taking an electrotype in the normal manner. The process is identical in principle to the one patented by Edward Palmer in 1842 (British Patent no.9227) and later called by him Glyphography (see E. Harris, 'Experimental graphic processes in England 1800–1859: Part III', *Journal of the Printing Historical Society*, no.5, 1969, pp.63–80). In letters in response to my enquiries, the late Sir James Pitman, grandson of Sir Isaac, revealed that this method of relief printing was introduced by his father, and implied that it was the one usually employed for shorthand publications when he joined the firm as a young man (letters to the Librarian, University of Bath, 23 Oct. 1981, and to me, 29 Oct. and 6 Nov. 1981). The process was often used for map printing, and specifically for many of the maps in the renowned eleventh edition of the *Encyclopaedia Britannica*.

[9] Reed, *Pitman*, p.34. In one of the letters referred to in note 8 (23 Oct. 1981), the late Sir James Pitman wrote: 'The view held in the family has been that Isaac read very carefully the proofs (or MS) of T. A. Reeds Life and that great credence should be attached to its completeness & accuracy.' Unless otherwise stated, all biographical information about Pitman in this chapter stems from Reed.

161, 162. I. Pitman, *Stenographic sound-hand* (London, 1837). Facing plates, written by Isaac Pitman and printed lithographically by T. Bedford, Bristol. Reproduced from Reed, *Biography* (1890).

published by Samuel Bagster, the London bible-publisher, at four pence (4d.) and, though undated, is known to have appeared in November 1837. It is a modest pamphlet consisting of twelve letterpress pages and two lithographed plates, and running below the entire width of these two facing plates is the imprint 'Drawn by Isaac Pitman, Stenographer / Bedford's Lithography, Bristol' [161, 162].[10]

The real programme of lithographed publications that stemmed from Pitman's tireless promotion of his system of phonography began with the appearance of the first number of the *Phonographic Journal* in January 1842. In its first year the production of the journal was undertaken by Bradshaw & Blacklock of Manchester, whose earliest railway timetables, the forerunners of Bradshaw's railway guides, had been published a few years before. Reed claims that Bradshaw & Blacklock introduced Pitman to lithography and that Pitman was told that 'if he would write a page of shorthand on "transfer paper" he could have an exact copy of it printed.'.[11] He goes on to say that Pitman was given a large sheet of transfer paper which he took back with him to his lodgings in Manchester and there wrote out in shorthand the first number of the *Phonographic Journal*.[12] This first number, which consisted of just eight pages, was printed in an edition of 1000 copies. It was published jointly by Pitman in Bath and Bagster & Sons in London, a firm that published most of Pitman's earliest productions.

The *Phonographic Journal* appeared monthly and contained contributions on a range of subjects. Many of them related to the dissemination of phonography, others took the form of exercises for learners; the issue for August 1842 raised the question, touched

[10] For descriptions of the publication, see Baker, *Life*, plates between pp. 34 & 35; Brown & Haskell, *Shorthand collection*, p.320; Reed, *Pitman*, pp.20–24; Westby-Gibson, *Bibliography*, p.178. Thomas Bedford was one of Bristol's earliest lithographic printers (possibly the earliest). He is listed in *Mathews's Annual Bristol Directory* over a long period, and for the first time as a lithographer in 1823. In 1835 he was described as a Bookseller & Stationer, Lithographic & Letterpress Printer at 14 & 15 Redcliff Street. A fine trade card of Thomas Bedford from the 1830s is reproduced above, p.30, [17].

[11] Reed, *Pitman*, p.34.

[12] Reed, *Pitman*, pp.34–35.

on earlier in this chapter, of the possibility of printing phonography from movable types. Pitman must have been one of the first to offer publications for sale at two rates according to whether postage had been pre-paid or not, and the first number of the *Phonographic Journal* advertised itself as 'Price 2d. or 3d. by Post, paid'. After the production of the first few issues in Manchester, the printing of the *Phonographic Journal* was transferred to a local lithographer in Bath, J. Hollway [163–165]. This must have made

163, 164. Pitman's *Phonographic Journal*, vol.2, 1843. Printed lithographically by J. Hollway, Bath. Page size 179 × 103 mm. [Cat. 5.40].

165. Pitman's *Phonographic Journal*, vol.2, 1843. Detail 63 × 87 mm.

things much easier for Pitman, and Hollway's firm soon established itself as his principal lithographic printer. Hollway is the lithographic printer most frequently named in Pitman's publications, and when an early lithographed item of his has no imprint it is reasonably safe to assume that Hollway was its printer. On occasions the firm's imprint is to be found in its phonotypic form: 'Holwa Lit. Bat'. The association between Hollway and Pitman must have been an unusually close and regular one because Pitman was able to claim around 1850 that '... three lithographic presses are kept constantly employed upon the shorthand periodicals and other works at the large lithographic establishment of Mr Hollway in this city'.[13]

By this time, however, Pitman already had his own letterpress printing establishment and employed eighteen people (eleven in the printing department and seven in the bindery).[14] Initially he used the services of John & James Keene, the proprietors of *Keene's Bath Journal*, but in December 1845 he set up his own workshop at his home at 5 Nelson Place, Bath.[15] There he compiled the works to be published, read the proofs, kept the books, undertook all the correspondence, and even worked at the case as a compositor. His regular hours of work at this stage were from six o'clock (occasionally five o'clock) in the morning until ten o'clock at night. After a few years he found he needed to expand and in 1851 he moved to Albion Place, Upper Bristol Road,[16] and then in 1855 to Parsonage Lane in the centre of Bath. From these addresses two kinds of letterpress publications emerged: instructional manuals about phonography, and journals and other works on phonotypy. The phonographic manuals (which had no extensive passages of shorthand writing in them) were set in ordinary type and then the special shorthand characters were dropped in as required afterwards. At the outset the shorthand characters were cut on wood,[17] but from the early 1850s a shorthand type, cast in two sizes by V. & J. Figgins, was available for the simpler forms, such as consonants and vowels. More complex forms were etched in relief on metal blanks, each blank consisting of a whole word. These blanks were carefully distributed and kept in type cases for later use. At a later stage still, this use of specially-etched blanks became the normal practice for the printing of shorthand illustrations along with letterpress text.

Pitman's publications on phonotypy, such as the *Phonotypic Journal*, were produced in the normal letterpress manner using movable types [166]. Phonotypy involved the use of most of the characters of the traditional alphabet plus some newly designed ones. In order to support the expensive business of making phonotypic types, he put out an appeal in the early 1840s to raise funds.[18] These phonotypic founts appeared between 1844 and

[13] Reed, *Pitman*, p.68.

[14] Reed, *Pitman*, p.68.

[15] Reed, *Pitman*, p.47.

[16] A reproduction of a pencil drawing of the front of this building appears in the *Reporters' Magazine*, vol.8, no.86, p.19; in the accompanying text (p.18) the date for the move is given as December 1850.

[17] A note on the final page of Isaac Pitman's *Phonography; or, writing by sound* (5th ed., London, 1842), reveals that the characters were cut on wood by J. L. Whiting of Bristol.

[18] See the *Phonotypic Journal*, vol.2, 1843, pp.103, 132, 155.

166. Pitman's *Phonotypic Journal*, vol.8, March 1849. Letterpress. Detail approx. 135 × 165 mm.

1847[19] and were shown in a specimen which he made available at the Great Exhibition. They were first used in the *Phonotypic Journal* for January 1844 and, before he had a press of his own, Pitman used to go over to Keene's printing office to set up those pages of the journal that appeared in phonetic types.[20] All Pitman's phonotypic publications appear to have been printed letterpress, and so too were some of his phonographic ones that did not include long passages of shorthand writing. This underlines the fact that Pitman used lithography for his phonographic journals mainly because it was more convenient than letterpress at the origination stage.

Though Pitman had no lithographic press of his own, he played as important a role in the actual production of his lithographed publications as he did with his letterpress ones. His principal involvement took the form of writing out the texts on transfer paper. This was the technique he used for the production of his first wholly lithographed publication, the *Phonographic Journal*

[19] I. Pitman, *A Manual of phonography* (London, 1849), p.6.
[20] Reed, *Pitman*, p.47.

(which began publication in January 1842), and it remained his normal method for reproducing long passages of phonography until it was replaced by a relief-etching method right at the end of the last century or the beginning of this one.[21]

Pitman's output of lithographic pages of shorthand in the first decade or so of his promotion of phonography was enormous. In this period he seems to have done most, if not all, of the writing out of the journals himself. The writing was done on transfer paper. In an article he wrote in 1852 he claimed to have lithographed 4800 pages of phonography[22] during the previous four years – and all this in addition to his normal business work. On the assumption that he worked a six-day week, this meant an output of over three pages of lithographic transfers a day over this period. Understandably, his writing on transfer paper was often done in haste and amid interruptions;[23] on one occasion in 1867 he even took some transfer paper with him on holiday to the Isle of Wight so that he could keep up with his demanding schedule.[24] He maintained that he had had no formal training in writing on transfer paper and that he had never written anything for practice apart from 'an hour's trial with the lithographic pen' done in Manchester in preparation for the first number of the *Phonographic Journal*.[25] All the same, he was well suited to undertake such work by virtue of his skills and temperament. He seems to have been dexterous from an early age and Reed refers to two neatly written pocket books of his (one dated 31 May 1825, and therefore done when he was twelve)[26] and to his lifelong practice of copying music.[27]

It scarcely needs stating that Pitman was a skilled user of shorthand. The mass of his correspondence was done at speed in phonography, and with considerable economy of space. Reed provides us with this engaging description of a piece of Pitman's own shorthand writing:

> Written on a scrap of ruled paper, half the size of an ordinary
> page of note-paper, would be seen a series of lines, circles,
> and dots, sharp and delicate as if traced by a fairy, and con-
> taining as much matter as an ordinary letter of four pages.[28]

Pitman's style of shorthand writing does not seem to have altered much over the years, though Reed remarked that the characters in the later numbers of the *Phonographic Journal* were larger and clearer than those in the early ones.[29] His involvement with the writing of phonography on transfer paper must have waned over the years; all the same, when he had a slight accident in 1864 and was confined to bed for a week, the journal he was involved with at the time appeared without a supplement of phonography.[30] This seems to suggest that there was no one to replace him at the time. Though other writers must have taken a share of the load in later

21 See above, note 8.
22 *Phonetic Journal*, 28 Feb. 1852, quoted by Reed, *Pitman*, p.70.
23 Reed, *Pitman*, p.70.
24 Reed, *Pitman*, pp.109–110.
25 Reed, *Pitman*, pp.70–71.
26 Reed, *Pitman*, pp.7–8.
27 Reed, *Pitman*, p.96.
28 Reed, *Pitman*, p.98.
29 Reed, *Pitman*, pp.38–39.
30 Reed, *Pitman*, p.108.

years, the only other names I have come across in connection with the writing of Pitman's phonographic publications are T. A. Reed, who wrote the *Book of Common Prayer* (London, 1853), J. R. Lloyd, who may have written Dinah Mulock's *John Halifax, gentleman* (London, 1871) and some other books,[31] and Henry Swan, who engraved on stone some of the pages of the *Phonographic Examiner* (1853–55). Even in his later years, however, Isaac Pitman took on the writing of numerous publications, some of them quite extensive. In 1872 he began work on a further edition of a shorthand bible, which was to appear in parts as a supplement to the *Phonetic Journal* (his earlier edition was published in 1867 and ran to over 800 pages). But though the new edition was begun, it was never completed, because he received some bad scalds while taking a Turkish bath in 1874. He recovered fully, but his routine was interrupted for some ten weeks and he ceased writing on transfer paper all together after the accident.[32] At this stage, since the battle to establish phonography was already won, he began to concentrate more on his campaign for spelling reform.

The lithographed publications Isaac Pitman was reponsible for are – at least to non-shorthand readers – remarkably uniform in their presentation.[33] The most influential of them are the journals he published in order to promote his ideas. They are mostly small in format and in extent (small 8vos, 12mos, and 16mos running to 8, 12, or 16 pages) and sold for two or three pence an issue (that is, 2d. or 3d.) It was through these journals that Pitman kept his readership informed about what was going on in phonography and provided exercises for the benefit of those learning shorthand. Some articles were included of a more general kind, such as ones on Swedenborg, his principal religious mentor. The *Phonographic Magazine* (1844) even advertised itself on a window bill as 'A monthly serial, consisting of original papers on science and art, essays, tales, reviews, poetry, &c. &c. ...' [167].

A familiar visual feature of most, if not all, of Pitman's journals is that their pages are surrounded by borders. Similar features are to be found in some of the earliest German books of *Taschenbuch* size that are discussed in Chapter 2, and it is likely that they were introduced in order to unify pages visually and give them something of the appearance of the rectangular blocks of text associated

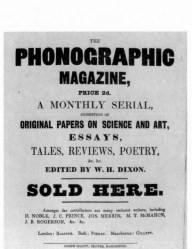

167. Window bill advertising Pitman's *Phonographic Magazine*, 1844. Letterpress. 213 × 185 mm.

[31] Reed, *Pitman*, p. 113.

[32] Reed, *Pitman*, p. 119.

[33] Both Reed, *Pitman*, pp. 180–182, and Baker, *Pitman*, pp. 355–357, provide good lists of Pitman's shorthand publications. Further entries can be found in Brown & Haskell, *Shorthand collection*; Westby-Gibson, *Bibliography*; and in the unpub-
lished 'Catalogue of books, periodicals, MSS, portraits, prints, etc relating to shorthand, secret writing and kindred subjects in the Library of William J. Carlton', University of London Library. Pitman was not consistent in his orthography (either in the titles to his publications or in his references to them). Sometimes he treated
them phonetically, sometimes not; some journals changed from one treatment to the other. Although some phonetic titles can be presented using traditional orthography, others cannot; I have therefore chosen to be consistent and to present all of them in traditional orthography, both in the text and in the Catalogue.

with letterpress printing. In Pitman's journals, the borders were usually drawn in single lines, though some of them (such as the *Phonographic Journal* and the *Phonographic Magazine*) have double-line borders [163–165, 168]. The usual practice was for running heads and folios to be included within these borders and to be separated from the text by a horizontal line. Sometimes a similar convention was adopted at the foot of the page to separate footnotes from the text. In the case of the *Phonographic Correspondent* (1871), the running heads, headings in text, and folios (and the index and title-page too) were transferred from type [169]. There is good reason to believe that the borders and inter-column lines in Pitman's journals were drawn in after the text was written, because they are sometimes broken to accommodate extra long lines of text and occasionally vary in their depth to cater for pages with extra lines.

Some of Pitman's journals have headings or key words written in traditional orthography, which means that it is possible for the non-shorthand reader to form some idea of their content. The contents pages of the bound annual volumes are also in traditional orthography. But it is difficult for anyone who is not a skilled reader of shorthand to comment sensibly even on the graphic aspects of the texts. The impression given by the standard works on Pitman is that he did all the shorthand writing of his journals himself; but quite apart from the enormous effort this would have entailed, stylistic evidence suggests otherwise. In the *Phonographic Journal*, for example, distinct changes seem to have been

168. Pitman's *Phonographic Magazine*, no.4, August 1844. Printed lithographically. Detail 103 × 135 mm. [Cat. 5.42].

169. Pitman's *Phonographic Correspondent*, 1871. Printed lithographically, the running heads and signatures transferred from type. Page size 133 × 88 mm. [Cat. 5.37].

made in the style of the writing during the latter part of 1843. That having been said, there is a general similarity about the overall design of the pages of Pitman's publications. Some pages of his journals were written in two columns, and the *Phonographic Star* (1844–57) is mostly organized this way [170]; but the normal practice was for the writing to occupy a single column. Lines of text were usually controlled in such a way as to give as even a right-hand edge to a page as was possible without resorting to noticeable compression or expansion of the characters or too varied word spacing.

In general, Pitman's journals have standard numbers of lines of text to a page. A noticeable exception to this is the *Phonographic Magazine* which, in its first numbers (1844), varies between twenty-six and thirty-three lines to a page, though every page makes more or less the same depth. In the case of publications with regular line increments, it seems that the transfer paper would have been pre-ruled or placed over ruled paper in order to provide a guide for the writer; it was certainly Pitman's custom to do his ordinary shorthand writing on ruled paper (see p.154). Though different line increments were used for different journals,

170. Pitman's *Phonographic Star*, July 1846. Printed lithographically. Page size 192 × 115 mm. [Cat. 5.48].

identical ones can be found in several of them; for example, the *Phonographic Star* [170], *Phonographic Correspondent*, *Phonographic Magazine*, and *Phonographic Reporter* all used the same line increments in the late 1840s and early 1850s. In the *Phonographic Journal* for 1843 two different approaches seem to have been adopted. All the pages up to and including page 92 have seventeen lines to the page, whereas thereafter some pages have seventeen and others twenty-two (even though they all make a similar page depth). These differences in line increment, which appear to have no regular pattern, support the view that not all the writing of these journals was done by Pitman himself.

The choice of an appropriate line increment in relation to the size of the writing and the length of the line was, of course, as crucial for shorthand as it was for other forms of writing and book design. Such matters must have exercised Pitman's mind. In the *Phonographic Examiner*, for example, there was a shift from twenty-three lines to a page in volume 1 (1853) to twenty lines to a page of similar depth in volume 2 (1854). Together with the introduction of a more formal style of writing, this reduction in the number of lines to the page and the consequential increase in spacing between the lines, seems to help with the horizontal scanning of the lines. In many pages of the second volume, and occasionally in other volumes too, the writing appears on dotted lines; but this practice was not generally followed in Pitman's lithographed publications.

Pitman referred to his first trials at writing on transfer paper as having been done for Bradshaw & Blacklock with a 'lithographic

pen'. This term suggests a steel pen of the kind recommended by Senefelder, Engelmann, Hullmandel, and many other writers on lithography. Nevertheless, it is possible that Pitman used a quill when writing on transfer paper, since there is reliable evidence to suggest that he used one when writing shorthand on ordinary paper. In notices to correspondents that appeared in his *Phonotypic Journal* in 1843 he referred to a phonographic pen. Whatever kind of tool this was, it had to be capable of producing thick and thin strokes, since these were essential when making distinctions between certain shorthand characters. In May he wrote that 'A Phonographic Pen will shortly be prepared, made as steel pens generally are . . .',[34] but in June he admitted defeat:

> We have tried several specimens of the best steel pens, with the intention of keeping a good one on sale as a *Phonographic Pen*; but as we find that none of them are equal to a quill for swift writing, and as the announcement of a phonographic pen would imply a preference for it rather than for a quill, we shall not add this article to the list of phonographic stationery.[35]

He then goes on to suggest that phonographers unable to 'mend pens' should select the finest steel pens available, and recommends Gillott's best. All these comments relate to shorthand writing with ordinary ink on ordinary paper. Whether Pitman used a quill for writing with lithographic ink on lithographic transfer paper is quite a different matter.

Not all Pitman's lithographed publications would have been written on transfer paper. The *Phonographic Examiner*, which first appeared in 1853, described some of its volumes as having been 'Engraved on stone' [171, 172]. Precisely what was meant by the word 'engraved' in this context is not clear. It may have been used generically to describe the making of an image for printing, though by the middle of the nineteenth century this would have been an unusual use of the expression. The more likely explanation is that it relates to one of several techniques called engraving on stone which were initially developed by Senefelder and used for commercial purposes throughout most of the nineteenth century. The simplest and most widely used of these involved coating the surface of a polished stone with gum arabic mixed with lampblack. This coating was removed with a sharp instrument where marks had to appear in the final print, and the whole surface of the stone was then charged with lithographic ink. The exposed parts of the stone attracted the ink, whereas the gummed parts were protected from it. After washing away the original coating, the stone was treated in the normal way for lithographic printing. Such a technique may have been possible in shorthand writing using a tool like a steel nib, which would have given thicker

[34] *Phonotypic Journal*, vol.2, 1843, p.60.
[35] *Phonotypic Journal*, vol.2, 1843, p.72.

171, 172. Pitman's *Phonographic Examiner*, vol.3, 1855. Engraved on stone by Henry Swan and printed lithographically. Page size 147 × 93 mm. [Cat. 5.38].

173. Pitman's *Phonographic Examiner*, title opening for vol.1, no.8, September 1853. Printed lithographically. Page size 147 × 93 mm. [Cat. 5.38].

strokes the harder it was pressed on to the stone, but the writing would have had to be done in reverse. The change in the style of the writing of the journal from the first to second years of its publication coincides with its introduction of the term engraved on stone, which suggests that there may have been a change in the means used for its production at the same time. The wrappers of the journal for December 1855 state that in the following year it would 'cease to be engraved'.

The shorthand writing of Pitman's journals, when it was not done by Pitman himself, was likely to have been done by people who were much better versed in phonography than lithography. The reverse would have been the case with the title openings for individual issues and the title-pages to the annual volumes. Though they are fairly modest in their pretensions, most of them show a level of competence in lettering and a control over lithographic tools that only a specialist lithographer would have had. The *Phonographic Examiner* in its first year (1853) had some of the most elaborate of these title openings [173], and the title-pages for the annual volumes of the *Phonographic Journal* and *Phonographic Correspondent* in their early years show a very competent organization of lettering in imitation of printing types [163, 174]. Other title openings, such as those for the *Phonographic Magazine* for 1844 [168], are more naive in their presentation and execution and may well have been lettered by Pitman himself.

Occasionally decorative borders and motifs are to be found in Pitman's phonographic journals. For some years the *Phonographic Star* and *Phonographic Correspondent* made a regular practice of including illustrations on their opening pages [175, 176] and on the title-pages to their annual volumes. Some of these drawings are

174. Pitman's *Phonographic Correspondent*, vol. 1, 1844. Printed lithographically by J. Hollway, Bath. The title-page lettered in imitation of printed types. Page size 218 × 135 mm. [Cat. 5.36].

175 (left). Pitman's *Phonographic Star*, December 1850. Printed lithographically, the illustrations probably drawn by William Fisher. Page size 150 × 90 mm. [Cat. 5.48].

176 (right). Pitman's *Phonographic Correspondent*, December 1850. Printed lithographically, the illustrations probably drawn by William Fisher. Page size 150 × 90 mm. [Cat. 5.36].

signed 'William Fisher', or its phonetic equivalent. It seems that Fisher worked for Pitman's journals on a regular basis in the late 1840s and early 1850s, and also contributed illustrations to some of his books. Fisher's untimely death from tuberculosis on 5 April 1852, at the age of twenty-four, was announced in an obituary notice that appeared in the *Phonographic Correspondent* for June of that year. The notice was based on a letter written to the editor by Elizabeth Fisher, William's sister. It reveals that he was born in Bishop Burton in Yorkshire in 1827 and that he was apprenticed to the enterprising York firm of William Monkhouse as a lithographic draughtsman. The apprenticeship began when he was fifteen and lasted six years. The implication of this account is that Fisher continued to work from York, and this is supported by a decorative title-page to one of Pitman's editions of the *Book of Psalms* (1849), which is signed (phonetically) W. Fisher and described as 'Del et Lith. Yorc'.

Most of Pitman's lithographed publications have no printer's imprint. The likelihood is that many such items were printed by Hollway of Bath, whose connection with Pitman has already been discussed. Nevertheless, some other printers are known to have done occasional work for him. Thomas Bedford of Bristol has been mentioned in connection with the printing of *Stenographic soundhand* in 1837, and Bradshaw & Blacklock with the production of the first few numbers of the *Phonographic Journal* (1842–43). The names of other lithographic printers mentioned in imprints are F. & H. Swan of Dalston, Liverpool Street, or Kingsland Green,

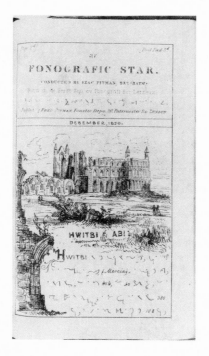

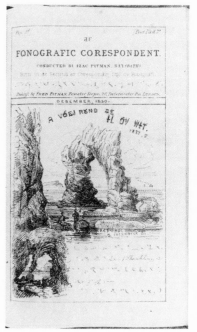

who printed the *Book of Common Prayer* (1853) and some volumes of the *Phonographic Examiner* (1853); William Monkhouse of York, who printed volume two of the *Phonographic Star* (1845); and A. Steele of Edinburgh, who printed the *Phonographic Review* (1867–69) and some other publications of the 1860s.

The principal lithographed publications of Isaac Pitman are printed in the Catalogue (5.1–5.66), and a study of this might lead one to ask why Pitman felt it necessary to publish quite so many phonographic journals. The answer to such a question is found beneath the titles of some of the journals and in the advertisements produced for them. These sources make it clear that the four monthly journals on phonography that he was publishing more or less simultaneously in the 1840s and 1850s were meant to cater for different needs and therefore different markets. The *Phonographic Star* was written 'in the First or simplest Style of Phonography, for learners', the *Phonographic Correspondent* 'in the Second or Corresponding Style', the *Phonographic Magazine* 'in an easy style of Reporting, at the rate of 100 words per minute', and the *Phonographic Reporter* 'in the Third or Reporting Style, at the rate of from 120 to 200 words per minute'.[36]

In addition to the phonographic journals and the editions of the Bible referred to above, Pitman published many other works in phonographic form in order to give people practice in the reading of shorthand. Among these were several editions of the *Bible* (1867, 1890, 1891), *Book of Psalms* (1848, 1849, 1853), the *New Testament* (1849, 1853, 1865, 1867, 1872), and the *Book of Common Prayer* (1853, 1867, 1869, 1871). He also published editions of Macaulay's *Biographies* (1868, 1870), Swedenborg's *Heaven* (1872), Milton's *Paradise lost* (1871) and popular nineteenth-century poems and novels, including Gray's *Elegy* [1866], Goldsmith's *Vicar of Wakefield* [1876], Dinah Mulock's *John Halifax, gentleman* [1871], and Scott's *Waverley* [1868] and *Ivanhoe* [1886]. In addition, he published major reference books about phonography which were lithographed, such as the *Phonographic dictionary of the English language* (1846) [177–179], the *Phonographic and pronouncing vocabulary of the English language* (1850, 1852, 1867), and the *Reporter's assistant* (1867).

Many of the lithographed books Pitman published from the 1860s onwards made copious use of transfers taken from letterpress type for such elements as title-pages, headings in text, running heads, folios, and signatures (though not all of these on every occasion). These transferred elements give his books something of the structure of a traditional letterpress book and also help those who cannot read Pitman shorthand to find their way around the texts. Occasionally, Pitman included letterpress title-pages with his lithographed books, but the title-pages of most of those

[36] Advertisements appearing regularly in the *Phonotypic Journal* during 1849.

177, 178. I. Pitman, *Phonographic dictionary of the English language* (London and Bath, 1846). Printed lithographically. Page size 215 × 135 mm. [Cat. 5.54].

179. Detail of 178 (p.71), showing the entry for the word lithography. 85 × 135 mm.

published in the 1860s and 1870s were transferred from type and printed lithographically, even though they often look as though they were printed letterpress. Such transferred elements – along with the ubiquitous borders that surround pages, the vertical lines between columns of text, and the horizontal lines that separate running heads and folios from the text – give Pitman's rather loosely constructed lithographed books something of the formality they would otherwise have lacked.

The scale of Pitman's publishing activities must account for the consistent use of signatures in his books from the 1840s. This practice sets him apart from most others responsible for lithographed books of the period and suggests that his printers had mastered the organizational aspects of large-scale lithographic book production. A few of his books have gatherings signed with letters of the alphabet, which was the custom at the time in Britain, but most are signed with arabic numerals (sometimes along with a word or part of a word from the title of the book). There is no clear chronological development from the one system to the other (numerals are to be found for the signatures of his books as early as 1849), and it is possible that the two approaches were adopted by different printers.

Unlike some other producers of lithographed books in the age of the hand press, Pitman did not turn to lithography because it was economical for short-run publishing, though that may have proved an incidental advantage in the first place. His main reasons for choosing the process had to do with the difficulty of originating a printing surface in shorthand. As it happens, he must have stretched the resources of printing by lithography on a hand press to the extreme, bearing in mind the length of runs required for his journals and the frequency of their appearance. Each of the groups of four related journals referred to above sold more than 1000 copies monthly,[37] and in an article written in 1852 Pitman claimed that the number of shorthand sheets printed for him each year around that time averaged more than 100,000.[38]

The distribution of Pitman's first phonographic publications was handled in London by the bible-publishing house of Samuel Bagster & Sons of Paternoster Row. With the growth of Pitman's activities generally, this side of the business was taken over by the Pitman family. In 1846 one of Isaac Pitman's brothers, Benn, took charge of the London depot that had previously been managed by Bagster; and in 1847 his youngest brother, Frederick, then only nineteen, took over from him. Two years later the depot was moved to larger premises at 20 Paternoster Row.[39] Pitman's lithographed publications represent only a part, probably only a small part, of his total output of printed works. Some idea of the overall scale of his publishing enterprise in its early years can be gleaned

[37] I. Pitman, *A Manual of phonography* (London, 1849), p.6.

[38] *Phonetic Journal*, 28 Feb. 1852, quoted by Reed, *Pitman*, p.70.

[39] Reed, *Pitman*, p.56.

from a claim he made at a meeting in Birmingham in 1845 that he was sending out from his Bath office alone seven hundredweight of items a month and was receiving about 10,000 phonographic letters a year.[40] Later on in the century his output of publications was vast: by 1890, for example, 150,000 copies of the *Phonographic Teacher* (a letterpress production) were being bought every year.[41]

Pitman's main achievement in the context of lithographic book production was to have seized upon the possibilities offered by the process for the multiplication of phonography and to have used it consistently for a programme of publications over a long period of time. The lithographed books he produced are clearly out of the ordinary and it is difficult to assesss their quality. But it cannot be said that they contributed much to lithographic book design as a whole, and even the most ardent admirer of Pitman's work would have to admit that they lack visual appeal. Most of them appear to be strictly utilitarian in approach and, since all were printed on machine-made paper, they lack even the tactile qualities of some earlier lithographed books of a utilitarian kind, such as those produced at Chatham by the Royal Engineer Establishment in the 1820s.

It would be wrong, however, to judge Pitman's contribution to lithographic book production in terms of the visual features of his books and journals, or by considering any single publication on its own. His contribution was to direct a whole publishing programme that mobilised lithography to help promote phonography over a period of half a century. The peculiar nature of the publications he issued and their relative inaccessibility – in terms of both locating and understanding them – means that they have been almost entirely ignored by historians of the book. It will need someone with a good understanding of the early forms of his method of shorthand to take this story much further. Nevertheless, what can be said at present without much fear of contradiction is that Pitman's programme of phonographic works justifies his being considered the most prolific publisher of lithographed books and journals of the middle of the nineteenth century.

[40] Reed, *Pitman*, p.53.
[41] Reed, *Pitman*, p.181.

Books with pictures

Lithography lent itself to the production of books that combined pictures with poetry or short passages of prose. Texts of this kind could be written out with comparative ease, either on transfer paper or on stone, and the process offered artists a whole gamut of techniques for the production of pictures. What is more, lithography gave aspiring writers and artists the opportunity to play a part in the production of their own books and to have small editions of them run off economically. This was merely an extension of the facility lithography offered amateur artists for multiplying their own drawings, which was referred to over and over again in the earliest accounts of lithography.

Though few early examples of the kind of book discussed in this chapter have been traced, it seems likely that others were produced and have simply escaped notice because they failed to find their way into major libraries. Of those that have been traced, most would probably be classed by bibliophiles as vanity books; that is, they were privately produced by writers or artists for distribution to their friends. Whether any or all of these lithographed books with pictures deserve this mildly offensive epithet is not for us to determine. We know so little of the intentions of those who originated them that it would be foolhardy for us to try to read too much into the limited evidence we have at our disposal, but it may be worth pointing out that several of the earliest of them, including some of the finest, were conceived by women.

The books discussed in this chapter are similar to one another in that they all combine words and pictures, but they are disparate in other respects. They seem to fall into four broad but overlapping categories: travel books and books of views, flower books, poetry books, and books of humorous sketches.

The first publication to be discussed here is one of several that fall into more than one of these categories and is both a poem and a kind of travelogue. It is also one of the finest lithographed books to have been produced in the age of the hand press. It is an edition of a poem by Georgiana Spencer, Duchess of Devonshire, which she wrote following a trip she took through Switzerland. It was

published in Paris in a French translation by the Abbé de Lille, along with its original English text, with the title *Passage du Mont saint-Gothard* [180–187].[1] Though the publication is undated, the address of its imprint 'Imprimerie Lithographique de C. de Lasteyrie rue du Bac No. 58', suggests that it must have been printed between 1817 and 1825. An incomplete copy of the book in Cambridge University Library has a letterpress title-page dated 1816. Such evidence, taken along with the style of the lithographic work, suggests a dating nearer 1817 than 1825.[2]

Georgiana Spencer married the fifth Duke of Devonshire in 1774 at the age of seventeen, and soon became a central figure in the fashionable circles of the day. Her poem was based on a trip through Switzerland which she undertook with some friends in 1793 from the direction of Italy. It had been published many times before the lithographed edition under discussion was printed; it was originally written in English and first appeared in 1799 in the *Morning Chronicle* (20 December) and the *Morning Post* (21 December).[3] The Abbé de Lille's French translation of it was first published, along with the original English text, in a letterpress publication of 1802. Italian and German translations followed in 1803 and 1805 respectively. The lithographed edition of the poem appeared posthumously and consists of the text in both French and English (the French on rectos, the English on versos), followed by many pages of notes. These notes are also in both languages and are arranged on facing pages in the same manner as the poem itself. The lithographic illustrations are placed at appropriate points in the book, all of them oriented at right angles to the text. Though they were printed on a similar kind of paper to that used for the poem, they were not printed with the text and appear as independent plates with their reverse sides blank [180, 181].

All but one of the book's twenty lithographed plates were made after paintings by Lady Elizabeth Foster, who accompanied the poet on her continental trip (the remaining illustration is after a painting by Lady Bessborough, who went on the earlier part of the trip). The fascination of the publication today lies partly in the well-documented connection between the poet and its leading illustrator, Lady Foster.[4] After an unhappy marriage to John Foster,

[1] The late Mr Laurie Deval and Dr Charles Warren were kind enough to draw my attention to this publication some years ago. Since then Dr Warren has pointed me to the two other publications on Alpine subjects that are discussed in this chapter and has written a paper on Georgiana Spencer's poem ('An Alpine bibliographical curiosity', *Alpine Journal*, vol.89, 1984, pp.141–144).

[2] The British Library catalogues and W. H. Lowndes, *The bibliographer's manual of English literature* (revised by

H. G. Bohn, London, 1864), both give the date of this lithographed edition as 1802. Such a date is quite out of the question. 1802 may have stemmed from a transposition of the last two digits of 1820, a date which would accord with lithographic evidence, or it may have been a straightforward confusion with an earlier letterpress edition. The *Dictionary of National Biography* gives the date as 1816. Both

Lowndes and Martin, *Bibliographical catalogue*, claim that only fifty copies were printed and that they were not for sale.

[3] Warren, *Alpine Journal*, p.141.

[4] For lively accounts of the relationship, see D. M. Stuart, *Dearest Bess: the life and times of Lady Elizabeth Foster* (London, 1955) and B. Masters, *Georgiana: Duchess of Devonshire* (London, 1981).

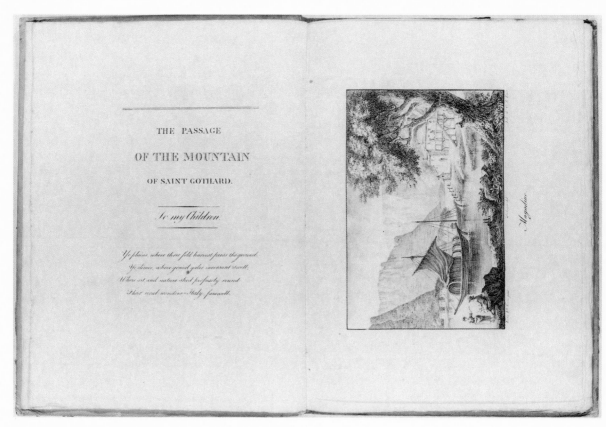

180, 181 (above and opposite).
Georgiana Spencer, *Passage du Mont saint-Gothard* (Paris, *c.* 1817). Printed lithographically by Lasteyrie, Paris. The illustrations drawn on stone by J.-E. Deshayes after originals by Lady Elizabeth Foster. Page size 320 × 240 mm [Cat. 1.196].

an Irish politician, Lady Elizabeth Foster was befriended by Georgiana Spencer. The Duchess supported her financially and even provided her with a home at Devonshire House, thus creating one of the most celebrated *ménages à trois* of the period. Lady Elizabeth Foster became the Duke's mistress and bore two children by him, but throughout all this Elizabeth and Georgiana remained the closest of friends. Georgiana Spencer died in 1806 whereupon, after a respectable interval of three years, Lady Elizabeth Foster became the new Duchess of Devonshire. Lady Elizabeth died in 1824, and we may perhaps see the production of the lithographed edition of the *Passage du Mont saint-Gothard* as one of the final manifestations of their remarkable friendship.

It seems likely that Lady Elizabeth was the guiding spirit behind the lithographed edition of the poem. During the latter part of her life she was living in Rome, where she became known for her sponsorship of archaeological, bibliographical, and artistic activities. It would have been absolutely in keeping with her interests to commission such a book. If she did do so, it is scarcely surprising that she should have turned to Paris for the lithographic work, and specifically to Le Comte de Lasteyrie, whom Bouchot styled 'l'imprimeur de la société'.[5] Lady Elizabeth would have had

[5] H. Bouchot, *La Lithographie* (Paris, 1895), p.40.

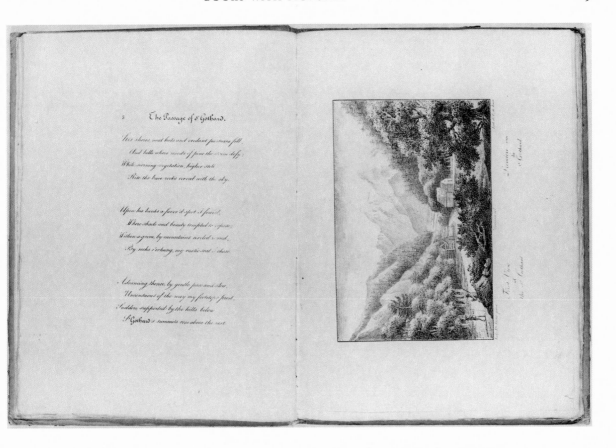

ample opportunity to make contact with Lasteyrie. She was friendly with Vivant Denon and Madame Récamier, both of whom were present on 24 November 1816 when Horace Vernet made a sketch on stone of Madame Perregaux, which Lasteyrie printed.[6] If it was Lady Elizabeth who commissioned Lasteyrie to print the book, a likely occasion would have been during one of her trips to Paris; she may even have done so as late as the winter of 1818–19 when she spent some three months there.[7] Lasteyrie was well qualified to take on the work; not only was he successful in attracting society ladies to turn their hands to lithography, but he had shown his abilities in the field of commercial jobbing printing through his work at the Ministre de la Police.[8]

What form Lady Elizabeth Foster's original paintings took is not known, and not much can be deduced about their quality; but it can be imagined that they were tidied up for publication in the usual manner by the professional lithographic draughtsmen employed to put them on to stone – though unfortunately not sufficiently in every case. The two men responsible for this work were J.-E. Deshayes and Alexandre Regnault, who rendered the originals on the stone in a rather soft and timid style of crayon lithography [182].

[6] Bouchot, *Lithographie*, pp.40–42. One of the copies of the lithographed edition of *Passage du Mont saint-Gothard* at Chatsworth is inscribed in pencil with the name of Mme Récamier.

[7] Stuart, *Dearest Bess*, pp.229–230.

[8] Twyman, *Lithography*, pp.50–52.

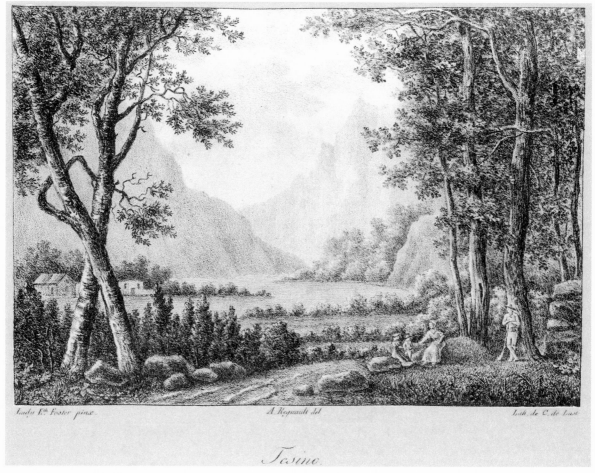

Lady E.th Foster pinx. A. Regnault del Lith. de C. de Last

Tesino.

182. Georgiana Spencer, *Passage du Mont saint-Gothard*, 'Tesino', drawn on stone by A. Regnault after an original by Lady Elizabeth Foster. Image 150 × 199 mm.

The writing of the actual poem is in a formal *anglaise* hand [183]; it is neatly and regularly executed and compares favourably with the best copper-engraved work of the period. Running heads on the pages that carry the poem are lettered in a *ronde*, as are the names of places when they appear in the poem. In the extensive notes at the end of the book the opposite convention is adopted: cross references to the poem are written in an *anglaise* and the notes themselves in a small *ronde* [184]. The book is immaculately written and seems to have been executed backwards on the stone (there are indications of hesitation here and there and of unnatural spacing between characters). Its displayed lettering is equally accomplished [185]: it makes a calculated play on variety so that important items are picked out in different styles of lettering and, in addition, small flourishes and swelled rules are sensitively introduced to provide visual interest. The whole publication must have been organized by someone with a thorough understanding of book conventions and its pages have generous and well-proportioned margins.

183. Georgiana Spencer, *Passage du Mont saint-Gothard*. Detail of 181 showing an *anglaise* hand used for the text and a *ronde* for the heading. Approx. 70 × 120 mm.

5 The Passage of S.ᵗ Gothard.

His shores, neat huts and verdant pastures fill,

And hills where woods of pine the storm defy;

While, scorning vegetation, higher still

Rise the bare rocks coeval with the sky.

184. Georgiana Spencer, *Passage du Mont saint-Gothard*. Detail of a page of notes showing the use of a *ronde* hand. Approx. 90 × 130 mm.

NOTES. 28

de la partie de la Suisse qui environne Lucerne, ne lui donne que 9075 au-dessus de la Méditerranée. Il forme le centre d'une chaîne de montagnes que les anciens appeloient Adule, et qui séparoit les Alpes Rhétiennes des Alpes Péniennes. Sa pente graduelle nous le fit paroître moins élevé que le mont du grand S.ᵗ Bernard.

Un ruban de granit de sa longue ceinture.

M.ʳ Raymond, éditeur de M.ʳ Cox, l'appelle un ruban de granit jetté sur la montagne. Cet ouvrage étonnant est un chemin d'à peu près 15 pieds de large,

185. Georgiana Spencer, *Passage du Mont saint-Gothard*. Detail of displayed lettering. Approx. 75 × 120 mm.

ÉPITRE

à

Madame la Duchesse

de Devonshire.

186. Georgiana Spencer, *Passage du Mont saint-Gothard* in its characteristic quarter-bound form, with glazed paper-covered boards and gold-tooled morocco labels. Boards 335 × 250 mm.

The letterer of the work is acknowledged on the title-page, where the words 'Moulin script.' appear, somewhat immodestly, in lettering slightly larger and rather more prominent than that used for the printer's imprint. I know nothing about Moulin, except that the name is found again on an ambitiously lettered set of lithographed title-pages of the late 1820s.[9] It must be assumed that he or she was a specialist letterer and had been trained in engraving on copper. Copper-engraved lettering was much more commonly signed than lithographed lettering and it is unlikely that French lithographic writers could have become so assured in the art of lettering on stone by the time Georgiana Spencer's book appeared, unless they had been trained in a related field.

According to both Lowndes and Martin, *Passage du Mont saint-Gothard* was not for sale and was printed in an edition of only fifty copies.[10] Two of these copies are to be found in the Alpine Club in London, one in the British Library, and a further incomplete copy in Cambridge University Library. The Trustees of the Chatsworth Settlement own four copies; three of these are untrimmed and, like other untrimmed copies that have been inspected, their text pages measure approximately 325 × 240 mm. The book appears to have been issued quarter-bound in an interesting range of glazed paper-covered boards; all copies I have seen in this form of binding have morocco labels on their spines and are subtly different in their gold tooling [186]. The same white wove paper, bearing on some pages the watermark '63', was used for all these copies. Unfortunately, Lasteyrie's printing does not quite do justice to the excellence of the book's design and lithographic writing; it is a little fuzzy in places, particularly on its title-page, and in at least one copy there is a missing line at the foot of page 20. Impression marks from the edges of the stones are visible on some pages, and from these it can be established that the text pages were printed two to view on relatively small stones.

One accidental feature of the book deserves our attention, even though it is hardly noticeable. On close inspection, the title-page reveals that the stone from which it was printed was cracked through the middle of the line that reads 'Traduit de l'Anglais'. In some of the copies I have seen there are also clear signs of chipping around the crack [187], which suggests that the stone had probably broken into two. Even the four copies at Chatsworth, the home of the Devonshire family – which must surely include among them some of the best-printed copies of the edition – show both the crack and the chipping. It seems reasonable to conclude, therefore, that the damage was done at the very outset of the printing. Though cracked and broken stones could be repaired temporarily by mounting them on to plaster of Paris and tying the parts together,[11] the problem of printing from such stones can only have

9 'Panorama musical', nd, published in Paris by Aulagnier and printed by Mlle Formentin, one of the leading printers of music titles of the time.

10 See above, note 2.

11 See Engelmann, *Traité*, pp.384–387, and Twyman, 'Lithographic stone', pp.31–32, plates xviii-xx.

POEME

PAR

Madame la Duchesse

De Devonshire

Traduit de l'Anglais

PAR

M. L'ABBÉ DE LILLE

un des quarante de l'Académie Française.

187. Georgiana Spencer, *Passage du Mont saint-Gothard*. Detail of title-page, photographed with a raking light so as to show a crack in the stone through 'l'Anglais' and chipping to the right of it. Approx. 115 × 145 mm.

got worse during the course of printing a run. As it happens, at least two of the copies that have been traced (one in Cambridge University Library, the other in a private collection) lack the lithographed title-page.

Another early book of illustrated poetry to be discussed here has something of the look of those common-place books in which people, usually 'ladies', used to write out their favourite texts and provide them with appropriate illustrations. It differs from such books not only because it was printed, but also because the poems in it were all written (either in the original or in translation) by the same person. It was the artist who seems to have been the driving force behind the publication and it is her name that appears on its decorated boards and title-page: *Flowers. A series of short poems, original and translated. Illustrated with figures drawn and coloured by Aza Curtis* [188, 189]. The imprint of the book reads 'London; Privately printed at R. Martin's Lithographic Office, 124, High Holborn 1827'. It is tempting to look for some

connection between Aza Curtis and the well-known family of botanists with the same surname but, if there was such a connection, it is not recorded and she appears not to be known in botanical circles today.

According to the preface of the book, the poems were selected by Aza Curtis to provide an accompaniment to her illustrations. Some were originally written in English, others were translated from the Italian and appear along with the originals. The author/translator of these poems signs the preface 'E.W.B.'. He can probably be identified as Edward William Barnard (1791–1828), who held a living at Brantingham in Yorkshire and is described in the *Dictionary of National Biography* as a poet and divine. Support for this attribution comes from the appearance of a 'Mr Barnard' at the head of the book's list of subscribers.

Aza Curtis's fourteen lithographed plates of flowers, which are placed opposite the relevant poems, were drawn in crayon lithography [190]. If the wording of the title-page is to be taken literally, they were coloured by the artist herself. The hand-colouring is certainly extensive and rich in hue and the lithographic work provides little more than a basis for what are, to all intents and purposes, water-colour paintings. The designer of the book made no attempt to integrate text and illustrations in production terms; as with the Duchess of Devonshire's poem, the illustrations were printed separately from the text and have their reverse sides blank.

Nevertheless, the book was designed as a unity and is altogether charming in its effect. It is demy quarto in format; its text pages were printed on paper with the watermark 'J. Whatman 1827' and its illustrations on a heavier stock. Its pale pink paper-covered boards were printed lithographically on both front and back: the front is lettered with the full title, which is surrounded by a floral arrangement drawn in crayon [188], the back carries a simpler floral motif with the word 'Flowers.' set within it. Its title-page was written in a formal copperplate hand, with the main word of the title picked out in a shaded Clarendon letter [189]. It is organized with less understanding of book conventions than the title-page of *Passage du Mont saint-Gothard*; it makes little use of space to separate items of the copy and sits a little low on the page. The book's preface, its twenty-two pages of poems, and its list of subscribers all appear to have been written directly on to stone, and therefore backwards [191]. Its leaves are printed on one side only and, unusually for a book of such quality, have no foliation.

Robert Martin, the book's printer, is known to have been an expert in lithographic writing and an additional imprint on the book's front cover, which is lettered 'R. Martin's Lithography.', may indicate that he did the lithographic writing himself. He was

188. Aza Curtis, *Flowers* (London, 1827). Lithographed boards, printed on pale pink paper by R. Martin, London. 270 × 220 mm. [Cat 1.79].

189, 190. Aza Curtis, *Flowers*
(London, 1827). Title-page and (below)
double-spread with hand-coloured
crayon lithograph. Page size
265 × 215 mm.

The Rose.

Favourite of man! Ne'er pleased where thou are not,
He seeks thee in his mental wanderings.
And pauses in his daily toil to glean
Refreshment from thy sweetness. Thine the hue
He loves in beauty's cheek; and thine the pure
And lasting fragrance that his fancy gives
To virtue. Not a bower, a place of rest,
A mimic Eden, can arrest his foot
If thou be wanting; and his wistful eye
Ne'er looks on Heaven with such intent delight,

191. Detail of 190 showing writing
done in reverse on the stone.
75 × 135 mm.

[12] He was also responsible for writing
a 'New interest table' of a similar date
which, likewise, was printed by Willich
(British Library, Tab. 597. a. 1. 21).
[13] Twyman, *Directory*, pp.40–41.
[14] Vol.98, part 1, 1828, p.541 n.
[15] G. Dunthorne, *Flower and fruit prints
of the eighteenth and early nineteenth
centuries* (Washington, 1938), 19. My
information about the book is taken from
two booksellers' catalogues (Bookman,
San Francisco, third series, no.1, Sept.
1983, item 1; and an entry in an unidenti-
fied catalogue issued by Charles Traylen
of Guildford).

among the earliest people in Britain to specialize in lithographic writing. Indeed, this kind of work may have provided his introduction to lithography as the inscription 'R. Martin scr. 1819' is found on items of lithographic printing by Charles M. Willich in the John Johnson Collection of the Bodleian Library.[12] By 1820, however, Martin was printing on his own account,[13] and thereafter soon built up a reputation as a specialist in writing on stone and similar precision work. The year after Aza Curtis's *Flowers* was published, the *Gentleman's Magazine* declared that 'For the beauty and clearness of his writing [on stone] no one can be more deservedly admired than Martin of Holborn.'[14] Like the *Passage du Mont saint-Gothard*, Aza Curtis's *Flowers* was produced in a small edition for private circulation; its list of subscribers at the back of the volume includes ninety-six names and accounts for ninety-nine copies.

What appears to be a very similar flower book to Curtis's *Flowers* was published in Edinburgh a year earlier. It is listed by Dunthorne,[15] but I have been unable to see a copy of it. It is the work of someone who describes herself as 'A lady' and consists of four sets of hand-coloured prints under the title *Ten lithographic coloured flowers with botanical descriptions. Drawn and coloured by a lady* (Edinburgh, 1826). The flower drawings are referred to in the preface as having been 'taken from Nature as studies, by the author at her leisure hours, without any intention that they should ever leave her Portfolio', and are accompanied by

handwritten and lithographically printed botanical descriptions. One account of the book refers to R.H. Nimmo as the lithographer, though it is not clear whether he was the lithographic draughtsman or the printer. The only lithographic printers recorded as having been working in Edinburgh at the time were Robertson & Ballantine, who printed Bewick's lithograph 'The cadger's trot' in 1823.

Rather less like books than Curtis's *Flowers*, but similar to it in that they fall into the category of publication Wilfred Blunt has aptly called the sentimental flower book,[16] are two publications with illustrations by Jane Elizabeth Giraud: *The flowers of Shakespeare* and *The flowers of Milton*. The former appeared in three editions; a copy of the first edition in the British Library carries a manuscript dedication from the artist to her brother dated 18 February 1845, whereas the second editon includes a similar lithographed dedication, which is dated 1 January 1846. A third edition, published by Ackermann in 1850, is also recorded. *The flowers of Milton*, though undated, belongs to much the same period. These publications are quartos and were printed throughout by lithography, though on one side of the paper only. They are also similar in that they present crayon lithographs of flowers along with appropriate quotations on the same page. All the lithographs in them were drawn on stone by Giraud in the form of vignettes and are fully and meticulously coloured by hand. The quotations that appear beneath the pictures are carefully lettered in an open form of black-letter and have above them the name of the appropriate flower in letters that are reinforced by hand-colouring. The stones for the second edition of *The flowers of Shakespeare* were entirely redrawn; the flowers appear to be much the same as those of the first edition, but the decorated letters are different and the lines of the quotations are much more closely spaced down the page. Both editions have thirty plates, including the title-page (which carries the imprint 'Day & Haghe' in the first edition and 'Day & Son' in the second). *The flowers of Milton* also has thirty plates, including a title-page and a part-title, and two of its plates carry the imprint 'Day & Haghe, lithrs to the Queen'. It is so similar in approach and style to *The flowers of Shakespeare* that it must belong to the same period. Though Elizabeth Giraud's drawings are considerably more refined than those of Aza Curtis in *Flowers*, her publications have less of the pioneering spirit about them and, as examples of lithographic book production, are not nearly so appealing.

All the flower books discussed above have to be considered as collections of pictures with accompanying passages of text rather than proper illustrated books; indeed, the preface to Aza Curtis's book explicitly states that the poems were selected as an accom-

[16] W. Blunt, *The art of botanical illustration* (London, 1950), pp.219–20.

13

of Brick within the time mentioned.

This Building consisted of a Quadrangle of about seventy feet square in the centre of which was the Entrance, on each side, small Turrets. The Door of entry led through a Cloister into a Court, in the interior of which, and facing the Entrance, was a Porch, of Roman Architecture, over the Arch, engraved on Grey Marble, were the following Latin Lines, which were written by Sir Nicholas Bacon.

Hac cum perficit Nicolaus tecta Baconus
Elizabeth regni lustra fuere duo;
Factus eques, magni custos fuit ipse sigilli;
Gloria sit soli tota tributa Deo
Mediocria firma

From the Porch, an ascent of four or five Steps, led to the upper end of the Hall. In the centre of the lower end, was a Door

192. Charlotte Grimston, *The history of Gorhambury* (c. 1821), showing one of the author's crayon lithographs and a page of professionally handwritten text. Page size 330 × 250 mm. [Cat. 1.113].

paniment to the drawings. The dividing line between collections of pictorial prints bound up in book form and books with texts that have been illustrated is by no means an easy one to draw, and nowhere is this more so than in topographical publications. Collections of topographical views were often published serially in parts, with their sheets loosely sewn in wrappers, whereas other copies of the same images were sometimes made available in book form and with explanatory text at the close of publication. Somewhat surprisingly, very few of the numerous collections of lithographed views that were published in the first half of the nineteenth century appear to have been produced with their accompanying text lithographed. The reason for this probably stems from the fact that lithography merely took over from aquatint in this field; and in books with aquatint plates there was really no alternative to letterpress for the text matter.

Probably the earliest topographical book with its text lithographed is Charlotte Grimston's *The history of Gorhambury* [192]. This gives no publisher or place of publication and is undated, but a caption to one of its illustrations which reads 'The remains of the interior Court at Gorhambury. Standing 1821' suggests a date

of 1821 or soon after. Such a dating would be broadly consistent with the watermarks of its paper (Whatman 1820). Though Charlotte Grimston's book is a serious historical publication, it could be described as a vanity book because it contains the author's own pictorial plates together with some extremely inept plans (which would have been more appropriately done by a professional).

The book is a small folio of ninety pages and is written throughout in a regular, but not fully cursive, copperplate hand. It has many features of a proper book of the time, including generous margins, folios at the heads of pages, and even footnotes. It also includes ten plates of topographical views and plans, which are printed on one side of the leaf only and grouped at various points through the text. Nine of these plates are lithographs and, curiously, one is an etching. Some text pages have line drawings of coats of arms in their fore-edge margins; furthermore, the title-page includes the family coat of arms and has its lettering set within an architectural panel.

The most striking feature of the book is the discrepancy between the assurance of the writing of the main text and the naivety of the drawings, plans, title-page, and some footnotes. Everything points to the fact that Charlotte Grimston employed a professional lithographic writer to undertake the tedious task of writing out the text, but did everything else herself. Unfortunately, the book contains no information at all about its printer. One copy I have seen includes a lithographed portrait of the Hon. Charlotte Grimston facing its title-page;[17] the plate has the imprint of the printer Graf & Soret, but this firm is not listed in the directories until 1832,[18] which seems an unlikely date for the publication as a whole.

The other topographical publication to be mentioned here was printed outside Europe and, strictly therefore, falls outside the scope of this book. However, it is so much in the idiom of a topographical publication of the period that it seems appropriate to discuss it here. In any case, as an Anglo-Indian work, it is steeped in British culture. The publication in question is J. Grierson, *Twelve select views of the seat of war* (Calcutta, 1825) [193–195], which records the sites of the first Burmese war of 1824 and claims to have been the first application of lithography to landscape in India.[19] It is a landscape folio work and consists of twelve crayon lithographs, drawn on stone by E. Billon after original drawings by Grierson, each of which faces a page of descriptive text. It also has a title-page and other preliminary matter. Its title-page is competently displayed in a range of different kinds and sizes of letterforms [193, 194], and its text pages are carefully written in a copperplate hand. Because of the book's landscape format there was really no alternative to organizing its text in two

[17] British Library, Grenville Collection, G.3797.

[18] Twyman, *Directory*, p.34.

[19] This point is made in the 'Apology to subscribers'. See also J. R. Abbey, *Travel in aquatint and lithography 1770–1860*, 2 vol. (London, 1956–57), 403.

193. J. Grierson, *Twelve select views of the seat of war* (Calcutta, 1825). Printed at the Asiatic Lithographic Press, Calcutta. Page size 320 × 480 mm. [Cat. 1.112].

194. Detail of 193. Approx. 115 × 165 mm.

columns. The use of key-line borders around each page seems to owe something to early German lithographed books. An unusual feature of its text pages is the use in headings of what the British call Italian letters, that is, letters that have their thick and thin strokes in unorthodox places. The book was printed lithographically throughout by the Asiatic Lithographic Press in Calcutta and its subscription list accounts for as many as 258 copies.

195. J. Grierson, *Twelve select views of the seat of war*. Illustration drawn in crayon on stone by E. Billon and printed on India paper. Page size 320 × 480 mm.

As in Aza Curtis's *Flowers*, the text pages and plates of *Twelve select views of the seat of war* were printed on one side of the leaf only and its pictures on a heavier stock than its text (some leaves of the text pages are watermarked '1824' and some of those used for its pictures 'J. Whatman 1816' or 'C. Brenchley 1817'). Unlike other publications discussed in this chapter, its illustrations were printed on India paper, which was mounted during the actual printing.[20] What makes the publication rather unbook-like is that its unnumbered leaves appear to have been printed singly as broadsides and then guarded into the volume. Overall, *Twelve select views* was strongly influenced by European taste, and particularly by the Anglo-Indian community for which it was intended, both in its lettering and writing and in its pictorial lithography. Nevertheless, considering its period and place of production, it is a remarkable publication.

Most of the books discussed in this chapter so far have their pictures on separate pages from their text matter, and in some cases their pictures can legitimately be called plates because they were printed on a different stock from the text pages. Apart from the modest use of marginal drawings in Charlotte Grimston's book, none of them was designed to take advantage of the major benefits that arose from the use of lithography in book production – the ability to combine pictures and text matter more freely than

20 See Twyman, *Lithography*, p.233, n.2.

could normally be done using letterpress and intaglio printing together. In this respect they were not nearly as innovatory as the manuals with technical illustrations from the military establishments at Chatham and Metz considered in Chapter 3.

Most of the items to be discussed in the remainder of this chapter abandon the custom of separating text from pictures and, in varying degrees, integrate the two. The first two publications of this kind to be considered here are both Alpine items and were printed in the south-east of France. They pick up the travel theme referred to at the beginning of this chapter and, in this respect, have something in common with Georgiana Spencer's *Passage du Mont saint-Gothard*.

The earlier of the two was written and illustrated by the French architect and draughtsman, Louis-Pierre Baltard (1764–1846), and records a journey he undertook in Savoie in 1837: *Journal descriptif et croquis de vues pittoresques faits dans un voyage en Savoye du 10 au 21 août 1837* (Lyons, c. 1837) [196, 197]. The publication is undated, but it can be assumed that it was completed not long after his journey. Baltard's name does not appear on the title-page, but as a signature on the last page of the text. On the same page Baltard refers somewhat defensively to the fact that his travels could not have slowed down work on the Palais de Justice – which was undergoing extensive alterations at the time – since he was always ahead with his work.

Baltard's *Journal descriptif* is one of the most appealing improper books, and its illustrations reveal a keenness of observation and a freshness of touch which single it out from most of the other books with pictures discussed in this chapter. The book has thirty-four illustrations, which are distributed fairly evenly throughout the text (on thirty-one of its forty-five pages). The illustrations relate closely to Baltard's verbal account of his excursion and appear at appropriate points in the text. They are all vignettes and most of them occupy about half a page. They bring considerable visual variety to the book because they occupy different positions on its pages and usually fall short of or extend beyond the width of the text. The majority of the illustrations were drawn with a soft lithographic crayon, the remainder with pen and ink (seven of them) and crayon and pen and ink combined (one only). The text was carefully written out, probably on transfer paper, in an upright form of a style of writing that would probably have been described at the time as a *coulée*. Though the book may lack some of the features of letterpress book production, such as a contents page, running heads, and captions, it was carefully printed – by Brunet et Cie of Lyons – on a good quality white wove paper.

The illustrations of Baltard's *Journal descriptif* are genuinely

196, 197 (above and opposite).
L.-P. Baltard, *Journal descriptif et croquis de vues pittoresques faits dans un voyage en Savoye* (Lyons, c. 1837). Printed lithographically by Brunet et Cie, Lyons. Page size 350 × 268 mm. [Cat 1.16].

integrated with its text, and this must have presented some technical problems for its printer. Foremost among these would have been the problem of combining rather soft crayon drawings, which required a stone with a grained surface, with writing which, whether done directly on the stone or transferred to it, would have required a polished surface. There were several ways in which such a problem could have been resolved, though three single themselves out as being the most likely: first, the crayon drawings could have been printed separately from the pen and ink work; secondly, the crayon drawings and the pen and ink work could have been done on different kinds of transfer paper and then transferred to the same stones; thirdly, the stones could have been polished overall first and then given a grain in those parts that had to take crayon drawings. Of these three possibilities, the first approach can probably be ruled out for reasons of cost and the second on the grounds that transfer lithography was unlikely to pick up the range of tone and subtlety of Baltard's crayon work. The technique of giving a single stone different kinds of surfaces according to the type of work to be done on it is described in some nineteenth-century handbooks on lithography,[21] and seems to have been the most likely approach in this particular case.

21 See, for example, W. D. Richmond, *The grammar of lithography* (London, 1878), p.62.

The second of the two Alpine books to be discussed here is later in date than Baltard's book, and altogether less attractive in almost every respect. It was written and illustrated by the Vicomte Paul de Choulot, under the pseudonym Paul de Kick, and was published with the title *Huit jours au pas de charge en Savoie et en Suisse* (Chambéry, nd). The author's true identity is revealed on a list of his other publications on the final page of the book. It is a landscape format book and has its seventy-eight pages of text organized in two columns within key-line borders. It was published in yellow paper-covered boards and used the same pictorial title for both its title-page and front cover. Choulot's illustrations are all in crayon and, apart from six full-page plates, are integrated with the text. Some of them take the form of historiated initials and relate to the text to the extent of spelling the first letter of the opening word of a chapter. Though there was nothing new in this practice in book design generally, I cannot recall having seen it in other improper books produced by lithography. Though *Huit jours au pas de charge* was probably published a decade or so after Baltard's *Journal descriptif*, it may well have been produced by much the same means. Its printer was the local Savoie lithographer Jules Aubert et Cie of Chambéry, who defined his role at the foot of the

title-page and front cover as being responsible for both its litho-
graphy and 'Autographie'. It seems likely therefore that the trans-
fer process was used for at least part of the book's production.

The remaining books to be discussed in this chapter have their
texts even more fully integrated with their pictures. Indeed, most
of them are better described as picture books with legends. The
humorous books of the Swiss artist and writer Rodolphe Töpffer
form the largest group of such books. Töpffer was born in Geneva
in 1799, the son of a well-known painter of landscapes and genre
pieces. He too aspired to be a painter but, supposedly because he
had problems with his eyesight, he devoted himself to writing and
humorous drawing and also took up a post as a teacher of aesthetics
at the academy in Geneva. His short stories and idylls have been
described by Gombrich as among the gems of Swiss literature.[22]
Whatever the reasons may have been for his turning away from
painting as a profession, he continued to take an interest in
pictures and the medium of drawing. He used drawing as a means
of telling humorous stories and adopted a free, linear style of
working that was easily accommodated by transfer lithography.

Töpffer told his stories in books through a sequence of related
pictures and captions. Though he may not have been the very first
to have adopted such an approach to the telling of stories, he
appears to have been the first to have done so consistently in the
field of humour. And for this reason he is regarded as the father of
the comic strip. Töpffer is a figure with a considerable following
in his native Geneva, but it is Gombrich who has been largely
responsible for drawing the attention of the wider art historical
world to his importance.[23] Gombrich's interest in Töpffer lies
primarily in his contribution to caricature and in the way in which
he exemplifies certain approaches to picture making and picture
viewing. In particular, Gombrich has drawn attention to two
aspects of Töpffer's work which he believes to be important: first,
his recognition that an artist can rely on viewers to supplement
from their own experiences what is omitted from a drawing;
secondly, his systematic exploration of the ways emotions can be
expressed in the field of humour by modifying crucial human
features. Such important aspects of Töpffer's work cannot be
explored here, but Gombrich – with characteristic perception and
with no particular axe to grind – also pointed out that lithography,
because of its facility and cheapness, gave Töpffer just the oppor-
tunity he needed to publish his picture stories.

In the first instance Töpffer had no intention of publishing the
picture stories he drew, but the first of them was much admired
by Goethe who encouraged him to have it printed. Between 1833
and 1845 Töpffer published several of his picture books [198–202];
all were lithographed throughout and appear to have been pub-

[22] E. Gombrich, *Art and illusion* (London
and New York, 1960), p.337.
[23] For Töpffer, see particularly Gombrich,
Art and illusion, pp.336–342, 435, and
Oeuvres complètes de Rodolphe Töpffer
(Geneva, 1944).

198, 199. R. Töpffer, *Histoire de Mr. Jabot* (Geneva, 1833). Printed lithographically by J. Freydig, Geneva, from writing and drawings done on transfer paper by Töpffer. Page size 150 × 245 mm. [Cat. 1.213].

lished by him privately. Shortly before he died in 1846 he wrote a small pamphlet, *Essai de physiognomonie* (Geneva, 1845) – which was also lithographed throughout – in which he set out his ideas about story-telling through pictures. In it he discussed the importance of physiognomy in relation to the expression of emotions, and also referred to the value of telling stories through pictures. He claimed that picture stories speak with greater directness and conciseness to children and to the masses than do stories told through chapters, lines, and words. Töpffer's reference here to such graphic units of verbal stories is particularly interesting because it suggests that he probably approached the whole business of telling stories in a way that paralleled the segmental structure of verbal language.

Töpffer's humorous story books are all in landscape formats, which allowed him to present a sequence of picture units side by side more effectively than if he had adopted the more traditional upright book format. The earliest of his picture story books, *Histoire de Mr. Jabot* (Geneva, 1833) [198, 199] is printed on its rectos only, but his later books, *Histoire de Monsieur Crépin* (Geneva, 1837) and *Les Amours de Mr Vieux Bois* (Geneva, 1837), took greater advantage of the horizontal format by printing on both sides of each leaf [200–202]. This later approach gave him the opportunity to present a greater number of picture units on a spread and so allowed him to organize his stories, at least to some degree, in terms of double-page spreads. The usual pattern in these books is for four to six separate picture units to be shown side by side on a double spread, though occasionally a single picture fills each of the facing pages. The picture units are surrounded by thin borders, drawn in the same fluid line as the drawings themselves, and beneath each picture unit are a few lines of text written out in an informal hand. *Histoire de Mr. Jabot* has a pictorial title-page [198], but the other publications referred to eschew such formalities and launch straight into a preface. All Töpffers's lithographed books seem to have been drawn and written on transfer

200, 201. R. Töpffer, *Histoire de Monsieur Crépin* (Geneva, 1837). Printed lithographically by Frutiger, Geneva, from writing and drawings done on transfer paper by Töpffer. Page size 136 × 225 mm. [Cat 1.212].

202. R. Töpffer, *Les Amours de Mr Vieux Bois* (Geneva, 1837). Printed lithographically by Frutiger, Geneva, from writing and drawings done on transfer paper by Töpffer. Page size 135 × 225 mm. [Cat. 1.205].

paper, and most of them specifically state that this was the case by using the word 'autographie' in their imprints. All were initially printed in Geneva, the earliest ones by J. Freydig, the others by Frutiger (in the 1830s) and Schmi[d]t (in the 1840s). They appear to have been extremely popular and several of them were republished many times, sometimes in rather more prestigious forms than the original editions. For example, a reprint of *Histoire de Monsieur Crépin*, printed by Caillet in Paris, probably around 1860, has all its pages redrawn and printed on rectos only on heavy cartridge paper. In this form it loses much of the attraction of the unpretentious original edition.

Though Töpffers's books have been scrupulously catalogued by Suzannet,[24] they remain a bibliographical nightmare. Later editions of some of them were authorized by Töpffer, but many plagiarized editions and facsimile reprints were also published in the course of the nineteenth century. The first pirated edition seems to have been a version of *Mr. Jabot*, which was published by Aubert in Paris as early as 1839.[25] In the mid 1840s copies of most of Töpffers's story books were made by the German artist Bode for publication by J. Kessmann in Geneva and Bernhard Hermann in Leipzig. In the second half of the century copies and facsimile reprints of the original editions continued to be published in several countries. For example, plagiarized versions of *Monsieur Vieux Bois*, with the title *Adventures of Mr Obadiah Oldbuck*, were issued by two American publishers and by Tilt and Bogue in Britain. By the middle of the century three of Töpffers's stories had been translated into English.[26]

Töpffer's books have rather more in common with the humour of the twentieth century than they have with humorous publications of their own age. Gombrich referred to them as 'the innocent ancestors of today's manufactured dreams'[27] and maintained that 'Everywhere in these countless episodes of almost surrealist inconsequence we find a mastery of physiognomic characterization which sets the standard for such influential humorous draftsmen of the nineteenth century as Wilhelm Busch in Germany.'[28]

Much of the appeal of Töpffer's story books has to do with their apparently artless drawing, which only lithography among the mass printing processes could have catered for at the time. Because humour needs spontaneity to be effective, the freedom with which a draughtsman could work in lithography made it particularly suitable for such work. But it was not just that lithography allowed Töpffer to work freely with a common drawing instrument; it also allowed him to make his drawings and do his writing on transfer paper the same way round as they would appear when printed. This must have been very important for Töpffer. His method of

[24] A. Suzannet, *Catalogue des manuscrits livres imprimés et lettres autographes composant la bibliothèque de La Petite Chardière: Oeuvres de Rodolphe Töpffer* (Lausanne, 1943).

[25] Suzannet, *Catalogue*, 107.

[26] See D. Kunzle, '*Mr. Lambkin*: Cruikshank's strike for independence' in R. L. Patten (Ed.), *George Cruikshank: a revaluation* (Princeton, 1974), p.178.

[27] Gombrich, *Art and illusion*, p.336.

[28] Gombrich, *Art and illusion*, p.337.

presenting picture stories relied heavily on 'reading direction', both in the sequence of the frames and, less obviously perhaps, within the frames themselves. The only way to achieve a proper sense of direction using one of the other printing processes available at the time would have been to conceive the images in reverse at the outset, which would have been exceedingly difficult, or to conceive them the right way round and then draw them again back to front for production. Both these approaches would almost certainly have led to a loss of spontaneity. One wonders what would have been lost had Töpffer's little picture stories been engraved on wood throughout and, conversely, what *Alice's adventures in wonderland* might have looked like had the spirited drawings of Dodgson's original manuscript been done on transfer paper and printed lithographically?

Though Töpffer is generally credited with having developed the idea of the comic strip, some reference should perhaps be made to two earlier publications that have something in common with this genre. They are both humorous periodicals: the *Glasgow Looking Glass* (Glasgow, 1825), later called the *Northern Looking Glass* (Glasgow, 1825–26), and the *Looking Glass* (London, 1830–32). The earlier of these two publications [203] came out fortnightly from 11 June 1825, and changed its title after number 5. It continued to be produced lithographically up to and including number 8; thereafter it was produced by a combination of etching and letterpress until number 17 (3 April 1826) when it announced its discontinuation.[29] The publication consists of three or four folio pages an issue and referred to itself as a newspaper. All its numbers were printed and published by John Watson of Glasgow, who gave his address as 'Lithographic Press, 169 George Street'.

The *Looking Glass* published in London [204] used the same basic title as its northern namesake. This was a common enough title at the time, but the technical and stylistic similarities between the two periodicals suggests some kind of influence. The *Looking Glass* came out in monthly parts from January 1830 and was published by Thomas McLean. The history of its production is the reverse of that of its northern counterpart: its first seven numbers were etched by William Heath and printed intaglio, whereas all the later numbers were drawn on stone by Seymour, Doyle, and others and printed lithographically by Charles Motte. Each number consisted of four folio pages and, in common with many journals, copies for the year were bound up with a separate title-page.

Both these short-lived periodicals consist of numerous small sketches along with captions and other relatively short passages of text and, superficially at least, have something in common with the comic strip. In terms of design and production, however, they

[29] An alternative version of no.8 of the *Northern Looking Glass* was produced by etching. It is dated 26 Oct. 1825 and has similar illustrations on its first page to those in the lithographed no.8. It may therefore have been done in preparation for the changeover to etching in no.9.

203. *Glasgow Looking Glass* (Glasgow), vol.1, no.1, 11 June 1825. Printed lithographically by John Watson, Glasgow. Page size 390 × 265 mm. [Cat. 1.110].

204. *Looking Glass* (London), vol.1, no.9, 1 September 1830. Drawn on stone by Robert Seymour, printed by Charles Motte, London. Page size 397 × 270 mm. [Cat. 1.143].

relate much more to the tradition of the satirical print than they do to the improper book.

No discussion of humorous improper books would be complete without some reference to Lear's *Book of nonsense* [205–208], which was composed in the first place simply to amuse the grandchildren, nephews, and nieces of the 13th Earl of Derby, for whom Lear worked for a while as a natural history draughtsman. His *Book of nonsense* was originally published in 1846, and has probably been reprinted more often than any other lithographed book of the first half of the nineteenth century. Edward Lear was a highly skilled and meticulous zoological and topographical draughtsman. In his early years he worked as a lithographer and illustrated or produced plates for numerous publications, including his *Illustrations of the family of Psittacidae or parrots* (1830–32), which must stand as one of the finest achievements of natural history illustration in lithography. Lear's *Book of nonsense* falls into an altogether different category of work; his approach to lithography in it required little or no understanding of the subtleties of the process and is more in line with Töpffer's than it is with that of his other lithographed work.

205, 206. E. Lear, *Book of nonsense*
(2nd ed, London, *c.* 1855). Printed
lithographically, the limericks
transferred from type. Page size
135 × 195 mm. [Cat. 1.134].

There was an Old Man of Coblentz,
The length of whose legs was immense
He went with one prance
From Turkey to France,
That surprising Old Man of Coblentz

There was an Old Man of the Abruzzi
So Blind That he couldn't his foot see;
When they said, " That's your toe,"
He replied, " Is it so?"
That doubtful Old Man of the Abruzzi.

207, 208. E. Lear, *Book of nonsense.*
Details of 205 and 206. 207 shows a
well transferred limerick with no
retouching (45 × 85 mm); 208 shows a
poorly transferred limerick with
substantial retouching in the first
three lines (approx. 50 × 90 mm).

It is by no means clear what led Lear to use lithography for his *Book of nonsense*, or how he got his drawings on to stone. It is said that his original intention was to have the drawings engraved on wood, and that some wood-engravings were actually made from them.[30] But lithography, with the opportunity it offered for the integration of informal writing and sketches, was the obvious choice for the production of the printing surface; the use of wood-engravings and type in later editions merely serves to emphasize this point. It seems likely that Lear made his drawings and wrote out his limericks for the first edition on transfer paper. A letter of his survives from around 1833 in which he replied to a request for his opinion about some transfer paper by saying 'I understand nothing of that part of the art of Lithography.'[31] But a dozen years on he would have had plenty of time to learn about it.

The first edition of the *Book of nonsense* (London, 1846) was printed throughout in lithography and is a scruffy production. Nevertheless, it is a much prized collectors' item and Holbrook Jackson pointed out in his introduction to *The complete nonsense of Edward Lear* (London, 1947) that it was 'easier to find a *First Folio Shakespeare* than a first edition of *The Book of Nonsense*'.[32] In the first edition Lear's limericks were written out in italic capitals. In the second edition of around 1855, which was also printed lithographically, the limericks were transferred from type [205–208]. The transferring was done so badly on some pages that the stones had to be retouched, in some instances to the extent that whole words had to be hand-written on the stone. It may have been the use of the transfer process that led to the transposition of some of the limericks and drawings in this edition.[33] Subsequent editions were printed letterpress and lost some of the delightful naivety of the original publication. The decision to revert to more orthodox methods of letterpress book production may have been influenced by the need to cope with larger print runs as Lear's work became better known. But it is equally possible that notions of orthodoxy in book design, even in relation to such a book, may have persuaded the publishers to abandon all traces of the book's original means of production.

Shortly after the first edition of Lear's *Book of nonsense* was published, John Leighton, using his pseudonym Luke Limner Esq.,[34] produced at least four small landscape-format picture

[30] D. Bland, *A history of book illustration* (London, 1958), p.252.

[31] The letter, which is preserved in the archives of the Royal Society of Arts (B6/22 Lear), is undated. The transfer paper in question was developed by a Mr Cardano. In an earlier passage Lear wrote 'had I been at all accustomed to practise transferring I should have felt very glad to have given it [his opinion].' The letter was addressed to Arthur Aitkin of the Society of Arts and was referred to the Society's Committee of Polite Arts on 13 Mar. 1833.

[32] H. Jackson, *The complete nonsense of Edward Lear* (London, 1947), p.xxviii.

[33] See V. Noakes, *Edward Lear 1812–1888*, Royal Academy of Arts, exhibition catalogue (London, 1985), p.168.

[34] For a discussion of John Leighton, with special reference to his work as a designer of cases for books, see the chapter on him in D. Ball, *Victorian publishers' bindings* (London, 1985), and S. Pantazzi, 'John Leighton, 1822–1912: a versatile Victorian designer: his designs for book covers', *Connoisseur*, no.152, Apr. 1963, pp.262–273.

209, 210. J. Leighton [using pseud. of Luke Limner], *London out of town or the adventures of the Browns at the sea side* (London, *c.* 1847). Printed lithographically by Leighton & Taylor, London. The front cover (right) in tinted lithography, the double-spread (below) monochrome. Page size 110 × 142 mm. [Cat. 1.137].

books, three of which were published in London by David Bogue. They are all undated, but two of them are related by their subject matter to the Great Exhibition of 1851. The four are: *The Ancient story of the old dame and her pig*; *Comic. Art-manufactures*; *London out of town or the adventures of the Browns at the sea side* [209, 210]; and *The rejected contributions to the Great Exhibition*. Copies of the second and last of these little books are bound up together in the Victoria & Albert Museum Library and have the following manuscript inscription: '2 Brochures published in the dark ages of art about 1848 & 51 / Plates very much injured a few copies printed off prior to destroying them'. Both the tone and content of this inscription suggest that it was written by Leighton or by someone closely enough connected with the publications to be trusted. Three of these books are similar in style and consist of numerous small humorous sketches with captions or a

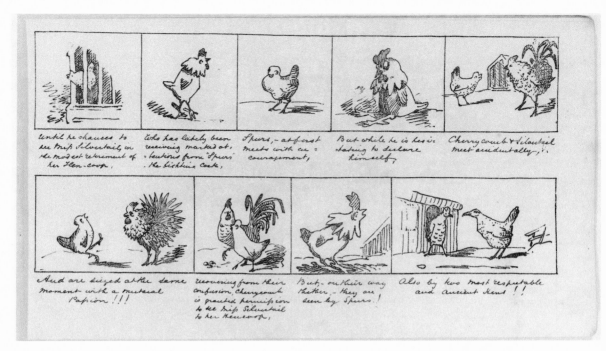

211. AMJ, *A page from the log of 'the Good Ship Nile' containing the only true account yet published of the lives loves & adventures of Cherrycomb & Silvertail*. Page size 128 × 248 mm. [Cat. 1.123].

written commentary, and have their drawings and lettering (which is in capitals throughout) very neatly executed. All four books carry a Leighton imprint (C. Blair Leighton, Leighton & Taylor, or Leighton Bros), and were printed on one side of the leaf only so that double spreads alternate with two blank pages throughout.

In addition to the books of Töpffer, Lear, and Leighton, other illustrated humorous books in small landscape formats (some with concertina folds) were printed by lithography in the middle of the nineteenth century [211]. It is almost as though the genre came to be associated with this kind of format. In the following decades similar humorous books were produced in larger formats, such as Atkinson's *Indian spices for English tables* (London, 1860) and G. Finch Mason's *Sporting sketches* (Cambridge & London, c. 1879) and *Country sketches* (London, c. 1881). But many such books are no more than collections of sketches and, because of their size and poorer quality drawing, are not nearly as attractive as earlier humorous books produced by lithography.

Though the books discussed in this chapter do not form anything like a homogeneous group in terms of subject matter, they are related by virtue of the fact that pictures were either their *raison d'être* or, at the very least, played an essential part in them. Some of the books discussed may have been produced lithographically simply because the process provided a cheap way of multiplying a few copies of an intended publication; but since others must be considered among the most prestigiously produced improper books, economy does not appear to have been the critical

DORA.

WITH Farmer Allan at the farm abode
William and Dora. William was his son,
And she his niece. He often look'd at them,
And often thought, "I'll make them man and wife."
Now Dora felt her uncle's will in all,
And yearn'd towards William; but the youth, because
He had been always with her in the house,
Thought not of Dora.

 Then there came a day
When Allan call'd his son, and said, "My son:
I married late, but I would wish to see
My grandchild on my knees before I die:

212. A. Tennyson, *Dora* (London, 1856). Illustrated by Mrs Paulet St John Mildmay. Printed lithographically by Vincent Brooks, London, the text transferred from type. Page size 515 × 390 mm. [Cat. 1.204].

213. T. Hood, *Miss Kilmansegg and her precious leg* (London, 1870). Illustrated by Thomas S. Seccombe, engraved by F. Joubert. Printed lithographically. Page size 200 × 150 mm. [Cat. 1.117].

factor in every case. In support of this view, it should be remembered that all the flower books referred to were diligently coloured by hand. Present-day attitudes to book production might lead us to believe that the opportunities offered by lithography for combining text and pictures on the same page was a deciding factor in the choice of the method of production for these books. But this too does not stand up to scrutiny since, apart from the books of Töpffer and Leighton, not many of these lithographed publications had their pictures and text integrated in the commonly accepted use of that term in book production.

So it seems that we must search for some additional reasons for the use of lithography for the production of these books. In many cases it looks as though lithography was chosen largely for the opportunities it offered the artist in terms of range of expression and control over the end product. As we have seen, books were often just a pretext for bringing together collections of pictures; some flower books and Grierson's *Twelve select views* can be considered in this light. In such cases, lithography seems to have been used because it allowed the artists concerned – most of whom were amateurs – to produce images of a kind that could not easily have been produced using any other process. By the same

token, transfer lithography allowed Töpffer to multiply his own spirited and apparently artless sketches better than any other process could have done. We should be unwise therefore to look for a single reason to account for the use of lithography in the books with pictures discussed in this chapter. All that can be stated here with some confidence is that in nearly every case it was the pictures, rather than the texts, that determined the choice of printing process.

The books discussed in this chapter do not bring the story of improper books with pictures to an end. In the second half of the nineteenth century, and on into the present century, such books continued to be printed lithographically, and possibly in greater numbers than hitherto. An outstanding book in this later period is an editon of Tennyson's poem *Dora* (London, 1856), which was illustrated by Mrs Paulet St John Mildmay and lithographed and printed throughout in brown ink by Vincent Brooks [212]. It is an extremely handsome large folio and has alternating leaves of text and illustrations, all set within oval floral borders.[35] Thomas Hood's well-known poem *Miss Kilmansegg and her precious leg* (London, 1870) [213], which was published by Moxon, provides a rare example of a lengthy book which was produced and sold through the normal trade channels of the time,[36] whereas M. A. Cooke's slight volume of *Poems* (Bordage, Guernsey, c. 1860), may perhaps serve as an example of the continuing tradition of the small-scale vanity book.

[35] Tennyson's *Dora* is a very unusual book in terms of production. The poem was transferred from type, and each page of text appears within the same floral border as the pictorial page that follows it (in the Grenville Library copy in the British Library the sequence of two of the pages is reversed). The same stone was used for each pair of pages and it is clear that the drawings within these oval borders must have been etched away with a very strong etch in order to clean the stone for the subsequent transfer of the poem. The evidence for this lies in the impression marks left in the paper as a result of the very deep etching of the stones and in traces of the illustrations that still survive near the borders. The whole process must have been extremely risky and would have called for considerable skills on the part of the printer.

[36] The first edition (London, 1869) was engraved and printed intaglio. See J. S. L. Gilmour, 'Some uncollected authors VII: Thomas Hood', *Book Collector*, vol.4, no.3, Autumn 1955, p.247.

Reprints of books and facsimiles of old documents

The possibilities offered by lithography for the reproduction of old documents, both printed and manuscript, were first realized by its inventor. Indeed, it could be argued that Senefelder came to understand the essence of his invention only after experimenting with making transfers from leaves of old books. He described in his treatise how he coated such leaves with a solution of gum arabic and then inked them carefully with a sponge charged with oil colour. He claimed that he could obtain fifty or more transfers from a leaf of paper by such means, though the images were, of course, in reverse of the original. His next step was to produce prints the right way round by treating one of the transfers in the same way that he treated the original leaf. And at this point in his narrative he pointed out that 'Old books could be republished in this manner easily and without great cost.'[1] He did not explore this particular line any further at the time, partly because he found paper to be too fragile, and partly because these experiments led him directly to discover the planographic branch of lithography. But the idea of making facsimiles of old documents continued to attract his attention, and in his treatise he included an example of

214. A. Senefelder, *Vollständiges Lehrbuch der Steindruckerey* (Munich and Vienna, 1818). Facsimile of part of a page from Fust & Schöffer's Psalter of 1457. Printed lithographically in red, blue and black by Senefelder. Image 143 × 220 mm.

[1] A. Senefelder, *The invention of lithography*, translated from the Munich edition of 1821 by J. W. Muller (New York, 1911), p.25.

a transfer from old printing type and a fine facsimile in colour of part of a page from Fust and Schöffer's famous Psalter of 1457 [214].[2]

In the course of the nineteenth century, several different techniques were used for making facsimiles of old documents by lithography. It might be helpful to consider them briefly at this stage, even though some have already been discussed elsewhere in this book. The main methods can be described very simply as follows:

1. The original document was traced and drawn in reverse with lithographic ink on to stone or a metal plate.

2. The original document was traced and then drawn the right way round with lithographic ink on to transfer paper so that the image could be transferred to stone or a metal plate.

3. Translucent transfer paper was laid on top of the original document, which was then traced with lithographic ink so that the image could be transferred to stone or a metal plate.

4. The original document was damped with gum water and then charged with lithographic printing ink so that its image could be transferred to stone or a metal plate.

5. The original document was photographed and its image exposed on a specially sensitized paper, which attracted and retained lithographic ink only on its exposed parts. The inked-up image was then transferred to stone or a metal plate.

6. The original document was photographed and the resulting negative exposed directly on to a specially sensitized stone or metal plate, which was then charged with lithographic ink.

The first of these was the traditional method of working in lithography and was not particularly appropriate for the production of facsimiles because it involved both an intermediate tracing stage and working back to front. The second had little to recommend it over the first since it too involved an intermediate tracing stage; and though it enabled the work to be done the right way round, there was always some deterioration of the image at the transfer stage. The third method was touched upon by Senefelder,[3] and was taken up by Joseph Netherclift and others in the 1820s. It had considerable advantages over the first two in terms of accuracy. It was probably the usual method for facsimile work before photography began to be applied to lithography in a serious way, and must have been widely used for the production of facsimiles of autographs of the kind discussed in the following chapter. The fourth method – which today seems not far removed from vandalism – had a chequered history, but was practised in France, at least experimentally, in the late 1830s and 1840s. The process rested on the antipathy of grease and water and worked only with documents printed in greasy ink; it was the only one of the six

[2] Both appear in the first edition of Senefelder's treatise, *Vollständiges Lehrbuch der Steindruckerey* (Munich & Vienna, 1818). Only the transfer from old printing type appears in the French translation, *L'Art de la lithographie* (Paris, 1819), and only the Fust and Schöffer detail in the first English edition, *A complete course of lithography* (London, 1819).

[3] First English edition (London, 1819), p.169–171; Muller translation of second Munich edition of 1821 (New York, 1911), p.145–148.

methods listed above that could not be applied to the production of documents written with ordinary ink. Photography began to be applied to lithography around 1850, but it was not until the fifth method was perfected around 1859–60 that photolithography (strictly speaking photozincography) was used for the reproduction of old documents. Though mechanical techniques for reducing and enlarging images were in use before the invention of photography, the development of photolithographic techniques opened up the possibility of making reproductions of documents that were different in size from the originals. Photolithography was such an important breakthrough in the production of reprints of books and facsimiles of old documents that it is discussed separately in Chapter 12.

Apart from the reproduction of autograph letters, facsimile work in lithography fell into few well-defined areas. As we have seen, the techniques used for making reprints and facsimiles were both numerous and varied. What is more, the range of work falling into this category is wide: in addition to autographs and autograph letters, it includes medieval books and charters, early printed books, contemporary journals, ancient inscriptions, and some kinds of drawings. But however hard this category of lithography may be to define, there can be little doubt that many lithographers were familiar with it. Several trade cards of lithographic printers survive that mention the services they offered in this field,[4] and some lithographers, notably John Harris, the Netherclifts, George Tupper, and C. W. Wing, seem to have specialized in it.[5] It was clearly a field in which lithographers felt that they had an edge over printers using other processes. The difficulty for the historian of printing is that, outside a few well-defined areas, lithographed facsimiles are thinly spread through a wide range of publications. In this and the following chapters we can do no more than touch on a few representative examples and point to some of the most important trends.

The pattern for facsimile work in lithography was established in Germany with two publications, both of which were printed by Senefelder in 1808. They were published in the period when Senefelder was in partnership with Johann Christoph Freiherr von Aretin, then Director of the Royal Library in Bavaria, and it is reasonable to suppose that these excursions into facsimile work were prompted by the opportunities offered by Aretin's position. One of these works was a nine-page facsimile of a piece of early

[4] Willich (1820), Whittock (c. 1825), Cartwright, Day & Haghe, Ingrey, and Rowe in the 1830s, Vacher and Wrightson in the 1840s, and Swinford Bros (c. 1850).

[5] For John Harris see an advertisement in the Great Exhibition Collection, Reading University Library, and R. Cowtan, *Memories of the British Museum* (London, 1872), pp. 334–38; for C. W. Wing see an obituary notice (8 May 1875) in the Linnean Society of London archives. Joseph Netherclift and his son, Frederick George, are discussed in Chapter 11, and Tupper in Chapter 12. See also Twyman, *Directory*, pp. 42 and 50.

215. J.C.F. von Aretin, *Über die frühesten universalhistorischen Folgen der Erfindung der Buchdruckerkunst* (Munich, 1808). Lithographed double-spread with hand rubrication, printed by Senefelder. Page size 255 × 200 mm. [Cat. 1.9].

216. Detail from the opening page of the book shown in 215.

printing which accompanied Aretin's paper *Über die frühesten universalhistorischen Folgen der Erfindung der Buchdrucker-kunst* (Munich, 1808) [29, 215, 216].[6] To give extra authenticity, the facsimile was printed on antique laid paper, which was not commonly used in lithography at the time as it tended to make printing that much more difficult. In the copy that I have seen, one page appears a little grey and on other pages there is some scumming up, but, in general, the printing looks good. The rubrication of the facsimile was added by hand as it would have been in the original. Though it is not known what methods were used for getting these pages on to stone, the general effect produced by the publication is extremely convincing and it must surely be considered the most effective facsimile of an early printed book yet published. Just over a decade later, Senefelder produced a selection of eight facsimile pages from the Fust and Schöffer Psalters of 1457 and 1459.[7] Most of these pages were printed in black, red, and blue, and among them is one with an initial 'B', a

[6] Winkler, *Lithographie*, 711:9. See also S. W. Singer, *Researches into the history of playing cards* (London, 1816), p. 158.

[7] *Duorum Psalteriorum Moguntinorum* (Munich, 1822); Winkler, *Lithographie* 536:17, 711:57.

portion of which Senefelder had already reproduced in his treatise of 1818 [214].

The other major facsimile work undertaken by Senefelder in this early period was *Albrecht Dürers Christlich-Mythologische Handzeichnungen* (Munich, 1808).[8] This book, which was published in seven parts, reproduces the set of forty-three marginal drawings Dürer produced for the Prayer Book of the Emperor Maximilian now in the Bayerische Staatsbibliothek in Munich. Each drawing occupies a separate page and the central part of each page, which carries the text in the original, is left blank. The drawings were sensitively copied on to stone by J. N. Strixner and were printed in a range of single colours to match those of the originals (though some copies were printed in black throughout). Preliminary pages of the book include a title-page, one or two portraits of Dürer (the number varies from copy to copy) and a foreword of two handwritten pages; but there was no text as such. The significance of this publication in the context of the development of lithographic facsimile work is that it was extremely influential. The first important publication of Ackermann's press in London, *Albert Durers designs of the Prayer Book* (London, 1817) [217] was a version of it and had drawings copied from those of Strixner. Another edition was produced by Stuntz in 1820 with prayers written out in a variety of scripts and languages in those areas that had been left blank in earlier editions. Further editions were published by Stöger in 1839 and 1845.[9]

Because they avoided the problem of reproducing text matter, the various editions of Dürer's marginal drawings for the Prayer Book of the Emperor Maximilian fall outside the mainstream of lithographic facsimile work. So too does a remarkable facsimile edition of the Italian sketch book of Inigo Jones [218, 219]. The original sketch book [220, 221], begun in Rome in 1614 and added to later, was acquired by the 4th Duke of Devonshire in the following century and is now preserved at Chatsworth. The facsimile edition was commissioned by the 6th Duke of Devonshire and was printed in a hundred copies, for private distribution to his friends, in 1831. Inigo Jones's sketch book consists of pen and ink studies of figures and drapery, made mainly from Renaissance works of art, with notes and observations about things he had seen. The facsimile had therefore to cope with two different kinds of work: drawings that were somewhat more difficult to reproduce than those of Dürer for the Prayer Book of the Emperor Maximilian, and freely written notes similar in kind to the autographs discussed in Chapter 11. The task of reproducing such work must have been a formidable one since Inigo Jones's sketches are very free in style and were drawn in an ink which varied in tone and – now at least – show through to the reverse of many leaves.

[8] Winkler, *Lithographie*, 831:12–14.
[9] Winkler, *Lithographie*, 831:15–16.

217. *Albert Durers designs of the Prayer Book* (London, 1817). Page with
marginal drawings by Dürer, engraved on stone by one of Ackermann's
draughtsmen after the German facsimile edition of 1808. Printed by
R. Ackermann, London. Image 287 × 198 mm. [Cat. 1.92].

218, 219. Lithographed facsimile of Inigo Jones's Italian sketch book. Printed by
G. E. Madeley, London (c. 1831). Page size 212 × 136 mm. [Cat. 1.126].

220, 221. Inigo Jones's Italian sketch book, begun in Rome in 1614 and added to later; now at Chatsworth. Page size 200 × 130 mm.

The lithographed facsimile of Jones's sketch book could hardly have done justice to the original, and a generation used to fine screen photolithographic reproduction will almost certainly find it wanting. Nevertheless, it has to be seen as an astonishing production for its period. It retains much of the spirit of the original, though rather more in the writing than in the drawing which, line for line, is not always very faithful. In a letter dated 22 December 1831,[10] which accompanied the copy presented by the Duke of Devonshire to the Society of Antiquaries, the Librarian at Chatsworth, Payne Collier, wrote that he was present while the lithographic work was being done. And he went on to remark that it gave 'an exact notion, externally and internally, of the original.'[11] What he must have meant by this was that the sketch book was reproduced in facsimile in virtually every respect. Not only was every page reproduced as faithfully as the methods of the period would allow, but blank pages were left between drawn pages and at the end of the volume to match the make-up of the original sketch book. In addition, the whole facsimile of 128 pages (which includes blanks) was bound in vellum in the manner of the original. Only a slight difference in size, which is referred to below, and a failure to match the laid paper and torn pages of the original, are obvious departures from an exact facsimile.

The printer of the facsimile – referred to by Payne Collier without naming him – was G. E. Madeley.[12] The imprint of this lithographic firm, which operated from 3 Wellington Street Strand, for about thirty years, is to be found at the foot of the first page of one of the three copies preserved at Chatsworth. Strangely it does not appear on the other two copies, though neither of them has been trimmed to a greater extent than the one with the imprint. This suggests that the imprint was removed from the stone after some proofs had been taken, possibly because it was felt to diminish the effect of the facsimile.

The original Inigo Jones sketch book and one copy of the facsimile edition are preserved together in a slip case at Chatsworth. This invites a comparison of the two and makes it obvious that they differ from one another in size. The page size of the facsimile edition is something like 10 mm deeper and 5 mm wider than that of the original. Similar differences are evident when comparing the sizes of the images on the pages. Such discrepancies stem from the use of transfer paper, which stretched when it was damped and pulled through the press face to face with the stone under considerable pressure. Images transferred to stone in this way would therefore have become larger than they were when originally copied on transfer paper by tracing over the original. The tendency for work done on transfer paper to stretch is remarked upon by at least one nineteenth-century writer on lithography.[13] The amount

[10] Printed in J. Martin, *Bibliographical catalogue of privately printed books* (2nd ed., London, 1854), pp.409–412.

[11] Martin, *Catalogue*, p.411.

[12] See Twyman, *Directory*, p.40.

[13] [Waterlow & Sons], *Every man his own printer; or, lithography made easy* (2nd ed., London, 1859), p.10.

of stretching in this facsimile appears not to have been consistent, and probably varied according to the dampness of the paper and the amount of pressure applied during the act of transferring. It may also have been modified at the printing stage as a result of using damp paper, which would have shrunk a little after printing as the paper dried.[14]

The earliest facsimile of a printed book to be produced in Britain by means of lithography was probably an edition of Pynson's *The solempnities and triumphes ... at the spousells and marriage of the Kings daughter the Ladye Mayre to the Prynce of Castile Archeduke of Austrige*. It was reproduced from the copy in the British Museum and printed by Ackermann, on behalf of John Dent, as a Roxburghe Club publication for 1818 [222, 223].[15] Judg-

222. Facsimile of *The solempnities and triumphes ... at the spousells and marriage of the Kings daughter ... to the Prynce of Castile*. Lithographed after Richard Pynson's early sixteenth-century publication. Printed by R. Ackermann for the Roxburghe Club, 1818. Page size 238 × 185 mm. [Cat. 1.181].

223. Detail of 222, 28 × 43 mm.

[14] For a discussion of the discrepancy between the size of an image on a stone and the print taken from it, see M. Twyman, 'Thomas Barker's lithographic stones', *Journal of the Printing Historical Society*, no.12, 1977/78, tables 1, 2, and pp.7, 9.

[15] N. Barker, *The publications of the Roxburghe Club 1814–1962* (Cambridge, 1964), 23.

ing by the edition sizes of other Roxburghe Club publications of the time,[16] it can be assumed that no more than fifty copies were issued. The book is a slim volume and consists of letterpress preliminary material followed by the fifteen-page facsimile of Pynson's early sixteenth-century publication, all printed lithographically on eight leaves of heavy wove paper. The facsimile includes a woodcut on its first page and Richard Pynson's printer's device on the last. It is impressively printed, particularly when judged by the standards of British lithography of the period. Its pages back up well, and so too do the individual lines of type; its ink is richly black, and the edges of its printed marks are clean. In many ways this Ackermann production is comparable in quality with the very similar kind of facsimile which Senefelder printed ten years earlier for Aretin's paper.

Even before he printed this Roxburghe Club publication, however, Ackermann's mind must have turned to the possibility of using lithography for facsimile work. The evidence for this is

224. [Rarekes, H.], *Algemeene ophelderende verklaring van het oud letterschrift, in steenplaatdruk* (Leyden, Deventer, Groningen, 1818). Lithographed folding plate, 290 × 230 mm.

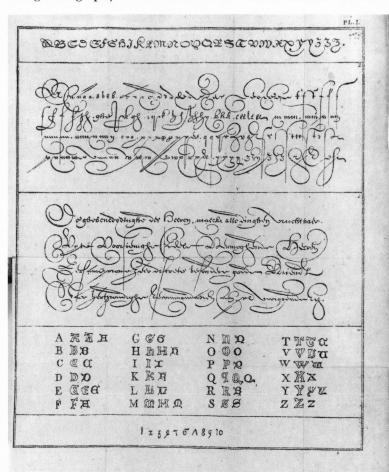

[16] Lowndes, *Bibliographer's manual* (1864), Appendix, p.2.

225. A Champollion, *Paléographie des classiques latins* (Paris, 1839). Lithographed plate printed in black, with hand-colouring on the letter R. Image 213 × 121 mm.

provided by a folding facsimile of a page from a Bodleian Library manuscript, the Codex Laudanus, which was included in the issue of the *Repository of Arts* for June 1817, along with a note commenting on the suitability of lithography for this kind of work.[17]

More significant than this single Ackermann plate as an indication of future developments in the making of lithographic facsimiles of documents is a Dutch book on palaeography, which was published a year later: [Hendrik Rarekes] *Algemeene ophelderende verklaring van het oud letterschrift, in steenplaatdruk* (Leyden, Deventer, Groningen, 1818) [224]. This octavo book presents as its *raison d'être* forty-eight lithographic facsimiles of handwriting from medieval times to the seventeenth century, which are transcribed and commented on in letterpress notes. The facsimiles are grouped on seventeen folding plates, which are gathered together at the rear of the volume after the letterpress text. They give the impression of being faithful facsimiles, and a passage in the introduction to the book stresses their accuracy, even to the point of reproducing ink blots, and reveals that they were made by means of translucent transfer paper.[18] They were capably printed, but unfortunately there is no way of identifying their printer.[19] The book certainly justified Ackermann's views about the suitability of lithography for making facsimiles of documents; moreover, it demonstrated the capabilities of the emergent process for such work and established a pattern for palaeographical books later in the century. Its use of the old Dutch word for lithography, *steenplaatdruk*, serves to draw attention to the forward-looking nature of the publication. A typical example of a later book which makes use of lithography for facsimile work is A. Champollion, *Paléographie des classiques latins* (Paris, 1839) [225]. It is more prestigious than the Dutch book in every respect, and by the time it was published the reproduction of old documents had become a small but identifiable area of the lithographic trade. In addition to such palaeographical works, countless biographical and historical books were published in the first half of the nineteenth century with occasional plates of documents reproduced by lithography.

The next impetus to the reproduction of old documents came in the 1830s when attempts were made to transfer images from early printed books to lithographic stones. These processes may not have developed much beyond the experimental stage, but they deserve to be mentioned for several reasons: first, they attracted a good deal of attention in the late 1830s in France, particularly in the pages of the trade journal *Le Lithographe*; secondly, they demonstrated the need for an accurate means of providing copies of old documents before photography could be used for this purpose; thirdly, some complete books were produced by such

means; and, fourthly, the methods used were both remarkable and, judged by present-day attitudes to conservation, barbaric.

Transferring images from old documents attracted most attention in France, where it was seen as a branch of *typolithographie*, which in turn was seen as the sibling of *chalcolithographie*. *Typolithographie* involved the transfer of letterpress prints to stones or plates, *chalcolithographie* the transfer of engraved prints. The words appear to have been coined by Jules Berger de Xivrey in a paper read to the Académie royale des Sciences, Belles-Lettres et Arts de Rouen in 1836.[20] In theory, transfers could be taken from both relief and intaglio prints, whether the item concerned had just been printed and had ink that was not yet dry, or whether it had been printed centuries before. Transferring images from freshly printed documents presented no real problems and became a regular branch of lithography all over Europe, but transferring images from old printed documents presented much more of a challenge.

The branch of *typolithographie* that was concerned with the reproduction of old printed documents became a central interest of several French lithographic printers and was practised by some of them in the late 1830s and 1840s. The process was as follows. The document to be copied was first thoroughly damped; it was then charged with greasy lithographic printing ink so that the ink adhered to the printed parts of the original, but not to the blank parts that had absorbed the water. The principle underlying the process was identical to that of lithography itself, though it has to be said that the practice appears to have been a good deal more critical than straightforward lithography. The original document, inked up in this manner, was then placed face down on to a stone, washed on the back with dilute nitric acid, and pulled through the press under pressure. The process stemmed from Senefelder's discovery that it was possible to take fifty or more copies from a leaf of an old book by moistening it with gum water and charging it with ink before each impression. It was this process that led Senefelder to the discovery of lithography, so in one sense transferring images from old documents can be said to be as old as, if not older than, lithography itself. In his treatise, Senefelder mentioned the transferring of leaves of old books to stone almost in passing, and made no mention of it at all in the English edition published in 1819. It is scarcely surprising, therefore, that it attracted little attention among lithographers at first. But though neglected for a time, it was never entirely forgotten. In 1834 the Société d'Encouragement offered a prize for the 'transport des anciennes gravures sur la pierre lithographique' to take effect from 1836.[21] And in the same year (1834), Ch. d'Aiguebelle exhibited a transfer from an old

[20] 'Sur les premiers essais de la Typo-lithographie et de la Chalcolithographie', 20 May 1836; see *Le Lithographe*, vol.2, 1839, pp.183–191, 251–254. See also A. Jammes, *Typographie, histoire du livre, bibliographie*, cat.249 (Paris, 1985), no.1159 (item 5).

[21] *Le Lithographe*, vol.2, 1839, p.315, n.2.

book of 1590 at the Exposition des Produits de l'Industrie at Paris, for which he was awarded a silver medal.[22]

Later on in the 1830s transferring old documents to stone became an extremely topical issue in France and was the subject of a lot of public bickering over the question of priority. Several French provincial printers, Berdalle de la Pommeraye of Rouen, Châtenet of Angoulème, and Auguste Dupont of Périgueux, all claimed the process for themselves. Their rivalry led to the production of a long report on the subject by J.-J. Delalande, which was printed in successive numbers of *Le Lithographe* during 1839.[23] In turn, this opened the way for editorial comment and correspondence on the subject. Eventually, the question of the relative effectiveness of the different methods used by lithographers for transferring images from old books and prints to stone – though not the question of priority – was resolved by a competition which involved extraordinary acts of bibliographical cannibalism. Details of the competition are difficult to disentangle from the long account in *Le Lithographe*, but it seems that it was organized by the Jurors of the Exposition des Produits de l'Industrie of 1839. Three old books, among them such venerable productions as the Nuremberg Chronicle and a book of hours printed by Simon Vostre, were made available to the competitors, who were to detach a leaf from each to use as a test piece. The competition was intended to be by invitation only, but was kept open as a result of a petition from a large number of Parisian printers. Twenty lithographers are recorded as having taken part, including such well-known firms as Engelmann, Kaeppelin, and Thierry *frères* and two of those involved in the dispute, Auguste Dupont and Châtenet. The outcome was that the silver medal was awarded to the brothers Auguste and Paul Dupont, a bronze medal to Châtenet, and an honorable mention to Jacotier.[24] In arriving at their verdict, the Jurors considered the likely applications of the process and concluded that it would have particular value for making good the missing pages of defective volumes. In 1839 the Duponts took out a patent for their process which they called – somewhat confusingly – *lithotypographie* (rather than *typolithographie*).[25] And at about this time they announced that they had set up a special studio for transferring old books and prints to stone.[26]

What was actually produced in France by means of *typolithographie* while these squabbles were going on is hard to work out. *Le Lithographe* published three specimen plates in its volume for 1839 to illustrate the various notices on the subject that appeared in its pages. One of these plates was a re-transfer of the specimen Ch. d'Aiguebelle had exhibited in 1834; another was a page from an edition of the Idylls of Theocritus, originally printed in Venice

[22] *Le Lithographe*, vol.2, pp.181–182; vol.3, 1842, p.66 (first pagination).

[23] *Le Lithographe*, vol.2, pp.183–191, 205–220, 234–254, 274–287, 300–316. The report was originally published in the journal of the Société Libre d'Émulation of Rouen.

[24] *Le Lithographe*, vol.3, 1842, pp.77–84.

[25] Dupont *frères*, 'Pour un procédé de lithotypographie', no. 11633, 23 Dec. 1839.

[26] *Le Lithographe*, vol.2, 1839, p.265.

226. Specimen of *lithotypographie*.
Produced by Auguste Dupont from
a page of an edition of the Idylls of
Theocritus, printed in Venice in 1539.
The specimen was published in *Le
Lithographe*, vol.2, 1839. Image
125 × 71 mm.

in 1539 and reprinted by Auguste Dupont [226]; and the third, and
most impressive, was the competition piece of Auguste and Paul
Dupont [227]. This was a reproduction of a leaf from the life of
Scanderbeg, printed in Augsburg in 1523, which consisted of both
woodcuts and text matter. The lithographed facsimile was printed
on both sides of the paper and had to be folded to fit into the octavo
format of the journal. It is impressive in its general effect, but there
is a softness to the edges of its marks that distinguishes it from
lithographic facsimiles drawn by hand with a brush or pen. Such
a defect may perhaps explain why the Jurors thought fit not to
award the Duponts a gold medal.

For all the limitations of their competition piece, the Duponts
went on to make use of their process commercially and are known
to have produced reprints of whole books by means of *lithotypo-
graphie*, some of them very substantial publications. As early as
1839 an editorial comment in *Le Lithographe* welcomed the initia-
tive taken by the Duponts who, it was claimed, 'already sell
through the book trade not single experiments but complete
volumes.'[27] It is difficult to disentangle the contributions that the
two Dupont brothers made to the development of *lithotypo-
graphie*, but it seems that Auguste Dupont pioneered the work at
his press at Périgueux, and that Paul Dupont became the major
user of the process later on. The two men's names were usually
linked when the process was discussed in contemporary
accounts,[28] and Paul Dupont was meticulous in acknowledging
the contribution made by his brother, both in his imprints and
when he came to write about the process. In his book on printing,
published in 1849, he gave Auguste credit for the development of
lithotypographie, though he also pointed out that it had been
perfected in his own workshops in Paris.[29] He went on to refer to
three major works that had been reprinted by means of the process.
Two of these have been traced: one was printed by his brother in
Périgueux in 1842, the other by him in Paris in 1847.

These two publications are the outstanding examples of the
early use of lithography for reprinting old editions. Though the
later publication is considerably larger in scale than the earlier
one, both have to be seen as major undertakings. And in terms of
quality both compare very favourably with the earliest facsimile
reprints produced by photolithography, the first of which were
then some twenty years away. On a number of accounts, therefore,
they deserve to be considered among the more important examples
of lithographic book production of the first half of the nineteenth
century.

The earlier of the two was printed in Périgueux by Auguste
Dupont in 1842: *L'Estat de l'église du Périgord, par le R.P. Jean
Dupuy récolet* [228–236]. The original letterpress edition of this

27 *Le Lithographe*, vol.2, 1839, p.317.
28 The patent for *lithotypographie* was
taken out in the names of Dupont *frères*
(see above, note 25) and the silver medals
of the Exposition des Produits de l'Indus-
trie of 1839 and of the Société d'Encourage-
ment of 1842 were awarded to them
jointly.
29 P. Dupont, *Essais pratiques d'imprim-
erie* (Paris, 1849), p.38.

227. Specimen of *lithotypographie*. Produced by Auguste and Paul Dupont's process from a leaf of an edition of the life of Scanderbeg, printed in Augsburg in 1523. The specimen was published in *Le Lithographe*, vol.2, 1839, on both sides of a folding leaf. Image 260 × 155 mm.

L'ESTAT

DE L'EGLISE

DV PERIGORD,

DEPVIS LE CHRISTIANISME,

PAR LE R. P. JEAN DVPVY RECOLLECT.

A PERIGVEVX,

Par PIERRE & JEAN DALVY Imprimeurs,
& Marchands Libraires. 1629,

AVEC APPROBATION.

228. Lithographed facsimile edition of Dupuy, *L'Estat de l'église du Périgord*, after the original printed in Périgueux in 1629. Reproduced by *lithotypographie* by Auguste Dupont in Périgueux in 1842. Title-page printed in red and black. Page size 253 × 192 mm. [Cat. 1.90].

229. Lithographed facsimile edition of *L'Estat de l'église du Périgord*. The notes to vol. 1 transferred from newly-set type. Page size 253 × 192 mm.

230. Detail of 229. 23 × 29 mm.

book was printed in 1629 by Pierre and Jean Dalvy in one volume, though its two parts were separately paginated. The lithographic reprint of it was published as a two-volume work with separate title-pages and extensive critical and historical notes by the Abbé Audierne. The imprint to the facsimile editon tells us that the book was 'Reproduit par le procédé Auguste Dupont en 1842' and that it was published by Baylé, a bookseller in Périgueux. In his preface, the publisher pointed out that the book had become very rare and that the reprint was made from a copy in good condition which he owned. The notes to the first volume were transferred from type and printed lithographically [229, 230], whereas those to the second were printed letterpress. The reason for Auguste Dupont's reverting to traditional methods of book production must surely have been economic, since the notes were well enough printed in the first volume and are by no means easy to distinguish from the letterpress ones that appear in the second. Apart from this small portion of the book that was printed from type, the rest, which amounts to over 500 pages, was printed lithographically.

Both volumes of the reprint edition have a two-colour (red and black) title-page [228]. The remaining pages [231, 232] include such features as decorated initial letters, rows of printers' flowers, and marginal notes, all contained within a single-line border. It is not clear whether this border indicates the edges of rather closely cropped pages, or whether they were printed like this in the original edition.[30] Overall, the reprint seems to capture the feel of a seventeenth-century book remarkably well, except in regard to

[30] Dupont refers to the volume as being octavo (*Essais pratiques*, p.39), which suggests the former. Unfortunately I have not been able to trace a copy of the original publication.

231, 232. Lithographed facsimile edition of *L'Estat de l'église du Périgord*. Page size 253 × 192 mm.

233. Detail of 232. 13 × 29 mm.

its paper, which is a thin wove with a mechanical feel to it. It is only on closer inspection that the limitations of *lithotypographie* are seen. In common with many photographic line reproductions of early letterpress printing, it accentuated those accidental distortions to letterforms that arose from printing on hand-made paper [234]. In particular, terminals and internal shapes of letters became rounded, thin strokes disappeared, and heavy areas fattened up. Types printed in small sizes and italics appear to have presented a special problem. Some pages of the book did not reproduce at all well, and many stones were touched up by hand, particularly in those parts with italics, flowers, and decorated initial letters. Some of these parts of the reprint include marks that could not possibly have derived from typefounding or woodcutting. On some pages (for example, at the foot of page 51 [236]) whole lines of italic were written in by hand on the stone. On other pages it can be seen that the writing of occasional words does not quite coincide with a ghostly transferred image. But such modifications

234. Detail of roman type from the lithographed facsimile edition of *L'Estat de l'église du Périgord* (vol.1, p.95) showing the accentuation of features of letterpress printing through the use of the process of *lithotypographie*. 23 × 29 mm.

235. Detail of italic type from the lithographed facsimile edition of *L'Estat de l'église du Périgord* (vol.2, p.12) showing a successful use of the process of *lithotypographie*. 23 × 29 mm.

236. Detail of italic type from the lithographed facsimile edition of *L'Estat de l'église du Périgord* (vol.2, p.51) showing parts of the text written out by hand, presumably because the process of *lithotypographie* failed to work properly. 23 × 29 mm.

to the process of *lithotypographie* are noticed only when looking through a glass. Though this edition of *L'Estat de l'église du Périgord* may fall short of the highest standards of early photo-lithographic reprint work, its quality must surely come as a surprise to those who have done no more than read accounts of Auguste and Paul Dupont's remarkable process.

Much larger in scale and even more impressive in its effect than *L'Estat de l'église du Périgord* is a reprint of volume 13 of *Recueil des historiens des Gaules et de la France* [237, 238]. This was produced by Paul Dupont in Paris in 1847. The whole publication was a mammoth undertaking, running to twenty-four folio volumes and spanning the period 1738 to 1904. Volume 13 was originally published in 1786, its printer being Philippe-Denis Pierres, First Printer in Ordinary to Louis XVI. According to Paul Dupont, sheets of this volume were destroyed in a fire,[31] which meant that many sets of the publication were not complete. The imprint of the reprint of volume 13 states that it was produced at the lithographic press of Paul Dupont and 'Réimprimé par le Procédé Litho-Typographique de MM. Paul & Auguste Dupont.'. Elsewhere, Paul Dupont claimed that fifty copies of it were printed and that they sold for 150 francs, compared with the 600 to 800 francs which the original edition then fetched at sales.[32]

Unlike *L'Estat de l'église du Périgord*, the whole of the reprint of volume 13 of *Recueil des historiens des Gaules et de la France* was lithographed; what is more, it involved considerably more work than Auguste Dupont's earlier reprint. The copy I have seen at the British Library has a page size of 425×270mm and was printed on laid paper. It has a two-colour (terracotta and black) title-page, which matches the others in the series, and runs to close on a thousand pages. Superficially it may not seem as well printed as *L'Estat de l'église du Périgord*, since its characters are not very sharp at their edges [238]; but it relies far less on hand-touching and is actually a much more faithful facsimile than the earlier publication. Though nothing is stated about the production of the book other than on its imprint page, Paul Dupont's claim to have perfected the process in his Paris works[33] seems to have been thoroughly borne out by it. The transferring of the original text to stone appears to have been most successful; it shows little of the kind of distortion to letterforms discussed above in relation

[31] *Essais pratiques*, p.39. The catalogues of the Library of Congress claim that copies of the original volume 13 were destroyed during the French Revolution. Though the two explanations are not mutually exclusive, it is hard to understand how one volume alone came to be destroyed during the Revolution, unless it was in production at the time. By virtue of his position of First Printer in Ordinary to Louis XVI, Pierres was more at risk than other printers but, even so, it is unlikely that a book with the publication date 1786 would still have been in the course of production when the Revolution began three years later.

[32] *Essais pratiques*, p.39. In a *Notice concernant l'établissement typographique de M. Paul Dupont* (Paris, 1851), p.30, Dupont gives the edition size as 100.

[33] *Essais pratiques*, p.38.

237. Facsimile of vol. 13 of *Recueil des historiens des Gaules et de la France,* after the original volume printed by Philippe-Denis Pierres in 1786. Reproduced by Paul Dupont in Paris in 1847. Page size 425 × 270 mm. [Cat. 1.182].

238. Detail of 237. 45 × 73 mm.

239. M.Baudier, *Histoire de l'incom-
parable administration de Romieu*
(Paris, 1635). Letterpress. This book
was reproduced in *lithotypographie*
by Paul Dupont, but no copy has been
traced. Page size 146 × 90mm.
[Cat. 1.17].

34 *Essais pratiques*, p.39.
35 *Essais pratiques*, p.39.

to the book printed by his brother, and the capital letters in
particular retain their integrity as types. The presswork is even in
colour, unprinted parts are clean, and the type areas back up well.
As a comparison with the letterpress volumes of the series reveals,
the production is staggeringly convincing for facsimile work of the
period. It is entirely understandable, therefore, that Dupont chose
to show it at the Great Exhibition of 1851 and that it is erroneously
described in the catalogues of the British Library as a photolitho-
graphic reprint.

The whole series of *Recueil des historiens des Gaules et de la
France*, which is a major source book for French history, was
issued again from 1869. Some of the volumes for this edition
including volume 1, were printed lithographically. Whether these
volumes were produced by means of *lithotypographie* or by the
newly-developed methods of photolithography is not known, but
it has to be said that they compare most unfavourably with
Dupont's 1847 production.

The third book Paul Dupont referred to as having been produced
by *lithotypographie*[34] was Michel Baudier, *Histoire de l'incompar-
able administration de Romieu*. This book was a reprint of what
Dupont thought to have been a unique copy of the 1635 edition in
the possession of the Romieu family. Dupont claimed that copies
of the reprint 'do not differ at all from the original volume',[35] but
no copy has been traced for this claim to be put to the test.
However, the original edition, which is a 16mo of only 84 pages
[239], suggests that it presented much less of a challenge than the
two publications discussed in detail above.

Similar processes to *typolithographie* / *lithotypographie* were
adopted in Germany and Britain. Precise details of them have not
yet been established, but there was undoubtedly a link between
the use made of transfer lithography for facsimile work in the
two countries. Early in October 1841 the British journal the
Athenaeum received from its correspondent in Berlin a reprint of
four pages of the issue of the journal for 25 September of that year.
The correspondent knew little about its means of production, but
the *Athenaeum* assumed that it must have been produced by
lithography. The editor offered to exhibit copies of it at the
journal's Wellington Street office in London so that the facsimile
could be compared with the original letterpress version, and had
this to say about it in the issue for 4 December 1841:

> The copy was so perfect a facsimile, that had it reached us
> under other circumstances, we should never have suspected
> that it had not been issued from our own office – and even
> with our attention thus specially directed to the subject, the
> only difference we could discover was, that the impression
> was lighter, and that there was less body in the ink; from

which we infer that the process is essentially lithographic, the impression of the original page being, in the first instance, transferred by some means on to the surface of the stone or zinc plate. This, however, is but a conjecture, and our correspondent is unable to throw light on the subject.[36]

Part of the correspondent's letter was printed in the *Athenaeum*. From this we learn that the process by which the facsimile was produced was discovered by 'a gentleman at Erfurt', that it was 'kept a profound secret', and that a thirteenth-century Arabic manuscript and a leaf of a book printed in 1483 had been produced without the slightest injury to the originals. We further learn that those in possession of the secret intended to republish numbers of the *Athenaeum* in Berlin on a regular commercial basis, beginning with the first number for 1842. The editor of the *Athenaeum* put on a brave face and claimed not to have been worried by the threat of such a facsimile edition to his overseas sales, but it is not without reason that his comments appeared in the *Athenaeum* under the heading 'Printing and piracy – new discovery'. He expressed particular concern for book publishers, and especially those producing illustrated books which involved high origination costs. In this context he revealed that plans were afoot to produce a facsimile edition of Knight's *Shakspere*, the parts of which were to sell at sixpence each.

This may well have been the first occasion on which questions of principle relating to facsimile work had been raised. The main question related to international copyright and provided a foretaste of the problems that arose in the twentieth century with the explosion of reprint publishing by means of photolithography. In anticipation of the problems associated with facsimile publishing of the kind announced in Berlin, the *Athenaeum* called upon the British Government to 'take active measures for the establishment of some international law for the protection of the honest men of all nations'.[37] What happened in the short term is not known.[38] Nor has any evidence come to light as to whether those in possession of the gentleman of Erfurt's secret actually produced further facsimiles of the *Athenaeum* or went ahead with their plans for Knight's *Shakspere*. Surviving work of the period produced by similar processes suggests that such projects would not have been as easy to see through the press successfully as may have been thought.

The process used for the facsimile pages of the *Athenaeum* was introduced to Britain by the German engineer William Siemens in 1844 and given the name 'Anastatic printing'. Siemens came to England in March of that year, hoping to exploit both his newly-invented Chronometric Governor and this printing process. In his biography of Sir William Siemens, written towards the end of the

[36] 'Printing and piracy – new discovery', *Athenaeum*, no.736, 4 Dec. 1841, p.932.

[37] *Athenaeum*, no.736, 4 Dec. 1841, p.932.

[38] According to a note in a later number of the *Athenaeum* (no.899, 1845, p.71) the facsimile sent from Berlin was submitted to the commissioners appointed to enquire into Exchequer Bill forgeries 'in proof of the difficulty of guarding against fraud by any mere typographical arrangement.'

nineteenth century, Pole tells us that Siemens learned about the new printing process in Berlin from its inventor, Mr Baldamus, who originally lived at Erfurt.[39] That this was the 'gentleman at Erfurt' referred to in the *Athenaeum* in 1841 is confirmed by a note in the same journal four years later, where he is referred to as Baldermus.[40] Siemens and his younger brother joined Baldamus in a business venture and, in particular, helped by designing a powered printing press for use with the new process.[41] On arriving in England, Siemens was introduced to a London civil engineer, Joseph Woods, who agreed to work with him in promoting both the Chronometric Governor and the printing process. Woods took out patents in Britain for both inventions, the one for anastatic printing being taken out on 6 June 1844 (no. 10219). Siemens did his best to promote the process and was assisted throughout by a former workman of Baldamus, Rudolph Appel, who had been brought over from Germany specially for this purpose. Experiments were made with presses, particularly with a self-acting steam press, and these were put in the hands of two firms, Easton & Amos of Southwark and Ransome & May of Ipswich.[42] But things did not go too well, and on 30 December 1846 Siemens was forced to write to Appel that the premises would be closed in the middle of the following month. Despite the fact that Faraday thought the process important enough to give an evening lecture on it to the Royal Institution on 25 April 1845,[43] anastatic printing failed to get off the ground commercially at this stage. As we have seen in Chapter 4, Rudolph Appel used the process on his own account at a later stage and included Sir Thomas Phillipps among his customers.

The word anastatic was given to the process by Edward Woods, the brother of Joseph Woods in whose name the patent was taken out;[44] it derives from the Greek and means 'of the nature of revival'. In terms of its broad objectives and scope it was more or less identical to what the French called *typolithographie* or *lithotypographie*. The major difference was that instead of stones it made use of zinc plates, which had the advantage that they could, if necessary, be wrapped around cylinders and fitted to steam-driven machines. Wood's anastatic patent covered the transferring of freshly printed images as well as leaves from old books and prints; it also covered the taking of transfers from drawings made with special ink on transfer paper (though there was nothing

[39] W. Pole, *The life of Sir William Siemens* (London, 1888), p.55.

[40] *Athenaeum*, no.899, 1845, p.71.

[41] For Siemens's connection with anastatic printing, see especially Pole, *Siemens*, pp.54–58, 60.

[42] The ledgers of the firm of Ransome & Co. in the Institute of Agricultural History of the University of Reading confirm that drawings were made for 'Wood's Anastatic Press' (no.8800) and for a hand printing press (no.8801). The drawings themselves

no longer survive.

[43] See F. W. Stoyle, 'Michael Faraday and Anastatic Printing', *British Ink Maker*, Nov. 1965, pp.46–51.

[44] Pole, *Siemens*, p.55 n.

whatsoever new about this beyond the fact that the images were to be transferred to zinc). To obtain impressions from leaves of old books and prints by Wood's patented process, the original document had first to be prepared chemically so as to free the oily particles that had to be transferred to the zinc.

The anastatic process has attracted considerable attention in Britain in recent years, but it was really no more than an identifiable and known branch of lithography. There was certainly nothing so special about it as to warrant its separation from similar lithographic processes in use on the continent at much the same time and, in the case of France, somewhat earlier. The anastatic process was new to Britain only in that it involved special techniques for making facsimiles from old printed documents using the transfer method. Paradoxically, while it was taken up widely for the transfer of specially-made drawings, as in the publications of the Anastatic Drawing Society, it does not appear to have been used at all commercially for the purpose which gave its name to the process – the printing of facsimiles of old documents.

Philip De la Motte, who wrote a little book called *On the various applications of anastatic printing and papyrography* (London, 1849), introduced the word papyrography to cover the transferring of drawings made with special ink or crayon to a lithographic stone or plate. He noted that the reprinting of old impressions seemed at first to have been the most useful part of anastatic printing, but that the original expectations had not been realized because of the uncertainty of the chemical operations involved with it. Often, he claimed, the original was destroyed without even producing a copy.[45] British lithographers had little success with the process of making facsimiles by transferring leaves of old books, and no facsimile books appear to have been produced by such means in Britain. It is probably a measure of the superiority of French lithographers at this time that they could make the process work whereas British lithographers could not.

[45] De la Motte, *Anastatic printing*, p.4.

CHAPTER 11

Facsimiles of autographs

240. Facsimile of a letter from Henri IV to the Marquise de Verneuil. Folding plate from G. Engelmann, *Manuel du dessinateur lithographe* (Paris, 1824). The same plate appeared in the first edition of 1822. 280 × 205 mm.

This chapter focuses attention on one specific category of facsimile lithography, the production of collections of autograph letters written by distinguished or notable people. Lithography became the recognized method for reproducing such items in most of the leading countries of Western Europe from the mid 1820s onwards, and many writers of lithographic treatises of the first half of the century included facsimiles of handwritten documents to illustrate the capabilities of the process for this kind of work. Even Engelmann and Hullmandel, whose treatises were primarily directed at artists, chose to include plates of this kind: Engelmann reproduced a letter from Henri IV to the Marquise de Verneuil [240] and Hullmandel a set of examples of handwriting by Napoleon and others.[1]

As it happened – and this may not have been entirely coincidental – the growth of lithography went hand in hand with the fashion for collecting autographs. In Britain, an interest in autographs had made itself felt well before lithography came on the scene;[2] and in the course of the first half of the nineteenth century it developed into a veritable cult, which was amply served by lithographed publications. The first published collection of autographs is generally held to be J. Thane's *British autography* (London, 1788), which consists of a letterpress text and a series of etched plates, printed in two colours, of portraits and autographs of 'royal and illustrious personages'. This was followed by J. G. Nichols's *Autographs of royal, noble, learned and remarkable personages conspicuous in English history* (London, 1829), which has intaglio plates reproducing parts of around 600 documents, but no portraits. By this time the fashion for collecting autographs had spread abroad and France probably led the field. It was in France that the first books on the subject of autograph collecting were published: G. Peignot, *Recherches historiques et bibliographiques sur les autographes et sur l'autographie* (Dijon, 1836) and P.-J. Fontaine, *Manuel de l'amateur d'autographes* (Paris, 1836).

The author of the first of these books, the well-known bibliophile Gabriel Peignot, had taken an interest in lithography almos

[1] G. Engelmann, *Manuel du dessinateur lithographe* (Paris, 1822 and 1824), pl.viii; C. Hullmandel, *The art of drawing on stone* (London, 1824), pl.xviii.

[2] For the growth of autograph collecting, see especially A. N. L. Munby, *The cult of the autograph letter in England* (London, 1962).

twenty years before. His *Essai historique sur la lithographie* was published in Paris as early as 1819 and was the first monograph on the history of the subject. It is hardly surprising, therefore, that he came to recognize the importance of the connection between lithography and autograph collecting. In his book on autographs he referred to the contribution made by transfer lithography (*autographie*) in spreading the taste for collecting autographs, and as a demonstration of the capabilities of the process he introduced the book with a four-page letter written in his own hand and printed lithographically.

As Peignot fully recognized, lithography was ideally placed to promote the growing fashion for collecting autographs. During the 1820s the process had become firmly established in commercial terms in most of the major towns of Europe and transfer lithography, which was well suited to the production of facsimiles of autograph letters, was sufficiently advanced to be used with confidence. It is hardly surprising, therefore, that the possibilities offered by lithography for the production of collections of autographs were explored to the full and that publications of lithographed facsimiles began to appear in various parts of Europe.

Such publications are too numerous to discuss in detail here and were already a subject of bibliographical interest by the middle of the nineteenth century. Towards the end of his life, the British antiquarian and autograph collector, Dawson Turner,[3] published a little work on the subject: *Guide ... towards the verification of manuscripts, by reference to engraved fac-similes of handwriting* (Yarmouth, 1848).[4] He made use of 138 publications that contained facsimiles of autographs and printed in tabular form the locations of the items listed within them. All but a dozen of the publications he referred to belonged to the nineteenth century; most of them were biographies or collections of correspondence by individuals, but he also included many general collections of facsimiles. Some years later in France, M.-F.-A. de Lescure, who did not seem to know of Dawson Turner's *Guide*, compiled a more substantial catalogue of such works as part of his book *Les Autographes*.[5] Not all the books Dawson Turner and Lescure listed contained facsimiles that were produced by lithography, but the majority of those which were published after 1830 did, and certainly the most important ones. An aside in Dawson Turner's preface lends support to the view that by the middle of the nineteenth century the lithographic process had become inextricably linked with the publication of facsimiles of writing: in a passage relating to a collection of botanical tickets in the British Museum, which had been brought together by Sir Thomas Banks, he remarked that thanks 'would be due to any one who would publish a facsimile of them in lithography.'[6] The output of lithographed facsimiles in

[3] Dawson Turner's contribution as a collector of autographs is discussed by Munby, *Cult*, pp.33–60.
[4] Dawson Turner, *Guide to the historian, the biographer, the antiquary, the man of literary curiosity, and the collector of autographs, towards the verification of manuscripts, by reference to engraved fac-similes of handwriting* (Yarmouth, 1848).
[5] M.-F.-A. de Lescure, *Les Autographes et le goût des autographes en France et à l'étranger* (Paris, 1865), pp.183–269.
[6] Turner, *Guide*, p.viii.

241. Facsimile letter from C. de Lasteyrie, *Lettres autographes et inédites de Henry IV* (Paris, c. 1815). Page size 305 × 228 mm.

the nineteenth century was considerable, and all that can reasonably be done in this chapter is to highlight a few of the collections of them that were brought together in book form and seem significant from the point of view of lithographic book production.

Lasteyrie's *Lettres autographes et inédites de Henry IV* [241] deserves pride of place in any discussion of the subject. Lasteyrie claimed that it was the first production of his press in Paris, in which case it must date from around 1815. It consists of ten pages of facsimile letters, together with preliminary pages and a portrait of the monarch drawn by F. Gérard in crayon lithography in a style that derives from eighteenth-century portrait engraving. Lithography was used throughout and the whole publication was richly printed on a heavy laid paper. Though modest in scale, it was a seminal work as far as lithography goes and there can be little doubt that Engelmann's inclusion of a letter written by Henri IV in his *Manuel du dessinateur lithographe* (Paris, 1822 and 1824) owed something to it.

Most of the other early French publications to contain lithographed autographs were similar in kind to Thane's *British autography* in that the autographs played second fiddle to the portraits. The finest of these publications are *Iconographie des contemporains*, published in Paris by Delpech between 1823 and 1832, and *Iconographie française*, published by Delpech's widow from 1828; both are folio volumes and contain superb portrait lithographs and facsimiles of complete documents.

One publication that stands out from all the others, both in France and elsewhere, in terms of its importance in the history of published facsimiles of autographs is *Isographie des hommes célèbres ou collection de fac-simile de lettres autographes et de signatures* (Paris, 1828–30), which was edited jointly by S. Bérard, H. de Chateaugiron, J. Duchesné *aîné*, Trémisot, and Berthier. The word 'isographie' derives from the Greek (*isos* – equal; *graphein* – to write) and appears to have been adopted as a somewhat more narrowly defined term than facsimile, which was used to apply equally to drawn and written images. The word still survives in French, but its English equivalent is regarded as obsolete.[7] *Isographie des hommes célèbres* was printed by Th. Delarue and was originally issued in parts, each consisting of twenty-four sheets, in letterpress wrappers (at *6 fr en papier ordinaire*; fifteen copies at *10 fr en papier vélin*).[8] In its bound form it runs to three or four volumes, each with its own title-page. It appears to be royal quarto

[7] 'Isographie' is defined by D. Muzerelle in his *Vocabulaire codicologique* (Paris, 1985), p.228, as 'Fac-similé d'un échantillon d'écriture d'un personnage, établi à des fins d'identification.' 'Isography' is to be found in the complete Oxford English Dictionary.

[8] The title-pages imply that the work was published by the bookseller Alexandre Mesnier, but the wrappers reveal that Delarue was the publisher. Bernard et Delarue submitted a *cadre* of examples of *isographie* at the Exposition des Produits de l'Industrie française of 1827 and received an honorable mention.

242. Facsimile of a letter from Oliver Cromwell to the Rev. Henry Hich in *Isographie des hommes célèbres* (common to 1828–30 and 1843 editions). Page size 315 × 235 mm.

in size and, apart from its wrappers, was printed throughout by lithography. Its title-pages are elegantly arranged in a variety of styles of lettering of the kind associated with copper-engraving. The rest of the publication consists of nearly 650 autographs arranged in alphabetical order, together with a seven-page preface written immaculately in a *ronde* hand, a list of subscribers, and a fourteen-page list of the names of those whose autographs are included. The autograph letters were drawn from both public and private collections and include items by French people and foreigners. Most of the items are complete documents and occupy separate pages; some are printed across a double spread, so that the book has to be turned for them to be read, others run to several pages. Every effort seems to have been made to give the autographs the appearance of the originals. The whole publication is a thoroughly competent piece of lithographic book production and Delarue proudly declares his responsibility for it in an elegantly displayed imprint on the last page of the list of *hommes célèbres*.

A second, much enlarged, edition of *Isographie des hommes célèbres* appeared in 1843 [242–249]. It is identical to the first edition in its list of subscribers [245], preface [246, 247], and errata page; but it has different title-pages, a letterpress list of *hommes célèbres*, and a letterpress index giving the prices fetched at sales since 1820 by documents written by those represented in the publication. The new title-pages, though lithographed, were entirely redrawn in a rather tighter style of lettering [243, 244], and Delarue's name appears prominently on them as printer and joint publisher (with Truttel et Wurtz). The number of autographs printed in the second edition runs to more than 850, some 200 more than in the first edition.

Most of the facsimiles that appear in both editions [242] seem to be identical, and there can be no doubt that they were printed from the same stones. The point at issue is whether the stones were stored and re-used after an interval of nearly fifteen years or whether unused sheets from the first edition were bound up along with some new items for the second edition. The items that appear in both editions were printed on the same laid paper; this has the watermark 'Canson', the date 1822 or 1827, and chain lines at 26 mm intervals. What is more, the watermarks sometimes appear in identical positions on the same page in both editions, and in the case of rogue leaves that are badly foxed there is an exact match between the two editions. Those items which run across two facing pages in the first edition, and require the reader to turn the book to read them, were cut down and folded so that they appear upright in the second edition (and, of course, these pages have their chain lines running in the opposite direction to those of the other pages). All the autographs that were included for the first time in

ISOGRAPHIE

DES

Hommes Célèbres

ou COLLECTION de

FAC-SIMILE DE LETTRES AUTOGRAPHES

ET DE SIGNATURES

Exécutée & Imprimée par

TH. DELARUE

Lithographe

sous les auspices

de MM

Bérard, A.en Dép.ᵉ De Chateaugiron, Duchesne, Conservateur à la Bibl.que Roy.le, Tremisot

et Berthier.

VOL. 1.

A PARIS.

TH. DELARUE Impr. Lithographe, rue Notre Dame des Victoires 16.

TRUTTEL et WURTZ & les principaux Libraires de France & de l'Etranger.

1843.

244. Detail of 243. 38 × 95 mm.

245. First page of the list of subscribers to *Isographie des hommes célèbres* (common to 1828–30 and 1843 editions). Page size 315 × 235 mm.

243 (opposite). Title-page of *Isographie des hommes célèbres* (2nd ed., Paris, 1843). Printed lithographically by Th. Delarue, Paris. Page size 315 × 235 mm. [Cat. 1.122].

246. First page of the preface to
Isographie des hommes célèbres
(common to 1828–30 and 1843
editions). Page size 315 × 235 mm.

247. Detail of 246. 60 × 105 mm.

248. Facsimile of a letter from F.-A. de Thou in *Isographie des hommes célèbres* (1843), showing the use of crayon lithography to reproduce the pencil addition to the original. Page size 315 × 235 mm.

the second edition were printed on an unwatermarked laid paper with its chain lines at 30 mm intervals. All this evidence seems to point conclusively to the fact that the second edition consists, at least in some of its copies, of bound up sheets of unused material from the first edition.

The second edition of *Isographie des hommes célèbres* contains among its new items a few which take the production of facsimile documents a little further along the road to verisimilitude. Brown-based inks were used from time to time and, in the case of a letter by F.-A. de Thou [248, 249], an additional note which must have been written with a soft pencil in the original was reproduced by crayon lithography. There was no loss of quality in the production of the additional pages of the second edition of *Isographie des hommes célèbres*, and the two editions set the standard, as well as the style, for subsequent publications of autograph letters.

In Germany a few reports of scientific congresses were published between 1828 and 1838 with lithographed facsimiles of autographs,[9] and a particularly original approach to facsimile work was made when the lithographic printer Peter Wagner produced *Verfassungs Urkunde für das Grossherzogthum Baden* (Carlsruhe, 1831) for the benefit of local schools, with each of the statutes written out by a different member of the local government in his own style of handwriting [250]. The most important of the more orthodox German collections of autographs was *Sammlung historisch-berühmter Autographen, oder Facsimile's von Hand-schriften ausgezeichneter Personen alter und neuer Zeit* (Stutt-

249. Detail of 248. 135 × 170 mm.

250. *Verfassungs Urkunde für das Grossherzogthum Baden* (Carlsruhe, 1831). The statutes written on transfer paper by different members of the local government in their own hands. Printed lithographically by P. Wagner, Carlsruhe. Page size 170 × 210 mm. [Cat. 1.232].

gart, 1845–46) [251, 252]. It was published in eight parts in a quarto format and contains nearly 300 examples of autograph letters. Like *Isographie des hommes célèbres*, it is international in scope; but in terms of production and presentation it is much less distinguished than its French predecessor. Its paper is poor in quality, particularly in the first two parts where it is so thin that there is considerable show-through. One of the publication's useful features is that it reproduces letterheads as an integral part of some of the facsimiles. This provides a measure of the quality of the reproduction generally, and it has to be said that on occasions it leaves something to be desired on points of detail.

In Britain, production of facsimiles was dominated by one firm, that of the Netherclift family. The firm was founded by Joseph Netherclift, who has been referred to above as one of the draughtsmen and printers of Young's *Hieroglyphics* and as a specialist in facsimiles of non-latin scripts (see pp. 130, 134). Joseph Netherclift appears to have begun as a specialist lithographic writer in London around 1820. At that time he worked either from

251. Lithographic title-page of *Sammlung historisch-berühmter Autographen* (Stuttgart, 1845–46). Crayon and ink. Page size 270 × 215 mm. [Cat. 1.186]

252. Facsimile of a letter from Alois Senefelder in *Sammlung historisch-berühmter Autographen*. Produced by transfer lithography. Page size 270 × 215 mm.

42 Rathbone Place or 5 Everett Street, Russell Square, and probably had no press of his own. He was brought in as a specialist letterer to execute the writing on a folding map of Brazil that Hullmandel printed for James Henderson's *A history of Brazil* (London, 1821), and to provide the lettering for numerous title-pages and wrappers for the publications of Ackermann, Rodwell & Martin, and Rowney & Forster in the early 1820s.[10] Shortly afterwards he was responsible for two lithographed plates, dated 1 October and 1 November 1823, and probably intended for an encyclopaedia, which illustrate the different styles of writing in use from the time of William I to Elizabeth I. From then on Netherclift seems to have established a reputation for himself, at least in Britain, as the leading specialist in the reproduction of manuscript documents. In this field he, and later his son F. G. Netherclift, remained pre-eminent until photography began to replace the draughtsman for this kind of work in the 1860s. Joseph Netherclift also appears to have built up something of a reputation in another, related field, his son writing of him as being 'well known in the Courts of Law, as the clever detector of forged writings'.[11]

Joseph Netherclift's work for the Royal Asiatic Society has already been touched on in Chapter 7 (see p.144). Initially, he produced all the plates for the Society's *Transactions*, the first volume of which appeared in 1827, and early on assumed the title of 'Lithographer to the Royal Asiatic Society'. By this time he was in business as a lithographic printer and was operating from 8 Newman Street in London. From this address he issued a trade card (a copy of which is in the Guildhall Library) which stresses his connection with the Royal Asiatic Society. But he took on other kinds of work as well, particularly for the British Museum, and continued to run a general lithographic business in London (with changing addresses) for something like a quarter of a century.[12] He was awarded a silver medal by the Society of Arts in 1828 for his method of making transfer lithographs,[13] and in an article published in 1831 was singled out as being the most eminent of printers working in the field of maps and circulars, and as someone 'who writes in a most beautiful style, and has produced the most elaborate specimens of ink lithography, by the method of transfer'.[14] He was best known, however, as a facsimilist, and surviving correspondence reveals that at one stage he kept two men exclusively for this kind of work.[15]

[10] Among them may be mentioned A. Aglio, *Architectural ornaments* (1820–21); A. Aglio, *Woolley-Hall, Yorkshire* (1821); D. Dighton, *Progressive studies of cattle* (1820); J. Fudge, *Six views in the north of France* (1821); A. Orlowski, *Costume of Persia* (1820–21); Pinelli, *Roman costumes* (1820–21); S. Prout, *Marine sketches* (1820); H. Richter, *Illustrations* (1822).

[11] F. G. Netherclift, introduction to *The hand-book to autographs* (London, 1862).

[12] Twyman, *Directory*, p.42.

[13] *Transactions of the Society of Arts*, vol.47, pp.x–xi, 42–45.

[14] 'A view of the present state of lithography in England', *Library of the Fine Arts*, vol.1, no.3, Apr. 1831, p.215.

[15] Archives of the Department of Egyptian Antiquities, British Museum.

253. J. Netherclift, *Autograph letters
... of illustrious and distinguished
women of Great Britain* (London,
1838). Detail of gold-blocking on
the brown cloth case. 105 × 85 mm.
[Cat. 1.163].

254. Facsimile autographs from the
time of Elizabeth I and James I, in
J. Netherclift, *Autograph letters ... of
illustrious and distinguished women
of Great Britain* (London, 1838).
Produced by transfer lithography.
Collected, copied, printed and pub-
lished by Joseph Netherclift. Page size
375 × 265 mm. [Cat. 1.163].

Joseph Netherclift's reputation for the production of high qual-
ity facsimiles of historical documents seems to have been estab-
lished with a series of independent prints that attracted attention
in the pages of the *Gentleman's Magazine* in 1833.[16] These
included facsimiles of King Charles's death warrant, the letter
which led to the uncovering of the Gunpowder Plot, the signals
used at the Battle of Trafalgar, and some royal signatures.[17] But the
works of his that call for our attention here are complete books of
historical autographs along the lines of *Isographie des hommes
célèbres*. Netherclift produced several of these in the 1830s and
1840s, all of which were merely national in scope: *Autographs of
the kings and queens, and eminent men, of Great Britain* (London,
1835); *Autograph letters, characteristic extracts and signatures,
from the correspondence of illustrious and distinguished women
of Great Britain* (London, 1838) [253, 254]; and *A collection of one
hundred characteristic and interesting autograph letters, written
by royal and distinguished persons of Great Britain* (London,
1849) [255].

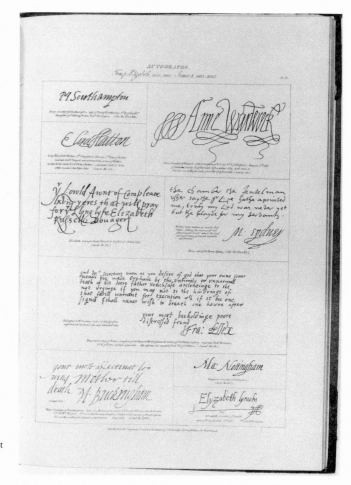

[16] See the *Gentleman's Magazine*,
vol. 103, part 2, 1833, p. 447.
[17] Shortly after this the Maitland Club
used lithography for thirty-five facsimile
letters from royalty in *Letters to King
James the Sixth* (Edinburgh, 1835). It is not
known who was responsible for the pro-
duction of these facsimiles.

255. Facsimile of a letter from Princess Elizabeth (later Queen Elizabeth I) to the Duke of Somerset, in J. Netherclift, *A collection of one hundred ... autograph letters, written by royal and distinguished persons of Great Britain* (London, 1849). Produced by transfer lithography. Copied, printed, and published by Joseph Netherclift and Son. Page size 320 × 240 mm. [Cat. 1.164].

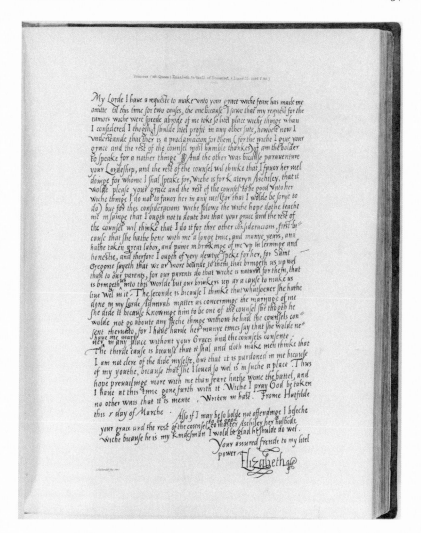

These three books were all printed and published by Joseph Netherclift, the last while he was working in partnership with his son. Though the 1849 publication contains letterpress transcriptions of the autographs, the emphasis in all three publications is on the lithographed facsimiles, and the two earlier publications were lithographed throughout. *Autographs of the kings and queens* is a collection of over 500 signatures and short passages from documents organized on seven double-page spreads of a folio volume, but the other two publications follow the pattern established in *Isographie des hommes célèbres* by reproducing many documents in their entirety. Netherclift attached great importance to accuracy and the facsimiles he produced carry such phrases as 'copied in perfect fac-simile ...' (1835), 'copied from the originals ...' (1838) and 'J. Netherclift fac-sim:' (1849). Though it would be wrong to pass judgment on these facsimiles without comparing them with the original documents from which they were copied,

256 (top). Detail of a facsimile of a letter from Margaret Tudor to Wolsey, 1517, in J. Netherclift, *A collection of one hundred . . . autograph letters*. 50 × 160 mm.

257 (bottom). Detail of the letter shown in 256, from the original in the British Library (Cotton MS Caligula BI folio 267). 50 × 160 mm.

which would be an extremely time consuming thing to do other than with the occasional example [256, 257], they have the appearance of being very faithful. Cursive hands flow convincingly and, as in some other facsimile works discussed here, deletions and accidental blots and smudges are carefully reproduced [258]. In some of the longer passages of the 1849 publication, even the colour of the ink was varied, presumably to match the range of inks in the original document. In every respect, except scope and the number of autographs reproduced, these books of Netherclift compare well with the more ambitious *Isographie des hommes célèbres*.

The value of such lithographed publications extended beyond the field of autograph collecting, and the publisher's advertisement for Netherclift's 1849 publication included a letter of recommendation from Thomas Crofton Croker which pointed to other benefits that stemmed from them. Croker had a longstanding connection with lithography and knew a lot about it; he was also a founder member of the Camden Society, which was set up in 1838 to publish texts of historical importance. In his letter, Croker wrote of transfer lithography that 'Nothing can be so well adapted for the preservation of such records [valuable historical documents], and no mode of publication can be so unquestionable as

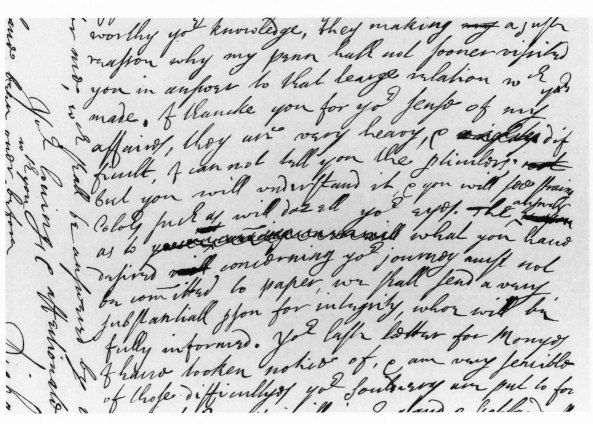

258. Detail of an informally written letter by Richard Cromwell to his brother, in J. Netherclift, *A collection of one hundred ... autograph letters.* 120 × 180 mm.

to accuracy.'. He pointed to the value of having State Papers reproduced in facsimile instead of having them transcribed and printed letterpress, with the consequent risk of printers' errors creeping in. And to emphasize the significance of transfer lithography in this regard he drew attention to errors of substance that had been discovered in a letterpress transcription of a sixteenth-century manuscript.

It remains a puzzle how Netherclift managed to get permission to make tracings from the original documents he copied, which was a pre-requisite for accurate facsimile work before the days of photography. Tracing over originals on translucent transfer paper was bound to do some damage and was likely to have been just as risky as some other practices that were forbidden in public collections. We know, for example, that Sir Thomas Phillipps's request to transcribe documents in the Public Record Office using anastatic ink instead of the statutory pencil was turned down in 1852, though he was allowed to have Public Record Office staff do such copying on his behalf.[18] Only skilled craftsmen would have been capable of achieving the results seen in Netherclift's facsimiles of documents, and we have to assume that he was more persuasive with keepers of archives than was Sir Thomas Phillipps.

Something of Netherclift's concern to secure the co-operation

[18] See Munby, *Phillipps studies*, vol.4, pp.109–110.

of private collectors of autographs can be gleaned from a long and interesting letter he wrote on 17 March 1840 to Dawson Turner, one of the foremost British collectors of autographs.[19] Netherclift had just embarked on the production of a collection of lithographed letters to serve as a companion to Edmond Lodge's well-known series of portraits.[20] He revealed that the autographs were to be in the same octavo format as the Lodge volumes, and pointed to the economies that could be made by choosing letters that needed no folding and that did not run over to a second page. At the time of writing, he had already published two numbers and had arranged the content of a third. He was anxious to involve Turner in the selection and arrangement of subsequent parts and wrote of 'the amazing advantages to be derived from the vast store of originals that I have heard you have been so long collecting'. In another passage he raised the question of using items in Turner's collection, stressing that they would come to no harm:

> You will see at the back of No. 2 – the letters intended for No. 3. – I am anxious to get a Number out monthly as nearly as I can. Should you have a good letter of Knox – or any others you see there – I would introduce them instead of the Museum originals, many of which have already been printed in letter press – this would show also that you had really opened your Stores for the work & would give the public great confidence in the undertaking – & I hope you would feel perfectly satisfied that not the least injury would come to any original you entrusted me with, which I should carefully lock up in my private room.

This passage reveals that the numbers were to appear at roughly monthly intervals; elsewhere in the letter Netherclift mentions that he intended completing volume 1 in twelve numbers and that it would contain the early letters of the period 1500 to 1600. Unfortunately, no trace can be found of this publication, which must have been underway in 1840.

Joseph Netherclift's mantle of leading producer of lithographed facsimiles in Britain was taken over by his son Frederick George Netherclift, who issued *The autograph miscellany* (1855) and *The autograph souvenir* (1863–65) in the idiom of his father's publications. They were intended to be annual publications, but neither appears to have got beyond the first issue. Both contain complete documents 'executed in facsimile' by Frederick Netherclift himself, with letterpress transcriptions by Richard Sims of the Department of Manuscripts of the British Museum (and it is possible that this association provides us with an explanation for the success of the Netherclifts in getting permission to copy documents there). Both these publications have decorative title-pages printed lithographically in red, blue, and gold, and their facsimiles, some of

[19] The letter is with the Dawson Turner correspondence in Trinity College Library, Cambridge, and is referred to by Munby, *Cult*, p.99. With it is a shorter letter from Joseph Netherclift to Dawson Turner, dated 3 Oct. 1836, which refers to *Autograph letters . . . of illustrious and distinguished women of Great Britain*.
[20] E. Lodge, *Portraits of illustrious personages of Great Britain, engraved from authentic pictures*, 4 vol. (London, 1821–34); 12 vol. (London, 1835).

259. Page with facsimile autographs in L. B. Phillips, *The autographic album* (London, 1866). Produced by transfer lithography by F. G. Netherclift, London. Page size 210 × 165 mm. [Cat. 1.174].

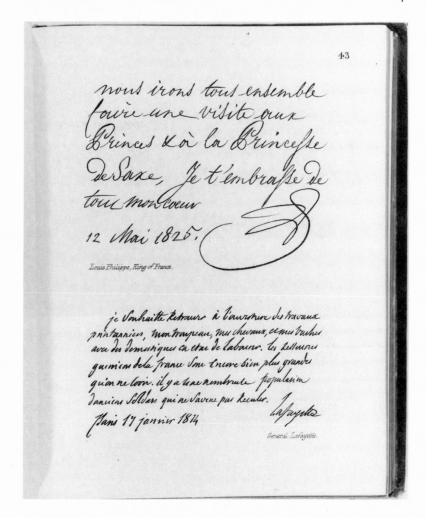

which were printed in brown ink to match the originals, are comparable in quality to those of his father. *The autograph miscellany* was printed and published by Netherclift while he was in partnership with Durlacher, and *The autograph souvenir* by Netherclift when on his own. Two other collections of autographs were produced by Frederick Netherclift in this period: *The handbook to autographs* [1862], with a biographical index by Richard Sims, and *The autographic album* (1866) with biographical notices by L. B. Phillips [259]. They are much smaller in format than all the other Netherclift volumes of facsimiles discussed here and were principally meant as handy reference books to help librarians and collectors assess whether a document was genuine. They are utilitarian productions, consisting primarily of hundreds of short excerpts of items printed more than one to a page, rather than facsimiles of whole documents to be savoured and read.

These publications of Frederick Netherclift mark the end of the widespread use of hand-drawn transfer lithography for the copying

of documents. Even before his last works had been published, the first number of the journal *The Autographic Mirror / L'Autographe cosmopolite* had appeared on 20 February 1864 with its specimen autographs produced by Vincent Brooks in photolithography [260, 261].

260. Masthead of *The Autographic Mirror*, no.1, 1864. Printed lithographically by Vincent Brooks, London. Approx. 90 × 250 mm.

261. *The Autographic Mirror*, no.1, 1864. Printed lithographically by Vincent Brooks, the autographs produced by photolithography. Page size 410 × 285 mm.

Few of the items discussed in this chapter exhibit many of the characteristics of proper books, and there may even be a doubt as to whether some of them should qualify as improper ones either. Not all of them incorporate what might be called a text and, of those that do, some fall back on letterpress printing. Features such as running heads and signatures are less evident among these publications than they are in others discussed in this book, and the nature of their material meant that it was by no means unusual for their pages to be printed on one side of a leaf only. But, having admitted all this, it is difficult to see how such carefully considered productions as *Isographie des hommes célèbres* and the publications of Joseph Netherclift can be excluded from a discussion of early lithographed books.

CHAPTER 12

Photolithographed facsimiles and reprints

Transferring old impressions to stone and the more popular method of making lithographed copies by hand provided no real solution to the problem of making accurate facsimiles of documents. Taking transfers from old impressions had specific limitations. In the first place, the process could be used only when the original document was produced with a greasy ink (which excluded most, if not all, handwritten documents). Secondly, it was extremely hazardous and in many cases would have led to the destruction of the original or severe damage to it. Thirdly, there is no real evidence to suggest that it could produce good enough results consistently. On the other hand, the traditional transfer methods all involved hand copying and an element of personal interpretation. Though they were widely used for making facsimiles of autograph letters and were superficially very effective, they must have seemed inadequate to an age that was devoted to the idea of verisimilitude and that had already begun to come to terms with photography. It was inevitable, therefore, that photography should have been applied to the production of facsimiles before long. In France, Baudelaire argued the case for the use of photography for such purposes. He wanted it kept away from what he saw as the domain of the imagination and urged that it should be used for more utilitarian purposes to 'rescue from oblivion those tumbling ruins, those books, prints and manuscripts which time is devouring'.[1] But photography on its own was not enough. There needed to be a way of multiplying photographic images in large numbers and economically; and in practical terms this meant finding a way of linking it with printing.

As it happens, lithography was the first of the major printing processes to be used successfully in conjunction with photography. The first photolithographic methods are generally held to have been those developed in France by Lemercier, Lerebours, Barreswil and Davanne in the early 1850s. A few years later Lemercier began using an improved method which had been patented by Poitevin in 1855.[2] These methods were used to multiply images of three-dimensional objects and views and involved

[1] Review of the Salon of 1859 in *The mirror of art: critical studies by Charles Baudelaire*, translated and edited by Jonathan Mayne (London, 1955), pp.230–231.

[2] 'Procédé d'impressions photographiques aux encres grasses', 27 août 1855. See H. and A. Gernsheim, *The history of photography* (London, 1955), p.338, and Twyman, *Lithography*, p.253.

coating the stone with a photosensitive substance and exposing it to light through a glass negative. An alternative approach, which involved making photographic images on paper and then transferring them to stone, was discovered by Edward Isaac Asser of Amsterdam in 1857.[3] In Asser's method, unsized paper was coated with bichromate of potash and then, after exposure through a negative, heated and damped. The exposed parts resisted water, whereas the unexposed parts accepted it. The paper was then charged with lithographic transfer ink, which took to the dry exposed parts but not to the moist unexposed parts. All that remained to be done was to transfer the image from the paper to a stone or a metal plate.

Shortly after Asser discovered his process, a modification of it was successfully used by Colonel Sir Henry James and his staff at the Ordnance Survey Office, Southampton, for the production of facsimiles of documents. Photography had been introduced to the Ordnance Survey in 1855 as a means of making accurate reductions of plans, but in 1859 it began to be used for transferring images to zinc plates or stones. Zinc plates were normally used, and for this reason James called his process Photozincography.[4] Details of the process were described by James[5] and also by Captain A. de C. Scott,[6] who was in charge of the work of the Ordnance Survey that involved the photographic reduction of plans. The process of photozincography as used at Southampton was as follows. A sheet of paper coated with a solution of gelatine and bichromate of potash was exposed to light through a negative of the image to be reproduced. The paper was then placed face down on to a zinc plate that had been covered all over with a thin coating of lithographic ink and varnish, and both were then pulled through the press together so that a film of ink was deposited all over the paper. The ink was later removed from the unexposed parts of the paper by immersing it in a bath of warm water for five minutes and gently rubbing its surface with a sponge dipped in gum water. When the sheet was free from unwanted ink and gum, the paper was placed face down on to a zinc plate or stone and the image transferred in the normal manner.

Oddly enough, the field in which the new process of photozincography was first explored was not map and plan production, but the making of facsimiles of old documents. How this came

[3] E. I. Asser, 'Procédé pour obtenir des positifs photographiques sur papier, à l'encre d'imprimerie ou à l'encre lithographique', *Bulletin de la Société française de Photographie*, vol. 5, 1859, pp. 211, 260–263.

[4] Introduction to *Domesday Book or the great survey of England of William the Conqueror*, 35 vol. (Southampton, 1861–63). The same introductory text appears in all volumes of the publication.

[5] H. James, 'The practical details of photozincography, as applied at the Ordnance Survey Office, Southampton', *British Journal of Photography*, Sept. 1860, pp. 249–251.

[6] A. de C. Scott, *On photo-zincography and other photographic processes employed at the Ordnance Survey Office Southampton* (London, 1862), pp. 10–15.

about is recorded by James in the Preface to Scott's report on photozincography at the Ordnance Survey Office. James wrote that Gladstone, who was Chancellor of the Exchequer at the time, asked him at a meeting connected with Survey business, whether he knew 'of any process by which some of our ancient manuscripts in the Record Office could be copied.'[7] The answer hardly needs recording and, as proof of the capabilities of photozincography, James had a facsimile made of a small deed from the time of Edward I. This was printed on 14 February 1860 and copies of it were bound up with the annual *Report of the progress of the Ordnance Survey* for the year 1859.[8] All parties appear to have been satisfied with this experimental print and James was subsequently directed to make a copy of the part of Domesday Book relating to the county of Cornwall. With this in mind, the relevant parts of the larger of the two volumes of Domesday Book were taken to the Ordnance Survey Office at Southampton in February 1861, where they remained for some ten days.[9] This facsimile reproduction of the parts relating to Cornwall must have been considered a success since it was decided to continue the venture county by county until Domesday Book was copied in its entirety.

It seems likely that Gladstone was under some pressure to take the initiative in this matter. The two manuscript volumes of Domesday Book, which had been kept in the Chapter House at Westminster since the mid-eighteenth century, were transferred to the new Public Record Office in Chancery Lane in 1859,[10] and the question of their security and the related need to make authentic copies of them, were clearly matters of concern at the time.[11] It is also worth recalling Crofton Croker's plea of a decade earlier that lithography (though he had in mind ordinary transfer lithography) should be applied to the reproduction of State Papers (see pp.238–239). James stressed the importance of photozincography for the reproduction of old documents. In particular, he drew attention to its capability for the production, at a low unit cost, 'of authentic copies of rare and valuable documents now locked up and inaccessible to the public'.[12] James was also alive to the advantages of photozincography over facsimile methods that

[7] Preface to Scott, *Photo-zincography*, p.v.

[8] I. Mumford, 'Lithography, Photography and Photozincography in English map production before 1870', *Cartographic Journal*, vol.9, no.1, June 1972, p.33.

[9] Public Record Office, *Domesday re-bound* (London, 1954), p.13, and E.M. Hallam, *Domesday Book through nine centuries* (London, 1986), p.154. Where these accounts differ on points of detail I have followed Hallam.

[10] For brief accounts of the travels of Domesday Book, see *Domesday re-bound*, pp.9–10, and Hallam, *Domesday*, pp.114, 115, 134, 148–153.

[11] Copper-engraved facsimiles of the parts relating to Worcestershire and Surrey were published in 1782 and 1804, and a letterpress version of the whole text was completed in 1783 using newly designed types to cater for abbreviations, contractions, suspensions, and special signs. At

one stage during the lengthy run-up to the 1783 publication consideration was given to producing a proper facsimile and, as an experiment, the first page of the Surrey section of Great Domesday was engraved and printed in two colours in 1768. See *Domesday re-bound*, pp.10–12, and British Library exhibition notes, 'Sir Henry Ellis and Domesday Book', 1986.

[12] James, 'Practical details', p.249.

involved tracing, both from the point of view of security and conservation, and wrote in the introduction to *Domesday Book*:

> In examining copies made by Photo-zincography, it must always be remembered that the original document is not even handled or touched by the copyist, each leaf of the book is placed in succession before the camera by the officer from the Public Record Office, in whose charge it constantly remains, and sometimes after an exposure of only twenty seconds, the copy is taken.[13]

For all this, the two original Domesday volumes had to be taken to Southampton for the facsimiles to be made from them. The larger of the two volumes, known as 'Great Domesday', travelled there in the custody of Joseph Burtt and remained at Southampton either with him or another assistant keeper of the Public Record Office until the completion of this part of the work in April 1863. Similar arrangements were made for the second and smaller volume, which was returned in December 1863.[14] In making the comments quoted above, 'that the original document is not even handled or touched by the copyist' and that 'each leaf of the book is placed in succession before the camera by the officer from the Public Record Office', James was being a shade disingenuous since the volumes had to be disbound to be photographed.[15] What is more, all the photographic work had to be done in the open air (262), and possibly in bright sunlight, which would scarcely be regarded as good conservation practice today.

James's contribution to the development of photozincography was not so much that of innovator as of entrepreneur. From a technical point of view it was Asser who provided the breakthrough, and some credit must also go to Captain A. de C. Scott, who was directly responsible for the photozincographic exercise at Southampton and later wrote a technical account of the methods adopted there.[16] In any case, very similar methods were being developed by J. W. Osborne at the Survey Department in Melbourne at much the same time. None of this should detract from James's contribution to the development of photozincography; not only was he a tireless promoter of the process, but he was also generous in recognizing the contributions of both Scott and Osborne. The names of other people associated with James's

262. Early process camera in operation at the Ordnance Survey Office, Southampton, about the time *Domesday Book* (1861–63) was being produced.

[13] *Domesday Book or the Great Survey of England of William the Conqueror*, 35 vol. (Southampton, 1861–63). James's comments should be seen in the light of Sir Thomas Phillipps's unsuccessful attempts to get permission to transcribe manuscripts in the Public Record Office using anastatic ink in 1852 (see above, p.239).

[14] For descriptions of the arrangements made for keeping Domesday Book at Southampton, see *Domesday re-bound*, p.13, and Hallam, *Domesday*, pp.154–156. Burtt was replaced in Jan. 1862 by William Basevi Sanders, who remained at Southampton until his retirement in 1885 and took charge of a whole series of manuscripts that were reproduced by photozincography.

[15] *Domesday re-bound*, pp.13, 18. The breaking up of the volumes into flat sheets presented an opportunity for the design of a new form of binding, over which controversy raged for some years.

[16] Scott, *Photo-zincography*.

successful venture are also known because the editor of one of the first publications to contain a photozincographic reproduction from the Ordnance Survey Office press pays tribute to the work of its photographer, Corporal Rider, and its printer, Mr Appel.[17] Rudolph Appel was employed by the Ordnance Survey for thirty-five years after the bankruptcy of his business in 1857, and his contribution to the printing of photolithographs was acknowledged in several of its publications. Following his part in the shortlived attempt of William Siemens to promote anastatic printing in Britain (see p.224), and a not very successful period working on his own account for such clients as Sir Thomas Phillipps (see Chapter 4), it seems that Appel had at last found an appropriate outlet for his skills.

The major facsimile production of the Ordnance Survey Office in terms of extent was the *Domesday Book or the great survey of England of William the Conqueror* (1861–63) [263, 264], which has already been referred to. Starting with the volume for Cornwall, the whole of Domesday Book was reproduced in facsimile county by county in thirty-five volumes. Most of the volumes are folio in size, though those for Essex, Norfolk, and Suffolk are quartos. The differences are accounted for by the different sizes of the two original volumes of Domesday Book. In 1863 a two-volume edition of the facsimile was issued in the same form as the original and with foliation to correspond with it. Each page of the facsimile was printed in black and red, both workings being produced by photozincography. Compared with the letterforms copied by hand by Netherclift and others, those in the *Domesday Book* facsimile appear a little rough at their edges; moreover, the backgrounds of some of the plates are a little spottier than those to be found in most hand-drawn facsimiles. Though the reproductions in the *Domesday Book* may well be accurate in terms of what the camera 'saw', the incidental effects produced by photozincography often look misleading,[18] as do similar line facsimiles of half-tone images produced today. Variations in the tones of pen strokes and the effects of show-through were not, of course, picked up at all, nor were some other incidental characteristics of the original [264, 265]. Moreover, the use of a smooth paper makes it hard for us to see the publication as anything more than a facsimile

[17] J. Earle, *Gloucester fragments* (London, 1861), p.vi.

[18] The difficulty of making judgments about such work is revealed by the confused comments of Henry Sweet in connection with the plates of his *Epinal glossary* (London, 1883), which were photolithographed by W. Griggs from the original eighth-century manuscript. In his preface to the publication Sweet complained that the proofs he had originally seen were substantially touched up by hand and that it was nearly two years before he obtained 'what professed to be ungarbled facsimiles.' And though he felt that the published facsimiles represented the manuscript accurately enough, he noted that they failed 'in reproducing its less distinct portions.' Two years later, however, he appears to have changed his tune. In an erratum slip that was inserted in some copies, he remarked that 'In many cases letters which are quite illegible in the MS. have come out distinctly in the photograph, and what is still more remarkable, the photolithograph is in one or two cases even clearer than the photograph.'

263. Double-spread from the Hampshire volume of *Domesday Book* (1861). Produced by photozincography and printed in red and black by the Ordnance Survey Office, Southampton. Page size 373 × 270 mm. [Cat. 1.85].

264. Detail of 263. 100 × 135 mm.

265 (opposite). A comparison of details of the same page from the Hampshire section of Domesday Book as reproduced in (top) the Ordnance Survey publication of 1861 and (bottom) *Great Domesday* (London, 1986), which was printed by continuous-tone offset lithography by Westerham Press Ltd and published by Alecto Historical Editions. Both 170 × 260 mm.

of the shapes of the written marks. Nevertheless, the production of such an ambitious work so soon after the development of the process of photozincography was no mean achievement, and it paved the way for numerous published facsimiles of old documents.

Over the next decade or so, the photozincographic productions of the Ordnance Survey Office became more and more ambitious technically. Principal among these productions are *National manuscripts of England* in 4 volumes (1865–68), *National manuscripts of Scotland* in 3 volumes (1867–72), *Facsimile of the black-letter prayer-book* (1871), and *National manuscripts of Ireland* in 4 volumes (1874–84). In the *National manuscripts of England* an innovation was made with the reproduction of a version of Magna Carta in two different sizes, both of them smaller than the original. This was something that could not easily have been done using non-photographic means, and was a breakthrough in facsimile work.[19] Some reproductions in the publication made use of a second printing, not just to pick out a second colour, but also to define a sheet of parchment or indicate darker areas of tone. In the latest of these collections to be published, *National manuscripts of Ireland*, such techniques were carried much further, and a few images were printed in a wide range of colours (up to ten workings). The norm, however, was for documents to be reproduced with a parchment-coloured background stone and for incidental effects of staining and the fall of light across the cockled surface of the parchment to be reproduced in a simulated half-tone of the brown working used for the text matter [266].[20] Such reproductions are not just facsimiles of the texts, as in general the plates of *Isographie des hommes célèbres* and the Netherclift publications are; they are facsimiles, albeit rather crude on occasions, of the visual appearance of sheets of parchment with writing on them. Whether this makes them more like the originals they were based on than most hand-drawn facsimiles is largely a matter of opinion, and it is by no means easy to decide which of two relatively unsatisfactory reproductions of the same original is the more faithful.

Whatever else these Ordnance Survey Office publications managed to do, they established photolithography as the normal method for making facsimiles of old documents, and from the mid 1860s onwards the older methods were at a disadvantage in all situations where it was possible to use photography. For example, *The Autographic Mirror / L'Autographe cosmopolite*, which was published in London three times a month starting 20 February 1864, had its examples produced photolithographically by Vincent Brooks [261]. And in the field of palaeography, Andrew Wright's standard work *Court-hand restored*, which was first published in

[19] In his preface to Scott, *Photo-zincography*, pp.iii–iv, James refers to the use of photography for the reduction of Ordnance Survey plans as though it was a stage leading up to the development of photozincography.

[20] This approach had been adopted by Day & Son as early as 1864. See T. Smith, *Memorials of old Birmingham. Men and names* (Birmingham, 1864), p.iv and folding plates.

LIII

266. *National manuscripts of Ireland* (1874–84). Produced by photozincography
and printed in two colours by the Ordnance Survey Office, Southampton.
A parchment-coloured working defines the shape of the substrate; a brown
working provides the written and drawn images and the half-tone effects. There
is also some hand-colouring. Image 325 × 230 mm.

1776 with copperplate illustrations, and appeared many times in this form, came out in its ninth edition in 1879 with additional plates printed by photolithography.

Within a few years of the beginning of James's programme for making facsimiles of early manuscripts by photolithography, others applied the process to the making of reprints of complete printed books. In a grand gesture comparable to James's production of the entire *Domesday Book*, a reprint was undertaken in 1866 of Shakespeare's first folio of 1623 [267–269]. The reprint was the idea of Howard Staunton, who had used photolithography for the reproduction of Shakespearian documents two years earlier in his *Memorials of Shakespeare* (London, 1864). His facsimile edition of the first folio was published in sixteen monthly parts at 10s. 6d. each and, like the *Memorials*, was both printed and published by Day & Son of Gate Street, London. Its title-page proudly proclaims that the book was produced 'By the newly-discovered process of photo-lithography', and even credits the man responsible for the work, R. W. Preston. A close look at the volume shows that it was printed from stone rather than metal plates. The whole undertaking has to be seen as a tremendous technical and organizational

267. H. Staunton's facsimile edition of Shakespeare's first folio of 1623 (London, 1866). Produced by photolithography and published by Day & Son. Page size 400 × 250 mm. [Cat. 1.191].

> The name, and not the
> *Ref.* Both, both, C
> *Hel.* Oh my good
> I found you wondrous
> And looke you, heeres
> When from my finger

> e thou thy husband, and
> n gueſſe, that by thy ho
> eptſt a wife her ſelfe, th
> and all the progreſſe m
> uedly more leaſure ſhall
> ſeemes well, and if it

achievement bearing in mind the infant state of photolithography at the time. It cannot have been easy to reproduce effectively the poor presswork of the original seventeenth-century letterpress printing and to cope with the curvature of the pages. Such difficulties may account for the fact that Staunton's photolithographed *Shakespeare* does not quite match up to the facsimile volume of *Recueil des historiens des Gaules et de la France* [237, 238], either in terms of its overall effect or accuracy of detail. Perhaps to compensate for this, it was given more generous margins than the seventeenth-century edition; and it has to be said that, as an artefact, it looks rather grander than the original from which it was reproduced.

Almost as though to prove that it could undertake work of a similar kind, the Ordnance Survey Office produced a facsimile of

the prayer book that Robert Barker printed in 1636. However, this was no ordinary copy of this edition of the prayer book; it was the particular copy that had been used for the revision of the prayer book in connection with the Act of Uniformity of 1662. The short title of the facsimile edition referred to here is *Fac-simile of the black-letter prayer-book containing manuscript alterations and additions made in the year 1661, 'out of which was fairly written the Book of Common Prayer* (London, 1871). According to the Dean of Westminster, who wrote the preface to this facsimile edition, the very existence of the marked-up copy of the 1636 prayer book was unknown until 1868. It was discovered following a search for a missing manuscript volume of the prayer book which was originally annexed to the Act of Uniformity of 1662. It turned out that this manuscript volume (now known as the Annexed Book) had been prepared as a clean copy from the marked-up copy of the 1636 edition.[21]

The revised text of 1662 incorporated the last substantial alterations to be made to the Book of Common Prayer before recent times. These changes were in the direction of catholicism and at the time many protestants refused to accept them. What prompted the printing of an expensive facsimile edition can only be a matter for conjecture, but the uncertain past of both the marked-up printed copy of the 1636 edition and the clean manuscript copy made from it, together with the increasing historical interest in the changes made to the text, would have been sufficient justification for the venture.

The 1636 publication, with its manuscript revisions and corrections, was photozincographed at Southampton under the direction of Sir Henry James [270, 271]. Though the facsimile was not actually published until 1871, the major part of the production seems to have been complete by 30 June 1870, which is the date borne by a page which carries the signatures of both William Basevi Sanders (Assistant Keeper of Her Majesty's Records) and James as evidence of its authenticity as 'a true photo-zincographic facsimile'. Apart from its seven-page letterpress preface and a title-page and page of authentication, both of which were lithographed from typeset material, the volume consists of 514 photolithographed pages, eighteen of them being in two colours (red and black). Fold and trim marks, which are preserved on some copies, show that the sheets must have been printed four pages to view.

Twenty years later, the Queen's Printers, Eyre & Spottiswoode, produced a photolithographed facsimile of the manuscript copy of the prayer book that had been annexed to the Act of Uniformity of 1662 (the Annexed Book). This was published as *Facsimile of the original manuscript of The Book of Common Prayer signed by Convocation December 20th, 1661, and attached to the Act of*

[21] For a discussion of the marked-up copy of the 1636 prayer book in the Library of the House of Lords, generally known as the Convocation Book, see E. C. Ratcliff, *The booke of common prayer of the Churche of England: its making and revisions* (London, 1949), pp. 109–110, pls. 71–79.

270. *Fac-simile of the black-letter prayer-book* (London, 1871). Produced by photozincography at the Ordnance Survey Office, Southampton. Page size 408 × 260 mm. [Cat. 1.31].

271. Detail of 270. 24 × 36 mm.

Uniformity, 1662 (London, 1891) [272]. Both this and the earlier facsimile of the prayer book provide evidence of the capabilities of photolithography, not just in terms of verisimilitude, but also in terms of its capacity to take on large-scale pieces of book production.

In the same year that the *Black-letter prayer-book* appeared, a photolithographic facsimile was published of the first printed edition of William Tyndale's translation of the New Testament from the Greek: *The first printed English New Testament* (London, 1871). The facsimile was made from the unique fragment in the British Museum and was edited by Edward Arber. It is not nearly so ambitious as the *Black-letter Prayer-book*, but deserves to be mentioned because it belongs to the first decade of photolithographic book production.

A real boost was given to the production of lithographed facsimiles of books with the 1877 celebrations to commemorate the quarcentenary of the introduction of printing to England by William Caxton. The occasion led to the publication of numerous facsimiles of Caxton's printing, mostly lithographic ones. Some consisted of mere fragments of publications, others were facsimiles of whole books. Some were made by the well-tried method of tracing the original on to translucent lithographic transfer paper,[22] others were photolithographed. Two of these photolithographed facsimiles will be discussed briefly here: *The fifteen O's and other prayers* (London, 1869)[23] and *The dictes and sayings of the philosophers* (London & New York, 1877). The first of these [273] is a facsimile of an unusual Caxton book, which has woodcut borders around every one of its forty-three pages. It was published by Griffith and Farran in a small quarto format and in paper covered boards that imitate parchment. Its title-page reveals that it was 'Reproduced in Photo-lithography by Stephen Ayling', who is described in an introductory note as having 'done so much to promote this modern process of reproduction'.

[22] Most such Caxton facsimiles are the work of G. I. F. Tupper, whose experience as a copyist led him to identify many special sorts used by Caxton and two states of one of his types. Bigmore & Wyman, *A bibliography of printing* (London, 1880), p.113, describe Tupper as having 'quite an unique reputation as a Caxton copyist.' They much preferred his method of hand-tracing to photolithography; they objected to the latter on the grounds that 'nothing is omitted and the modern scribbling on a page must be reproduced as well as the text; also, iron moulds and worm-holes are greatly exag-

gerated, and a crease in the paper appears as a black line.' However, they also revealed that hand-tracing was more costly than photolithography. On this whole subject of Tupper and his work on Caxton reprints see two papers by Robin Myers: 'William Blades's debt to Henry Bradshaw and G. I. F. Tupper in his Caxton studies: a further look at unpublished documents', *Library*, 5th series, vol.32, 1978, pp.265–283; and 'George Isaac Frederick Tupper, facsimilist, "whose ability in this description of work is beyond praise" (1820–1911)', *Transactions of the Cambridge Bibliographical*

Society, vol.7, no.2, 1978, pp.113–134. See also N. F. Blake, *William Caxton: a bibliographical guide* (New York and London, 1985).

[23] The publication is undated. Bigmore & Wyman, *Bibliography*, p.111, must be in error in dating it 1877. R. Cowtan, *Memories of the British Museum* (London 1872), pp.46–47, states that permission for the facsimile was granted by the Trustees in 1869, and most later sources ascribe this date to it.

272. *Facsimile of the original manuscript of The Book of Common Prayer* (London, 1891). Produced by photolithography and printed in two colours (black for the text and red for the rulings) by Eyre & Spottiswoode, London. Page size 380 × 260 mm. [Cat. 1.32].

273. Facsimile edition of Caxton's *The fifteen O's, and other prayers* (London, 1869). Produced by photolithography by Stephen Ayling. Page size 207 × 165 mm. [Cat 1.64].

274. Facsimile edition of Caxton's
*The dictes and sayings of the
philosophers* (London and New York,
1877). Produced by photolithography
and printed in red and black. Page size
292 × 220 mm. [Cat. 1.63].

275. Detail of 274. 24 × 36 mm.

The dictes and sayings of the philosphers [274, 275] was held in
the nineteenth century to be the earliest book printed by Caxton
and the facsimile edition of it was published to coincide with the
four-hundredth anniversary of the appearance of the original
edition in 1477. The name of the printer of the facsimile is not
revealed, but his work must have been rather more demanding
than that of Stephen Ayling for *The fifteen O's, and other prayers*.
Though it has no illustrations, it is longer than the other book and,
apart from its preliminary pages (which are printed letterpress), all
its leaves were printed in two colours to cater for the rubrication
of the original. In his preface to the book William Blades allowed
himself to reflect on the advances that had been made in printing
methods since Caxton's time:

> How would the printer [Caxton] have laughed to scorn the
> idea that an art which would employ sunbeams instead of
> types – one almost as useful and precious as his own – would
> one day be used to reproduce with minutest accuracy this
> early work of the English press ...[24]

Shortly after the publication of Blades's facsimile edition of *The
dictes and sayings of the philosophers*, artificial light generated
by electricity replaced 'sunbeams' for such work. But the commer-
cial development of photolithography rightly begins a new story,[25]
and by the time William Griggs began producing his successful
series of *Shakspere quarto facsimiles* by means of photolitho-
graphy in 1880[26] the age of the hand-produced facsimile was
effectively over.

[24] William Blades, Preface to Caxton's
The dictes and sayings of the philosophers
(London, 1877), p.vi.

[25] On photolithography in general, see
G. Wakeman, *Victorian book illustration*
(Newton Abbot, 1973), pp.89–95.

[26] The first fourteen of the forty-three
quartos were produced and published by
William Griggs (nos. 1–13, 17), the remain-
der by Charles Praetorius.

Postscript

It seems appropriate to close this account of lithographed books produced in the age of the hand press with a brief discussion of those accounts of the process of lithography that were themselves printed lithographically. They are not numerous. Of the hundred or so treatises on lithography published in various editions in the period 1810 to 1860, only a few were produced throughout by lithography. Why was this so? If lithographic printers who wrote books about lithography did not use the process for their own books, who else would have done so?

The answers to these questions have, I hope, been provided in previous chapters of this book. In these I have shown that people who used lithography for book production did so for one or more of several reasons, but mostly because traditional letterpress methods failed to meet all their needs. Sometimes this was because letterpress printing was too expensive for short-run publishing or could not cope satisfactorily with illustrations; on other occasions it was because a text involved considerable use of non-linear configurations, rule work, non-latin characters, or music. Most of the publications discussed in this book fall into one or more of these categories, and collectively they point to some of the inadequacies of letterpress printing.

On the other hand, there was nothing so difficult about the printing of the text of a lithographic treatise that would have called for the use of lithography. The central thesis of this book – that lithography presented a reasonable alternative to letterpress book production only under certain circumstances – is therefore confirmed by the fact that very few lithographic printers who wrote about lithography used the process to print the texts of their own books.

It is true that many writers on lithography of the first half of the nineteenth century included examples of lithographic writing or transfers of letterpress printing among their specimens of the process, but their treatises fall far short of being classed as improper books. The earliest treatises on lithography to be produced throughout by the process date from the 1820s. Most of them are

not very substantial and warrant only a brief discussion here. Three were produced by the printing house set up by Senefelder in Paris, which traded under the name A. Senefelder et Compagnie from Boulevard Bonne Nouvelle, No 31. One of these publications is an unillustrated set of instructions for printing from Senefelder's portable press [276–278]. It consists of a displayed title-page, an index, and eighteen pages of neatly written text with carefully lettered chapter headings, and bears the title *Instruction. Pour servir à l'usage des presses portatives et des pierres, planches et papiers lithographiques, ainsi que de la planche économique* (Paris, 1824). The only copy of this little book that has been traced survives in a mutilated form as separate leaves cut from a volume of miscellaneous publications. Nevertheless, it is fairly typical of the use made of lithography for small-scale books and pamphlets in the 1820s. The other two Senefelder productions were French and English editions of the same work about a refinement in drawing on stone that was called lithographic aquatint. They were issued anonymously with the following titles: *L'Aquatinte lithographique ou manière de reproduire des dessins fait au pinceau* (Paris, 1824) and *Lithographic pencil drawing or instructions for imitating aquatinta on stone* (London, 1824). The author of these books is described in the English edition as 'A Pupil of Mr Senefelder', but elsewhere he is revealed to be Bernard Gaillot.[1] Both editions of the book are slim quartos in lithographed wrappers; they contain a few pages of descriptive text and a collection of sample plates demonstrating the possibilities of lithographic aquatint. Though the writing of their texts is competently executed in an elegant copperplate hand, these two editions of the same work are even less like a book in terms of their overall design than Senefelder's *Instruction*.

About the same time, a German version of Englemann's *Manuel du dessinateur lithographe* was produced in lithographed form with the title *Unterricht für Künstler und Liebhaber die auf Stein zeichnen wollen*. Though it appeared without a place or date of publication, it was probably produced in Berlin in 1823. Responsibility for this publication is not at all clear: the foreword acknowledges that it was based on Englemann's *Manuel* and explains that all unnecessary material had been excluded and that one section had been re-written. This section was the one dealing with engraving on stone, which was more popular in Germany than in France at the time and had been treated somewhat dismissively by Engelmann. But the changes made to the text seem to have been more substantial than the foreword suggests, and it is possible that the book was published without Engelmann's authority and even without his knowledge. In support of this claim it should be said that Engelmann made no mention of it in the list of works on

[1] See Engelmann, *Traité*, p.44.

13.

l'on s'apperçoive, que le noir se détache et que les traits deviennent blancs. On perd quelquefois 3 à 4 heures pour desencrer ainsi une planche, qui aura resté plusieurs années, surtout sans encre grasse. Quand l'encre d'impression est totalement déséchée, ce n'est que par beaucoup d'efforts et de soins, que l'on parvient à rapeller les corps gras sur la surface de la pierre.

CHAPITRE. 8.

Manière de conserver la planche.

Pour conserver une pierre ou planche, il faut d'abord l'encrer proprement avec l'encre grasse après avoir enlevé l'ancienne. On la laisse sécher pendant une demi heure, ensuite on y passe une solution de gomme arabique avec un cinquième de sucre candi; après quoi une planche se conservera plusieurs années, surtout si l'on a soin de la mettre dans une cave ou tout autre endroit, où la gèle ne pourra l'atteindre.

La pratique et l'expérience sont indispensables pour un tirage suivi; l'intelligence de l'amateur doit faire autant que le peu de théorie, que nous venons de donner et à l'appui de laquelle nous supposerons quelques inconvéniens, qui se montrent le plus souvent dans l'exécution lithographique avec les causes et les moyens de les obvier ou d'y remedier. Voyez les questions et reponses.

276, 277. [A. Senefelder et Compagnie], *Instruction* (Paris, 1824). Lithographed throughout and printed by A. Senefelder & Compagnie, Paris. Disbound pages as shown, approx. 190 × 120 mm. [Cat. 1.190].

278. Detail of 277. 67 × 95 mm.

279. *Unterricht für Künstler und Liebhaber*, probably printed in Berlin in 1823. Lithographed. Detail of p.6 showing copious use of underlining. 100 × 160 mm. [Cat. 1.230].

lithography he published in his *Traité*, though he did refer to a German translation of his *Manuel* that was published in Berlin in 1833 with the title *Handbuch für Steinzeichner*.[2]

Unterricht für Künstler und Liebhaber was issued in blue-paper lithographed wrappers in a quarto format. Though it has a foreword and a contents list, it has no title-page, and no real attempt seems to have been made to produce anything other than a reproduction of a manuscript. Its thirty pages are neatly written in a traditional German cursive hand; headings to the sections appear in a larger form of the same hand and, along with key words and phrases in the body of the text, are underlined [279]. At the rear of the publication are two folding plates, which include close copies of selected parts from several plates in Englemann's *Manuel*.

Chevallier and Langlumé's *Mémoire sur quelques améliorations apportées à l'art de la lithographie* (Paris, 1828) is even less like a proper book than *Unterricht für Künstler und Liebhaber*. It looks like a report, which in a sense it is, since it describes the methods the authors had developed for making alterations to drawings on stone which led to their being awarded a gold medal by the Société d'Encouragement in 1828.[3] Its title is at the head of the first page and it is written throughout in a fairly informal *ronde* hand, with headings in larger sizes of an *anglaise*. The most impressive pages of the publication are fifteen crayon-drawn plates, which were printed by Langlumé. They show applications of the authors' improvements and, in particular, Langlumé's ability to show different states of lithographs, both before and after alterations had been made to them.

Another lithographic publication that need not detain us long is Philip De la Motte, *On the various applications of anastatic printing and papyrography* (London, 1849). Its text was produced

2 'Ouvrages publiés sur la Lithographie', *Traité*, pp.452–458.

3 For a brief description of the process used by Chevallier and Langlumé, see Twyman, *Lithography*, pp.136–137. When I wrote that account I had not been able to trace a copy of their 1828 publication and took its title from the bibliography in Engelmann's *Traité*, p.455.

throughout by the branch of transfer lithography that De la Motte called papyrography (which involved writing with lithographic ink on transfer paper and transferring the image to zinc plates). It is of special interest here only because it includes (on pages 6 & 7) an example of a page of letterpress printing facing a page of the same setting transferred to zinc and printed lithographically. The book includes sixteen examples of anastatic printing and papyrography, which were printed on one side of the leaves only and interspersed through the twenty-four pages of the text. The text and plates of the treatise were printed on rather heavy, inflexible paper and, as a result, it does not handle much like a book; moreover, though it has a lithographed title-page, it displays few of the features of a traditional book.

One lithographic treatise deserves to be singled out for detailed attention here. This is J. Desportes, *Manuel pratique du lithographe* (Paris, 1834) [280–282], which was published in a second edition (Paris, 1840) with the same title and some addditional material.[4] Both editions were printed and published by their author, the later one jointly with Maison, a Parisian bookseller. Jules Desportes was a lithographic printer of note who founded and managed the first lithographic trade journal, *Le Lithographe, journal des artistes et des imprimeurs* (Paris and Rotterdam, 1837–48). He won several awards from the Société d'Encouragement pour l'Industrie nationale, including a silver medal (1830) for his treatise and another (1839) for his journal.[5] Desportes described himself as 'Imprimeur lithographe, professeur de lithographie à l'Institut royal des Sourds-Muets de Paris'. It is by no means clear what this meant; the Institute offered lithography as one of the trades it taught the children in its care,[6] but Desportes also seems to have run his own commercial lithographic press. Both editions of Desportes's *Manuel pratique du lithographe* carry the imprint 'Imprimerie lithographique de Jules Desportes, pont neuf, no. 15, en face Henri IV' on their final page, and it has to be assumed that this press was different from the one at the Institut royal des Sourds-Muets about a mile away in the rue St Jacques. The press at the Institute printed most of the plates in Desportes's journal *Le Lithographe* and some of the plates in the second edition of his treatise. These plates carry such imprints as 'Lith. Desportes, Institut royal des Sourds-muets'. But whatever the circumstances

[4] In *Le Lithographe*, vol.2, 1839, p.83, Desportes referred to two lithographic treatises that he knew to have been produced by transfer lithography. I have not managed to trace any other substantial one, though it is possible that he was referring to the two editions of his own

book, the second of which must have been in preparation in 1839.

[5] See *Le Lithographe*, vol.3, 1842, 'Notice historique sur la lithographie', p.70. The date given for the award of a silver medal for his manual (1830) suggests that it took some years to produce, since it bears

the publication date 1834. The date of Desportes's medal is confirmed by Engelmann, *Traité*, p.450.

[6] *Galignani's new Paris guide* (Paris, 1847), p.423.

under which Desportes may have done his printing, he exercised
an important influence on French lithography in the 1830s and
1840s, and his *Manuel pratique du lithographe* provides the best
example I know of the work of a lithographic printer who used the
process of lithography to produce his own book.

Desportes's manual is also important in terms of what it tells
us about lithography. It adds considerably to our understanding of
the process in the decade after the publication of the first two
editions of Engelmann's short but seminal book, *Manuel du
dessinateur lithographe* (Paris, 1822 and 1824), and prepares the
way for the same author's comprehensive work *Traité théorique
et pratique de lithographie* (Mulhouse, 1835–40).

Our concern here, however, is solely with its design and pro-
duction; and on these accounts it must rank as one of the most
substantial and book-like improper books of the period. The first
edition runs to 272 pages (including a title, 32 preliminary pages,
and 238 text pages), and it has four plates of lithographic utensils
and materials. It has all the ingredients one would expect to find
in a book of the period: a carefully considered title-page; generous
margins disposed in the conventional proportions; displayed chap-
ter openings that begin on a fresh page; a regular measure; the
same number of lines to each page; centred folios at the head of
the page; footnotes in a different size from the text; and, most
significant of all, signatures. In other words, it was designed and
produced by people who understood books.

The two editions of Desportes's book are very similar, and for
this reason they can be discussed together. Apart from a change of
title-page design in response to new tastes in letterforms and
methods of display, some additional preliminary pages, and a few
new plates (that were also published in *Le Lithographe*), the
second edition is the same as the first. It seems clear from a passage
in the supplementary text which appeared with the second edition,
that the book was mostly made up from unused sheets of the first
edition, and that only a few sheets that fell short of the others in
numbers were newly printed. A comparison of imperfections in
the printing of the two editions confirms that many of their sheets
must have come from the same print run.

The presswork of Desportes's manual is not of the highest order,
but otherwise the book was extremely well produced. Its writing
is fluent and regular, and changes its style according to the cate-
gory of information being handled. For example, the main body of
the text is in a flowing cursive hand [281], whereas the 'Avertisse-
ment' is in a hand that would have been described as a *coulée*, and
the section on 'Lois et Reglements' and the footnotes are in a
ronde. Chapter headings are in a large *ronde* which, by virtue of
its size and thickness of stroke, gives them some of the character-

280, 281. J. Desportes, *Manuel pratique du lithographe* (Paris, 1834). Lithographed. Printed by Desportes, Paris. Page size 203 × 125 mm. [Cat. 1.83].

282. Detail from Desportes, *Manuel pratique du lithographe,* showing a bold-looking *ronde* and a range of other styles of writing at the opening of a section. Approx. 65 × 90 mm.

111

Lois et Réglements sur la Presse.

Formalités

pour obtenir

un Brevet d'Imprimeur en lettres,

de lithographie ou de Libraire

istics of bold type in letterpress printing [282]. Lines of solid text were given an even profile to the right by means of the well-tried manuscript custom of introducing flourishes on terminal letters of words towards the end of a line, and particularly on the last word of a line. Word divisions were used occasionally, but not as frequently as would normally have been the case when setting type to a similar measure. The book was written on transfer paper, and it is possible that it was the work of a M. Foucher, who was credited by Desportes with having written a half-sheet of lithographed text (eight pages) that appeared in an article on 'Autographie' in his journal *Le Lithographe.*[7]

The most unusual aspect of Desportes's treatise is its use of signatures. Apart from some music books produced by major music publishers, and the publications of Isaac Pitman, relatively few other improper books have signatures. Desportes printed signatures on sheets throughout his treatise, except on those of the preliminary sections and two other sheets (where they were inadvertently omitted). It is also worth mentioning that a few of its pages have catchwords. By the 1830s catchwords were a somewhat old-fashioned feature of book production, and this may account for the fact that they were used very infrequently and in a seemingly random way in this book.

Though it is likely that Desportes wanted to demonstrate some applications of the process he was writing about, there can be little doubt that he turned to lithography for the production of his manual because he had on hand the facilities to do so. His manual can therefore be considered as the work of an 'in-plant' press. In this respect it has something in common with the productions of the military presses of Chatham and Metz. It differs from these

[7] See *Le Lithographe,* vol.2, 1839, p.84; the lithographed pages are pp.85–92.

and most other lithographed books of the period in that its text presented few of the problems that led the authors and publishers of the books discussed in the foregoing pages to turn to lithographic methods of production.

Desportes's *Manuel pratique du lithographe* is an exception among lithographic treatises, and for this reason it is useful to consider it here by way of conclusion. It serves to highlight the fact that the majority of lithographers who wrote about their trade – in common with the majority of authors and publishers of straightforward texts in the nineteenth century – found it more appropriate and convenient to have their books printed by conventional letterpress methods than by lithography.

Lithographic writers

A checklist of lithographic writers and letterers in the age of the hand press in Europe

This checklist includes professional and amateur writers, whether they contributed to the production of the books listed in Appendix B or not.

Many lithographic firms referred to lithographic writing and lettering on their trade cards; the names of such firms have been included only when this kind of work is known to have been one of their specialities.

References to illustrations in the text are in square brackets.

ASHBEE & TUCKETT. Described on one of their trade cards, c. 1843–52, as 'Lithographers and printers in colors', undertaking work in ornamental writing and for title-pages, deeds and charters. The card (in a private collection) is reproduced in G. Wakeman and G. D. R. Bridson, *A guide to nineteenth century colour printers* (Loughborough, 1975), p. 5.

B., L. J. D. [L. J. Du Blar]. Described as 'Sténographe, artiste-écrivain, et dessinateur' on the title-page of his treatise, *Coup-d'œil sur la lithographie* (Brussels, 1818). The author's full name is known from a signed dedication included in a copy belonging to Leonard B. Schlosser. *See* Twyman, *Lithography*, p. 92, 94–95.

B., R. Monogram, with the two letters sharing a common stem and the R reversed. Appears on several items printed by Hullmandel in the 1820s, including the wrappers of R. Newenham, *Picturesque views of the antiquities of Ireland*, 2 vol. (London, 1830) and two sheet-music covers of the 1820s (J. Blewitt, 'Love a gypsey', and A. Lee, arr., 'Buy a broom!'). RB may perhaps be identified with the artist referred to in the *Library of the Fine Arts*, vol. 1, no. 3, Apr. 1831, p. 215, as Baker of Sydenham, who is said to have produced the much praised specimen of ink lithography which served as an advertisement for the lithographic printer Robert Martin (*see below* under Martin).

BERRY, William. Registering Clerk at the College of Heralds, London, for many years. He wrote out on transfer paper five volumes of his series of *County genealogies* in the late 1830s and early 1840s. *See above* p. 100–102, [98–100], and Cat. 1.20–1.24.

BOLLINGER, F. Signed title-page of C. Mielach, 'Teutsche Lieder und Romanzen'. *See* Liesbeth Weinhold, 'Joseph Anton Sidler ein Münchner Lithograph, Musikalienhändler und Musikverleger der Biedermeierzeit (1785–1835)', in *Musik in Bayern*, no. 22, 1981, p. 199.

BROWN, H. Lettered his own trade card, 'Specimen of Brown's lithography', Coventry, *c.* 1840 (private collection).

BUTTERWORTH, James. Author of several shorthand books which he wrote out in his own hand. *See* Cat. 1.48–1.54.

CARTWRIGHT, Richard, & Son. Firm of London law stationers, specializing in law forms, writing, and lithographic printing. Worked in the second quarter of the nineteenth century. *See* Twyman, *Directory*, p. 26.

CHIFFERIEL, Frederick. Firm of London stationers, established in 1819. Provided a service in the lithographic copying of documents. A trade card with the address 34 & 35 Cursitor Street, Chancery Lane, and dated 2 Nov. 1858, describes the service in detail (John Johnson Collection, Bodleian Library).

COGGIN, Thomas. Responsible for the writing out of *The New Testament in Lewisian short hand* (London, 1849), which is signed and dated 21/12/1844. *See* Cat. 1.28.

DALL'ARMI, Giovanni. Author and, according to its final page, lithographic writer of *Ristretto di fatti acustici* (Rome, 1821–22). *See* Cat. 1.80.

FELLOWS, Frank P. Author and lithographic writer of *Poems* (*c.* 1883). *See* Cat. 1.98.

FEUQUIÈRES, Jules. Responsible for the writing and hieroglyphs in J.-F. Champollion, *Dictionnaire égyptien* (Paris, 1841–43). *See above* p. 141, [154–156], and Cat. 1.65.

FORSTER, Andre. Munich lithographer whose first recorded lithograph is dated 1805 (Winkler, 221). Later worked at the land registry printing office and undertook some lettering in the style of Mettenleiter. There are examples of his work in the Winkler Collection, Munich.

FOUCHER. Referred to in *Le Lithographe*, vol. 2, 1839, p. 84, as having written on transfer paper the half sheet of lithographed pages which appeared in the same issue of the journal as p. 85–92. Foucher is described in the text as one of the foremost artists in this field. *See above* p. 266.

HARRIS, John (junior). Described on his trade card of *c.* 1851 as 'Artist, Lithographer and Copyist, 40, Sidmouth Street, Regent Square' (Great Exhibition Collection, Reading University Library). *See above* p. 202.

HORNBLOW, (Mr). Lithographic writer of H. Stanley, *Chinese manual* (London, 1854), where he is described as a transcriber at the British Museum who familiarized himself with Chinese. *See* Cat. 1.197.

JOHANNOT, Charles Isaac (Karl) (1790–1824). Signed a trade card of Guyot-Desmarais, *c.* 1809 (Bibliothèque Nationale, Paris). *See above* p. 127, [140].

KREINS, H. Signed some pages of Feigneaux, *Cours théorique et pratique de tenue de livres en parties doubles* (Brussels, 1827). *See above* p. 92, 93, [86], and Cat. 1.97.

KROSKY, E. Early nineteenth-century lithographic writer working in Munich. There are signed items of his ephemeral work (e.g. a visiting card) in the Winkler Collection, Munich.

L., A. Signed title-page of F. Stœpel, *Méthode théorique et pratique de chant* (Paris, 1836). *See* Cat. 1.199.

L., H. These initials, possibly of a lithographic writer, appear on the final page of C. L. H. von Tiedemann, *Vorlesungen über die Tactik* (Berlin, 1820). *See* Cat. 1.258.

LACROIX, P. Signed some pages of Feigneaux, *Cours théorique et pratique de tenue de livres en parties doubles* (Brussels, 1827). *See above* p. 92, [84], and Cat. 1.97.

LAFONT, A. Signature, possibly of a lithographic writer or letterer, on the title-page of A. Panseron, *Méthode complète de vocalisation pour mezzo-soprano* (Paris, 1855). *See* Cat. 1.167.

M., I. *See below* under Magenis.

M...R, L. Signed a series of articles on lithographic drawing and writing in *Le Lithographe*, vol. 2, 1839, and vol. 3, 1842. The abbreviated form of the name (which appears in vol. 2, p. 342, and vol. 3, p. 27) is followed by the description 'écriv. dess. lithogr.'.

M'NEVIN, J. Signed some pages of E. Ryde, *Ryde's hydraulic tables* (London, 1851). *See above* p. 96–98, [91], and Cat. 1.184.

MAGENIS, J. Often used the monogram IM, with the letter I super-imposed on the M. This monogram is found on several items printed by Hullmandel in the mid 1820s, including the following: the boards and title-page of Hullmandel's *The art of drawing on stone* (London,

1824); the title-page of E. H. Locker, *Views in Spain* (London, 1824); the wrappers of H. Walter, *Studies of various animals* (London, nd); and the wrappers of Lady Elton, *Four panoramic views of the city of Edinburgh* (1823). The identity of this writer and letterer is established beyond reasonable doubt by Richard Lane's *Studies of figures by Gainsborough* (London, 1825), where the dedication is signed with the IM monogram and the title-page is lettered in full 'J. Magenis Scr:'.

MARSH, C.	Signed the title-page of T. Barker, *Thirty two lithographic impressions, from pen drawings of landscape scenery* (Bath, 1814). *See* Twyman, 'Thomas Barker's lithographic stones', *Journal of the Printing Historical Society*, no. 12, 1977/8, p. 7–9.

MARTIN, Robert.	Signed a 'Specimen' of lithographic writing which was printed by Charles Madinger Willich in 1819. In the following year he is referred to in an advertisement as a lithographic writer at 23 Rochester Street, Vincent Square, Westminster (*Gentleman's Magazine*, Dec. 1820). By 1825 he was working as a lithographic printer, and he continued to do so for at least twenty years. He is best known for an outstanding 'Specimen of ink lithography' (1830, 1831), which was hailed as a tour de force. *See above* B., R., and p. 32, 34, 173, 174, 177, and Cat. 1.79. *See also* Twyman, *Directory*, p. 40–41.

METTENLEITER, Johann Evangelist (1792–1870).	The major German lithographic writer and letterer of the first half of the nineteenth century. He was renowned for his intricate and decorative style of lettering, often engraved on stone. His earliest recorded work dates from 1813. Almost fifty years later he engraved on stone a series of specimens of lettering with the title *Schriften-Magazin für Freunde der Kalligraphie* (Leipzig, 1860). *See above* p. 31–32, and Cat 1.88. *See also* R. A. Winkler, *Die Frühzeit der deutschen Lithographie* (Munich, 1975), 536, for numerous items lettered by him.

MOREAU, César.	French Vice-Consul in Britain, economist, and author. Signed and dated the last page of several of his lithographed publications of the 1820s. *See above* p. 89–91, and Cat. 1.250–1.256.

MOULIN.	Signed title-page of Georgiana Spencer, Duchess of Devonshire, *Passage du Mont saint-Gothard* (Paris, c. 1817) and the title-page of a piece of sheet-music printed by Mlle Formentin in Paris in the 1820s. *See above* p. 172, 172n, [187], and Cat. 1.196.

NETHERCLIFT, Frederick George.	Son of Joseph Netherclift and took over from him as the leading lithographic facsimilist in Britain. Worked as a facsimilist with his father and then, in 1855, with Durlacher (Netherclift & Durlacher) at 18 Brewer Street, Golden Square. By 1862 he was printing and publishing under the style F. G. Netherclift from 17 Mill Street, Conduit Street, Regent Street. *See above* p. 202, 235, 240–241, and Cat. 1.159–1.161, 1.174.

NETHERCLIFT, Joseph. Father of Frederick George Netherclift.
Probably the earliest regular lithographic writer in Britain. Frequently
signed his work. Already working as a lithographic writer in 1820
from 42 Rathbone Place, and 5 Everett Street, Russell Square. At this
stage he seems to have been concerned with lettering on title-pages
and wrappers and worked for several of the leading printers (N. Chater,
C. J. Hullmandel, and Rowney & Forster) and publishers (R. Acker-
mann and Rodwell & Martin). Later he turned to the reproduction of
non-latin scripts and facsimiles of old documents. In 1827 he used the
style 'Lithographer to the Asiatic Society'. By 1829 he had his own
press at 8 Newman Street, Oxford Street. His address changed to
54 Leicester Square around 1832 and, from about 1834, to 23 King
William Street, Strand. He continued as a printer, in later years in
partnership with his son, until at least July 1858, by which time the
address was St Martin's Lane. *See* Cat. 1.115, 1.162–1.164, 1.240, 1.252,
1.256, and Index. *See also* Twyman, *Directory*, p. 42.

PATTAGAY. Lithographic letterer of title-page of P. Leo Stöcklin,
'15 Kirchen-Lieder', Basel (H. Baron Collection, Reading University
Library).

PHILLIPPS, Sir Thomas (1792–1872). Antiquary, bibliophile, and
amateur lithographic writer. Responsible for writing out on transfer
paper at least two of his own publications. *See* Cat. 4.7, 4.11, and Index.

PIERRON. Signed the title-pages of two publications of the École
d'Application de l'Artillerie et du Génie, Metz, of the mid 1820s. *See
above* p. 66 n, [20], and Cat. 3.18, 3.25.

PITMAN, Sir Isaac (1813–97). Prolific writer of phonography on trans-
fer paper for his own books and journals from the early 1840s to 1874.
See Index.

ROBERTSON, J. Described as a 'Lithographic Draughtsman & Writer'
at 9 Hatton Garden on a trade card of *c.* 1830 (Guildhall Library, Prints
& Drawings).

ROSENBERG, (Hauptmann). Writer of wrappers of C. Viehbeck (Ed),
Die Gebirgswohner in Ober Osterreich Salzburg und Tyrol (1818)
(Winkler Collection, Munich).

SCHAEFER. Signed title-page of F. Fraenzel, 'Trois quatuors concer-
tants pour deux violons, alto & violoncelle' (Charenton: Vernay,
c. 1804) (H. Baron Collection, Reading University Library).

SENEFELDER, Clemens. Lithographic writer of *Erinnerungs-Buch für
das Jahr 1813. See* Cat. 1.94.

SENN, S. Signed two large advertisements for 'Parfum du Sacre' and 'Chocolats . . . de la fabrique du Fidèle Berger', printed by Engelmann in the 1820s. The first appears to have been entirely his own work, the other, which includes a pictorial surround, also refers to the draughtsman, Le Roy (Engelmann, Albums de référence, Cabinet des Estampes, Dc 516, Bibliothèque Nationale, Paris).

SIDLER, Joseph Anton. Signed title-page of K. Neuner, 'Die Schöpfungs-Tage'. *See* Liesbeth Weinhold, 'Joseph Anton Sidler ein Münchner Lithograph, Musikalienhändler und Musikverleger der Biedermeierzeit (1785–1835)', in *Musik in Bayern*, no. 22, 1981, p. 199.

SWAN, Henry. Responsible for engraving shorthand on stone for some issues of the *Phonographic Examiner* in the 1850s. *See above* p. 155, [171, 172], and Cat. 5.38.

TÖPFFER, Rodolphe (1799–1846). Swiss author and artist. Wrote out on transfer paper many of his illustrated books of the 1830s and 1840s. *See* Cat. 1.205–1.229 and Index.

TUPPER, George Isaac Frederick (1820–1911). Facsimilist, specialized as a copyist of Caxton. *See above* p. 202, 256 n, and two papers by Robin Myers: 'William Blades's debt to Henry Bradshaw and G. I. F. Tupper in his Caxton studies: a further look at unpublished documents', *Library*, 5th series, vol. 32, 1978, p. 265–283; and 'George Isaac Frederick Tupper, facsimilist, "whose ability in this description of work is beyond praise" (1820–1911)', *Transactions of the Cambridge Bibliographical Society*, vol. 7, no. 2, 1978, p. 113–134.

VANHYMBEECK, Auguste. Signed a trade card of the lithographic printer J. Cluis, Place du Châtelet, Paris, *c.* 1840 (Winkler Collection, Munich).

VACHER, Thomas, & Sons. Specialized in parliamentary work and copying old documents. Trade card in the John Johnson Collection, Bodleian Library. *See* Twyman, *Directory*, p. 51.

VERSTRAETE, Hippolyte. Music writer. Signed final page of S. Daniel, *Grammaire philharmonique*, 2 vol. (Bourges, 1836–37). *See* Cat. 1.81.

VIALON, A. Signed title-page of A. de Garaudé, *New method of singing* (Paris and London, *c.* 1845). *See* Cat. 1.107.

WEBER, Johann Friedrich. Signed title-page of 'Musikalischer Jugendfreund'. *See* Liesbeth Weinhold, 'Joseph Anton Sidler ein Münchner Lithograph, Musikalienhändler und Musikverleger der Biedermeierzeit (1785–1835)', in *Musik in Bayern*, no. 22, 1981, p. 199.

WHITTOCK, Nathaniel. Described himself as 'Lithographic Engraver and Printer to the University of Oxford'. First recorded at 11 London Place, St Clements, Oxford. A trade card of his of the mid 1820s (John Johnson Collection, Bodleian Library) refers to 'Fac-similes, & MS in any character' and illustrates several non-latin examples. He later moved to London. A trade card of Whittock & Goodman, c. 1828 (private collection), with the address 14 Paternoster Row, refers to 'Ms's and Fac Similes in any Characters Circular Letters, &c &c &c.' *See* Twyman, *Directory*, p. 53.

WILLICH, Charles Madinger. Several trade cards and circulars of his firm exist from around 1819 (Gregson Correspondence, Liverpool Record Office, and elsewhere). They reveal that he specialized in lithographic writing for jobbing printing. *See* Twyman, *Directory*, p. 53.

WILME, B. P. Author of *A manual of writing and printing characters . . . for the use of architects, engineers and surveyors, engravers, printers, decorators, and draughtsmen* (London, 1845). Includes numerous examples of lettering drawn on stone or zinc by Wilme. *See above* [19].

WISSLER, J. Signed title-pages of music in the 1820s which were printed by Engelmann in Paris (Engelmann, Albums de référence, Cabinet des Estampes, Dc 516, Bibliothèque Nationale, Paris).

WYLD, James (senior). Acknowledged as the writer of *Catalogue of books in the Library of the Military Dèpot, Q. M. Genls. Office* (London, 1813). *See above* p. 49, 51, [41–43], and Cat. 1.60, 1.238.

Catalogue

A catalogue of books printed entirely or mainly by lithography
in the age of the hand press in Europe.

Though this catalogue is defined as relating to the age of the hand press,
it seems likely that a few of the later books listed in it were printed on
powered machines. The geographical scope of the catalogue is also a
little elastic, and some books have been included that were produced for
the British community in India. For further discussion of the scope of
this catalogue, see the Preface, p.9.

For the most part the catalogue follows the recommendations of
ISBD(A): *International Standard Bibliographic Description for older
monographic publications (Antiquarian)* (London, 1980). In the notes
to entries, emphasis has been put on features that relate to lithography.

I have given format statements only when I felt reasonably confident
in making them on the basis of artefactual or documentary evidence
(e.g. stone impression marks or a publisher's description), but such state-
ments do not necessarily indicate format in a strict bibliographical sense.
Statements of signing are given, rather than regular collational formulas,
and are limited to initial signings of gatherings. The presence of signa-
tures reflects the physical structure of gatherings in some, but not all,
cases. Some of the books described are extremely unorthodox in their
use of signatures and in their production generally; others are so tightly
bound that it would be impossible to report on their physical make-up
without first pulling them apart. All departures from the conventional
twenty-three characters of the printer's alphabet have been recorded.

The locations of most of the copies that have been studied are given
on p.338.

The following forms of abbreviation have been used
for publications:

Abbey, *Life*	Abbey, J. R., *Life in England in aquatint and litho-graphy 1770–1860*. London, 1953.
Abbey, *Scenery*	Abbey, J. R., *Scenery of Great Britain and Ireland in aquatint and lithography 1770–1860*. London, 1952.
Abbey, *Travel*	Abbey, J. R., *Travel in aquatint and lithography 1770–1860*. 2 vol. London, 1956–57.
Baker	Baker, A., *The life of Sir Isaac Pitman*. 2nd ed. London, 1913.
Blake	Blake, N. F., *William Caxton : a bibliographical guide*. New York and London, 1985.
Bridson & Wakeman	Bridson, G., & Wakeman, G., *Printmaking & picture printing : a bibliographical guide to artistic & industrial techniques in Britain 1750–1900*. Oxford & Williamsburg, 1984.
Brown & Haskell	Brown, K., & Haskell, D. C. (Comp.), *The Short-hand Collection in the New York Public Library: a catalogue of books, periodicals, & manuscripts*. New York, 1935.
Brunet	Brunet, J.-C., *Manuel du libraire et de l'amateur de livres*. 6 vol. Paris, 1860–64.
DNB	*Dictionary of National Biography*. Oxford, 1897–98 (reprinted 1959–60); and supplements.
Dobell	Dobell, B., *Catalogue of books printed for private circulation*. London, 1906.
Dunthorne	Dunthorne, G., *Flower and fruit prints of the 18th and early 19th centuries*. London, 1938.
Dussler	Dussler, L., *Die Incunabeln der deutschen Litho-graphie (1796–1821)*. Berlin, 1925.
Fenwick	Fenwick, T. F. (Ed.), *The Middle Hill Press: a short catalogue of some of Sir Thomas Phillipps' privately printed works*. London, 1886.

HAL *Historical accounting literature: a catalogue of the collection of early works on book-keeping and accounting in the Library of the Institute of Chartered Accountants in England and Wales.* London, 1975.

Halkett & Laing Halkett, S., and Laing, J., *Dictionary of anonymous and pseudonymous English literature.* 8 vol. new edition edited by J. Kennedy, W. A. Smith, and A. F. Johnson (vol. 1–7), and D. E. Rhodes, and A. Simoni (vol. 8), Edinburgh and London, 1926–56.

JPHS *Journal of the Printing Historical Society.*

Kampmann Kampmann, C., *Die Literatur der Lithographie von 1798–1898.* Vienna, 1899.

Kraus Kraus, H. P., *A catalogue of publications printed at the Middle Hill Press 1819–1872.* New York, 1972.

Lowndes Lowndes, W. T., *The bibliographer's manual of English literature.* Edition revised by H. G. Bohn. 4 vol. London, 1864.

Martin Martin, J., *A bibliographical catalogue of books privately printed.* London, 1834; 2nd edition London, 1854 (the 2nd edition is the one referred to unless otherwise stated).

NSTC *Nineteenth century short title catalogue.* Series II, phase I: 1816–70. Newcastle-upon-Tyne, 1986–.

Osborne *The Osborne Collection of early children's books.* 2 vol. Toronto, 1958, 1975.

Pantazzi Pantazzi, S., 'A versatile Victorian designer : his designs for book covers – John Leighton, 1822–1912'. *Connoisseur,* April 1963, p.262–273.

Schwerdt Schwerdt, C. F. G. R., *Hunting hawking shooting illustrated in a catalogue of books manuscripts prints and drawings collected by C. F. G. R. Schwerdt.* 4 vol. London, 1928.

Sotheby Sotheby & Co. (Hodgson's Rooms), *Catalogue of printed books comprising publications of the Middle Hill Press from the celebrated collection formed by Sir Thomas Phillipps.* London, 1969.

Suzannet Suzannet, A. de., *Catalogue des manuscrits livres
 imprimés et lettres autographes composant la
 Bibliothèque de La Petite Chardière : Oeuvres
 de Rodolphe Töpffer*. Lausanne, 1943.

Twyman Twyman, M., *Lithography 1800–1850: the
 techniques of drawing on stone in England and
 France and their application in works of topo-
 graphy*. London, 1970.

Twyman, *Directory* Twyman, M., *A directory of London lithographic
 printers 1800–1850*. London, 1976.

Wakeman Wakeman, G., 'Anastatic printing for Sir Thomas
 Phillipps'. *Journal of the Printing Historical
 Society*, no.5, 1969, p.24–40.

Westby-Gibson Westby-Gibson, J., *The bibliography of shorthand*.
 London and Bath, 1887.

Winkler Winkler, R. A., *Die Frühzeit der deutschen Litho-
 graphie: Katalog der Bilddrucke von 1796–1821*.
 Munich, 1975.

General

1.1 AGUEDO, Manoel Nunes. Methodo geral para a viola franceza : Com principios de musica, escalas, arpejos, e preludios para todos os tons, que ensinão a acompanhar o canto . . . / Extrahido de diversos methodos os mais acreditados por Manoel Nunes Aguedo. – [S.l. : s.n.], Anno de 1840 (Lith. de A. C. de Lemos. Largo do Quintella Nº.1.). – 40 p. : ill., music ; 4°, 23 × 30 cm.

Lithographed throughout, apart from letterpress blue-paper wrappers. – The text drawn directly on stone in imitation of type. – Decorative title-page with border design. – Mainly music after p. 12. – The copy in the H. Baron Collection, which is uncut from p. 29–40, reveals that the printing was done four pages to view.

1.2 Allgemeines Erinnerungs-Buch für das Jahr 181[?]. – Mit Königlich baier'schen allergnädigsten Privilegium gegen den Nachdruck und den Verkauf der Nachdrucke. – München : in der Zeller'schen Handlung. – [216] p. ; 18 cm.

Lithographed throughout from handwriting. – The first 180 p. lithographed, the pages ruled for various purposes and with decorative headings for the beginning of each month. – The remaining pages letterpress. – The copy in the Winkler Collection has manuscript additions, including an alteration of the date on the title-page to 1823, and is incomplete. – For Zeller, *see* Winkler, 946.

1.3 ALSTRUP, Theodor. Skrivebog med Boghol-deri. En Øvelsesbog for Forretningsfolk samt til Brug ved Skoler og til Selvstudium. – Kjøbenhavn : Axel E. Aamodts Forlag, [c. 1883]. – [21] leaves, printed on versos only ; 23 cm.

HAL, p. 248. – Lithographed throughout from handwriting. – Letterpress wrappers with inner front cover printed with lithographed foreword. – No title-page. – Publication details are taken from the wrappers. – The date derives from examples of accounting in the text, many of which include the date Dec. 1883.

1.4 ANDRÉ, A. Thematisches Verzeichniss sämmtlicher Kompositionen von W. A. Mozart, so wie er solches vom 9ten Februar 1784 an, bis zum 15ten November 1791 eigenhändig niederge-schrieben hat. / Nach dem Original-Manuscripte herausgegeben von A. André 1805. – Offenbach a/M : bey Joh: André, [c. 1805]. – [6], 63 p. : ill., music on rectos ; 8° (25 cm).

Lithographed throughout, the text handwritten. – Parallel title-page in French reads: Catalogue thématique de toutes les compositions de W. A. Mozart, depuis le 9 février 1784, jusqu'au 15 novembre 1791. Mis au jour d'après le manuscrit-original, par A. André en 1805. – André's plate number (1889), which appears on all pages with music, is in agreement with a dating of 1805.

1.5 ANDRÉ, A. W. A. Mozart's thematischer Catalog, so wie er solchen vom 9. Februar 1784. bis zum 15. November 1791 eigenhändig geschrieben hat, / nebst einem erläuternden Vorbericht von A. André. – Neue mit dem Original-Manuscript nochmals verglichene Ausgabe. – Offenbach a/M : bei Johann André, [1828]. – [2], 63 p. : ill., music on rectos ; 27 cm.

Lithographed throughout, the text handwritten. – Preface is dated Nov. 1828 on p. 5, but André's plate number (5000) suggests that the publication may have been begun in 1827. – Lithographed portrait of Mozart as frontispiece signed 'A Hatzfeld lith'. – The copy in the Hirsch Collection of the British Library has a tipped-in engraved portrait.

1.6 The Anglican mysteries of Paris revealed in the stirring adventures of Captain Mars and his two friends Messieurs Scribbley & Daubiton / Depicted & described by a new firm with an old name videlicet Smith Payne & Co. – London : E. Moxon Son & Cº, 1870. – [3], 53 leaves printed on one side only (all but one rectos) : ill. ; 2° (38 cm).

Lithographed throughout in the tinted style with numerous pen and ink sketches and legends, usually

more than one to a page. – The initials JMS and JBP at the foot of the title-page (and JMS on many of the sketches) suggest that the authors were J. M. Smith and J. B. Payne.

1.7 Anglo-Venetian memorials. – Venice: [s.n.], 1851. – [20] leaves : ill. ; 2° (36 cm).

Lithographed facsimiles, mainly of 'Autographs concerning England from the Archives in Venice'. – Printed on one side of the sheet to make conjugate leaves.

1.8 Archiv für Stenographie. – Berlin : No. 1, 1849, to c. 1873 (thereafter mainly letterpress to c. 1914).

Brown & Haskell, p.486. – Lithographed throughout from handwriting until at least 1873. – At some stage after 1873 letterpress began to play an increasingly important part in the production of the journal. – It was initially edited by C. Witte and printed by Robert Winckelmann (or Winkelmann) in Berlin and published by the Commissionsverlag von A. Förstner in Berlin in 16 p. parts (17 cm). – Other printers who produced the journal in the 1850s were L. Veit, Metall Umdr. d. Königl. Lith. Inst. zu Berlin, and Th. Wendisch. – In the course of 1856 the Commissionsverlag von Enslin took over the publication, and in July 1859 W. Wackernagel became editor. – The format of the journal increased in size (to 20 cm) in 1879.

ARDANT, Paul-Joseph. *See* 3.1–3.4

1.9 ARETIN, J. C. F. von. Über die frühesten universalhistorischen Folgen der Erfindung der Buchdruckerkunst. : Eine Abhandlung vorgelesen in einer öffentlichen Sitzung der Academie der Wissenschaften in München, als diese den Tag ihrer Stiftung zum fünfzigstenmale feyerte am 28. März 1808. / von J. Christ. Freyherrn von Aretin, königl. Central-Bibliothek-Direktor. ; Herausgegeben mit dem vollständigen Fac simile des ältesten bisher bekannten teutschen Druckes. – München : [s.n.], 1808. – 50, [1] p., [5] leaves insert ; 4° (26 cm).

Dussler, p.247; Winkler, 711:9. – Letterpress text, with a 9 p. lithographed facsimile of the so-called Türkenkalender, Mainz, 1454, printed by J. A. Senefelder and hand-coloured to match the original. – *See also* Singer, S. W., *Researches into the history of playing cards* (London, 1816), p.158 n and *Der Türkenkalender* (Wiesbaden, 1975), p.9.

1.10 ATKINSON, G. F. Indian spices for English tables; or, a rare relish of fun from the Far East. Being, the adventures of 'Our special correspondent' in India, illustrated in a series of one hundred and twenty humorous sketches, and exhibiting, in all its phases, the peculiarity of life in that country. / By Capt. G. F. Atkinson, Bengal Engineers ... – London : Published by Day & Son, Lithographers to the Queen, [March 16th 1860]. – [6] p. : ill., 27 plates ; 28 × 38 cm + publisher's advertisement.

Lithographed throughout, apart from letterpress preliminary pages and advertisement. – Most plates consist of several sketches with handwritten legends. – The date is taken from the lithographed boards.

1.11 Auswahl katholischer Gebete aus bewährten Gebetbücher gesammelt und auf Stein geschrieben. – München : bey J. B. Oettl, 1819. – [3], 108, [4] p. ; 8° (17 cm).

Text lithographed throughout from handwriting. – Each page surrounded by a triple border (thin, thick, thin). – Vignette on title-page. – Frontispiece lettered 'In Stein gravirt von Ant: Falger'. – For Falger, *see* Winkler, 203.

1.12 B, H. A. [?]. Neilondé. An Egyptian scrap-book / by H A B [?]. – Dublin : William Robertson ; London : Simpkin, Marshall, and Co., '60. – [1], 20 leaves, printed on rectos only : ill. ; 26 × 38 cm.

Lithographed throughout by the transfer process. – Each leaf contains several pen and ink sketches with handwritten legends. – The author's initials are in the form of a monogram and may not be correctly identified or in the correct sequence. – The unusual form of the date follows the monogram.

1.13 B., L. G. The history of a hare. A true story. / By L. G. B. – [S.l. : s.n., c. 1850]. – [84] p. ; 4° (20 cm). – Sig: a-j⁴ k².

Lithographed throughout from handwriting, apart from signatures. – All pages, including the title-page, are surrounded by the same ivy-leaf border, which must have been transferred from a master image. – The writing is in a cursive copperplate with a norm of only four to six words to the line (70–80 mm). – Signatures are almost hidden in the lower borders and were either printed letterpress or stamped by hand. – Pressure marks suggest that the book may have been printed from metal plates. – Evidence for the dating comes from the text (which refers to the birth of the hare in June 1845) and a presentation inscription dated Jan. 1851. – Cased in red cloth, blind embossed and gold blocked.

1.14 BAILLOT, Pierre. Méthode de violon. / par MM. Baillot, Rode et Kreutzer. ; Redigée par Baillot adoptée par le Conservatoire de Musique à Paris. pour servir à l'étude dans cet établissement. – Violin

Schule. / von Rode, Kreutzer und Baillot. von dem Conservatorium der Musick [sic] in Paris zum Unterricht eingeführt. – Bonn und Cöln : bei N. Simrock, [c. 1812]. – 60 p. : ill., music ; 2° (34 cm).

Lithographed throughout. – Pages 3–7, 46–50, 53–60 have text in French and German in parallel columns. – The remainder of the book consists of music. – The title-page has a pasted correction slip giving the publisher's imprint as 'Cöln : bei P. J. Simrock'. – The date derives from the plate number (35) which appears on every page. – Pressure marks from the stones reveal that the pages were printed two to view. – Paper watermarked 'Van der Mu...len & Comp.'. – First edition 1803.

1.15 BALL, Robert. Rough sketches intended to aid in developing the natural history of the seals (Phocidae) of the British Islands / [by] R. Ball. – Dublin : s.n., 1837. – [13] leaves printed on rectos only : ill. ; 2° (37 cm).

Lithographed throughout. – No title-page. – All information about the publication is taken from a leaf listing the contents. – 12 plates (some signed by Ball) contain 39 crayon drawings, mainly in line. – The paper is watermarked 'G H Green 1834'. – The contents leaf of the British Library copy is inscribed by Ball 'For the British Museum R B' at its head.

1.16 BALTARD, Louis-Pierre. Journal descriptif et croquis de vues pittoresques faits dans un voyage en Savoye du 10 au 21 août 1837 / [by Baltard]. – Lyon : Imprimerie de N^ce. Brunet et C^ie., [c. 1837]. – [2], 45 p. : ill. ; 4° (36 cm).

Lithographed throughout, the text handwritten. – Contains 34 vignetted illustrations (either crayon or ink) in text. – The statement of responsibility is taken from the signature 'Baltard' on p. 45; confirmation that this is the architect L.-P. Baltard is provided by a reference to the Palais de Justice on the same page.

BARNARD, Edward William. *See* 1.79

1.17 BAUDIER, Michel. Histoire de l'incomparable administration de Romieu, Grand Ministre d'Estat en Provence lors quelle estoit en souveraineté. – A Paris : chez Jean Camusat, 1635.

Not traced. – Facsimile reprinted by Paul Dupont using his process of *lithotypographie* and referred to by him in *Essais pratiques d'imprimerie* (Paris, 1849), p. 39.

1.18 Bavariae Kneip-Lieder. – In Traunstein : Lithographische-Anstalt von J. Anton Miller, 1842. – 96 p. ; 17 cm.

Text lithographed throughout from handwriting. – The displayed title-page includes a monogram which can be read as 'CTevB!'.

1.19 BERLIOZ, Hector. Die moderne Instrumentation und Orchestration – Grand traité d'instrumentation et d'orchestration modernes / par Hector Berlioz. – Berlin : chez A^d. M^t. Schlesinger ; Paris : Schonenberger ; Moscou : Lehnhold, [c. 1843–44] ([Berlin : Lithographie und Druck der lithograph. Anstalt von F. Silber]). – [2], 332 p. : ill., music ; 2° (34 cm). – Sig: π^1 [1–4]^2 5–83^2.

Lithographed throughout, apart from engraved title-page. – The text handwritten in German and French in parallel columns – The title-page states that it was translated from the French by J. C. Grünbaum. – The statement of responsibility for the printing is taken from the foot of p. 332. – Pages with signatures also have 'Berlioz Instrumentation' (or similar) on them.

1.20 BERRY, William. County genealogies : Pedigrees of Berkshire families / Collected by W^m. Berry fifteen years Registering Clerk in the College of Arms London. – [London] : Published by Sherwood Gilbert and Piper Paternoster Row, 1837 (London : printed in Lithography by E. Barwick). – [4], xix, [1], 155, [14] p. : ill., genealogical trees ; 2° (36 cm).

Lithographed throughout by the transfer process from Berry's own handwriting. – Consists primarily of genealogical trees. – Often found bound up with the volumes for Buckinghamshire and Surrey under the series title 'County genealogies. Berkshire. Buckinghamshire. and Surrey.' – Uses the same title-page stone as these items, but with the county name and coat of arms changed. – Barwick's address is given as 2, Shorter's C^t.

1.21 BERRY, William. County genealogies : Pedigrees of Buckinghamshire families / Collected by W^m. Berry fifteen years Registering Clerk in the College of Arms London. – [London] : Published by Sherwood Gilbert and Piper Paternoster Row, 1837 (London : printed in Lithography by E. Barwick). – [2], xv, [3], 103, [13] p. : ill., genealogical trees ; 2° (36 cm).

Lithographed throughout by the transfer process from Berry's own handwriting. – Consists primarily of genealogical trees. – Often found bound up with the volumes for Berkshire and Surrey under the series title 'County genealogies. Berkshire. Bucking-

hamshire. and Surrey.' – Uses the same title-page stone as these items, but with the county name and coat of arms changed. – Barwick's address is given as 2, Shorter's Ct.

1.22 BERRY, William. County genealogies : Pedigrees of Essex families / Collected by Wm. Berry. Fifteen years Registering Clerk in the College of Arms London . . . – [London] : Sherwood, Gilbert & Piper, Paternoster Row, [c. 1840] ([London] : Printed in Lithography by E. Barwick). – [6], xii, vii, [1], 169, [1], iv, xv p. : ill., genealogical trees ; 2o (35 cm).

Lithographed throughout by the transfer process from Berry's own handwriting. – Consists primarily of genealogical trees. – The decorative title-page follows the same general design as that of the Hertfordshire volume (1.23), but differs from it and has the appropriate name and coat of arms. – Lowndes, p.164, gives a date of 1841, the British Library suggests a date around 1840.

1.23 BERRY, William. County genealogies, : Pedigrees of Hertfordshire families. / Collected by Wm. Berry, fifteen years Registering Clerk to the College of Arms London. . . . – London : John Russell Smith, [c. 1842] (Printed in Lithography by Fredk. Alvey). – [4], xvi, [1], 256, [22] p. : ill., genealogical trees ; 2o (35 cm).

Lithographed throughout by the transfer process from Berry's own handwriting. – Consists primarily of genealogical trees. – The decorative title-page follows the same general design as that of the Essex volume (1.22), but differs from it and has the appropriate name and coat of arms. – Lowndes, p.164, gives a date of 1844, the British Library suggests a date of 1842.

1.24 BERRY, William. County genealogies : Pedigrees of Surrey families / Collected by Wm. Berry fifteen years Registering Clerk in the College of Arms London. . . . – [London] : Published by Sherwood Gilbert and Piper Paternoster Row, 1837 (London: printed in Lithography by E. Barwick). – [2], ix, [3], 110, [12] p. : ill., genealogical trees ; 2o (36 cm).

Lithographed throughout by the transfer process from Berry's own handwriting. – Consists primarily of genealogical trees. – Often found bound up with the volumes for Berkshire and Buckinghamshire under the series title 'County genealogies. Berkshire. Buckinghamshire. and Surrey.' – Uses the same title-page stone as these items, but with the county name and coat of arms changed. – Barwick's address is given as 2, Shorter's Ct.

1.25 BESTA, Fabio. Computisteria mercantile; / sunti delle lezioni tenute del Professore Fabio nob Besta della R. Scuola Sup. di Commercio di Venezia. Anno scolastico 1901–1902. – [Venice : s.n.], Anno Scolastico 1901–902 [sic] (Litografia Luigi Kirchmäyr). – 447 p. ; (27 cm).

HAL, p.248. – Lithographed from handwriting by the transfer process. – Examples of accounting in the text.

1.26 BESTA, Fabio. Lezioni di contabilità di stato / del Prof. Fabio Besta. – Venezia : R. Scuola Superiore di Commercio, [s.d.] (Lt Luigi Kirchmair). – 1064 p. ; (25 cm).

HAL, p.248. – Lithographed from handwriting by the transfer process. – Examples of accounting in the text.

1.27 Beurtheilende Übersicht derjenigen durch den Druck vervielfältigten Karten, Situations- und Festungs- Pläne von Europa, welche für deutsche Militairs von praktischem Interesse sind. – Erster Theil. Central-Europa. – [Prussia?] : Bearbeitet in der topographischen Abtheilung d. Königl: Preussi-schen General Stabes, 1849 ([Druck des Königl. lith. Instituts]). – [2], 2, 242 p. : ill., maps ; 4o (29 cm).

Lithographed from handwriting. – Some text pages are blank apart from their pagination (e.g. p.6–7, 73–76, 169–171, 178–182). – Brown-paper wrappers carry the same information as the title-page. – The statement of printing is taken from p.242.

1.28 BIBLE: NEW TESTAMENT. The New Testament in Lewisian short hand, / lithographed from the manuscript of Thomas Coggin . . . – London : Nisbet & Co. and Routledge & Co., and may be had also at Lewis's Short Hand Establishment, Strand, and of all Booksellers, 1849 ([London : Day & Son Lithrs. to the Queen]). – [8], 207 p. ; 18 cm.

Westby-Gibson, p.114. – Lithographed through-out. – The text from handwriting, the title-page carefully lettered, other preliminary pages transfer-red from type. – Signed and dated 'Thomas Coggin Scripsit 21/12/1844' on p.207. – The statement of printing is taken from the lithographed part-titles of an unbound copy in the Carlton Collection of the University of London Library.

1.29 BIBLE: NEW TESTAMENT. The New Testament of our Lord and Saviour Jesus Christ. / In Taylor's system of short-hand, as improved by George Odell. – London : George Odell, R. Groom-bridge, [c. 1849]. – [4], 290 p. ; 20 cm.

Westby-Gibson, p.145. – Lithographed throughout

from handwriting. – The date derives from an owner's inscription. – Westby-Gibson gives the date as 1843.

BIBLE: NEW TESTAMENT. *See also* 1.51; 5.5–5.9

1.30 BIBLE: PSALMS. [H. H. Baber's Psalms]
Not traced. – Referred to in a manuscript note by the Rev. George Hunt accompanying the St Bride Library copy of his *Specimens of lithography*, 1819 (1.118). Hunt wrote: 'The first Work printed in England by Lithography. – Mr. Baber's Psalms was the next.' Baber had already edited a letterpress edition of the Book of Psalms: *Psalterium Graecum e Codice MS. Alexandrino* (London, 1812), but no lithographed version is known. It is possible that Hunt had in mind Baber's *Vetus Testamentum Graecum e Codice MS. Alexandrino* (London, 1816–28), which was also printed letterpress, but with specimens of Greek hands engraved by Basire.

BIBLE: PSALMS. *See also* 1.49; 5.11–5.12

BOILEAU. *See* 3.5

1.31 BOOK OF COMMON PRAYER. Facsimile of the black-letter prayer-book containing manuscript alterations and additions made in the year 1661, 'out of which was fairly written' the Book of Common Prayer subscribed, December 20. A.D. 1661, by the Convocations of Canterbury and York, and annexed to the Act of Uniformity, 13 & 14 Car.II., C.4, A.D. 1662. / Photo-zincographed at the Ordnance Survey Office, Southampton (Major-General Sir Henry James ... Director-General) ; and published for the Royal Commission on Ritual, by authority of the Lords Commissioners of Her Majesty's Treasury. – London : Longman and Co ... and Basil M. Pickering ; also by Parker and Co., Oxford, and Macmillan and Co., Cambridge, 1871 (Southampton : Ordnance Survey Office). – [12], 514 p. ; 4° (42 cm).
Lithographed throughout, apart from a 7 p. letterpress preface by A. P. Stanley, Dean of Westminster, dated 30 June 1870. – Title-page and page of authentication lithographed from transfers of new typesetting, the remainder a photolithographed facsimile (with p. 33–50 printed in red and black). – The page of authentication signed by Henry James and William Basevi Sanders and dated 30 June 1870 certifies 'that this is a true photo-zincographic facsimile of the Black-letter Prayer-book of 1636, with the marginal manuscript notes and alterations ...'. – An uncut copy reveals that the sheets were printed four pages to view.

1.32 BOOK OF COMMON PRAYER. Facsimile of the original manuscript of The Book of Common Prayer signed by Convocation December 20th, 1661, and attached to the Act of Uniformity, 1662 (13 & 14 Charles 2. Cap.4). – London: Eyre & Spottiswoode, Her Majesty's printers ... ; C. J. Clay & Sons, Cambridge University Press Warehouse, 1891. – [8], 544, [16] p., including 3 p. of plates : ill. ; 2° (40 cm).
Photolithographed facsimile, with letterpress preliminary pages. – Printed in black with red rulings (the final 4 p. have red rulings only). – The plates are facsimiles of the back of the original book. – The pagination is that of the original. – The preface explains that the book was reproduced from photographs of the original which were taken by Eyre & Spottiswoode 'page by page, without disturbing the binding, and without removing the volume from the precincts of the House of Lords, or from the custody of Mr. J. H. Pulman, the present Librarian.'.

1.33 BOOK OF COMMON PRAYER. The shorthand prayer book, according to the use of the United Church of England and Ireland. / Printed in lithography, from manuscript characters in the celebrated 'Lewisian system' of short-hand. – London : Published for J. H. Lewis, Esq., 1832. – x, [2], 221 p. ; 12 cm.
Brown & Haskell, p. 425; Westby-Gibson, p. 114. – Lithographed throughout, apart from letterpress preliminary pages. – The letterpress printed by J. H. Lewis, 15 Frith Street, Soho. – Lithographed pages are surrounded by single-line borders. – Another edition of 1832, printed from the same lithographic stones (or plates), has its letterpress pages differently set and printed by Wildash; this edition differs from the other in its pagination (xi, [1], 221 p.) and in not hyphenating 'short hand' on the title-page.

BOOK OF COMMON PRAYER. *See also* 1.48; 5.13–5.17

1.34 BOOTY, Frederick. The stamp collectors guide; being a list of English and foreign postage stamps with 200 fac-simile drawings / by Fredk Booty. – Brighton : H. & C. Treacher ; London : Hamilton, Adams & Co., 1862. – [48] leaves, printed on rectos only : ill. ; 20 cm.
Lithographed throughout, the text handwritten. – Green glazed-paper wrappers printed lithographically. – Contains illustrations of each of the stamps described. – Introduction signed by Booty and dated Aug. 1862.

1.35 BOURSIN, Léopold. Leçons d'histoire naturelle médicale. – Première partie. : Zoologie médicale. / [by L. Boursin]. – Paris : [s.n.], 1874. – 328, [4] p. ill. ; 24 cm.

Lithographed throughout, the text handwritten. – 61 small line illustrations mainly in left-hand margins. – The statement of responsibility is taken from a prefatory note on p.3 dated 'Mai 1874' (this states 'Bien que le format, la nature du papier et l'impression fassent revenir ce travail à un prix relativement élevé, j'ai dû les conserver, car ils plaisent à l'immense majorité des Etudiants que j'ai consultés à cet égard.'). – The date of the prefatory note and the passage quoted suggest that part 1 was published after part 2 (see 1.36).

1.36 BOURSIN, Léopold. Leçons d'histoire naturelle médicale. – 2ᵐᵉ. partie. : Botanique médicale. / [by L. Boursin]. – Paris : Librairie des Ecoles A. Morant, 1874 ([Paris] : Imprimerie I. Dejey et Cⁱᵉ., 18 R. de la Perle). – 335, [3] p. : ill. ; 24 cm.

Lithographed throughout, the text handwritten. – 104 small line illustrations mainly in left-hand margins. – The statement of responsibility is taken from a prefatory note on p.3 dated 'Avril 1874' (this states 'Ce travail paraitra chez Morant, Libraire, 20, rue de la Sorbonne, par fascicules tirés à un nombre d'exemplaires relativement restreint, de façon que la botanique médicale soit terminée vers le commencement du mois d'Août.'. – The only copy seen has a plain slip pasted over the statement of publication on the title-page. – Though described as part 2, the date of the prefatory note suggests that it was produced, or at least started, before part 1 (see 1.35).

1.37 BOWERS, Georgina. Canters in Crampshire, / by G. Bowers. – London : Chatto & Windus, [c. 1878]. – [22] leaves, printed on rectos only : ill. ; 30 × 44 cm.

Lithographed throughout. – Pen and ink sketches with brief handwritten legends. – Colour-printed lithographed boards have the imprint 'Banks & Co. Edinburgh'. – The date is taken from the British Library catalogues.

1.38 BRAMBILLA, Guiseppe. L'Azienda commerciale e industriale : Lezioni di Banco Modello per la Scuola Tecnico Litteraria Femminile di Milano. / G. Brambilla. – Milano : Tipo-Litografia C. Tamburini, [1900]. – [4], 111, [1] p. ; 19 cm.

HAL, p.248. – Lithographed throughout from handwriting, apart from preliminary letterpress pages. – The author's name is given at the head of the title-page. – The date is taken from the rear wrappers of Brambilla's *La Contabilita* (1.39). – Examples of accounting in text.

1.39 BRAMBILLA, Guiseppe. La Contabilita del capomastro. : Lezioni per la Scuola dei Capomastri di Milano. / G. Brambilla. – II. edizione. – Milano : Tipo-Litografia C. Tamburini, 1900. – [4], 267, [1] p. ; 19 cm.

HAL, p.248. – Lithographed throughout from handwriting, apart from preliminary letterpress pages. – The author's name is given at the head of the title-page. – Examples of accounting in text.

1.40 BRAMBILLA, Guiseppe. Lezioni di computisteria / G. Brambilla. – Milano : Tipo-Litografia C. Tamburini, 1901. – [4], 249, [1], xvi, [1] p. ; 19 cm.

HAL, p.248. – Lithographed throughout from handwriting, apart from preliminary letterpress pages. – The author's name is given at the head of the title-page. – Examples of accounting in text.

1.41 BRETON, Peter. On the history and physical and chemical properties of the Swietenia Febrifuga and of its comparative effects with those of the Peruvian Bark. : and remarks and observations on the efficacy of the bark of the Punica Granatum in expelling taenia / by Peter Breton Surgeon in the service of the Honble East India Company. – [Calcutta] : Printed at the Asiatic Lithogᶜ. Press, [c. 1820]. – [2], 138 p. ; 8º (25 cm).

Lithographed throughout from handwriting. – The latest date of correspondence quoted in the text is 23 May 1819. – The title-page is displayed in a range of styles of lettering (copperplate, black letter, upright capitals). – The text has long 'f's and catchwords.

1.42 BRETON, Peter. A vocabulary of the names of the various parts of the human body and of medical and technical terms in English, Arabic, Persian, Hindee and Sanscrit for the use of the Members of the Medical Department in India / By Peter Breton Surgeon in the service of the Honᵇˡᵉ. East India Company and Superintendent of the Native Medical Institution. – Calcutta : Printed at the Government Lithographic Press, 1825. – [12], 85 [3], 64, [2], 46 p. ; 28 cm.

Lithographed throughout, the text handwritten. – Consists mainly of vocabularies in English, Nagari, and Persian organized in tabular form with rules between columns and around column headings. – The second pagination is in Nagari and the third (working from the rear to the front of the book) in Persian numerals. – Dedication dated 'July 5ᵗʰ. 1824'. – The inside front cover of the British Library copy bears the original binder's lithographed label which reads 'Book Binding. Neatly Executed by T: Black Asiatic Lithog: Press'.

1.43 BROUGH, B.R. The Turkish alphabet / Designed by R.B.Brough & drawn by H.G.Hine. – London : David Bogue, [c. 1854] ([London] : Printed by L'Enfant). – [26] leaves, all but the first printed on one side only : ill. ; 14 cm.

Lithographed throughout from crayon work. – The title-page states that it was available 'Price 1s/– Colored 2s/6'. – The illustrations appear as conjugate pages, one for each letter of the alphabet. – The British Library copy, which is hand-coloured, has an accession stamp of 10 Jan. 1854 (10 JA 54).

1.44 BROWN, Miss [Pseud?]. The foreign tour of the Misses Brown Jones and Robinson being the history of what they saw & did at Biarritz & and in the Pyrenees / by Miss Brown. – London : Bickers & Son, [c. 1875] (Ipswich : Cowell's Anastatic Press). – [1], 49 leaves, printed on rectos only : ill. ; 4° (32 cm).

Lithographed throughout by the transfer process. – Pen and ink sketches with handwritten legends beneath them. – Lithographed boards printed in grey with the following title: 'The adventures of Miss Brown, Miss Jones and Miss Robinson at Biarritz and in the Pyrenees'. – Loosely based on Richard Doyle's *The foreign tour of Messrs. Brown, Jones, and Robinson; being the history of what they saw and what they did in Belgium, Germany, Switzerland, and Italy* (London, 1852 and numerous later editions).

BUNYAN, John. *See* 5.18

1.45 BURNES, Alexander. A memoir of a map of the eastern branch of the Indus giving an account of the alterations produced in it by the earthquake of 1819 & the bursting of the dams in 1826 ; also a theory of the Runns formation & some surmises on the route of Alexander the Great. / by Lieutt A.Burnes D.A.Q Mr General in Cutch. – [Lucput/Lakhpat] : Camp at Lucput, 28th. March 1827 13th. August 1828. – [2], 133, [1] p. ; 4° (21 cm).

Lithographed throughout, the text handwritten. – Blank page between p.45 and p.46. – A lithographed note on the reverse of the title-page indicates that the memoir had already been lithographed in another form.

1.46 BURNES, James. A sketch of the history of Cutch from its first connexion with the British Government in India to the conclusion of the treaty of 1819 / by James Burnes Civil Surgeon in Cutch. – [Bhooj/Bhuj] : Bhooj Residency, July 1829. – [95] p. ; 2° (32 cm).

Lithographed throughout, the text handwritten. – 2 parts in one volume, plus postscript and addenda.

– The title-page states that the book was 'Lithographed for the perusal of the author's private friends'. – The paper has watermarks of 'Snelgrove's 1824', 'Snelgrove's 1827', 'R Turner 1823', 'E Wise 1828', and 'Ruse & Turners 1824'.

1.47 BURTON, J. Excerpta hieroglyphica / [J.Burton]. – [Qahirah, 1828]. – [4] p., approximately 60 leaves of plates printed on rectos only, some folding ; 2° (24 × 33 cm).

Lithographed throughout, including rudimentary title-page, author's note, and four part-titles. – Lithographed blue-paper wrappers. – The statement of responsibility is taken from the plates, most of which are signed 'J.Burton' or 'J.B'. – Some plates also bear the initials of the printer [?] 'CH' or 'H'. – An author's note apologising for the delay of the letterpress to accompany the plates ends 'Qahirah January 1st 1828', and the dates borne by the plates range between 1823 and 1829. – Copies inspected have different numbers of plates.

1.48 BUTTERWORTH, James. The Book of Common Prayer / Lithographed in the reporting style of phonography by James Butterworth. – London : F.Pitman, 1865 [Glasgow : A.Steele & Co. Engravers and Lithographers]. – 176 p. ; 8° (17 cm). – Sig: 1–11⁸.

Brown & Haskell, p.436; Westby-Gibson, p.162. – Lithographed throughout. – Written in two columns within single-line borders. – The statement of printing is taken from the title-page verso.

1.49 BUTTERWORTH, James. The Book of Psalms, / lithographed in phonetic shorthand, by James Butterworth. – London : F.Pitman, 1865. – [2], 80 p. ; 8° (17 cm). – Sig: π¹ a–e⁸.

Lithographed throughout, apart from letterpress title-page. – The remainder written in phonography within single-line borders. – *See* Brown & Haskell, p.435, and Westby-Gibson, p.163, for an edition of 1865 which runs to 95 p., and Westby-Gibson, p.163, for two undated editions of the Book of Psalms lithographed by Butterworth (in the reporting style, 124 p; in the corresponding style, 128 p.).

1.50 BUTTERWORTH, James. Extracts from life: its nature, varieties, and phenomena. / By Leo H.Grindon. ; Lithographed in the corresponding style of phonography. By James Butterworth. – London : F.Pitman, 1866 ([A.Steele & Co. Printers, Glasgow]). – iv, 223, [1] p. ; 8° (16 cm). – Sig: π² a⁸ [b]⁸ c–i⁸ j–n⁸.

Brown & Haskell, p.440; Westby-Gibson, p.164. – Lithographed throughout, apart from letterpress

preliminary pages which are in traditional orthography. – The remainder written in phonography within single-line borders. – The statement of printing is taken from the final page. – Signatures include both i and j.

1.51 BUTTERWORTH, James. The New Testament, / lithographed in the reporting style of the 11th. edition of phonography, by James Butterworth. – To be completed in 10 monthly parts. – London : F. Pitman ; South Shields : James Butterworth, [1864–65] ([A. Steele & Co. Lithographers, Glasgow]). – [4], 268 p. ; 18 cm + part titles and advertisements.

Westby-Gibson, p.166. – Lithographed throughout. – Written in phonography, apart from part-titles and advertisements which are in traditional orthography. – The text written in two columns within single-line borders, but with tram lines for running heads and page numbers. – The first part-title is preceded by a decorative title-page. – Publication details are taken from the first part-title. – On later part-titles the statement of publication includes 'Bath : Isaac Pitman, Phonetic Institute'. – Published in 10 monthly parts from November 1864 to September 1865. – The name of the printer is found on some part-titles, though only once in the precise form given.

1.52 BUTTERWORTH, James. Selections from Goldsmith's poetical works, / lithographed by James Butterworth. – London : F. Pitman, 1867. – [2], 64, [1] p. ; 17 cm.

Brown & Haskell, p.439; Westby-Gibson, p.164. – Lithographed throughout. – Each page handwritten within the same decorative border, which must have been transferred from a master image.

1.53 BUTTERWORTH, James. Selections from the poets. / Edited, lithographed, and printed by James Butterworth. – London : F. Pitman, [186?]. – 144 p. ; 16o.

Brown & Haskell, p.437. – Not seen. – Written in the corresponding style of phonography.

1.54 BUTTERWORTH, James. The Sermon on the Mount. / Lithographed in the corresponding style of phonography, by James Butterworth. – London : F. Pitman, [1866]. – 16 p. ; 8o (17 cm).

Westby-Gibson, p.167. – Lithographed throughout. – 14 p. of phonographed text with title and advertisement pages in traditional orthography. – All pages written within single-line borders, but with tram lines for running heads and page numbers. – The date is taken from an announcement on p.16

of the *New Phonographic Magazine,* 2 July 1866, and a British Museum accession stamp (8 AU 66). – Price 2d. – An edition of the same work in the reporting style of phonography was published in almost identical form in the same year.

1.55 CADOZ, F. Le Secrétaire de l'Algérie ou le secrétaire Français-Arabe contenant des modèles de lettres et d'actes sur toutes sortes de sujets, un recueil de proverbes, des explications grammaticales etc. / Par Fçois. Cadoz. – Alger : F. Bernard, Libraire-Editeur, 1850 ([Alger : Lithographie de Made. Philippe]). – 180 p. ; 15 cm.

Lithographed throughout from handwriting, apart from letterpress wrappers (dated Alger, 1862). – The body of the book, p.8–125, consists of facing pages of model examples in Arabic and French. – Errata on p.180. – The statement of printing is taken from p.180.

1.56 CAMPBELL, Rev. J. McL. Notes of sermons / by the Rev. J. McL. Campbell. Minister of Row, Dumbartonshire. Taken in short hand. – Paisley : Printed only for the subscribers by John Vallance lithographer, 1831–32. – 3 vol. (approx. 473, 427, 399 p. in various pagings) ; 8o (24 cm).

Lithographed throughout, the text handwritten on transfer paper. – Collection of 36 sermons delivered between 14 Feb. 1830 and some time before Oct. 1832. – Each paginated and, apparently, published separately. – Undertaken '. . . to defray the heavy expences incurred by the employment of a short hand writer for the purpose of taking down [the] greater part of the sermons preached by Mr Campbell during a period of about two years.' (final page of vol. 3). – Ruled borders to every page. – The text crudely written with many lines extending beyond the borders. – Many corrections, some in lithography, some in ordinary writing ink. – Volume 1 sold at 3 guineas, volumes 2 and 3 at 2 guineas.

1.57 CAPON, David. A guide to the speedy acquirement of the Marat,ha language on the Hamiltonian System. / By Captain David Capon. – Bombay : [s.n.], March 1830. – [16], 71 p. ; 4o (25 cm).

Lithographed throughout, the text handwritten, probably directly on to stone. – The pagination in Maratha numerals. – The main body of the book printed with lines in Maratha alternating with lines of English translation, sometimes with lines which give a transliteration of the Maratha words. – Printed on pale blue wove paper with watermark 'J Whatman 1828'.

1.58 CARPENTIER, Ad. Le. Petit solfège avec accompag^t. de piano ... / par Ad. Le Carpentier Professeur au Conservatoire. – Mayence Anvers et Bruxelles : chez les fils de B. Schott, [c. 1844]. – 81 p. : ill., music ; 4° (24 × 29 cm).

Lithographed throughout by the transfer process, p.1–10 transferred from type, the remaining pages transferred from intaglio plates. – Lithographed wrappers with crayon-drawn picture. – Fold and trim marks show that the printing was done four pages to view. – Schott's plate number (7325) is on most pages.

1.59 CASSIN, Eugène. Choix de morceaux fac-simile d'écrivains contemporains et de personnages célèbres, destinés à enseigner à lire dans toutes les écritures / recueillis et publiés par M. Eugène Cassin. – Paris : Langlois et Leclercq, [1837]. – 128 p. ; 8° (22 cm).

Lithographed throughout, apart from p.1–4 which are letterpress. – An advertisement on the rear boards refers to two parts, each of 128 p., which were sold separately. – The preface states that the idea for the publication, a set of samples of writing for children, goes back to 1831. – The date is taken from Richard Sims, *The hand-book to autographs*, 1862. – A second edition (Paris, 1853) is recorded.

1.60 Catalogue of books in the Library of the Military Dèpot, Q. M. Gen^{ls}. Office. Printed from stone in the year 1813. / Written with chymical ink, by J. Wyld, draftsman. – [London : Quarter-Master-General's Office], 1813. – [10], 108 p. (numbered to 80) ; 2° (40 cm).

Martin (1834), p.138; Martin (1854), p.211; Twyman, p.33 (all of which are inaccurate on the pagination, which includes 12a–12h, 18a–18d, 24a–24h, 32a–32h to cater for 'Miscellaneous addenda' between parts). – Lithographed throughout, with many entries added in manuscript. – Mainly produced by the transfer process, though the two outer rules and two outer headings of most pages must have been drawn directly on the stone. – Some touching up on the stone of poorly transferred parts, especially in the headings. – Paper has the watermarks 'Budgens Wilmott 1812', 'B&W 1812', 'J Whatman 1805', and 'J Whatman 1808'. – Probably printed in no more than several copies. – The single copy known to exist is in the Library of the Ministry of Defence, London, and has a lithographed outer border on its title-page that has been cut from another sheet and pasted down. – The title-page also bears the manuscript note 'NB. There is besides this another Catalogue kept by myself for the purpose of knowing the price of each Book, with the Date

when, and where it has been purchased, or otherwise procured. Lindenthal, M. Genl.'. – Evidence from Army Lists dates this note before 12 Aug. 1819, when Major-General Lewis Lindenthal was promoted. – This catalogue is the first recorded example of lithographic book production in Britain.

1.61 CATEL, Charles-Simon. Trattato di armonia / di Carlo Simone Catel ... ; tradotto dal Francese dall'Abate Pietro Alfieri ... – Roma : Dalla Stamperia Litografica di Luigi Polisiero, 1840. – 83 p. : ill., music ; 2° (36 cm). – Sig: [A–B]² C–I² L–U² V² [X]².

The preliminary pages letterpress, p.9–83 lithographed, the text handwritten. – The work was first published in France in 1802.

1.62 CATLIN, George. The breath of life : or mal-respiration, and its effects upon the enjoyments & life of man. / By Geo. Catlin – London : Trubner & C°., 1862 ([Birmingham : Printed by T. Underwood, Lithographer]). – 75 p. : ill. ; 8° (22 cm).

Lithographed throughout, the text handwritten. – Paper-covered boards printed lithographically in two colours. – The statement of printing is taken from the rear cover. – Appendix on p.75 dated 'Rio Grande, Brazil, 1860'. – The word 'manu-graph' appears immediately after the title on the title-page ('Manugraph' on the front cover). – 26 line illustrations (not 25 as stated on the front cover) integrated with the text. – First edition in the British Library is identical except that it has no boards and has no details of publication other than the date 1861. – NSTC lists further editions of 1861 (New York), 1863, 1869, and 1870.

1.63 CAXTON, William. The dictes and sayings of the philosophers. : A facsimile reproduction of the first book printed in England by William Caxton, in 1477. / [with a preface by William Blades]. – London : Elliot Stock ; New York : J. W. Bouton, 1877. – xii, [150] p. ; 2° (30 cm).

Blake, B 28.1. – Photolithographed facsimile with letterpress preliminary pages. – The facsimile is printed in red and black. – The statement of responsibility for the preface is given on p.xii. – The preface is dated 'May, 1877'.

1.64 CAXTON, William. The fifteen O's, and other prayers. : Printed by commandment of the Princess Elizabeth, Queen of England and of France, and also of the Princess Margaret, Mother of our Sovereign Lord the King. By their most humble subject and servant, William Caxton. (circa m.cccc.xc.). / Reproduced in photo-lithography by

Stephen Ayling. – [London] : Griffith and Farran, Corner of St. Paul's Churchyard, [1869]. – [48]p. ; 4° (22 cm).

Blake, B 42.1. – Photolithographed facsimile, made from the copy in the Library of the British Museum. – 5 preliminary pages photolithographed from new typesetting, and 43 pages of photolithographed facsimiles. – The date is taken from the British Library catalogues and the Saint Bride Foundation, *Catalogue* (London, 1919).

1.65 CHAMPOLLION, Jean-François. Dictionnaire égyptien en écriture hiéroglyphique, / par J.F. Champollion le jeune. – Publié d'après les manuscrits autographes, et sous les auspices de M. Villemain Ministre de l'Instruction Publique, par M. Champollion Figeac. – Paris : Chez Firmin Didot frères, Libraires-éditeurs, Imprimeurs de l'Institut de France, 1841 [–1843] (Paris : Impie. Lithoge. de J.A. Clouet rue Furstemberg, 5). – [4], xxxvi, 487 p. : ill. ; 2° (34 cm). – Sig: π^2 a–d^4 e^2 1–122^2.

Brunet, 1, col. 1780. – Lithographed from handwriting, apart from a letterpress half-title, title-page, and preface. – The statement of printing comes from the colophon on p.487, which also states that the book was 'Dessiné et écrit par Jules Feuquières.'. – The date for the completion of printing is given on p.486 as '1er. novembre 1843'.

1.66 CHAMPOLLION, Jean-François. Grammaire égyptienne, ou principes généraux de l'écriture sacrée égyptienne appliquée à la representation de la langue parlée, / par Champollion le jeune. ; Publieé sur le manuscrit autographe, par l'ordre de M. Guizot, Ministre de l'Instruction Publique. – Paris : Typographie de Firmin Didot frères, 1836 [–1841]. – [6], viii, xxiii, [1], 555, [1]p. : ill., hieroglyphs ; 2° (34 cm). – Sig: π^3 A–B^2 a–f^2 1–137^2 x136–137^2.

Brunet, 1, col. 1780. – Printed by lithography and letterpress (p.1–376 lithography, the text transferred from type; p.536–548 lithography; p.377–535 the text printed letterpress from type, the hieroglyphs lithographed; the remainder letterpress from type). – Most pages between p.72 and p.156 printed in red and black, p.7–11 and p.47 hand-coloured. – A cancel leaf (signed 62), with p.245 and a blank verso, appears with the cancellandum. – Published posthumously and seen through the press by Champollion's elder brother, J.-J. Champollion Figeac, who wrote the dedication and preface. – The hieroglyphs drawn by Salvador Cherubini. – A list of books available from the bookshop of Firmin Didot, printed on the final page of vol.2 of the *Dictionnaire de l'Académie française*, 6th edn, Paris, 1835,

mentions that the first part was already on sale and that the second would appear at the end of 1835. – The final page reads 'Achevé d'imprimer au mois de mars 1841'.

1.67 Chant national suisse. : Principes élémentaires de musique. / Propriété de la Société de Chant National. – Genève : [s.n.], 1833. – 11 p. ; 4° (16 × 24 cm).

Lithographed from handwriting. – Letterpress blue-paper wrappers. – The wrappers carry the imprint 'De l'Imprimerie Ch. Gruaz'. – Fold and trim marks show that the printing was done four pages to view.

1.68 CHOULOT, Vicomte Paul de. Huit jours au pas de charge en Savoie et en Suisse / par Paul de Kick [pseud.]. – A Chambéry : Lithog. et autographie de Jules Aubert et Cie., [c. 1845]. – [2], 1–20, [2], 21–30, [2], 31–40, [2], 41–66, [2], 67–73, [2], 74–76, [2], 77–78, [1]p. : ill. ; 30 × 42 cm.

Lithographed throughout, the text handwritten in two columns, each within line borders. – The title-page design also appears on the front yellow, paper-covered boards. – Contains numerous crayon lithographs, both full-page and in text (pages with full-page illustrations are not paginated on their reverse). The full-page illustrations have Aubert's imprint. – A list of other publications on the final page reveals that Paul de Kick was the pseudonym of the Vicomte Paul de Choulot. – The date is that given by the Alpine Club Library.

1.69 CLEMENTI, Muzio. Méthode pour le piano forte / par Muzio Clementi. – 2de. édition. augmentée d'une traduction allemande. – A Offenbach s/M : chez J. André, [c. 1809]. – 31 p. : ill., music ; 4° (25 × 33 cm).

Lithographed throughout, the text handwritten in French and German in parallel columns. – The date derives from André's plate number (2738), which appears on the title-page and all other printed pages.

1.70 CLEPHANE, D.M. The journal of life, / by Miss D.M. Clephane, ; illustrated by Lady M. Alford, for the Irish Bazaar. – [S.l. : s.n.], 1847. – [8] leaves, printed on rectos only : ill. ; 24 × 30 cm.

Lithographed in pen and ink, with letterpress buff-paper wrappers. – Every page consists of a line illustration in a lunette-shaped panel and, beneath it, one or more verses of the poem. – Written on transfer paper. – The wording of the wrappers suggests that this was a charity publication.

1.71 COLEMAN, John. Coleman's farmers' accounts (improved edition) : Labour journal. – London : Relfe Brothers, [c. 1862]. – 14p. ; 21 × 34 cm.

Lithographed throughout from handwriting. – Specimens of accounting. – Begins on verso of first leaf and numbered by spread, 1–6, and then by page, 7–8. – Publication details are taken from a letterpress label on the boards. – The British Library copy has an accession stamp '6 JU 62', and seems to relate to Coleman's *A system of book keeping for farmers*, which Relfe Brothers published in 1862.

1.72 A Collection of moral precepts & reflections gathered from various sources in English and Hindostany and translated for the instruction of youth. – Lucknow : Printed at His Majesty the King of Oude's Lithographic Press, AD 1833. – [4], 169, [1], 17p. ; 26 cm.

Lithographed throughout, the text handwritten and probably directly on stone. – Parallel title-pages in English and Hindustani (Urdu). – The English title-page displayed in a range of styles of lettering (copperplate, shaded Egyptian and black letter). – Text pages written within double-line borders, the English on versos and the Hindustani on rectos (p.1 blank). – The final paging is a vocabulary.

1.73 COOKE, M. A. Poems / By M. A. Cooke. – Bordage, Guernsey : E le Lievre, [c. 1860]. – 12 leaves, printed on rectos only : ill. ; 28 cm.

Lithographed throughout, with pen and ink drawings integrated with handwritten text.

1.74 [Correspondence and reports to John Wood, Chairman of the Inland Revenue from Dugald Campbell, William B. Carpenter, Tho. Graham, J. D. Hooker, John Lindley, John Stenhouse, Alfred Swaine Taylor concerning chicory and coffee]. – [London : s.n., 1852–53]. – (8p., [3] leaves of plates, [2]p.) (13, [1]p., [4] leaves of plates, [2]p.) ([2], 37p.) (30, [1]p., [4] leaves of plates, 3p.) all printed on rectos only ; 2° (34 cm).

Lithographed throughout, the text handwritten and produced by the transfer process. – Four related items bound in one volume. – Statements of responsibility are given on the final pages of each item. – The third item, issued from University College, London, has the title 'Chemical report on the mode of detecting vegetable substances mixed with coffee, for the purpose of adulteration'. – The items are dated 9 June 1852, 9 Nov. 1852, 24 Dec. 1852, 10 Feb. 1853. – Plates of the fourth item have the imprint 'Lith: Waterlow & Sons, London.' and are colour printed, the rest are hand-coloured.

1.75 Court of Arches : Bishop of Salisbury v Dr. Williams. – [S.l. : s.n., c. 1862]. – 3 vol. ([1], 81, [1], 107, [1], 139, [1], 158 leaves) ([1], 116, [1], 145, [1], 141 leaves) ([1], 135, [1], 109, [1], 93 leaves) ; 2° (34 cm).

Lithographed throughout from handwriting by the transfer process. – All leaves printed on rectos only. – The proceedings of the Court of Arches, Westminster, before the Right Honorable S. Lushington, Dean of Arches, 20 Dec. 1861 to 13 Jan. 1862. – In ten parts corresponding to the ten days of the hearing, each preceded by a leaf with a lithographed label pasted down, as though taken from wrappers. – Printed on pale blue, laid paper with the watermark 'J Coles 1861' or 'J Coles 1862'.

CRAIK (Mrs). *See* 5.34

1.76 CRAWHALL, Joseph (Sen.). Grouse shooting made quite easy to every capacity. : Exemplified in a series of practical illustrations. / By Jeffrey Gorcock [pseud.]. – Killhope-Cross : [s.n.], August XII 1827. – 40 leaves, printed on one side of the sheet only : ill. ; 4° (30 cm).

Schwerdt, p.212; Felver, C. S., *Joseph Crawhall: the Newcastle wood engraver (1821–1896)* (Newcastle upon Tyne, 1972), p.3–4. – Lithographed throughout, including 35 plates. – Jeffrey Gorcock was the pseudonym of Joseph Crawhall the first (1793–1853). – The author's copy, with his own water-colour sketches interleaved, is referred to by Felver.

1.77 CRESCENTINI, Girolamo. Raccolta di esercizj per il canto all'uso del vocalizzo : Con discorso preliminare / del Signor Girolamo Crescentini. – Roma : Litografia Ratti e Ci., [c. 1828]. – [1], 62 p. : ill., music ; 2° (34 cm). – Sig: 1–16².

Lithographed throughout, the text handwritten. – Music only from p.9. – The publisher's plate number (540) is printed directly above the signature on most pages. – Made up of 16 sheets, each of which is signed on all four pages. – In binding, the sheets were quired [A⁶ B–F⁴ G⁶], as a result the signature marks appear in an anomalous sequence (e.g. 14, 14, 15, 15, 16, 16, 16, 16, 15, 15, 14, 14). – A companion volume by Crescentini, in four parts, 'Raccolta completa di esercizj di musica all'uso del vocalizzo', printed by Ratti Cencetti e Comp., consists entirely of lithographed music.

CRUIKSHANK, George. *See* 1.151

CRUIKSHANK, Percy. *See* 1.150

1.78 CULLIMORE, A. Oriental cylinders : Impressions of ancient oriental cylinders, or rolling seals of the Babylonians, Assyrians, and Medo-Persians, / Lithographed by A. Cullimore. – London : G. W. Nickisson, [1842, 1843]. – [1], 32, [3] leaves, printed on rectos only : ill. ; 8o (28 cm).

Lithographed throughout. – Consists of 174 small line illustrations on 32 p., together with a title-page and a 3 p. list of contents. – A note on the title-page refers to 6 numbers, but only 4 were published. – The date is taken from the British Library catalogues, which claim that the wrappers (now wanting) bore the date of publication.

1.79 CURTIS, Aza. Flowers. : A series of short poems, original and translated. / Illustrated with figures drawn and coloured by Aza Curtis. – London : Privately printed at R. Martin's Lithographic Office, 1827. – [41] leaves : ill. ; 4o (27 cm).

Lithographed from handwriting, with 14 hand-coloured crayon lithographs. – The writing and illustrations printed on one side of the leaf only. – The paper watermarked 'J. Whatman 1827'. – Pale pink paper-covered boards printed lithographically back and front. – The preface is initialled E.W.B. and dated 9 May 1827. – E.W.B. wrote or translated the poems and was probably Edward William Barnard (1791–1828) who held a living at Brantingham in Yorkshire. – The list of subscribers accounts for 99 copies.

1.80 DALL'ARMI, Giovanni. Ristretto di fatti acustici / di Giovanni Dall'Armi letto in accademia de' Lincèi. – Roma : Edizione litografica autografa, 1821 – Gennajo 1822. – 2 vol. ([2], ii, ii, 45 p.) (xviii p.) : ill. ; 4o (31 cm).

Lithographed throughout from the author's handwriting. – The second volume carries the following title at the head of p. 1: 'Appendice al ristretto di fatti acustici di G^ni Dall'Armi letto già col corredo degli esperimenti all'accademia de' Lincèi di Roma ne' giorni 27 Settembre e 4 Ottobre 1821', and is dated 'Roma in Gennajo 1822'.

1.81 DANIEL, Salvador. Grammaire philharmonique, ou cours complet de musique, contenant la théorie et la pratique de la mélodie, les règles de la transposition . . . / par Don Salvador Daniel. – Bourges : Imprimerie en Caractères et en Lithographie de P.-A. Manceron, 1836–37. – 2 vol. ([4], 129, [7] p.) ([4], 140 p.) : ill., music ; (27 cm). – Sig: (π² 1–17⁴) (π² [1]⁴ 2–13⁴ 13*¹ 14–16⁴ 17–18² 19¹).

Printed by a combination of letterpress and lithography. – With a few exceptions, versos are letterpress and rectos lithography. – The final page of music (vol. ii, p. 134) is signed 'Hippolyte Verstraete fecit.'.

1.82 DE LA MOTTE, Philip Henry. On the various applications of anastatic printing and papyrography. With illustrative examples / By Philip H. De la Motte. – London : David Bogue, 1849 ([Oxford : Delamotte, Anastatic Press]). – [2], 24 p. : ill., 16[?] plates ; 8o (22 cm).

Bridson & Wakeman, D44 ; Kampmann, p. 24. – Lithographed throughout. – The text handwritten and printed by the anastatic process, apart from p. 6 which is the letterpress page from which p. 7 was reproduced. – The plates show different applications of the process and vary in number in copies that have been inspected. – The statement of printing is taken from the lithographed boards.

1.83 DESPORTES, Jules. Manuel pratique du lithographe. . . . / par M. Jules Desportes imprimeur lithographe. – Paris : Chez l'auteur . . . , 1834 ([Paris] : Imprimerie lithographique de Jules Desportes, pont neuf, no. 15 en face Henri IV). – [2], xxxii, 230, [8] p. : ill., [4] leaves of plates ; 8o (21 cm). – Sig: π¹⁷ a–u⁴ v⁴ x–z⁴ a:–b:⁴ [c:]⁴ d:⁴ [e:]⁴ [f:]³.

Kampmann, p. 18. – Lithographed throughout, the text handwritten. – The statement of printing is taken from the colophon.

1.84 DESPORTES, Jules. Manuel pratique du lithographe . . . / par M. Jules Desportes, Professeur de Lithographie à l'Institut Royal des Sourds-muets, Directeur du Journal le Lithographe. – Seconde Édition. – Paris : Chez l'Auteur . . . Maison . . . , 1840 ([Paris] : Imprimerie lithographique de Jules Desportes, pont neuf, no. 15 en face Henri IV). – [2], xlviii, 230, [8] p. : ill., [10] leaves of plates ; 8o (21 cm). – Sig: π²⁵ a–u⁴ v⁴ x–z⁴ a:–b:⁴ [c:]⁴ d:⁴ [e:]⁴ [f:]³.

Lithographed throughout, the text handwritten. – The statement of printing is taken from the colophon. – Apart from the title-page and the Supplément (p. xxxiii–xlviii) the text seems to be identical to that of the first edition (1.83). – Some of the additional illustrations were used earlier by Desportes in his journal Le Lithographe.

DEVONSHIRE, Duchess of. *See* 1.196

1.85 Domesday Book or the great survey of England of William the Conqueror, A.D. MLXXXVI. – Southampton: Photo-zincographed by Her Majesty's command at the Ordnance Survey Office Southampton [under the direction of] Colonel Sir H. James, 1861–63. – 35 vol. of varying extents ; 4o (38, 31 cm).

A separate volume was issued for each county.
– Each volume consists of photolithographed
facsimile pages printed in red and black, a litho-
graphed title-page printed in red and black, and a
letterpress introduction. – The title-pages of some
volumes, including the first relating to Cornwall,
are lettered 'Etched by G. de Garlieb at the Ordnance
Survey Office'. – The format is given as Imperial
quarto in prospectuses, but the volumes are in two
sizes to match those of the original (with Essex,
Norfolk, and Suffolk in a smaller format). – In 1863
the facsimile was issued in two volumes to corres-
pond in both size and foliation with the original.
– A series of letterpress volumes was issued to
accompany the facsimile volumes by Vacher &
Sons, and Longman, Green, Longman, & Roberts,
with the title *A literal extension of the Latin text;
and an English translation of Domesday Book.* –
See Hallam, E. M., *Domesday Book through nine
centuries* (London, 1986), p.154–157.

1.86 DOYLE, Richard.　A journal / Kept by
Richard Doyle in the year 1840 illustrated with
several hundred sketches by the author ; with an
introduction by J. Hungerford Pollen – London :
Smith, Elder, & Co., 1885. – xii, [2], 152 p. : ill. ; 4°
(28 cm).

Photolithographed facsimile of Doyle's journal,
with wood-engraved frontispiece and letterpress
title-page and introduction. – A second edition was
published in 1886. – Doyle was fifteen when he
wrote and illustrated this journal; he died in 1883.

1.87 DOTZAUER, (Justus Johann) Friedrich.
Méthode de violoncelle / par J. J. F. Dotzauer. –
Violonzell-Schule von J. J. F. Dotzauer. – Mayence :
chez B. Schott Fils, [c. 1824]. – [8], 1, [3], 110 p. : ill.,
music and 2 line illustrations ; 2° (32 cm).

Lithographed throughout, the text handwritten
with German and French in parallel columns. –
A Schott plate number is on most pages (2014 up to
and including p.28, 2114 from p.29). – Schott's own
watermark 'B Schott Soehne in Mainz' is found on
some leaves.

DU-MOULIN, Louis.　*See* 4.3

1.88　Duorum Psalteriorum Moguntinorum inter
primitias artis typographicae annis MCCCCLVII et
MCCCCLIX impressorum : Specimina accurata arte
lithographica diligentissime depicta ob summam
raritatem illorum librorum et ne innumeri biblio-
phili eorum autopsia plane carerent / edidit et illus-
travit Fridericus Schlichtegroll Eq. – Monachii :
[s.n.], 1822. – 37 cm.

Dussler, p.114; Winkler, 536:17, 711:57. – Litho-
graphed title-page, engraved on stone, and 8 litho-
graphed facsimiles from the Mainz Psalter (includ-
ing the initial letter B reproduced in the first edition
of Senefelder's treatise) printed in two or more
colours. – The title-page printed by F. Weishaupt
and lettered 'Johann Evangelist Mettenleiter sculpsit
lapide 1820'.

1.89　DUPORT, Jean-Louis.　Essai sur le doigté
du violoncelle & sur la conduite de l'archet . . . /
par J. L. Duport. . . . – Français avec la traduction
allemande. – A Offenbach s/m : chez J. André,
[c. 1809]. – 165 p. : ill., music ; 4° (35 cm).

Lithographed throughout, the text handwritten
with French and German in parallel columns. – The
date is derived from André's plate number (2599)
which appears on the title-page and most other
pages. – A lithographed label on the front cover
reads 'Duport, Essai sur le doigté du violoncelle.
Français & Allemand. Prix f.11.'.

1.90　DUPUY, R. P. Jean.　L'Estat de l'église du
Périgord, / par le R. P. Dupuy, récolet ; annoté par
M. l'Abbé Audierne, et reproduit, d'après l'édition
primitive, par le procédé litho-typographique. –
[Facsimile edition]. – [A Périgueux : chez Baylé,
1842] ([Périgueux : Litho-Typographie Dupont]). –
2 vol. ([13], 274 p.) ([4], 242, xxx, [2] p.) – 26 cm.

Lithographed facsimile, produced by *litho-
typographie*, of the first edition printed by Pierre
and Jean Dalvy in 1629. – Lithographed throughout
apart from the final 32 p. of vol.2. – Many pages
include additional hand work on the stone. – Abbé
Audierne's first set of notes (vol.1, p.225–274) are
transferred from newly-set type, his second set of
notes (vol.2, p.i-xxx) are printed letterpress. – Publi-
cation details are taken from the imprint on the
page facing the first of the two title-pages to the
facsimile edition. – The date is that given for the
printing. – Both facsimile title-pages of the original
edition are printed in two colours. – Referred to by
Dupont, P., *Essais pratiques d'imprimerie* (Paris,
1849), p.39.

1.91　DÜRER, Albrecht.　Albrecht Dürers Christ-
lich-Mythologische Handzeichnungen. / [repro-
duced by N. Strixner]. – [München : den 16ten Febr.
1808]. – [6] p. : ill., 44 leaves of plates ; 2° (55 cm).

Winkler, 831:12–16. – Lithographed throughout,
apart from a 2 p. letterpress list of contents of the
7 parts. – The plates are facsimiles of the marginal
drawings made by Dürer for the Prayer Book of the
Emperor Maximilian. – The title-page, a self-portrait
of Dürer, and 43 reproductions of the drawings

(numbered 1–43) are all signed 'N: Strixner fecit.' –
The date is taken from a prefatory note. – Printed by
J. A. Senefelder in a range of single colours to match
those of the original. – A note at the foot of the list
of contents refers to a monochrome impression. –
Some copies have a second self-portrait. – Later
editions were published by Stuntz (Munich, 1820)
and Stöger (Munich, 1839 and 1845). – A photo-
lithographed edition was published by Prestel
Verlag, Munich, 1987.

1.92 DÜRER, Albrecht. Albert Durers designs
of the Prayer Book. – London : at R. Ackermann's
Lithographic Press, September 1st. 1817. – [3], 8 p. :
44 leaves of plates, printed on rectos only ; 2°
(39 cm).
 Winkler, 831:14; Abbey, *Life*, 202. – Lithographed
throughout, apart from the advertisement, intro-
duction, and list of plates. – The plates were copied
from the Munich facsimile edition of 1808 (1.91). –
The title-page and one unnumbered plate are printed
in red and black, a portrait of Dürer is in black, the
marginal drawings are in black or a single colour to
match the colours of the original. – Mainly pen and
ink drawings, though some are partially etched
or engraved on stone. – The introduction is by
J. B. Bernhart, Keeper of the Royal Library, Munich.

ECOLE D'APPLICATION DE L'ARTILLERIE ET
DU GÉNIE, METZ. *See* 3.1–3.45

1.93 ELWART, Antoine. Solfège du jeune âge
français et anglais / Composé par A. Elwart Profes-
seur au Conservatoire de Musique. – [S.l.] : [Elwart]
Lithographié sous sa direction, [*c.* 1840]. – [23] p.,
concertina folded : ill., pictures and music ;
16 × 259 cm.
 Lithographed throughout, the pictures in crayon
lithography. – The text in French and English. –
The copy in the H. Baron Collection carries an
owner's inscription dated 1841.

ENGELMANN, Godefroy. *See* 1.230

1.94 Erinnerungs-Buch für das Jahr 1813. – Mit
Koenigl: Baier: Allergn: Privilegium. – München :
in der Zellerschen Schreibmaterial:Handlung,
[1813]. – 18 cm.
 Dussler, p.254; Winkler, 712:31. – Not seen. –
Consists of 53 versos with borders for printing the
months in letterpress, also the same number of
rectos with borders. – The remainder text printing,
with 64 p. of lithographed writing lettered 'Auf Stein
geschrieben von Clemens Senefelder'. – The publica-
tion seems to have appeared annually until 1830

(*see* Kann, E., *Die Geschichte der Lithographie*
(Vienna, 1904), 1262–1266.

1.95 Exerzier Reglement für die Koeniglich
Baierische Landwehr : Ladung in zwoelf Tempos.
– Bamberg : bei J. B. Lachmüller, [1817]. – 74 p. : ill.,
2 plates (one folding) ; 4° (21 cm).
 Winkler, 455:5 ; Friedrich, F., *Bamberg und die
frühe Lithographie* (Bamberg, 1978), no.7. – Text
lithographed throughout from handwriting. – Green
paper wrappers. – The title information is taken
from the head of p.1. – The date is that given by
Winkler and Friedrich.

1.96 Facsimile of the Illustrated Arctic News,
published on board H.M.S. Resolute: Captn. Horatio
T. Austin, C.B. in search of the expedition under
Sir John Franklin . . . / [edited by] Lieut. Sherard
Osborne, & Mr. Geo: F. Mc. Dougall. – London :
Published by Ackermann & Co., 15th. March, 1852
(Nos 1–5, 31 October 1850 to 14 March 1851). – [4],
57 p. : ill. ; 2° (48 cm).
 The text lithographed throughout from handwrit-
ing in two columns. – Ink and crayon lithographs
within text, many of them signed G.F.Mc.D. (George
McDougall). – Some parts of the publication col-
oured by hand. – The imprint 'Day & Son, Lithrs.
to the Queen' appears on the title-page beneath a
vignette.

1.97 FEIGNEAUX. Cours théorique et pratique
de tenue de livres en parties doubles, démontrée
dans ses différentes applications à toutes les
branches de commerce; / par Feigneaux. – A Bruxel-
les : chez l'Auteur ; P.-M. de Vroom, 1827 ([Brussels]
: Lithographié chez Delfosse jeune). – 67, [1] p., 40
leaves between p.20 & 21, 60 & 61, 64 & 65, + 3 fold-
ing plates ; 2° (38 cm).
 HAL, p.248. – Letterpress text with lithographed
examples of accounting. – One folding plate, 'Tab-
leau Synoptique', measures 740 × 520 mm. – The
title-page refers to Delfosse as the lithographic
printer, but imprints on the lithographed pages
show that the lithographic printing was shared by
Delfosse and Auguste Macaire, both of Brussels.
The names of P. Lacroix and H. Kreins appear on
some pages as lithographic writers (Lacroix for
Delfosse; Kreins for Macaire). – Some plates are
dated 1828.

1.98 FELLOWS, Frank P. Poems. : In memoriam &c ... The Knights Hospitalers of of [sic] Saint John of Jerusalem ... / by Frank P Fellows. ; Composed, designed, etched, lithographed and printed by F P Fellows ... – S.l. : [the author], for private circulation, [c. 1883]. – [6], viii, 1–22 (includes 16a & 16b), [4], 2–214 p. (with many irregularities) : ill. ; 17 cm.

Lithographed throughout by transfer lithography, apart from the title-page and p.5–22 which are letterpress. – The text pages handwritten within decorative borders of several kinds, each of which is used repeatedly. – Full-page pen and ink illustrations throughout the book. – Illustrations have dates that range from 1880 to 1883. – The title-page states 'A few copies printed for friends.'.

1.99 FENAROLI, Fedele. Partimenti ossia basso numerato. / Opera completa del Sig.r Fedele Fenaroli. – Roma : Nella Stamperia Litografica di Musica con Privativa di Leopoldo Ratti, Gio. Batta. Cencetti, e Compagno, [c. 1823]. – [2], 76, 119 p. ; 2° (35 cm). – Sig: I–XIX² XX¹ A–I² Y² K–U² X² Z² 2A–2F².

Lithographed throughout, the text handwritten. – Evidence for the date comes from the plate number (104), which is printed directly above the signatures on all pages except the title-page. – Part one is made up of 19½ sheets, part two of 30 sheets; the sheets are signed on all four pages. – In binding, the sheets were quired [1² 2–10⁴ 11¹] [1–30⁴], as a result the signature marks appear in an anomalous sequence (e.g. II, II, III, III, III, III, II, II).

1.100 FERRAND, C. Comptabilité. : Exposé de divers systèmes de tenue des livres selon la pratique actuelle / par C. Ferrand. – Grenoble : Alexandre Gratier, [c. 1888]. – 216 p. ; (29 cm).

HAL, p.248. – Lithographed throughout from handwriting, apart from letterpress wrappers. – The date is taken from a manuscript addition to the copy in the Library of the Institute of Chartered Accountants in England and Wales. – Examples of accounting in text.

1.101 FÖRSTER, Friedrich. Einleitung in die allgemeine Erdkunde mit einer Vorschule der Feldkunde / von Dr Friedrich Förster. – Berlin : Bey Ernst Heinrich Georg Christiani, 1818.

Not traced. – The earliest source for this publication appears to be a review in the *Morgenblatt für Gebildete Stände* (23 Mar. 1819, p.279). A shortened translation of this review was published in the *Literary Gazette* (no.124, 5 June 1819, p.360) and a brief synopsis of it in the *Bulletin de la Société d'Encouragement pour l'Industrie nationale* (Aug. 1819,

p.269). Förster was a teacher at the university school of artillery and engineering in Berlin and is reported as having written the book on stone in his own hand. The book was erroneously described in all three notices, but in different ways, as the first lithographed book ('Das erste Werk in Steindruck'; 'The first Book printed by Lithographic Writing'; 'Le docteur *Foerster* ... est le premier qui ait appliqué l'art lithographique à l'impression des livres'). All three accounts point to the advantages of being able to insert figures along with text in lithographed books.

FRANÇAIS, J.-F. *See* 3.15–3.18

1.102 Frankfurter Stenographische Zeitung : Organ des Rheinischen Stenographen-Bundes. – Frankfurt : No.1 October 1861 to 30 December 1873. – 4° (27 cm).

Lithographed throughout from 1867 and possibly earlier. – Printed by R. Baist in Frankfurt. – Included with each issue is a lithographed supplement with the title *Reinische Blätter*.

1.103 GABELSBERGER, Franz Xaver. Neue Vervollkommnungen in der deutschen Redezeichenkunst oder Stenographie / von Fr. X. Gabelsberger. ; Mit Erläuterungen über das von ihm wieder aufgefundene Prinzip des Abbreviatur-Verfahrens in der römischen Stenographie, bekannt unter dem Namen: Tironische Noten. (Uebersetzung des stenographischen Theils.). – München : Im Verlage der Georg Franz'schen Buchhandlung, 1843. – Part 1, [2], 178 p. ; Part 2, [4], 147 p. ; 18 cm.

Part 1 is letterpress, but part 2 is entirely lithographed in stenography. – Part 2 is signed A–I*⁴ K². – A second edition was published in 1849.

1.104 GAILLOT, Bernard. L'Aquatinte lithographique ou manière de reproduire des dessins fait au pinceau : dédié à M.r le Comte Forbin. / [by Bernard Gaillot]. – Paris : Chez A. Senefelder et Compagnie, 1824. – 8 p. : ill., 12 plates ; 4° (28 cm).

Engelmann, G., *Traité théorique et pratique de lithographie* (Mulhouse, 1835–40), p.44; Johnson, W. McAllister, *French lithography: the Restoration Salons 1817–1824* (Kingston, Ontario, 1977), p.104–105 ; Kampmann, p.10 ; Twyman, p.126–127. – Lithographed throughout, the text handwritten. – No title-page. – Publication details are taken from the lithographed pink-paper wrappers. – The attribution to Gaillot is made by Engelmann. – All plates have the imprint of A. Senefelder et Cie, and four are signed by Gaillot (after Thomas, Le Prince, Bouton, and De Bez). – *See* 1.105

1.105 GAILLOT, Bernard. Lithographic pencil drawing or instructions for imitating aquatinta on stone / by a pupil of M^r. Senefelder, the inventor of lithography [i.e. Bernard Gaillot]. – London : Sold by S. & J. Fuller, 1824. – [2], 10 p. : ill., 8 plates ; 4° (32 cm).

Bridson & Wakeman, D19 ; Twyman, p.127, pls 52–54. – Lithographed throughout, the text hand-written. – No title-page. – Publication details are taken from the lithographed pink-paper wrappers. – All plates have the imprint of A. Senefelder et Cie and were, presumably, printed in Paris. – A translation of 1.104.

1.106 GARAUDÉ, Alexis de. Metodo completo di canto / del Maestro Alessio de Garaudé ... – Prima Edizione Romana. – [Rome] : Litog. Pittarelli e C°. in Via del Corso N°.145, [c. 1840]. – 167, [1] p. : ill., music ; 26 × 35 cm.

Lithographed throughout, the text handwritten. – Mainly music after p.5. – The copy described consists of parts 2 & 3 only.

1.107 GARAUDÉ, Alexis de. New method of singing principally composed for the voice of mezzo soprano, whith [sic] accomp^t. of the piano ... / by Alexis de Garaudé. – Paris : at the Author's ... 6 Petits-Champs Street ; London : at Martin and Comp^y, [c. 1845]. – [4], 110 p. : ill., music ; 2° (35 cm).

Produced by lithography from transfers taken from punched intaglio plates. – The text in French and English in parallel columns. – Page 2 has at its foot 'Gravé par M^me. Chiarini.'. – The publisher's plate number 'A.G.196' is on most pages. – The title-page is signed 'A. Vialon'. – Catalogue of Garaudé's didactic works on p.1.

1.108 GIRAUD, Jane Elizabeth. The flowers of Milton. / I.E.G. del et lith. – [London : Day & Haghe, lithrs to the Queen, c. 1846]. – 29 leaves of plates (including title-page), printed on rectos only ; 32 cm.

Lithographed throughout and hand-coloured. – The text consists of quotations from Milton, one to a page, beneath a flower picture. – The initials of Jane Elizabeth Giraud appear on all plates (printed on most plates, but in pencil on the title-page and two other plates of the British Library copy). – Day & Haghe's imprint appears on plates 10 & 14.

1.109 GIRAUD, Jane Elizabeth. The flowers of Shakespeare. / I.E.G. del et lith. – [London] : Day & Haghe Lith^rs to the Queen, [1845]. – [30] leaves of plates (including title-page), printed on rectos only ; 32 cm.

Lithographed throughout and hand-coloured. –

Quotations from Shakespeare are lettered beneath each picture. – The initials of Jane Elizabeth Giraud appear on the title-page and on many of the plates. – The British Library copy has a holograph dedication 'To Herbert Giraud Esq^re. M.D. of the Hon^le. E.I.C.S. Bombay. this Garland from his Native Land is dedicated by His Sister : Faversham Feb^y 18^th 1845'. – A second edition was published with a similar printed dedication 'Faversham, 1st January, 1846', and a further edition was published by Ackermann in 1850.

1.110 GLASGOW LOOKING GLASS. Glasgow looking glass. – Glasgow : Printed Published and Sold by John Watson, Lith Press 169 George St, and Richard Griffin & Co. 75 Hutcheson St, 1825. – Fortnightly, mainly 3 or 4 p. an issue : ill. ; 2° (42 cm).

The first five numbers (11 June to 6 Aug. 1825) lithographed throughout from handwriting and pen and ink drawings. – Numbers 6–17 (18 Aug. 1825 to 3 Apr. 1826) appeared under the title *Northern looking glass*; numbers 6–8 were lithographed and have the sub-title '... or litho^c. album'. – The remaining numbers produced by a combination of etching and letterpress, though an alternative version of number 8 was produced by etching. – The publication details are taken from number 1. – The journal continued to be printed, published and sold by J. Watson, but later lithographed numbers were also sold by R. Ackermann, London; Robertson & Ballantyne, C. Smith & Co., and E. West & Co., Edinburgh; R. Griffin & Co., and W. R. M^cPhun & M^cCallum & Co., Glasgow. – A hand-coloured version exists. – See 1.143.

GOLDSMITH, Oliver. *See* 1.52; 5.20

GORCOCK, Jeffrey (pseud.). *See* 1.76

GOSSELIN, T. *See* 3.20

GRAY, Anne Augusta. *See* 5.21

GRAY, Thomas. *See* 5.22

1.111 GRECHI, D. Francesco. Regole del canto fermo / ridotte alla maggiore brevità da D. Francesco Grechi. – Bologna : Presso Cipriani, e. C.C., [c. 1830–40]. – [1], 16 p. : ill., music ; 4° (29 cm).

Lithographed throughout, the text handwritten. – The title-page carries Cipriani's plate number (887). – The pagination begins with p.1 on the title-page verso.

1.112 GRIERSON, J. Twelve select views of the seat of war including views taken at Rangoon, Cachar and Andaman Islands / From sketches taken on the spot by J. Grierson Esqʳ. ; Drawn on stone by E. Billon. – Calcutta : Printed at the Asiatic Lithographic Press, 1825. – [27] leaves, printed on one side only : ill. ; 32 × 48 cm.

Abbey, *Travel*, 403. – Lithographed throughout. – Consists of 12 crayon-drawn plates with facing pages of handwritten text, plus 3 leaves of preliminary matter. – The plates printed on India paper mounted. – Some text leaves watermarked 1824, some leaves of plates watermarked 'J. Whatman 1816' or 'C. Brenchley 1817'. – The subscription list accounts for 258 copies.

1.113 GRIMSTON, Charlotte. The history of Gorhambury. / by Charlotte Grimston. – [S.l. : s.n., c. 1821]. – [2], 1–4, [2], 5–12, [2], 13–14, [6], 15–30, [2], 31–76, [4], 77–84, [4], 85–90 p. : ill. ; 34 cm.

Lowndes, p.947; Martin, p.342. – Lithographed throughout, apart from one etched plate between p.30–31. – Handwritten text. – 9 lithographed plates of views and plans, together with line illustrations of coats of arms in the fore-edge margins of some text pages. – A lithographed portrait of the Hon. Charlotte Grimston printed by Graf & Soret faces the title-page in the Grenville Library copy in the British Library. – The date derives from 'Whatman 1820' watermarks and one plate which is lettered 'The remains of the interior Court at Gorhambury. Standing 1821.'. – No printer's imprint in the book itself; Graf & Soret are not recorded as working before 1832 (Twyman, *Directory*, p.34).

GRINDON, Leo H. *See* 1.50

1.114 HARKNESS, Capt. Henry. Ancient and modern alphabets, of the popular Hindu languages, of the Southern Peninsula of India. / By Captain Henry Harkness, M.R.A.S. – London : Published for the Royal Asiatic Society, of Great Britain & Ireland. By John W. Parker, 1837 ([London] : L. Schönberg, Lith). – [4] p., 36 leaves of tables of characters, printed on rectos only ; 4° (28 cm).

Lithographed throughout. – The carefully-lettered title-page includes a roundel of the Royal Asiatic Society engraved on stone. – Grey-paper wrappers on a privately owned copy repeat most of the image of the title-page, but have a three-line border, a changed imprint, and a revised, ink-drawn roundel. – Schönberg's address is given as 108, Hatton Garden.

HART, John. *See* 5.23

1.115 HAWKINS, Edward. Select papyri in the hieratic character from the collections of the British Museum / with prefatory remarks. – London : Sold at the British Museum ; by Longman and Co. ; Payne and Foss ; and W. Pickering, 1844. : Part 2, London : Sold at the British Museum ; and by Longman and Co., 1860. – 2 vol. ([2], 12 p., 168 plates) ([2], 9 p., 19 plates). – 2° (52 cm).

Lowndes, p.276. – Preliminary pages letterpress, the remainder are facsimiles of papyri. – The plates are in black and a tint, some with an additional red working, some printed on their versos, some folding. – The 'Prefatory remarks' of both volumes appear above the name of Edward Hawkins, though he makes it clear that Mr Birch, then Assistant Keeper of the Department of Antiquities, was responsible for drawing up the remarks. – The lithographic work was the responsibility of Joseph Netherclift, who is referred to in the text of both parts (most fully in vol. 1, p.12) and has his imprint 'J Netherclift fac-sim: lithog:' or 'J Netherclift Lithog. fac-sim.' on the plates.

HEAD, F.B. *See* 2.10

1.116 HEBER, Reginald. A ballad / by the Revᵈ. Reginald Heber late Bishop of Calcutta. – [S.l. : s.n., c. 1827] (Chester: Lithog by W. Crane). – [12] leaves : ill. ; 20 × 24 cm.

Lithographed throughout and with lithographed wrappers. – Title-page, dedication, 5 p. of verse, followed by 8 crayon-drawn lithographed plates, printed on rectos only. – One plate signed VR. – Heber died in 1826.

HOLCOMBE, William Henry. *See* 5.24, 5.25

1.117 HOOD, Thomas. Miss Kilmansegg and her precious leg. : A golden legend / by Thomas Hood ; with 60 illustrations by Thomas S. Seccombe, R.A. Engraved by F. Joubert. – London : E. Moxon, Son & Co., 1870 [i.e. 1869]. – [6], 149, [1] p. : ill. ; 21 cm.

Printed throughout by lithography, probably from engraved stones. – The illustrations integrated with the text. – A large-paper impression, engraved throughout and printed on India paper on rectos only, was published in 1869, though it is dated 1870 on its title-page. – The 1869 dating for the first impression stems from a publisher's binding, and for the second impression from a manuscript inscription.

HUGHES, Thomas. *See* 5.26

1.118 HUNT, Rev. George. Specimens of lithography. / [by George Hunt]. – London : R. Priestley Nᵒ. 143 High Holborn, 1819 (London : Printed by C. Marcuard Nᵒ. 7 Manor Place Kings Road Chelsea). – [4], 32 p. : ill. ; 4ᵒ (21 cm).

Lithographed throughout by the transfer process. – An alternative title 'Specimens of stone printing.' appears on p. 1, together with the name of the author and the date 'Novʳ. 1. 1818'. – The book contains examples of middle-eastern and eastern languages and the direction of the pagination is as in Arabic language books. – An invoice in the St Bride Library reveals that 60 impressions were taken. – The paper is watermarked 'J Green 1814'.

1.119 Hydrographie de l'Empire de Russe à l'usage des élèves de l'Institut des Voies de Communication. – Première partie. – St. Petersbourg : [s.n.], 1833. – [2], vi, [2], 270 p. ; 2ᵒ (37 cm).

Lithographed throughout, the text handwritten, probably on transfer paper, the title-page carefully lettered.

ILLUSTRATED ARCTIC NEWS. See 1.96

1.120 ISHAM, Charles. The food that we live on. : instructive attractive astounding terrible true / [by] Sir Charles Isham Bart. – [Northampton : Sold by Mark & Bailey, [1879] (Printed by Law & Sons). – 33, [1] p. : ill. ; 21 cm.

Lithographed throughout, the text handwritten. – Hand-coloured decorations on most pages. – 2 introductory pages colour-printed. – Green paper wrappers repeat the title-page. – The publisher and place of publication are taken from the final page headed 'Notes', which also states that the book was 'Designed composed & lithographed by C.E.I.' and that 'The proceeds of the two first editions were given to the Northampton Orphanage.' – The date is taken from the British Library catalogues. – See Hallam, H. A. N., 'Lamport-Hall revisited', *Book Collector*, vol. 16, no. 4, 1967, p. 439–449, for a brief discussion of Sir Charles Isham and his books.

1.121 Isographie des hommes célèbres ou collection de fac-simile de lettres autographes et de signatures. – Paris : Alexandre Mesnier, Libraire, [1828 –30] ([Paris : Imprimerie lithographique de Th. Delarue]). – 3 to 5 vol. (approx. 800 leaves) : ill., facsimiles ; 31 cm.

Brunet, 3, col. 469–470. – Lithographed throughout. – Includes displayed title-pages, 7 p. preface, 4 p. list of subscribers, 14 p. alphabetic list of those represented, and almost 650 facsimiles. – Some pages watermarked 'Canson 1822' or 'Canson 1827'.

– The title-pages carry no statement of responsibility, but the wrappers state the following: 'Publié par Delarue, Imprimeur-Lithographe, sous la direction de MM. S. Bérard ... et de Chateaugiron ... Duchesné âiné ... Trémisot ... et Berthier'. – The wrappers also reveal that the work was published in parts of 24 leaves each (6 fr en papier ordinaire ... 10 fr en papier vélin, tiré à 15 exemplaires). – The statement of printing comes from the final page of the list of those represented in the publication. – See 1.122.

1.122 Isographie des hommes célèbres ou collection de fac-simile de lettres autographes et de signatures / Exécutée & imprimée par Th. Delarue lithographe ; sous les auspices de MM Bérard ... de Chateaugiron, Duchesne ... Tremisot et Berthier. – [2nd ed.]. – A Paris : Th. Delarue, Impr, Lithographe ... Truttel et Wurtz, & les principaux libraires de France & de l'Etranger, 1843. – 4 vol. ([2], 11 p., [242] leaves) ([213] leaves) ([202] leaves) ([222] leaves, 38, [1] p.) : ill., facsimiles ; 4ᵒ (33 cm).

Brunet, 3, col. 470. – Second edition of 1.121, made up in part from unused sheets of the first edition. – Lithographed throughout, apart from 11 p. alphabetic list of those represented, 38 p. list of those represented together with prices of items sold at auction since 1820, and 1 p. advertisement. – The letterpress printing by Felix Malteste et Cie. – Each volume has its own lithographed title-page. – The title-pages are different from those of the first edition, but the preface, list of subscribers, errata page and most of the facsimiles were printed from the stones of the first edition. – Some pages watermarked 'Canson 1822' or 'Canson 1827'. – Over 850 facsimiles, about 200 more than the first edition, some of them folding. – The advertisement at the rear of vol. 4 reveals that the complete work sold for 120 fr, including the list giving sale prices (the latter available separately for 8 fr); it also gives the names of M. J. Techener in Paris and booksellers abroad from whom copies may be had.

1.123 J., A.M. A page from the log of 'the Good Ship Nile' containing the only true account yet published of the lives loves & adventures of Cherrycomb & Silvertail / a m j, del | fec. – [S.l. : s.n., s.d.]. – 12 leaves, printed on rectos only : ill. ; 13 × 25 cm.

Lithographed throughout, including covers. – Consists of humorous pen and ink sketches with legends arranged in strip-cartoon form. – No title-page. – The title and initials of the author are taken from grey, glazed-paper pictorial covers. – There must be some doubt over the interpretation of the 'j' in the author's initials. – Stylistic and production evidence suggests a mid-nineteenth century dating.

JOHNSON, Samuel. *See* 5.28

1.124 JONES, Edward Thomas. The science of book-keeping, exemplified in Jones's English systems of single and double entry and balancing books. – London : Published by the Author, Edward T. Jones, Public Accountant, 1831 (London : Printed by T. C. Hansard). – vii, [1], 110, [141]p., in various pagings and numberings of spreads ; 2° (33 cm).

HAL, p.248. – Preliminary pages and p.1–110 + [2] are letterpress. – Examples headed 'Day Book.', 'Goods-bought Day-Book.', 'Cash-Book.', 'Journal.', 'Ledger.', are intaglio (though some have lithographic titles), the rest of the book is lithography. – Dean & Munday are identified as the lithographic printers on the decorative titles to the examples. – The preface is dated 'February 21st, 1831' on p.vii.

1.125 JONES, Edward Thomas. The science of book-keeping, exemplified in Jones's English systems of single and double entry and balancing books. – Second Edition. – London : Published by the Author, Edward T. Jones, Public Accountant, 1831 (London : Printed by T. C. Hansard). – vii, [1], 111, [1], 139p. (numbered 121–259) ; 2° (33 cm).

HAL, p.248. – Preliminary pages and p.1–111 are letterpress, p.121, 167–259 are lithography, p.123–166 are intaglio. – The numeration of pages and spreads of the first edition is retained for the examples of accounting, but an additional single sequence of numeration appears at the foot of such pages. – Dean & Munday are identified as the lithographic printers on the decorative titles to the examples. – The preface to this edition is dated 'May 31st, 1831'. – Some pages in the examples are different from those in the first edition. – Third and fourth editions were published in 1832 and 1834 with some lithographed examples.

1.126 JONES, [Inigo]. [Facsimile of a sketch book begun in Rome in 1614]. – [S.l. : for private circulation by the 6th Duke of Devonshire, *c.* 1831] ([London] : Lithographed by G. E. Madeley, 3, Wellington Stt. Strand). – [128]p. : ill., facsimile ; 22 cm.

Lowndes, p.1226; Martin, p.409–412. – Lithographed throughout in imitation of the original at Chatsworth. – The facsimile is slightly larger than the original (212 × 136 mm compared with 200 × 130 mm). – The statement of printing is taken from an imprint at the foot of the first page of one of the Chatsworth copies (this imprint must have been removed from the stone or plate as it does not appear on other copies with an equal amount of trim). – The facsimile matches the original sketch book in having the same number of blank pages, including

[p.104–128]. – One copy of the facsimile at Chatsworth bears the inscription 'F Chantry Esqr is requested by the Duke of Devonshire to accept this attempted facsimile of Inigo Jones's sketch book.'. – The date is established in one direction by a letter dated 22 Dec. 1831 from Chatsworth's Librarian, J. Payne Collier (printed by Martin). – According to Martin, 100 copies were printed. – *See also* Harris, J., and Higgott, G., *Inigo Jones: Complete architectural drawings* (London, 1989) p.288–290.

1.127 Journal de chant. – Bruxelles : Publié par J. Blasseau et Bielaerds, 1834. – [97] leaves, printed on one side only : ill., music ; 4° (27 cm).

Lithographed throughout in 12 parts, plus lithographed wrappers and a guarded-in letterpress page of contents. – Each part consists of 4 pairs of conjugate pages of songs (music and text) on 8 leaves. – The wrappers have decorated borders front and back and a crayon-drawn vignette on the front. – The title and publication details are taken from the wrappers.

1.128 KALKBRENNER, Frédéric. Méthode pour apprendre le piano à l'aide du guide-mains … suivie de douze études … / par Fréd. Kalkbrenner. – 6e. Edition. – A Paris : par J. Meissonnier Fils, [*c.* 1846] (Paris : Imp. Thierry Fs.). – [4], 76, [1]p. : ill., music ; 2° (35 cm).

Lithographed throughout, apart from letterpress wrappers. – The text pages produced by lithography from transfers taken from punched intaglio plates. – Mainly music after p.20. – The title-page and other pages carry the plate number 'J.M.3294'. – A full-page crayon-drawn portrait of the author on p.[3].

1.129 KELLER, S. L. Figurer henhørende til Ledetraaden ved Forelaesningerne i den beskrivende Geometries 1ste Deel, nemlig den rene beskrivende Geometrie ved den Kongelige militaire Høiskole / [by S. L. Keller]. – [Copenhagen : s.n.], 1830–31. – Approx. 580p. : ill. ; 2° (33 cm).

Not seen. – Information supplied by Dr Erik Dal. – Text lithographed from handwriting by the transfer process. – Contains numerous lithographed illustrations of geometrical figures.

KICK, Paul de (pseud.). *See* 1.68

1.130 KOLB. Berechnung wie viel 1 mal 61 bis 1000 mal 1000 im Ganzen, dann in Gulden und Kreutzer abwerfen. / Verfasst und revidirt von Kolb senior. – In München : [s.n.], 1815. – [2], 70, 2p. ; 16 cm.

Lithographed throughout from handwriting. – Consists of title-page and pages of tables. – The

tables within thick and thin borders; single, double, and triple rules separate the elements.

LAMBE, William. *See* 5.29

1.131 A LADY. Ten lithographic coloured flowers with botanical descriptions / drawn and coloured by a lady. – Edinburgh : Published by David Brown, [1826] ([Edinburgh] : Printed from stone by R.H. Nimmo, No.1 St. David Street]. – 36 cm.

Dunthorne, 19. – Not seen. – This entry has been compiled from descriptions in Dunthorne and antiquarian booksellers' catalogues. – Consists of lithographed title-page and introductory leaves, 40 hand-coloured lithographed plates on rectos, each facing a page of descriptive text lithographed from handwriting, and a subscription list. – The subscription list accounts for 111 copies. – One copy is described as having 4 slips, giving the titles of the plates in each number, and 3 lithographed title-pages. – Dated 1826 by two cataloguers, but not given a date by Dunthorne. – The preface states 'The accompanying drawings of Flowers were taken from Nature as studies, by the author at her leisure hours, without any intention that they should ever leave her Portfolio. As they increased the approbation bestowed on them by Friends on whose taste and sincerity she could rely, suggested the idea of submitting them to the Public.' – The discrepancy between the wording of the title-page and the number of plates suggests that the publication grew in the course of production.

1.132 LASTEYRIE (DU SAILLANT), Charles Philibert Comte de. Lettres autographes et inédites / de Henry IV ; avec le portrait de ce monarque dessiné par F. Gérard ; lithographié par le C^te. de Lasteyrie. – À Paris : [Lasteyrie, *c.* 1815]. – [5] p. : ill., 10 leaves of facsimiles printed on rectos only ; 4° (31 cm).

Twyman, p.51. – Lithographed throughout. – The date derives from a 2 p. dedication to Le Comte de Cazes, Ministre Secrétaire d'Etat au Département de la Police Générale, in which Lasteyrie refers to the publication as the first product of the press he set up at the Ministry. – Printed on laid paper. – The portrait of Henri IV by Gérard is a crayon lithograph.

1.133 LEAR, Edward. Book of nonsense. / [by Derry Down Derry, i.e. Edward Lear]. – [London : Thos. McLean, 1846]. – 2 vol. ([37] leaves) ([37] leaves), printed on rectos only : ill. ; 8° (14 × 23 cm).

Noakes, V., *Edward Lear 1812–1888*, Royal Academy of Arts, exhibition catalogue, 1985, 72 ; Osborne, 1, p.69. – Lithographed throughout. – Both

volumes consist of a title-page and 36 pen and ink drawings by Lear. – Only vol.1 seen – Each drawing is above a limerick, written in italic capitals (mostly on three lines). – The imprint on the title-page is dated 'Feb. 10. 1846.'. – Lithographed wrappers combine the title-page stone with a tint stone from which are reversed out the words 'A book of nonsense by Derry Down Derry'. – The publisher was also a lithographic printer, and it seems likely that he undertook the printing. – *See* 1.134.

1.134 LEAR, Edward. Book of nonsense. / [by Edward Lear]. – New edition. – London : Published by T. McLean, [*c.* 1855]. – [72] leaves, printed on rectos only : ill. ; 8° (14 × 20 cm).

Noakes, V., *Edward Lear 1812–1888*, Royal Academy of Arts, exhibition catalogue, 1985, 73. – Lithographed throughout. – Each drawing is done above a five-line limerick, transferred from upper- and lower-case italic type. – Some of the type must have transferred badly and several pages were substantially retouched by hand on the stone. – The statement of publication is taken from the first leaf. – Some copies do not have either the words 'New edition' or the imprint. – There are substantial differences between the first and second editions in three of the illustrations, and some minor differences in the text and illustrations on other pages. – Later nineteenth-century editions were printed letterpress. – *See* 1.133 and Osborne, 1, p.69–70.

1.135 LEIGHTON, John. [The A]ncient story of the old dame and her pig : A legend of obstinacy. Shewing how it cost the old lady a world of trouble, & the pig his tail. / Illustrated by Luke Limner Esq [pseud.]. – London : D. Bogue, [*c.* 1847] ([London] : Printed at the lithographic press of C. Blair Leighton, 6 Percy Street. – 12 p., printed on one side of each leaf so as to make conjugate pages : ill. ; 15 × 15 cm.

Pantazzi, p.273. – Lithographed throughout. – No title-page. – Front and rear pictorial covers printed lithographically in two colours on the reverse of p.1 & 12. – Each numbered page consists of a pen and ink picture with the relevant part of the story beneath in capital letters. – Publication details are taken from the front cover. – The beginning of the title on the front cover is obscured by right hand of old lady. – The rear cover gives a series title along with a variant title: 'Pictures poems & legendary lore for the homes of Merrie England. Collected & illustrated by Luke Limner Esq / No 1 The Ancient legend of the old woman & her pig'. – The date is taken from the British Library catalogues.

1.136 LEIGHTON, John. Comic. Art-manufactures. / Collected by Luke Limner Esq [pseud.]. – London : D.Bogue, [c. 1848] (London : Printed at the Lithographic Press of Leighton & Taylor). – 8 p., printed on one side of each leaf so as to make conjugate pages : ill. ; 8o (15 × 23 cm).

Pantazzi, p.273. – Lithographed throughout, with 64 humorous pen and ink sketches and legends. – No title-page. – Publication details are taken from lithographed, yellow-paper pictorial covers. – Price one shilling. – The copy in the Library of the Victoria & Albert Museum (which is bound up with 1.138) has an inscription on its fly leaf which reads '2 Brochures published in the dark ages of art about 1848 & 51 / Plates very much injured a few copies printed off prior to destroying them'. – A further copy (also bound up with 1.138), is described in an unidentified cutting from a bookseller's catalogue as bearing the following MS note signed by John Leighton: 'This little book consists of two brochures printed from zinc and one of the earliest by that method lithographically. The title-page is litho. The plates were damaged by bad storage. The first is a satire upon the Art Manufactures of 'Felix Summerley', Sir Henry Cole, C.B. The book is very rare. The second satire being upon the vagaries of the first great International Exhibition of 1851'. – Leighton & Taylor are first recorded in directories in 1851 (Twyman, *Directory*, p.39). – A variant exists in blue-paper wrappers with the imprint 'Vincent Brooks, Imp.'.

1.137 LEIGHTON, John. London out of town or the adventures of the Browns at the sea side / by Luke Limner. Esq [pseud.]. – London : Published by David Bogue, [c. 1847] ([London] : Printed at the Lithographic Press, Leighton & Taylor, 19 Lambs Conduit St.). – 16 leaves, printed on one side only so as to make conjugate pages : ill. ; 8o (12 × 15 cm).

Pantazzi, p.273. – Lithographed throughout, with front and rear covers in tinted lithography. – 16 numbered plates comprising 154 pen and ink drawings organized in the form of comic strips. – Leighton & Taylor are first recorded in directories in 1851 (Twyman, *Directory*, p.39), but a copy with the imprint 'Printed at the Lithographic Press of C.Blair Leighton, 6 Percy St, Rathbone Pl.', published in Dec. 1847, is known.

1.138 LEIGHTON, John. The rejected contributions to the Great Exhibition of all Nations. : With the classes in which they will not be found … / Collected by Luke Limner Esq. [pseud.]. – London : Ackermann & Co., [c. 1851] (London : Printed by Leighton Bros.). – 8p., printed on one side of each

leaf so as to make conjugate pages : ill. ; 8o (15 × 23 cm).

Pantazzi, p.273. – Lithographed throughout, with 70 humorous pen and ink sketches and legends. – No title-page. – Publication details are taken from lithographed, beige-paper pictorial covers. – Price given as one shilling, with 'An edition upon large paper, India proofs 2s. 6d.'. – *See* the notes to 1.136.

1.139 LEIXNER, Alois von. Lehrbuch der Kaufmännischen Buchführung (italienische und französische Doppik) mit besonderer Rücksicht auf den Selbstunterricht nach eigener Methode / bearbeitet von Alois v. Leixner. – Wien : Verlag von Moritz Perles, 1884. – 55, [4], 132 p. ; 30 cm.

HAL, p.50. – The first paging (preliminary pages and the 'Theoretischer Theil'), is letterpress, the second paging (containing the 'Praktischer Theil'), is lithographed. – An accompanying 'Aufgaben-Block' is entirely letterpress.

1.140 Lieder für Schweizerjünglinge. / Herausgegeben von dem Zofinger-Vereine schweizerischer Studirender. – Zweite Auflage. Mit Singweisen für drei Männerstimmen. – Bern : bei C.A.Jenni, Buchhändler, 1825 (à B[erne] : Lith. Jenni et Cie). – [151]p. : ill., music ; 13 × 22 cm.

Lithographed throughout. – A collection of 70 songs, the words of which are handwritten.

1.141 LE LITHOGRAPHE [Compiègne, c. 1837–?]

Not traced. – Journal referred to in the better-known journal of the same name, *Le Lithographe* (Paris), vol.2, 1839, p.31. – It is described as a weekly political journal, which had been published for almost two years by Levacher, a lithographic printer in Compiègne. – Said to have been produced entirely by lithography.

LIMNER, Luke (pseud.). See 1.135–1.138

1.142 LODER, John David. A general and comprehensive instruction book for the violin, containing upwards of one hundred preludes & exercises, in the major and minor keys … / The whole arranged with the proper fingering & bowing by J.D. Loder. – Sixth Edition. Considerably enlarged & improved by the author. – London : Hutchings & Romer, [c. 1865] ([London : Printed by Hutchings & Romer]). – [2], 67 p. : ill., music ; 2o (36 cm).

Lithographed throughout from transfers of intaglio plates. – Mainly music after the first 6 p. – The date is based on entries in trade directories. – The preface (dated Feb. 1841) is that of the fifth edition, which suggests that this is a reprinting of

the earlier edition with a changed title-page. – All pages other than the title-page carry a Hutchings & Romer plate number (1260).

1.143 LOOKING GLASS. The Looking glass; or, caricature annual. – [London] : Published by Thomas Mᶜ.Lean, 26, Haymarket, 1830–32. – Monthly, 4 p. an issue : ill. ; 2° (42 cm).

The first 7 numbers (1 Jan. to 1 July 1830) were etched and printed intaglio, the remainder (1 Aug. 1830 to 1 Dec. 1832) lithographed. – Each number consists of numerous crayon-drawn sketches with legends. – The printing was initially done by Charles Motte, 70 St Martin's Lane, then, from Feb. 1832, by his successor A. Ducôte at the same address and by Meifred, Lemercier & Co. (later Maguire, Lemercier & Co.). – William Heath is credited with responsibility for the 7 etched numbers, and Robert Seymour for the first 5 of the lithographed numbers and the title-pages of volumes 1 (1830) and 3 (1832). – The remaining numbers are neither signed nor credited to anyone, but on stylistic grounds can be attributed to the caricaturist HB (John Doyle), who was producing regular political caricatures for McLean at the time (*see* Trevelyan, G.M., *The seven years of William IV*, London, 1952). – The etched numbers refer to William Heath as the 'Author of the Northern Looking Glass' (*see* 1.110).

LUXMORE, T.C. *See* 2.14

MACAULAY, Thomas Babbington. *See* 5.32

1.144 MC.LUMMUND. The giant show or the adventures & misadventures of Benjamin Mc.Lummund Esq formerly of Beenstorke in the Isle of Skye, but now residing at Noland Castle Ayrshire / illustrated by a series of pen and ink sketches, originally thrown off for the delectation of the dear little denizens of a nursery, but now collected and published for the benefit of a small society recently established in the town of N ... for the diffusion of useful knowledge, good principles and warm flannel, among the poor of that place. – London : Bosworth & Harrison ; Nottingham : Simkins & Browne, [c. 1860] (Ipswich : Printed at the Anastatic Press). – [4] p., 48 leaves, printed on rectos only : ill. ; 15 × 22 cm.

Lithographed throughout by the transfer process, apart from the publisher's imprint on the title-page which is overprinted by letterpress. – Lithographed wrappers printed black on green paper. – Profusely illustrated with pen and ink drawings on every page. – The printer was probably S.H. Cowell, who printed

anastatically in Ipswich from the late 1840s (*see* Wakeman, p.27, 36–40).

1.145 MAINBERGER, Carle[s]

The journal *Le Lithographe*, vol.3, 1842, refers to two didactic publications for lithographers by Mainberger which may have been lithographed throughout. A publication of 'Alphabets à rebours' for lithographic writers, consisting of 10 plates showing 40 alphabets, is referred to (p.125–126) as having appeared in French and German editions, and as running into a second printing (p.256). A further publication with the title *Méthode d'enseignement du dessin et de l'écriture lithographiques* was announced (p.286–287) as appearing in two parts in Aug. and Sept. 1842, the first consisting of a course in pen drawing, the second dealing with writing backwards. Mainberger is referred to as though he was one of Desportes's lithographic writers, and both publications were available from the office of *Le Lithographe*. Neither has been traced.

MAINZ PSALTER. *See* 1.88

1.146 MALCOLM, John. Address / of Sir John Malcolm, G.C.B. Governor of Bombay delivered at a special meeting of the Literary Society of Bombay held on Wednesday 5th December 1827.

Lithographed throughout. – Seen once, but not subsequently traced.

1.147 MASON, G. Finch. Country sketches / by Finch Mason. – London : A.H. Baily & Co. [c. 1881] (Ipswich : Cowell, Anastatic printer). – [1], 20 leaves, printed on rectos only ; 28 × 38 cm.

Lithographed throughout by the transfer process. – Pen and ink humorous sketches, several to a page, with handwritten legends. – Printed on buff paper. – The pictorial title-page design is repeated on the front boards, which have additional red, buff, and green workings. – Price '10ˢ/6ᵈ'. – Finch Mason is described on the title-page as the 'Author of "Sporting Sketches" etc.'. – Several plates are dated 'Oct/ 81' and one 'Oct. 1881.'.

1.148 MASON, G. Finch. Sporting sketches / by G. Finch Mason. – Cambridge : W.P. Spalding ; London : W. Kent & Co. [c. 1879] (Ipswich : Cowells Anastatic Press). – [1], 25 leaves, printed on rectos only ; 27 × 38 cm.

Lithographed throughout by the transfer process. – Pen and ink humorous sketches, several to a page, with handwritten legends. – The pictorial title-page design is repeated on the front boards, which have

an additional red working. – Price 'half a guinea'. – The date is taken from the British Library catalogues. – A fourth edition [1882] was published in Cambridge and London by W. P. Spalding and A. H. Baily & Co.

1.149 MATTEI, Stanislao. Pratica d'accompagnamento sopra bassi numerati e contrappunti a piu voci sulla scala ascendente, e discendente maggiore, e minore con diverse fughe a quattro, e 8. / Opera composta ... dal Padre Maestro Stanislao Mattei. – Bologna : presso Cipriani e Cº. ; Firenze : presso Gaspero Cipriani ; Livorno : presso Fedele Gilardi, [c. 1825–1830] ([S.l.] : Litog: Cipriani). – 132 p. : 2° (34 cm).

Lithographed throughout, the text handwritten. – Mainly music after p. 15. – The initials of two music writers ('.T.' and '.B.') appear at the foot of some pages. – The lithographic writer's name at the foot of the title-page is not decipherable in the single copy studied because the page is cropped.

1.150 MAYHEW, Horace. Guy Faux. : A squib manufactured / Horace Mayhew and Percy Cruikshank (pupils of Guy's). – London : Sold by Grant & Griffith, [1849] ([London] : Ford & George, Lithographers, 54 Hatton Garden). – [18] leaves, concertina folded : ill. ; approx. 14 × 200 cm.

Osborne, 1, p.283. – Lithographed throughout. – Line drawings in strip cartoon form with handwritten legends beneath each picture. – No title-page. – Publication details are taken from the wrappers. – Lithographed pictorial wrappers (front and back) printed in three colours. – 1/6 Plain 2/6 Cold. – The date is taken from the British Library catalogues.

1.151 MAYHEW, Horace. The Tooth-ache. / Imagined by Horace Mayhew ; and realized by George Cruikshank. – [London] : To be had, of D. Bogue. 86 Fleet Strt. and all booksellers, [1849]. – [24] p., concertina folded : ill. ; approx. 13 × 180 cm.

Douglas, R. J. H., *The Works of George Cruikshank classified and arranged* (London, 1903), 252. – Lithographed throughout. – Consists of humorous pen and ink sketches, numbered 1–43, hand-coloured, with hand-lettered legends. – No title-page. – Publication details are taken from the wrappers. – 1/6 Plain, 3/- Colored. – The date is taken from the British Library catalogues.

1.152 MENZEL, Adolph. Die Armee Friedrich's des Grossen in ihrer Uniformirung. / Gezeichnet und erläutert von Adolph Menzel. – Berlin : Zu beziehen durch den Verfasser A. Menzel ... und den Drucker L. Sachse ..., 1851–57 ([Berlin] : Druck und

colorit des Lith. Inst. von L. Sachse & Cº.). – 3 vol. (approx. [624] leaves) : ill. ; 2° (37 cm).

Lithographed throughout, printed on one side of each leaf only. – Consists mainly of hand-coloured pen and ink lithographs of uniforms, but also contains hand-lettered title-pages, captions, and occasional pages of explanatory text. – Each title-page has a different vignette and is differently lettered : Erster Band 'Die Cavallerie', 1851; Zweiter Band 'Die Infanterie', 1855; Dritter Band 'Rest der Infanterie', 1857. – The title-pages and other verbal matter carefully executed. – British Library catalogues state that only 30 copies were printed. – *See* Bland, D., *A History of book illustration* (London, 1958), p.310.

1.153 Mercur : ein Taschenbuch zum Vergnügen und Unterricht mit Bemerkungen auf das Jahr 1816. – München : Auf Stein gedruckt in der K: Armen-Beschäftigungs-Anstalt am Anger 774, [c. 1816]. – [30] p. ; 16 cm.

Winkler, 907 : 11–13. – Lithographed throughout. – Consists mainly of ruled pages with headings, some of them pictorial. – Frontispiece of Mercury holding a sheet of paper bearing the note 'Bemerkungen für 1816' and signed 'Lith. v. J. Fr. Weber'.

MILTON, John. *See* 5.33

1.154 Mirabilia descripta per fratrem Jordanum a Severato, in India majori episcopum Columbensem (c. 1321–1325).

Not traced. – Lithographed facsimile of a manuscript referred to in *Bulletin de la Société de Géographie*, vol.1, part 2, 1824, no.16.

1.155 MLĆZOCH. Ant. Návod účetní k vedení kněh generálních zastupitelství 'Slavie' vzájemně pojišt'ovací banky v Praze na základě spůsobu složitého účetnictví / sepsal Ant. Mlczoch, vrchní účetní téže banky. – V Praze : Nákladem banky 'Slavie', 1872 (Autogr. tiskem J. Středy). – 47 p., [32] leaves + 1 loose leaf, 2 folding plates ; 30 cm.

HAL, p.248. – Lithographed by the transfer process from handwriting, apart from the folding letterpress plates. – The 32 leaves are examples of accounting, and include both paginated and unpaginated pages and numbered spreads.

1.156 Monument, van het driehonderdjarig bestaan der onveranderde Augsburgsche Geloofsbelydenis, opgedragen aan allen die dezelve zyn toegedaan. – Te Haarlem : door Sander & Compie. steendrukkers en uitgevers, 1830. – [6], 8, 12, [6], 46 p. : ill. ; 2° (41 cm).

Lithographed from handwriting apart from the first pagination, which is letterpress, and 3 lithographed plates. – Lithographed paper-covered boards. – The foreword by Sander & Comp^ie. mentions (p.7–8) that the book combines different kinds of lithography to show its progress, and states that the foreword was produced by transfer lithography whereas the text of the Augsburg Confession was written directly on to stone. – The pages of the Confession are set within ruled borders. – One of the plates is lettered 'A. Vinkeles R.Z. inv: del:', the others are portraits of Martin Luther and Philippus Melanchthon.

MOZART. *See* 1.4, 1.5

1.157 MÜHLAUER, Michael. Neue verbesserte und vermehrte theoretisch practische grosse Zither-Schule nebst 50 ausgewählten Übungs- und Unterhaltungs-Stücken ... / in tiefster Ehrfurcht gewidmet von Michael Mühlauer. – Neue Ausgabe. – München : bei Falter und Sohn, [1853]. – 81 p. : ill., music ; 29 cm.

Lithographed throughout, the text handwritten. – Falter's plate number appears on most pages in the form 'F. & S. N^o. 935'. – The preface (p.2) is dated 'München im Juni 1853'.

MULOCK, Dinah Maria (Mrs Craik). *See* 5.34

MUNIER & RODOLPHE. *See* 3.22

1.158 Muséum pittoresque : ou histoire naturelle des gens du monde. – Paris, [c. 1835].

Not traced. – Referred to by J.-J. Delalande in a report on 'Typolithographie' in *Le Lithographe*, vol.2, 1839, p.219, as having been produced by the printer Houbloup. It was begun in 1834 and exhibited at the Salon of 1835. It is said to have consisted of 50 leaves containing 800 subjects and to have had its text transferred from movable type.

1.159 NETHERCLIFT, Frederick George. The autograph miscellany : a collection of autograph letters interesting documents &c / executed in fac-simile lithography by Frederick Netherclift. – First series. Containing sixty examples. – London : Netherclift & Durlacher, 1855 (London : Printed by Netherclift & Durlacher). – [6] p., 60 leaves : ill., facsimiles ; 2^o (39 cm).

Published in monthly numbers. – 60 p. of fac-similes on rectos, produced by transfer lithography, face 60 p. of letterpress transcriptions. – The lithographed title-page is printed in red, blue, black, and gold. – The preface states that the letterpress trans-

criptions were made by Richard Sims of the British Museum.

1.160 NETHERCLIFT, Frederick George. The autograph souvenir, a collection of autograph letters, interesting documents, &c, / executed in facsimile, by Frederick George Netherclift ; with transcriptions & occasional translations, by Richard Sims, of the British Museum. – 1st series. – London : Printed & published by F. G. Netherclift, [1865]. – [165] leaves : ill., facsimiles ; 2^o (33 cm).

Facsimiles of 75 documents, produced by transfer lithography, interspersed with letterpress transcriptions on separate leaves. – Drawn from items in the collections of P. O'Callaghan and John Young. – The facsimile pages are printed in a brown or black ink, presumably to match the originals in colour. – Lithographed title-page printed in three colours, and dedication printed in one colour. – The date of publication is taken from the 'Prefatory remarks'.

1.161 NETHERCLIFT, Frederick George. The hand-book to autographs : being a ready guide to the handwriting of distinguished men and women of every nation. Designed for the use of literary men, autograph collectors, and others. / By Frederick G. Netherclift ... ; With a biographical index, &c. by Richard Sims. – London : F. G. Netherclift, lithographer and general printer, [1862]. – [2], 2 p., approx. 240 leaves printed on rectos only : ill., facsimiles ; 19 cm.

Lithographed throughout by transfer lithography, apart from the preliminary pages which are letterpress. – Consists primarily of facsimiles.

NETHERCLIFT, F.G. *See also* 1.174

1.162 NETHERCLIFT, Joseph. Autographs of the kings and queens, and eminent men, of Great Britain, from the 14^th. century to the present period : being fac-similes taken from original documents / by J. Netherclift. – London : Printed & published at J. Netherclift's Lithographic Office, 1835. – [14] leaves, printed on one side only so as to make conjugate pages : ill., facsimiles ; 2^o (38 cm).

Lithographed throughout. – Facsimile autographs produced by transfer lithography are grouped together within borders to make 7 plates designed to be viewed when the book is turned 90° clockwise. – The statement of publication is taken from the lithographed brown-paper wrappers.

1.163 NETHERCLIFT, Joseph. Autograph letters, characteristic extracts and signatures, from the correspondence of illustrious and distinguished women of Great Britain, from the XIV^th. to the XIX^th. century, / collected and copied in fac-simile from original documents, by J. Netherclift. – London : Printed & published at J. Netherclift's Lithographic Office, 1838. – [5], 36 leaves, printed on rectos only : ill., facsimiles ; 2° (39 cm).

Lithographed throughout, the facsimile leaves by the transfer process. – Title-page lettered 'J. Netherclift script^t. Lithog:'. – The facsimiles lettered 'Copied from the Originals, Printed & Published by J. Netherclift, 23 King William St. West Strand', or with a very similar imprint.

1.164 NETHERCLIFT, Joseph. A collection of one hundred characteristic and interesting autograph letters, written by royal and distinguished persons of Great Britain, from the XV. to the XVIII. century, / copied in perfect fac-simile from the originals, by Joseph Netherclift and Son. – London : Printed and published at Netherclift and Son's Lithographic Office, 1849. – [4], ii, 41 p., 106 leaves, one folding and many printed on rectos only : ill., facsimiles ; 2° (23 cm).

The title-page and all numbered pages letterpress, the remainder lithographed. – The facsimiles produced by transfer lithography to match the originals in tone and colour. – The dedication printed lithographically in three colours. – Many of the facsimiles lettered 'J. Netherclift fac-sim:'.

NEW TESTAMENT. *See* 1.28, 1.29, 1.51; 5.5–5.9

NORTHERN LOOKING GLASS. *See* 1.110

1.165 NOTT, George Frederick. An account of the opening of Bishop Fox's Tomb in Winchester Cathedral, January 28^th. 1820. / [by Geo. Fred. Nott]. – [Winchester : Close, Sep. 3^rd. 1821] (Oxford : N. Whittock lithog.). – [14] p. ; 4° (28 cm).

Lithographed throughout from handwriting done on the stone. – No title-page, the title and name of printer are taken from the lithographed, brown-paper wrappers. – The statements of responsibility and publication are taken from the final page.

1.166 Opéra. : Cahier des charges. – [Paris : Ministère de l'Intérieur], 31 juillet 1847. – [2], 32, [2] p. ; 2° (32 cm).

Lithographed from handwriting, with some manuscript additions and corrections and retouching of poorly printed parts. – Title-page inscribed

in ordinary ink '11' (after lithographed 'N°.') and 'M^r. Vatel, Directeur du Théâtre Italien'. – Page 32 signed 'Léon Pillet, Duponchel, and V. L. N. Rocoplan dit Roqueplan', and dated 'Paris, le 11 septembre 1847'.

1.167 PANSERON, Auguste. Méthode complète de vocalisation pour mezzo-soprano adoptée pour les classes du Conservatoire de Paris, dediée à son ami Rossini / par A. Panseron. – A Paris : chez G. Brandus Dufour et C^ie . . . et chez l'auteur, [1855]. – [4], 219 p. : ill., music ; 28 cm.

Lithographed throughout from transfers of intaglio plates, apart from p. 21–24 which are letterpress. – Mainly music after p. 25. – The name 'A. Lafont' [the lithographic letterer ?] appears at the foot of the title-page. – The initials 'M.M.P.' [the lithographic printer ?] appear on all the lithographed sheets. – The date is taken from a letter of recommendation dated 'Paris, le 15 octobre 1855'.

1.168 PARIS, Aimé. Guide pratique des cours d'enfans, ou série d'exercises gradués à l'usage des jeunes élèves / de M. Aimé Paris. – Gand : [s.n.], Février–Mai, 1842. – 335 p. : ill., music ; 2° (35 cm).

Mainly lithographed by the transfer process, with the text handwritten (p. 2–327). – The title-page and the 'Table des matières' (p. 329–335) letterpress. – The title-page is headed 'Théorie de Feu P. Galin. – Additions de M. Aimé Paris.'. – Page 67 bears the imprint 'Lith: de G: Jacqmain, rue basse, à Gand', though this printer may not have been responsible for the rest of the book as the page has finely drawn illustrations and does not seem to have been produced by the transfer process.

1.169 PARRY, John Orlando. John Parry's manual of musical terms and various other subjects connected with musical art. – London : Published by Thomas Mc.Lean, [c. 1855]. – 12 leaves, printed on rectos only ; 4° (22 × 29 cm).

Lithographed throughout by the transfer process, including brown-paper wrappers. – A series of humorous pen and ink sketches with captions. – Some leaves are printed 'Simpson 266 Regent Street'. – The title is taken from plate 1. – Price '2/6' on front wrappers. – John Orlando Parry (1810–79) was an actor and entertainer and the son of the musician John Parry (1776–1851).

1.170 PARRY, John Orlando. Ridiculous things : Scraps and oddities. Some with, and many without any meaning. / By John Parry. – London : Published by T. M'Lean, 1854. – Title-page, dedication, 32 leaves, printed on rectos only : ill. ; 2° (42 cm).

Lithographed throughout, mainly by the transfer process. – Humorous pen and ink sketches with legends. – The title-page and one plate printed with a tint, one other plate printed in three colours, the remainder printed in a single colour (blue, brown, black, or green). – 'Price 21s.' on the front cover.

1.171 PARTHENON. The Parthenon. – [London : Black, Young, and Young], 1825–26 ([London : At the Typolithographic Press, White Lion-court, Wych-street]). – Weekly journal, 16p. an issue : ill. ; 8º (24 cm). – Sig: B–H⁴ I–K² χ⁴ L⁴ (lithographed numbers only).

Numbers 1–5 (11 June to 9 July 1825, p.1–80) lithographed throughout by the typolithographic process (i.e., the text transferred from type), numbers 6–16 (16 July 1825 to Jan. 1826) printed letterpress with illustrations and music lithographed, some in a second colour. – The statements of publisher and printer are taken from a prospectus in the John Johnson Collection, Bodleian Library, which states that the journal 'will be printed on fine super-royal paper, folded in octavo, and stitched in a cover.'. – For the owners of the Typolithographic Press, see Twyman, *Directory*, p.46. – The process of typolithography is referred to in the prospectus and in a note on p.16 of the first number of the journal.

PASLEY, C.W. *See* 2.19–2.29

PERSY, N. *See* 3.23–3.25

1.172 PETITES AFFICHES. [Châtillon-sur-Seine : Thévenin, 1830s].

Not traced. – Referred to in *Le Lithographe* (Paris), vol.1, 1838, p.xxi, and vol.2, 1839, p.31–32, as a journal published by Thévenin, Châtillon-sur-Seine. Described as having been written in 'anglaise' and 'italique'.

1.173 PETTOLETTI, F.P. Kolonne-Bogholderi for Haandvaerkere, Fabrikanter og Kjøbmaend, med fuldstaendig Vejledning til Indrettelse og Selvstudium, ledsaget af trykte autograferede Skemaer / af F.P. Pettoletti ; Eneret paa min Under-visnings-Methode og Skemaer forbeholdes. – Kjøbenhavn : I Kommission hos V. Thaning & Appel, 1882. – [23]p. ; 2º (38 cm).

HAL, p.248. – 4p. letterpress followed by 19p. of examples of accounting lithographed from handwrit-ing. – Publication details are taken from the letter-press wrappers.

PHILLIPPS, Sir Thomas. *See* 4.1–4.14

1.174 PHILLIPS, Lawrence B. The autographic album. : A collection of four hundred and seventy fac-similes of holograph writings of royal, noble, and distinguished men and women, of various nations. Designed for the use of librarians, autograph collectors, literary men, and as a work of general interest … / by Lawrence B. Phillips, F.R.A.S. ; lithographed by F.G. Netherclift. – London : Robert Hardwicke, 1866 ([London : F.G. Netherclift]). – iv, [1]p., 234 leaves, printed on rectos only, 37p. : ill., facsimiles ; 4º (22 cm).

All leaves of facsimiles produced by transfer lithography. – Preliminary pages and biographical index printed letterpress in London by W.J. Perry. – It can be assumed from knowledge of Netherclift's firm that he was responsible for the lithographic printing in addition to the lithographic writing.

PIOBERT, Guillaume. *See* 3.26–3.27

PITMAN, Sir Isaac. *See* 5.1–5.66

1.175 PLANTIER, Joseph. Nouvelle sténographie universelle : La seule classique et unitaire sans maître : Méthode éclectique : Divisée en dix leçons théorie-pratique, mise à la portée des plus jeunes élèves des deux sexes des écoles, collèges, ecoles de droit, de médecine, militaire, Sorbonne, Collége de France, etc. etc., … – Douzième edition. / par Joseph Plantier. – A Paris : Au seul dépôt central, chez l'Auteur … et … chez M. Douriez, 1866 (Paris : Lith du Sénat, Barousse). – Part 1 [8], 84p.; part 2 154p. : ill. + 3 folding plates ; 8º (25 cm).

Lithographed throughout, the text produced by a combination of transferred type and handwritten stenography. – Copious decorative and pictorial work, with borders on all pages. – Stone marks are visible on some pages. – Yellow-paper wrappers printed lithographically. – The wrappers refer to a 'Tirage à cent-mille exemplaires'.

1.176 POCOCK, Rose R. To the most honorable John Alexander the youthful Marquess of Bath, these views, taken from the princely domain of Longleat; are most respectfully dedicated by the permission of the most honorable Marchioness of Bath ; / by her ladyships, most humble, most obedient servant, Rose R. Pocock. – [Bath : private circulation, c. 1840] (Bristol : A. Pocock Lith). – [13] leaves, printed on rectos only : ill. ; 42 × 57 cm.

Abbey, *Scenery*, 422. – Lithographed throughout. – No title-page. – Crayon-drawn lithographic plates of Longleat and its surroundings alternate with handwritten text pages, both kinds of pages printed with similar tinted backgrounds and borders. –

A manuscript note on what appear to be the original wrappers in the British Library copy reads 'only 100 Copies Printed at the expence of the Marchioness of Bath for private circulation only.'. – Most of the plates are lettered 'Sketched and Drawn on Stone by R. Pocock'.

PONCELET, Jean-Victor. *See* 3.28–3.35

PONSONBY, Colonel. *See* 2.30

1.177 POPPE, O. O. Poppe's Schule der Buchführung. : Bearbeitung für Zimmereigeschäft, Sägemühle und Holzhandel. – Zweite Auflage. – Stuttgart : Richard Hahn's Verlag, [*c.* 1885]. – 19 p. ; 23 × 36 cm.
HAL, p. 248. – Lithographed throughout from handwriting, apart from letterpress wrappers. – No title-page. – Publication details are taken from the wrappers. – Includes examples of accounting. – The date is taken from a manuscript addition to the copy in the Library of the Institute of Chartered Accountants in England and Wales. – Published with six exercise books for accounting.

1.178 POTTIER. Quelques psaumes de David / Rendus à leur mélodie primitive par M. Pottier Professeur à Paris, ex-musicien de l'Empereur et du Roi. – Bordeaux : [chez Mr le pasteur Vermeil], 1833 ([à Bordeaux : de la lithographie de Pallard rue Fondaudege No. 65]). – [8], 104 p. : ill., music ; 15 × 19 cm.
Lithographed throughout, the text handwritten. – The publication has two title-pages, and the information provided above is from the second (on p. 1). – The name of the publisher is taken from the 'Avis', the statement of printing from the first title-page.

PRAYER BOOK. *See* 1.31–1.33, 1.48; 5.13–5.17

1.179 Principes de musique vocale. – [S.l. : s.n., s.d.]. – [22] leaves : ill., music ; 24 × 32 cm.
Lithographed throughout from handwriting by the transfer process, apart from the title-page which is letterpress printed on the inner 'forme' only, and gathered [1–11]². – The first lithographed page is on the reverse of the title-page. – Some pages of the transferred work have been substantially touched up on the stone. – On stylistic grounds the publication appears to date from the period 1840–50.

1.180 PRITCHETT, Robert Taylor. Smokiana : historical : ethnographical / [by] R. T. Pritchett. – [London : Bernard Quaritch], 1890. – 102 p. : ill. ; 4° (24 cm).
Lithographed throughout, with a second colour on many pages. – Illustrations are all on rectos and are mostly printed in several colours. – The name of the publisher is taken from the binding. – Pritchett's monogram appears on the title-page and a version of his book-plate is printed on p. 4.

PRYNNE, Joh. *See* 4.1

PUPIL OF MR SENEFELDER. *See* 1.105

1.181 PYNSON, Richard. The solempnities and triumphes doon and made at the spousells and marriage of the Kings daughter the Ladye Marye to the Prynce of Castile Archeduke of Austrige. – London : [Roxburghe Club], 1818 ([London : R. Ackermann's Lithographic Press]). – [23] p. ; 4° (25 cm).
Barker, N., *The Publications of the Roxburghe Club 1814–1962* (Cambridge, 1964), 23. – Facsimile of a tract printed by Richard Pynson, made from the copy in the Library of the British Museum. – The first 4 leaves letterpress, printed by Wright and Murphy, Holborn, on rectos only, thereafter lithographed. – The statement of responsibility for the printing is taken from the letterpress dedication dated 17 June 1818.

QUARTER–MASTER–GENERAL'S OFFICE.
See 1.60

1.182 Recueil des historiens des Gaules et de la France. : Tome Treizieme. : Contenant la suite des monumens des trois regnes de Philippe I, de Louis VI dit le Gros, & de Louis VII surnommé le Jeune, depuis l'an MLX, jusqu'en MCLXXX. / Par des Religieux Bénédictins de la Congrégation de S. Maur. – A Paris: Chez la veuve Desaint, MDCCLXXXVL [i.e. 1786] (Paris : de l'Imprimerie de Phillippe-Denis Pierres]) : (Paris : Lithographie de Paul Dupont … Réimprimé par le Procédé Litho-Typographique de MM. Paul & Auguste Dupont, 1847). – [4], lxxx, 885 p. ; 2° (44 cm).
Lithographed throughout by Dupont's process of *lithotypographie*, and the outstanding application of this method of making facsimiles of printed documents. – This single volume of the publication was reprinted lithographically to replace copies destroyed by fire. – The title-page is printed in two colours. – Referred to by Paul Dupont in his *Essais pratiques d'imprimerie* (Paris, 1849), p. 38–39.

1.183 Recueil de psaumes et de cantiques, / publié par la Société Évangélique de Lausanne. – Lausanne : Lithographie de J. P. Zwahlen, 1839. – 224, 82, 7, [1]p. : ill., music ; 25 cm. – Sig: [a]⁴ b–i⁴ k–s⁴ ß⁴ t–u⁴ v⁴ w⁴ x–z⁴ 27–28⁴ 1–5⁸ 6⁵.

The pages of the first pagination, which consist of music with lyrics, are lithographed throughout. – The pages of subsequent paginations, which contain no music, are letterpress.

RICHMOND, Legh. *See* 5.61

ROYAL ENGINEER DEPARTMENT, CHATHAM. *See* 2.1–2.39

1.184 RYDE, Edward. Ryde's hydraulic tables, giving at sight the discharge & velocity of water & sewage flowing through pipes. : Practically adapted to the requirements of the civil engineer, architect, surveyor, contractor and builder. / by Edward Ryde. ... – London : Published by J. Weale ... Hullmandel and Walton ... and at the Office of the author, [1 May 1851] ([London : Printed from the zinc plates at the Lithographic Establishment of Hullmandel & Walton]). – 100, [4]p. : ill., mainly tables ; 4⁰ (25 cm). – Sig: [A]⁴ B–N⁴.

Lithographed throughout from zinc. – The pictorial half-title, title-page and some of the advertisement pages signed 'J M'Nevin'. – Reverse of half-title states that the book was 'Drawn upon zinc in the Office of Mʳ. Edward Ryde, 14 Upper Belgrave Place, Eaton Square'. – Consists principally of pictorial tables (p.11–100) altered up from a master image. – The statement of printing is taken from the title-page verso.

1.185 SALA, George. Practical exposition of Mr J. M. W. Turner's picture Hail rain steam & speed. : Trifles for travellers dedicated to to [sic] the world in general and unprotected females in particular / by an old stoker ... George Sala fecit. – London : Ackermann & Co, [c. 1850]. – [23] leaves, concertina folded : ill. ; approx. 13 × 230 cm.

Lithographed throughout. – Many humorous pen and ink sketches with hand-lettered legends. – Lithographed pictorial boards. – 1/- Plain 2/6 Colᵈ. – The date is taken from the British Library catalogues. – The sequence of the first two words of the title must be in some doubt (Turner's painting, called 'Rain, steam, and speed', was exhibited at the Royal Academy in 1844). – Twyman, M., *Printing 1770–1970* (London, 1970), pl.542.

1.186 Sammlung historisch-berühmter Autographen, oder Facsimile's von Handschriften ausgezeichneter Personen alter und neuer Zeit. – Erster Serie. – Stuttgart : Ad. Becher's Verlag, 1846. – [6]p., [248] leaves of facsimiles, mostly printed on rectos only ; 4⁰ (28 cm).

The facsimiles produced by transfer lithography. – Contains lithographed and letterpress title-pages and a 2 p. letterpress index of names. – Facsimiles numbered 1–280 (159 duplicated) and 1–6. – Letterpress wrappers of parts 1–7 are dated 1845 (parts 1–6 carry the imprint of Becher & Müller, part 7 that of Adolphe Becher).

1.187 SCHACKY, Maximilian von. Gründliche auf praktische Erfahrung sichstützende Anleitung die Guitarre spielen zu lernen zum Selbstunterrichte nach Giulianischer Methode u. Fingersatz / entworfen von Maximilian von Schacky. – München : in der k.b. Hof-Musicalien- u. Music-Instrumenten-Handlung von Falter u. Sohn ; Mainz u. Paris : bei B. Schotts Söhne ; Antwerpen : bei A. Schott, [c. 1835]. – [6], 20p. : ill., music ; 24 × 34 cm.

Lithographed throughout. – The preliminary pages handwritten, the numbered pages entirely music. – The publication details are from correction slips pasted on to the title-page and wrappers.

1.188 SCOTT, Sir Claude Edward. Comic illustrations to T. Moore's Irish Melodies / by Sir C. E. S. Bart [Sir Claude Edward Scott]. – London : Published for the Proprietor by Frederick Dangerfield, [c. 1865]. – [43] leaves, printed on rectos only : ill. ; 19 × 29 cm.

Lithographed throughout. – Humorous sketches with handwritten legends. – The title and the statements of responsibility and publication are taken from the lithographed boards. – The title-page reads: 'More-Irish Melodies illustrated'. – The identity of the author has been established by Halkett & Laing. – The dating is based on Dangerfield's address (22 Bedford Street, Covent Garden) and stylistic evidence.

SCOTT, Sir Walter. *See* 5.62–5.63

1.189 SEEL, Heinrich. Abhandlung staatswirthschäftliche [sic] über die Getraid-Reinigung auf den königl Getraidkästen / von konigl: baierischen Hofkammerrath und Rentbeamten Heinrich Seel. – München : [s.n.], 1809. – 16p. : ill., 1 folding plate ; 19 cm.

Winkler, 871:8. – Text lithographed throughout from handwriting. – The folding plate shows two

crayon-drawn views of a grain refining machine (275 × 475 mm).

1.190 SENEFELDER, Alois. Instruction. : Pour servir à l'usage des presses portatives et des pierres, planches et papiers lithographiques, ainsi que de la planche économique. – Prix Fr. 1.50cs. – à Paris : chez A. Senefelder & Compagnie, 1824. – [2], 18 p. ; 8o (19 cm).

Lithographed throughout from handwriting. – It is assumed that Senefelder was the author of this pamphlet, though no reference is made to him personally. – The address of A. Senefelder & Compagnie is given as 'Boulevart bonne nouvelle No. 31' on the title-page. – The only copy that has been traced is disbound, but an index on the title-page verso suggests that it is complete.

SENEFELDER, PUPIL OF. *See* 1.105

SERMON ON THE MOUNT. *See* 1.54; 5.64

1.191 SHAKESPEARE, William. The first collected edition of the dramatic works of William Shakespeare. : A reproduction in exact fac-simile of the famous first folio, 1623, by the newly-discovered process of photo-lithography ... / Executed ... at the suggestion, and under the superintendence of H. Staunton. – London : Day & Son, Limited, Lithographers and Publishers, 1866. – Approx. 920 p. in various pagings ; 2o (42 cm).

Photolithographed facsimile with letterpress title-page. – Photolithographed by R. W. Preston from copies in Bridgewater House and the British Museum. – The book has no pagination of its own and reproduces the irregular pagings of the original. – Published in 16 monthly parts at 10s. 6d. each or complete, appropriately bound, price £8.8s.

1.192 SHUBERT, Fedor Fedorovich. [Russian title] Symbols for the representation, on maps, of military units, fortresses, main roads, military roads, water communications and various infantry institutions. / Compiled in the Department of the General Staff [by, or under the direction of, Fedor Fedorovich Shubert]. – [Moscow] : Department of the General Staff, 1834. – 42 p. : ill., symbols in text ; 8o.

Not seen. – This description is taken from catalogue 215 of Howard S. Mott Inc., Sheffield Mass.

1.193 SIDLER, Joseph. Sammlung von Vorschriften für Volks: und Elementar: Schulen. – No. 1, München : Im Verlag bei Jos Sidler, 1815. – 18 × 23 cm.

Winkler, 722:3. – Not seen.

1.194 SIDLER, Joseph. Vorschrift zur Übung in der deutschen Current-, Canzley- und Fracturschrift für Liebhaber der Schreibe-Kunst / ausgearbeitet von Johann Valentin Götze Herzogl. Regierungs-Canzlist in Meiningen. – München, 1818. – Title and 27 plates ; 22 × 24 cm.

Winkler, 722:5. – Not seen.

SIMS, Richard. *See* 1.160

1.195 SMITH, John Spencer. Notice bibliographique sur un traité manuscrit du quinzième siècle jusqu'ici inédit avec une copie figurée de l'original dans la collection de l'auteur / par J.S.S. bibliophile anglois. – Caën: [le propriétaire], 1840 [1841]. – [22] leaves, printed on rectos only : ill., 3 plates ; 4o (31 cm).

Lithographed facsimile with letterpress title-page. – The full name of the author and his role as publisher are taken from the plates, all of which give the year of publication as 1841.

SMITH PAYNE & CO. *See* 1.6

1.196 SPENCER, Georgiana (Duchess of Devonshire). Passage du Mont saint-Gothard / Poeme par Madame la Duchesse de Devonshire ; traduit de l'Anglais par M. l'Abbé de Lille un des quarante de l'Académie Française. – [Paris] : Imprimerie Lithographique de C. de Lasteyrie, [c. 1817]. – [6], v, [4], 1, [2], 2–3, [2], 4–5, [4], 6–7, [6], 8–9, [6], 10–11, [6], 12–13, [4], 14–15, [4], 16–17, [4], 18–19, [2], 20–44 p. [i.e., 49 leaves] : ill. ; 34 cm.

Dobell, p.43. – Lithographed throughout, apart from one engraved plate in some copies. – The text handwritten. – A parallel title in English facing the main title reads: 'The passage of the Mountain of saint Gothard : a poem by Georgiana Duchess of Devonshire'. – Parallel texts throughout in English (on versos) and French (on rectos). – Pagination of text pages in arabic numerals begins on a verso. – All leaves with illustrations are unpaginated and printed on one side only. – Complete copies have an engraved plate with portraits, a facsimile of a verse in Georgiana's hand which was sent to the translator, and 20 crayon lithographs by Deshayes and A. Regnault after paintings by Lady Elizabeth Foster and (one only) by Lady Bessborough. – The title-page is signed 'Moulin scriptt.'. – Not all copies have the title-page, the stone for which cracked during printing. – *See* Warren, C., 'An Alpine bibliographical curiosity', *Alpine Journal*, vol.89, 1984, p.141–144.

1.197 STANLEY, H. Chinese manual. : Recueil de phrases chinoises, composées de quatre caractères, et dont les explications sont rangées dans l'ordre alphabétique français. / [adapted from the French by H. Stanley]. – London : [s.n.], 1854 ([London] : printed by Harrison and Sons, St. Martin's Lane). – viii, 75 p. ; 2º (34 cm).

Lithographed from handwriting by the transfer process, apart from preliminary pages which are letterpress. – Printed on blue paper. – The statement of responsibility comes from the preface (p.vii). – The editor states that the text was ready for the press in October 1851, but that he experienced difficulty in getting it printed because of the lack of Chinese type in London. – He goes on to refer to the facilities of the new Anastatic Process and reveals that the writing was done by Mr Hornblow, transcriber at the British Museum, who had 'employed his leisure in familiarising himself with Chinese writing'. – The editor apologises for errors and omissions 'which could not be rectified, as the Anastatic process does not give the same facilities for correction as typography'.

1.198 STEPHENS, H.L. Death and burial of Poor Cock Robin / from original designs by H.L.Stephens. – [New York : Hurd & Houghton ; London : Stevens Brothers, 1864] (New York : Lithographed by J.Bien). – [16] leaves, printed on rectos only : ill. ; 34 cm.

Lithographed throughout. – 15 pen and ink lithographs, each with a tint stone, mounted on to card with a key-line border and a verse of Poor Cock Robin printed in gold. – The lithographs lettered 'H.L.Stephens del' and 'Julius Bien lith.'. – Pictorial title-page printed in five colours. – The statement of publication is taken from a notice of the subscribers' edition of 100 proof copies on the reverse of the title-page.

1.199 STŒPEL, F. Méthode théorique et pratique de chant / par Mr. Fois. Stœpel ; Autorisée par le Ministre de l'Instruction publique pour l'usage des écoles normales primaires et les écoles primaires. – Paris : au Bureau des Methodes de Musique, 1836. – [2], 124 p. : ill., music ; 2º (35 cm). – Sig: π¹ 1–31² with gatherings 1 to 10 signed '1re. Livraison' to '10e Livraison' and 11 to 31 signed 'C.11' to 'C.31'.

Lithographed throughout. – The title-page produced by direct lithography, the text pages transferred from punched intaglio plates. – The title-page signed 'A.L.'.

1.200 STROBEL, A.M. Kleine für Kirche und Schule bestimmte Musikstücke, / gesammelt von A.M.Strobel. – 3te. Ausgabe. – Strasburg : bei F.G.Levrault, Steindrucker, 1829. – [84]p. : ill., music ; 4º (21 cm). – Sig: [1]⁴ 2–10⁴ 11².

Lithographed throughout, the text handwritten.

SWEDENBORG, Emanuel. *See* 5.65

SWIFT, Jonathan. *See* 5.66

1.201 TAALSPIEGEL, de. Een prentgeschenk voor leerzame kinderen. – Gouda : G.B. van Goor, [c. 1840]. – Landscape 8º.

Van Gendt Book Auctions BV catalogue, Amsterdam, 13–14 Sept. 1983. – Not seen. – Described as lithographed throughout, with 67 hand-coloured illustrations.

1.202 Taschenbuch zu Bemerkungen / auf Stein gedruckt und herausgegeben von der K[öniglich]. b[airischen]. Beschäftigungs Anstalt am Anger im Jahre 1813. – München : Königl. bairische Beschäftigungsanstalt, 1813. – [28]p. : ill. ; 12 cm.

Winkler, 922:36. – Not seen. – Lithographed throughout. – Title and 3 p. of handwritten text followed by a 24 p. calendar with 12 views of Munich. – Described for me by Dr K.T.Winkler.

1.203 TATTAM, Henry. A compendious grammar of the Egyptian language as contained in the Coptic and Sahidic dialects . . . / by the Rev. Henry Tattam . . . ; with an appendix, consisting of the rudiments of a dictionary of the ancient Egyptian language in the enchorial character: / by Thomas Young . . . – London : John and Arthur Arch, 1830. – x, xii (iii–xiv), 152, 24, 110, [2], xv p. : ill., 4 plates, one folding. – 8º (22 cm).

Lowndes, p.2579. – Mainly letterpress, but the 110p. of the enchorial dictionary and the plates are lithographed. – The folding plate is lettered 'Willich's Lithogc. Press 29, Bedford St. Covt. Gardn.' and 'On Stone by A.Ducôte.'

1.204 TENNYSON, Alfred. Dora / by Alfred Tennyson ; illustrated by Mrs. Paulet St. John Mildmay. – London : Henry Vernon, 1856 ([London] : Lithographed by Vincent Brooks). – [21] leaves, printed on rectos only : ill. ; 2º (53 cm).

Lowndes, p.2605. – Lithographed throughout, the text transferred from type. – Pages are surrounded by oval floral borders and alternate between text and illustration pages. – Each border design serves for a

text page and its accompanying illustration page, the illustration having been etched away and replaced by text in each case.

1.205 TÖPFFER, Rodolphe. Les Amours de Mr Vieix [i.e. Vieux] Bois. / [by] RT. – Genève : Autographié chez Frutiger, 1837. – [2], 83, [1] p. : ill. ; 8° (14 × 23 cm).

Suzannet, 114. – Lithographed throughout by the transfer process. – Pictorial title-page and pen and ink illustrations with legends. – The pagination of the plates runs 5–88. – An owner's manuscript inscription reads 'James Baudeuil [?] 1839 original Edition'. – Suzannet also describes (115) a second edition (Geneva, 1839) and a fifth edition (116) with drawings copied by the German artist Bode, and with legends in French and German (Geneva & Leipzig, 1846). – A further edition was published by Aubert (Paris c. 1839).

1.206 TÖPFFER, Rodolphe. Le Docteur Festus / [Autographié par l'auteur]. – Paris : Abm Cherbuliez et Ce, [s.d.] ([Genève : Lith de Schmidt]). – 88 p. of drawings with legends ; 8° (17 × 27 cm).

Suzannet, 119–121. – Lithographed throughout by the transfer process. – Pale green paper wrappers with advertisement for Töpffer's books at rear. – Suzannet also describes (122) a fifth edition with drawings by the German artist Bode, and with legends in French and German (Geneva & Leipzig, 1846).

1.207 TÖPFFER, Rodolphe. Essais d'autographie / par R.T. – [A Genève : Autographié chez Schmid, 1842]. – 24 plates ; 8° (15 × 23 cm).

Suzannet, 123, 124. – Consists of 12 landscapes and 12 caricatures produced by transfer lithography. – Lithographed cream-paper wrappers.

1.208 TÖPFFER, Rodolphe. Essai de physiognomonie / par RT. – Genève : [Autographié chez Schmidt], 1845. – [2], 36 p. of text and drawings ; 4° (30 cm).

Suzannet, 130. – Lithographed throughout by the transfer process. – The statement of production is taken from p. 36. – Lithographed blue-paper wrappers. – Rear wrappers carry an advertisement listing Töpffer's lithographed publications.

1.209 TÖPFFER, Rodolphe. Excursion dans les Alpes. 1832. – [Genève : Autographié chez J. Freydig, 1833]. – Title-page, 110 p. of text and drawings ; landscape 8°.

Suzannet, 62, 63. – Not seen. – Lithographed throughout by the transfer process.

1.210 TÖPFFER, Rodolphe. Excursion dans l'Oberland. 1835. – [Genève: Autographié de Frutiger, 1835]. – Title-page, map, 67 p. of text and drawings ; landscape 8°.

Suzannet, 71. – Not seen. – Lithographed by the transfer process.

1.211 TÖPFFER, Rodolphe. Histoire d'Albert / par Simon de Nantua [pseud.]. – Genève : [s.n.], 1845 ([Genève : Autographié chez Schmidt]). – [2], 40 p. of drawings with legends + advertisement ; 8° (17 × 27 cm).

Suzannet, 128. – Lithographed throughout by the transfer process. – Blue-paper wrappers. – The statement of printing is taken from p. 40, which is also signed R.T. – The advertisement lists Töpffer's lithographed publications. – Suzannet describes (129) a second edition (Geneva & Leipzig, 1846).

1.212 TÖPFFER, Rodolphe. [Histoire de Monsieur Crépin] / [by R.T.]. – A Genève: Autographié chez Frutiger, [1837]. – 88 p. of drawings with legends ; 8° (14 × 23 cm).

Suzannet, 109. – Lithographed throughout by the transfer process. – No title-page, the title, statement of responsibility and date are taken from the colophon. – Pen and ink illustrations integrated with handwritten text in the form of strip cartoons. – An owner's manuscript inscription reads 'James Baudeuil [?] 1839 original Edition'. – Suzannet describes (110) a fifth edition with drawings copied by the German artist Bode, and with legends in French and German (Geneva & Leipzig, 1846). – Further editions were published by Aubert (Paris, c. 1839) and printed by Caillet (Paris, c. 1860), both with illustrations on rectos only.

1.213 TÖPFFER, Rodolphe. Histoire de Mr. Jabot / [by R.T.]. – Genève : [Autographié chez J. Freydig], 1833. – [2], 52 leaves of drawings with legends, printed on rectos only ; 8° (16 × 26 cm).

Suzannet, 106. – Lithographed throughout by the transfer process. – Pictorial title-page and pen and ink illustrations integrated with handwritten text in the form of strip cartoons. – An owner's manuscript inscription reads 'James Baudeuil [?] 1839 original Edition'. – Suzannet describes (107) a counterfeit edition published by Aubert in Paris in 1839, and a fifth edition (108) lithographed by Schmid in Geneva with drawings copied by the German artist Bode, and with legends in French and German (Geneva & Leipzig, 1845).

1.214 TÖPFFER, Rodolphe. M^r Criptogame. : Ci-derrière sont représentées au naturel les vicissitudes de Monsieur Criptogame, et comme quoi c'est dans le ventre de la baleine qu'il fit connaissance avec l'Abbé. ; Aux dites sont annexés l'hymen de la belle Provençale et la fin tragique d'Elvire, qui fut victime du papier timbré. – / Autographié par l'auteur [Rodolphe Töpffer]. – A Genève : Lithogr. de Schmidt, s.d. – 8 leaves ; landscape 8°.

Suzannet, 125. – Not seen. – The starting point for Töpffer's *Histoire de Monsieur Cryptogame. 1845.*

1.215 TÖPFFER, Rodolphe. Monsieur Pencil / Autographié à Genève par l'auteur [Rodolphe Töpffer]. – [Genève] : Lithographie de Schmid, 1840. – 72 p. of drawings with legends ; 8° (17 × 27 cm).

Suzannet, 117. – A further statement of production is found on p.72. – Suzannet also describes (118) a fifth edition with drawings copied by the German artist Bode, and with legends in French and German (Geneva & Leipzig, 1846).

1.216 TÖPFFER, Rodolphe. Souvenirs de Lavey. 1843. – [S.l. : s.n., s.d.]. – 6 p., 5 plates ; landscape 4°.

Suzannet, 93, 94. – Not seen. – Lithographed throughout by the transfer process.

1.217 TÖPFFER, Rodolphe. Le Tour du lac. – [A Genève: Autographié chez Schmid, 1841]. – Map, 40 p. of text and drawings ; landscape 8°.

Suzannet, 84, 85. – Not seen. – Lithographed throughout by the transfer process. – Suzannet also describes a re-issue in facsimile (Geneva, 1906).

1.218 TÖPFFER, Rodolphe. Voyage aux Alpes et en Italie. – [A Genève : Autographié chez Frutiger, 1837]. – Title-page, map, 126 p. of text and drawings ; landscape 8°.

Suzannet, 75, 76. – Not seen. – Lithographed by the transfer process.

1.219 TÖPFFER, Rodolphe. Voyage à Chamonix. 1835. – [S.l. : s.n., s.d.]. – Frontispiece, 41 p. of text and drawings ; landscape 8°.

Suzannet, 70. – Not seen. – Lithographed by the transfer process.

1.220 TÖPFFER, Rodolphe. Voyage à Gênes. 1834. – [Genève : Autographié chez Frutiger, 1835]. – Title-page, map, 62 p. of text and drawings ; landscape 8°.

Suzannet, 69. – Not seen. – Lithographed by the transfer process.

1.221 TÖPFFER, Rodolphe. Voyage à la Grande Chartreuse. 1833. – [A Genève : Autographié chez J. Freydig, s.d.]. – Frontispiece, itinerary, list of travellers, 52 p. of text and drawings, [1] p. of vignettes ; landscape 8°.

Suzannet, 64. – Not seen. – Mainly lithographed by the transfer process. – Suzannet also describes (65) a second printing in which drawings on several pages have been redone and the text newly written.

1.222 TÖPFFER, Rodolphe. Voyage à Milan. 1833. – [A Genève : Autographié chez J. Freydig, 1833]. – Frontispiece, map with itinerary, 86 p. of text and drawings, [1] page with vignettes ; landscape 8°.

Suzannet, 67, 68. – Not seen. – Lithographed by the transfer process.

1.223 TÖPFFER, Rodolphe. Voyage autour du Mont Blanc, dans les vallées d'Hérens de Zermatt et au Grimsel. 1843. / Autographié par RT. – A Genève: Lith. Schmid, [s.d.]. – [2], 48 leaves of plates with captions, 4 p. text between plates 35 & 36 ; 4° (20 × 27 cm).

Suzannet, 92. – Lithographed throughout by the transfer process. – Lithographed cream-paper wrappers. – All but the text pages printed on rectos.

1.224 TÖPFFER, Rodolphe. Voyage en Suisse et en Italie. – 64 p.

In Library of Congress catalogues. – Not seen.

1.225 TÖPFFER, Rodolphe. Voyage à Venise. 1841. – [A Genève : Autographié chez Schmid, s.d.]. – 109 p. of text and drawings, plan ; landscape 4°.

Suzannet, 87. – Not seen. – Suzannet also describes (88–90) copies of a second printing with modifications to some drawings and a newly written text.

1.226 TÖPFFER, Rodolphe. Voyage en zigzag par monts et par vaux. 1836. / [Ecrit par David Jaquet]. – [Genève : Autographié par J.-F. Frutiger, s.d.] – Title-page, map, 112 p. of text and drawings ; landscape 8°.

Suzannet, 73, 74. – Not seen. – Lithographed by the transfer process.

1.227 TÖPFFER, Rodolphe. Voyage de 1838. – [Genève : s.n., 1838]. – Frontispiece, map, 102 p. of text and drawings ; landscape 8°.

Suzannet, 77, 78. – Not seen. – Lithographed by the transfer process.

1.228 TÖPFFER, Rodolphe. Voyage de 1839. : Milan , Côme, Splügen. – [A Genève : Autographié chez Frutiger, s.d.]. – Title-page, map, 75 p. of text and drawings ; landscape 8º.

Suzannet, 79, 80. – Not seen. – Lithographed by the transfer process.

1.229 TÖPFFER, Rodolphe. Voyage de 1840. – [S.l. : s.n., s.d.]. – [2], 67 p. of text and drawings ; 8º (17 × 27 cm).

Suzannet, 81, 82. – Lithographed throughout by the transfer process, the drawings integrated with the text. – Lithographed pink-paper wrappers with pictures front and rear.

1.230 Unterricht für Künstler und Liebhaber die auf Stein zeichnen wollen. / [after Godefroy Engelmann]. – [S.l. : s.n., s.d.]. – [4], 30 p. : ill., 2 folding plates ; 4º (28 cm).

Kampmann, p.10. – Lithographed throughout, the text handwritten. – Based on Engelmann's *Manuel du dessinateur lithographe* (Paris, 1822, 1824). – This is referred to in the foreword, which explains that all unnecessary material had been omitted and section 8 reworked. – Not listed in Engelmann's own bibliography of works published on lithography (*Traité théorique et pratique de lithographie*, Mulhouse, 1835–40, p.452–458), which suggests that it was a pirated edition. – A copy in the Höhere Graphische Bundes-Lehr- und Versuchsanstalt in Vienna has a manuscript inscription 'Berlin 1823', and Kampmann records the same place and date of publication. – The title is taken from lithographed blue-paper wrappers. – Printed on laid paper. – Trim marks at the head of some pages show that the book was printed four pages to view. – Two folding crayon-drawn plates include drawings that closely follow parts of several plates in Engelmann's *Manuel.*

1.231 VALE, Rev. Benjamin. Philological lectures / by The Revᵈ. B. Vale, L.L.D. ; dedicated to the Mechanic's Institutions of Tunstall. Burslem. Hanley. Stoke. Longton. Tean. Uttoxeter. Rugely [i.e. Rugeley]. and Stafford. – Longton, Staffordshire : To be had of the Author, of Mʳˢ. Shaw, Mʳ. Hill, Martin, [c. 1854] (Chester : Lithographed by J. Mᶜ. Gahey, Bold Sqʳ.). – [2], 86 p. : ill., tables etc ; 8º (23 cm).

Lithographed from handwriting. – The date is that ascribed to it by Boase, F., *Modern English biography* (1921, 2nd imp. 1965), vol.vi, p.730–731. – Local directories record a McGahey as working as a lithographic printer and photographic artist from the above address in Chester in 1856, and as a photo-

graphic artist from a different address in 1857 (*see also* Napper, D., 'Looking for an artist', *Deesider*, no.84, Oct. 1971, p.24–25). – Vale was Rector of Longton, Staffordshire, from 1839 to 1863.

1.232 Verfassungs Urkunde für das Grossherzogthum Baden. / Eigenhändig von den Mitgliedern der hohen IIᵗᵉⁿ Kammer des Landtags von 1831 geschrieben, und durch den Ueberdruck als Fac-simile vervielfältigt, zur Leseübung verschiedener Handschriften, für badische Schulen. – Carlsruhe : Verlag der P. Wagner'schen Lithographie, 1831. – [2], 47 p. ; 17 × 22 cm.

Lithographed throughout. – The statutes written out on transfer paper, and in their own hands, by different members of the local government.

1.233 WAKE, Henry Y (Bookseller). Monthly catalogue of books, Mss, coins, antiqs &c. – Nos 200–269. – Fritchley, Derby : May 1892 to January 1897. – 180 leaves : ill. ; 8º.

Listed in Blackwell's rare book catalogue A53. – Not seen. – Described as lithographed from hand-writing by the transfer process, and printed by Bemrose in Derby.

1.234 WEBBER, C.M. Geology familiarly illustrated. / By C.M.W. – [London : Printed and Published by J. B. Goodinge], 1859. – Concertina folded from six sheets : ill. ; 14 × 327 cm.

31 hand-coloured pen and ink lithographs with legends. – The statement of publication is taken from a label on the rear inside cover. – British Library catalogues identify C.M.W as C.M. Webber.

1.235 WEDEMANN, Wilhelm. 100 auserlesene deutsche Volkslieder mit Begleitung des Claviers / gesammelt von W. Wedemann. – Zweites Heft. – Ilmenau : Lithographirt und verlegt bey B. F. Voigt, 1833. – iv, 201 p. : ill., music ; 15 cm. – Sig: π^2 1–8¹² 9⁵.

Lithographed throughout, apart from leaves π which are letterpress. – The lyrics handwritten.

1.236 WEDEMANN, Wilhelm. 100 auserlesene deutsche Volkslieder mit Begleitung des Claviers / gesammelt von W. Wedemann. – Erstes Heft. Zweite verbesserte Auflage. – Weimar : Lithographirt und verlegt bei B. F. Voigt, 1836. – Zweites Heft. Zweite verbesserte Auflage. – Weimar : Lithographirt und verlegt bei B. F. Voigt, 1838. – 2 vol. ([6], 201 p.) ([4], 201 p.) : ill., music ; 15 cm. – Sig: (π^3 1–8¹² 9⁵) (π^2 1–8¹² 9⁵).

Lithographed throughout, apart from leaves $\pi_{2–3}$ in vol.1 and π_2 in vol.2 which are letterpress. –

The lyrics handwritten. – Vol. 1 includes a preface to the first edition dated '1 November 1830'. – Both volumes have the label of the publisher, Ch. A. André, Frankfurt, pasted over the original imprint.

1.237 WEDEMANN, Wilhelm. Hundert Gesänge der Unschuld, Tugend und Freude, mit Begleitung des Claviers. Gemüthlichen Kinderherzen gewidmet / von Wilhelm Wedemann. – Zweites Heft. Sechste verbesserte Auflage. – Weimar : bey Bernhard Friedrich Voigt, [1838]. – [2], iv, 208 p. : ill., music ; 11 × 14 cm. – Sig: π^3 1–6^{16} 7^8.

Lithographed throughout, apart from leaves π_{2-3} which are letterpress. – The lyrics handwritten. – Preface dated '1 October 1838'.

1.238 WYLD, James (senior). Voyages that have been attempted to discover a Northern Passage to the Pacific Ocean / Compiled by J. Wyld and printed from stone in the Quarter-Masr General's Office, Horse Guards 1818. – [London : Quarter-Master-General's Office, 1818]. – [2], 6 p. ; 2° (33 cm).

Lithographed throughout from handwriting by the transfer process. – The writing has long 'f's and the pages have catchwords.

1.239 YOUNG, Charles John. Little Charlie's life. / By himself. [Charles John Young] ; Edited by the Rev. W. R. Clark, M.A., Vicar of Taunton. With a preface by the editor. – London : Saunders, Otley, and Co., 1868. – 15 p., [20] leaves of facsimile, 32 p. advertisement : ill. ; 4° (22 cm).

Osborne, 2, p.797. – The facsimile lithographed, the remainder letterpress. – The facsimile, which appears to have been made by copying on transfer paper, includes drawings. – The preface refers to the book as 'the autobiography of a child between six and seven years of age, written with his own hand, and without any assistance whatever.'. – The attribution is taken from the Osborne entry, which provides no source for it. – The publisher's advertisement describes the book (p.8) as 'In foolscap 4to, Facsimile Lithograph. Master Charlie: being the Autobiography of a child six years of age.'.

1.240 YOUNG, Thomas. Hieroglyphics, collected by the Egyptian Society, / arranged by Thomas Young . . . – London : [The Egyptian Society], 1823. – Hieroglyphics, continued by the Royal Society of Literature. / Arranged by Thomas Young . . . – Vol II. – London : [The Royal Society of Literature], 1828. – 2 vol. ([1], iii, [1] leaves, 37 leaves of plates) (3, [2] leaves, 58 leaves of plates, some folding) ; 2° (54 cm).

Lowndes, p.3022. – Lithographed plates, drawn by

M. A. Nicholson, J. Netherclift, and G. Scharf, and printed by Ackermann, N. Chater, C. J. Hullmandel, J. Netherclift, and Rowney & Forster. – Title-pages, index, and contents lists printed letterpress by Howlett and Brimmer. – Lithographic and letterpress workings on rectos only.

ADDENDA

1.241 BALDWIN, George [Baldwin's Museum]. – [S.l. : s.n., c.1822–1825]. – [114] leaves, printed on one side only so as to make conjugate pages : ill. ; 31 cm.

Brunet, 1, col. 625. – Lithographed throughout, the text handwritten directly on to stone. – No title-page, the title given here is taken from British Library catalogues. – Consists of 54 pages of text in English on versos facing 54 pages of plates on rectos, followed by 6 plates on rectos. – Text and plates printed separately. – Stone impression marks suggest that each text page was printed from a separate stone. – Most plates are of classical gems, drawn in crayon lithography by V. T. Bouvier (mostly signed 'T. Bouvier del' or 'Bouvier del'). – A copy in Arizona State Library has 48 plates and 6 original blue-paper wrappers. – British Library catalogues give the date as 1810(?), which is out of the question on technical grounds if the book was printed in Britain. – One plate in a privately owned copy has the watermark date 1822, which provides a reasonable *terminus ante quem*. – George Baldwin, who was British Consul in Egypt, died in 1818, so the book is likely to have been produced posthumously and possibly, therefore, as a memorial production. – Brunet states, and gives the source for the information, that the book remained unfinished and was not put on sale.

1.242 BIBLE: PSALMS. The Book of Psalms. / [edited and written out by S.R.]. – [S.l. : s.n., 1855]. – [14], 284, [5] p. ; 27 cm.

Lithographed throughout from handwriting by the transfer process. – The title is given in Hebrew above the English. – The introductory text is signed and dated 'S.R. 1855.'. – The book is described in the introductory text as a revision of the 'Common Prayer Book version' of the Psalms in a metrical arrangement, written in SR's seventy-seventh year 'whilst his eye is yet tolerably clear, and his hand steady . . .'. – All pages of the Psalms are written within a single-line border, with running heads between tramlines. – Printed on unwatermarked wove paper. – Cased in brown cloth, with the word 'Psalms' gold-blocked on the spine and front cover,

and with a binder's label of Bone & Son, 76, Fleet Street.

1.243 BLACKBURN, J.B. Scenes of animal life & character from nature & recollection / by J.B. – London : Griffith and Farran, [c. 1858]. – [1], 19 leaves, all but one printed so as to make conjugate pages : ill. ; 25 cm.

Lithographed throughout. – Pen and ink sketches with captions, several to a page. – Pictorial title-page. – 1, 3, 5, 7, 9, 11 fall on versos; 13, 15, 17, 19 on rectos. – Griffith and Farran are described as 'Successors to Newbery and Harris' and changed their style from Grant & Griffith between 1856 and 1857. – A 'JB' signature that appears on some pages can be associated with Mrs J.B.Blackburn (Halkett & Laing). – The latest date borne by a drawing is 1858.

1.244 CAAN, H.J. Redevoering bij gelegenheid van het vijftigjarig bestaan der Maatschappy tot Nut van't Algemeen gevierd in het Departement Voorburg den 17 November, 1834. / Uitgesproken door Jonkhr. Mr. H.J. Caan. – Te 'S Gravenhage : bij S. de Visser en Zoon, 1838 (Lith. v. S. de Visser). – 46 p. ; 21 cm.

Not seen. – Lithographed throughout, the text handwritten. – The title-page carefully lettered and printed in gold (bronze-dusted). – Information kindly supplied by Johan de Zoete. – *See* 1.257.

1.245 CHEVALLIER, A., & LANGLUMÉ. Mémoire sur quelques améliorations apportées à l'art de la lithographie. / Par M. Mrs. Chevallier, Pharmacien chimiste & Langlumé, Lithographe. – [Paris : s.n., 1828]. – 8 , [1] p. : ill., 15 plates ; 2° (35 cm).

Kampmann, p.11. Lithographed throughout, the text handwritten. – No title-page. The title and statement of responsibility are taken from p.1. – The text relates to improvements to lithography that led to the award of a gold medal to Chevallier and Langlumé by the Société d'Encouragement in 1828 (Twyman, p.136, 137). – The plates show, principally, different states of several crayon-drawn lithographs. – The plates printed by Langlumé in Paris, some of them dated 1828.

1.246 CHILDE, Frances C. The Passion of the Saviour represented at Ober Ammergau Bavaria on Trinity Sunday 1870 / translated and illustrated by Frances C. Childe. – Kinlet : [s.n.], 1871. – [29] leaves, printed on rectos only : ill. ; 47 cm.

Lithographed by the transfer process, the text handwritten. – Printed in two tones of brown on board, with substantial hand-colouring. – The preface describes the text as 'a free translation, and adaptation, from the German ...'. – The illustrations include decorative borders, drawings after Dürer, and Childe's own recollections of the performance at Oberammergau.

1.247 Dundee Volunteer Bazaar 6th 7th 8th & 9th October, 1886. Ye. Levée at Holyrood Ye Olden Tyme. Handeboke. / by Major Rankin ... Secretary of the Bazaar ; illustrations by Martin Anderson ; illuminated by D. Clark. – Price 12 pennies. – Dundee : Lithographed and published by John Leng & Co., [1886]. – 51, [3], xvii p. : ill. ; 21 cm.

Lithographed, apart from the title-page, contents page, and pages after 48, all of which are letterpress. – Paper-covered boards, lithographed front and back. – Publication details are taken from the boards rather than the title-page. – Pagination counts from the outside front boards. – Pages 9, 10, 13, 15, 17, 19–26, 43–47 transferred from type, the remainder of the lithographed pages are handwritten, illustrated, or both. – The illustrations were drawn on textured transfer paper. – Stone marks are visible on p.22. – Pages i–xvii are advertisements.

1.248 FRITH, J.Henry. Repository exercise, compiled for the use of the Madras Artillery, at the Depot of Instruction, St. Thomas' Mount, / by J. Henry Frith, Lieutt. Colonel, Director Artillery Depot. – Fort St. George: Published at the Lithographic Press, Chief Engineer's Office ... by authority of the Government, 1830. – [2], 76, [4]p. : ill., 45 plates printed on rectos only ; 38 cm.

Lithographed throughout, the text handwritten. – Printed on laid paper with the device of the East India Company and one of the following: 'E Wise 1825', E Wise 1826', 'E Wise 1827', 'J Whatman 1825', 'J Whatman 1826', 'Whatman Balston & Co 1827'. – Pressure marks from the stones reveal that the pages were printed two to view.

1.249 M., R. Caw! Caw! or the chronicle of crows : A tale of the spring-time / by R M ; illustrated by J B. – London : Grant & Griffith, [c. 1855]. – [1], 14 leaves, printed on rectos only : ill. ; 25 cm.

Lithographed throughout. – Hand-coloured pen and ink illustrations surrounding text transferred from type. – Pictorial title-page, the exclamation marks formed from elements of the picture. – Grant & Griffith are described as 'Successors to Newbery & Harris' and changed their style to Griffith & Farran between 1856 and 1857. – A 'JB' signature that appears on all pages can be associated with Mrs J.B.Blackburn (Halkett & Laing). – British Library catalogues give the date as [1870].

1.250 MOREAU, César. British and Irish produce and manufactures exported from Great Britain. / By César Moreau ... – London: Sold by Treuttel and Würtz ; also at Paris and Strasbourg, [March 1826]. – Price five shillings. – [8] leaves ; 33 cm.

Lithographed throughout from handwriting by the transfer process. – No title-page. – Parallel titles in English and French appear on the first page. – Text in English and French throughout in parallel columns or pages. – Consists mainly of tables. – Referred to as 'Entered at Stationers Hall, March 1826'. – Four other publications by Moreau are listed. – Printed on cream wove paper.

1.251 MOREAU, César. Chronological records of British finance from the earliest period (A.D. 55.) to the present time. (1828.) founded on official documents ... / The whole carefully compiled, digested and arranged by César Moreau ... – London : Sold by Treuttel & Würtz, Treuttel Jun\.\ & Richter ; Paris and Stasbourg : Treuttel and Würtz, [1828]. ([London] : Litho: by J.M. Hill, 11, Frith Street, Soho). – Price 15 shillings. – [2], 27p. ; 28 × 45 cm.

Lithographed throughout from handwriting by the transfer process. – The text written in three or more columns. – Numerous tables in text. – The publication date is implied from the title, but is confirmed by a signed note on p. 27 which reads 'Finis. London, (21 Soho Square) 15th. December 1827. César Moreau' and must refer to the writing rather than the printing. – Seven other publications by Moreau are listed. – Printed on unwatermarked wove paper.

1.252 MOREAU, César. Chronological records of the British Royal and Commercial Navy, from the earliest period (A.D. 827) to the present time (1827) founded on official documents : derived chiefly from authenticated original manuscripts and records of Parliament, the Admiralty Office, Board of Trade, accounts of the Custom House, & from the works & scarce tracts of the ablest writers, British & Foreign, : Illustrated by copious tables, constructed on a new plan and exhibiting many facts never before made public and disposed in each year during the last ten centuries; / by César Moreau ... – Price two guineas. – London : Sold by Treuttel & Würtz, Treuttel Jun\.\ & Richter ; Paris & Strasbourgh [sic] : Treuttel & Würtz, [1827] ([London] : J. Netherclift Lithog. 8 Newman St). – [2], 85 p. ; 28 × 45 cm.

Lithographed throughout from handwriting by the transfer process. – The text written in three or more columns. – Numerous tables in text. – The title-page states that the work was 'Entered at Stationers Hall. 1827', and p.85 is signed 'Finis.

London (21 Soho Square) 1st. Feby. 1827. César Moreau'. – At the foot of the title-page is the statement 'N.B. Very few Copies of this Work have been printed.'. – Printed on unwatermarked wove paper.

1.253 MOREAU, César. East India Company's records founded on official documents shewing a view of the past and present state of the British possessions in India as to their revenue, expenditure, debts, assets, trade, and navigation, : to which is added a variety of historical, political, financial, commercial and critical details from the period of the first establishment (1600) of the Honourable East India Company to the present time (July 1825.) / The whole carefully compiled and arranged ... by César Moreau ... – Price, one guinea. – London : Sold by Kingsbury, Parbury, and Allen. (Booksellers to the Honourable East India Company), [1825]. – [4], 8, [40]p. ; 24 × 40 cm.

Lithographed throughout from handwriting by the transfer process. – The text mostly in three columns. – Tables in text and full-page tables. – The title-page states that the work was 'Entered at Stationers' Hall, July, 1825'. – Pagination from p.2 to p.8, but not thereafter. – Printed on wove paper, some leaves with the watermark 'John Hayes 1822' and 'Smith & Allnutt'.

1.254 MOREAU, César. Past and present state of the navigation between Great Britain and all parts of the world. : Exposed in three views ... / by César Moreau ... – London : Sold by Treuttel and Wurtz, Treuttel Jun\.\ and Richter ; also at Paris and Strasbourgh [sic], [May 1827]. – Price two shillings and sixpence. – [4]p. ; 45 cm.

Lithographed throughout from handwriting by the transfer process. – The title printed on p.1 and positioned at right angles to the other pages so as to be read when folded (as in particulars of property sales). – Consists of three full-page tables. – Referred to as 'Entered at Stationers' Hall, May 1827.'. – Five other publications by Moreau are listed.

1.255 MOREAU, César. The past and present statistical state of Ireland exhibited in a series of tables, constructed on a new plan, and principally derived from official documents and the best authorities ... / by César Moreau ... – Price 30 shillings. – London : Sold by Treuttell & Würtz, Treuttell Jun\.\ & Richter ; Paris & Strasbourgh [sic] : Treuttell & Würtz, 15th October 1827 ([London] : Litho: by J.M.Hill, 11, Frith Street Soho). – [2], 56p. ; 46 cm.

Lithographed throughout from handwriting by the transfer process. – The text written in two

columns. – Numerous tables in text. – Signed on p.56 'Finis. London (21 Soho Square) October 1827. César Moreau'. – Five other publications by Moreau are listed. – Printed on unwatermarked wove paper.

1.256 MOREAU, César. Rise and progress of the silk trade in England, from the earliest period to the present time (Feb^y. 1826,) founded on official documents. : Illustrated by copious tables, constructed on a new plan ... the whole carefully compiled, digested, and arranged ... / by César Moreau ... – Price five shillings. – London : Sold by Treuttel and Würtz, Treuttel Jun^r. and Richter ; Paris & Strasbourgh [sic] : Treuttel & Würtz, [1826] ([London] : Netherclift Lithog: 8 Newman St.). – [2], 18 p. ; 24 × 40 cm.

Lithographed throughout from handwriting by the transfer process. – The text mostly in three columns. – Tables in text. – The title-page states that the work was 'Entered at Stationers Hall, February, 1826', and p.18 is lettered 'London (21 Soho Square) 30^th. Jan^y. 1826 Finis.'. – Printed on wove paper, some pages with the watermark 'John Hall 1823'.

1.257 Proeve van steendruk lithographie en autographie tot uitbreiding der Maatschappy tot Nut van't Algemeen. – [Voorburg : verhandeling bij gelegenheid van de inwijding van het Voorburgsch Departement der Maatschappy tot Nut van't Algemeen op den 10 December 1824]. – [44]p. : ill. ; 21 cm.

Not seen. – Lithographed throughout, the text handwritten. – Carefully lettered title-page with crayon lithograph in oval form, another illustration on final page. – The statement of publication is taken from p.3. – H.J. Caan, who was commissioned by William I of the Netherlands to investigate the suitability of lithography for government publications, stated that the lithographed proposal to found the Voorburg Department eventually led to the establishment of a state lithographic printing office (Caan, H.J., *Redevoering, uitgesproken bij gelegenheid der feestviering van het vijfentwintig jarig bestaan van de Voorburgsche Afdeeling der Maatschappij: tot Nut van't Algemeen*, Voorburg, 1849, p.11–15); he also provided a list of authors of other publications, without indicating whether they were produced by lithography. – Information kindly supplied by Johan de Zoete.

1.258 TIEDEMANN, Carl Ludwig Hermann von. Vorlesungen über die Tactik ; bearbeitet von einem Officier des General-Staabes [C.L.H. von Tiedemann]. ; Mit Anmerkungen versehen. – Berlin :

[s.n.], 1820. – 310, [4]p. : ill. ; 25 cm.

Not seen. – Lithographed throughout, the text handwritten, the title-page carefully lettered. – Diagrams on two folding plates, tables in text. – Printed in the centre of swelled rules are the word 'Lithographiert' (p.310) and the initials 'H.L.' (final page). – The statement of responsibility comes from M.Holzmann and H.Bohatta, *Deutsches Anonymen-Lexikon Bd VI, 1501–1910, Nachträge und Berichtigungen* (Hildesheim, 1961), no.8195, p.321. – Information kindly supplied by Dr K.T. Winkler.

1.259 Verhandeling bij gelegenheid van de eerste gewone vergadering van het Voorburgsch Departement der Maatschappy tot Nut van't Algemeen over het gewigt der Opvoeding op den 27^en. October 1825. – [34]p. ; 21 cm.

Not seen. – Lithographed throughout from handwriting. – No title-page. – The statement of publication is taken from the first page of the copy that has been traced. – Information kindly supplied by Johan de Zoete. – *See* 1.257.

Chatham

Establishment for Field Instruction,
Royal Engineer Department

2.1 Account of the operations performed in the Field Day, which took place at Chatham, on the 11th. August 1848, in the presence of Lieut. General Sir James L. Lushington . . . Major General A. Galloway . . . and the Court of Directors of the Honorable East India Company. – [Chatham : Lithographed at the Royal Engineer Establishment, 1848]. – 32 p. : ill., 11 folding plates ; 8o (23 cm).

Lithographed throughout from handwriting. – The title is taken from the head of p.1. – The statement of publication is taken from the plates.

2.2 [Attack of fortresses.] – [S.l. : s.n., s.d.]. – 192 p. : ill. ; 8o (21 cm).

Lithographed throughout from handwriting. – Only an incomplete copy without title-page is recorded, and the pagination is that borne by its last surviving page. – The title is taken from the running heads. – Bound up with other items of the Royal Engineer Department in the Royal Engineer Corps Library, Chatham. – Sig: probably A–Y²

2.3 Batteries. : Report of an experimental four gun elevated fascine battery, constructed in July 1842 under the direction of Ensign Crommelin, E.J.C. Engineers, at the Royal Engineer Establishment Chatham, Commanded by Lt. Coll. Sir Frederic Smith . . . – [Chatham] : Lithographed at the Royal Engineer Establishment, 1842. – [14] p. : ill., 3 plates (included in the paging) ; 8o (22 cm).

Lithographed throughout from handwriting. – Reverse of title-page carries the note 'Papers and Plans Lithographed at the Establishment for the use of the Corps are not to be published, or used as materials for publication.'.

2.4 Circular instructions to commanding engineers in the French Service for drawing up descriptive memoirs upon the actual state and the defences of the fortresses under their charge : Issued in 1813. – Chatham : Lithographed at the Establishment for Field Instruction Royal Engineer Department, 1823. – [4], 14 p. ; 8o (21 cm).

Lithographed throughout from handwriting. – Reverse of title-page carries the note 'Papers and Plans Lithographed at the Establishment for the use of the Corps are not to be published or used as materials for Publication.'. – First issued in 1813, translated from the French in 1823.

2.5 Description of Professor Daniell's voltaic battery. and of the methods for exploding gunpowder by it, under water, under ground, and in blasting rock, / as adopted at the Royal Engineer Establishment, Chatham. under the command of, Lt. Colonel Sir Frederic Smith, . . . – [Chatham] : Royal Engineers, 1843. – 32 p. : ill. ; 8o (22 cm).

Lithographed throughout from handwriting. – The title appears on p.1. – Facing the title is a blue-paper leaf on which is a label carrying the note 'Papers and Plans Lithographed at this Establishment for the use of the Corps, are not to be published or used as materials for publication.'.

2.6 Detail of the exercise of Light Infantry and the bugle sounds of the Royal Sappers & Miners. – Second edition. – Chatham : Lithographed at the Establishment for Field Instruction Royal Engineer Department, 1823. – [4], 20 p. : ill., music ; 8o (22 cm).

Lithographed throughout from handwriting. – An introductory note states that it was issued as a supplement to Sir Neil Campbell's instructions on the Exercise of Light Infantry.

2.7 The exercise of military bridges of casks according to the practice of the Establishment for Field Instruction Royal Engineer Department. – Chatham : Lithographed at the Establishment, 1822. – [2], 50 p. : ill. ; 8o (22 cm).

Lithographed throughout from handwriting. – Reverse of title-page carries the note 'Papers and

Plans lithographed at the Establishment for the use of the Corps are not to be published or used as materials for publication.'. – Copies exist with the title-page, reverse of title, and p.1, 4, 5 and 8 in variant states. – A copy bound up in a volume which is lettered on its front and rear covers 'Lieut. Colonel Pasley's New Pontoons, and Bridge of Casks.' suggests that Pasley may have been its author.

2.8 Extracts from General Orders. – [S.l. : s.n., s.d.]. – 22 p. ; 8° (21 cm).

Lithographed throughout from handwriting. – The title is given at the head of p.1 before the text. – Bound up with other items of the Royal Engineer Department in the Royal Engineer Corps Library, Chatham.

2.9 Fortress of Alessandria in Italy. – [Chatham : Establishment for Field Instruction, Royal Engineer Department, 1823]. – 7 p., 1 folding plan ; 8° (22 cm).

Lithographed throughout from handwriting. – No copy with a title-page has been traced. – Publication details are taken from a folding plan lettered 'Drawn by Lieut C. Oldershaw Royal Engineers'. – The plan and text are described as having been taken from a work entitled 'Analyse De l'ouvrage intitulé Réflexions critiques sur l'art moderne de fortifier; Par un Officier Général. 1805.'.

2.10 HEAD, F.B. Narrative of the means adopted for pulling down some very dangerous ruins after the great fires at Edinburgh in the month of November 1824 / by F.B. Head, Lieutenant in the Corps of Royal Engineers. – Chatham : Lithographed at the Establishment for Field Instruction Royal Engineer Department, 1825. – [2], iii, [1], 19 p. : ill., 4 folding plates ; 8° (21 cm).

Lithographed throughout from handwriting. – Reverse of title-page carries the note 'Papers and Plans lithographed at the Establishment for the use of the Corps are not to be published or used as materials for publication.'.

2.11 Instructions for teaching the method of loading and throwing hand grenades. &c. – Second edition. – Chatham : Lithographed at the Establishment for Field Instruction Royal Engineer Department, 1823. – [2], 8 p. : ill. ; 8° (22 cm).

Lithographed throughout from handwriting. – Reverse of title-page carries the note 'Papers and Plans Lithographed at this Establishment for the use of the Corps are not to be published, or used as materials for Publication.'.

2.12 Journal of the practical operations in mining carried on under the Glacis in front of the left face of the Ravelin and the right face of the Duke of Cumberland's Bastion Chatham lines, during the months of October and November 1844. – [S.l. : s.n., s.d.]. – 95 p. ; 8° (22 cm).

Lithographed throughout from handwriting. – The title is taken from p.1. – The attribution to the Chatham press is based on content and style and on the existence of a copy of the work in the Royal Engineer Corps Library, Chatham.

2.13 Journal of the siege operations; commenced 8th. Septemr 1846. – [S.l. : s.n., s.d.]. – 48 p., 16 plates ; 8° (23 cm).

Lithographed throughout from handwriting. – No title-page. – The title is taken from the head of p.1. – The attribution to the Chatham press is based on content and style and on the existence of a copy in the Royal Engineer Corps Library, Chatham.

2.14 LUXMORE, T.C. A description of the groins used on the coast of Sussex for preventing the encroachments of the sea / by Lieut. T.C. Luxmore R.E. – Chatham : Lithographed at the Establishment for Field Instruction Royal Engineer Department, 1822. – [2], 8 p. : ill. ; 8° (21 cm).

Lithographed throughout from handwriting. – Reverse of title-page carries the note 'Papers and Plans lithographed at the Establishment for the use of the Corps are not to be published or used as materials for publication.'. – A variant title-page exists with exactly the same wording, but entirely re-written.

2.15 Measuring distances. – [Chatham : Establishment for Field Instruction, Royal Engineer Department, c. 1823]. – 4 p. ; 8° (22 cm).

Lithographed throughout from handwriting. – No title-page. – Bound up with other items from this Chatham press dated 1822 or 1823.

2.16 Military course of engineering at the Regimental School at Arras. : Rules for the practical course of study. : Course of bridges / Translated from the original French copy presented to Colonel Sir Frederic Smith K.H. by Colonel Revel the Commandant of the Regimental School at Arras. – Chatham : Lithographed at the Royal Engineer Establishment, 1850. – [4], 92 p. : ill., 8 plates ; 8° (22 cm).

Lithographed throughout from handwriting. – The plates drawn by Corporal Andrew Callaghan.

2.17 Military course of engineering at the Regimental School at Arras. : Rules for the practical course of study. : Course of mining. / Translated from the original French copy presented to Colonel Sir Frederic Smith K.H. by Colonel Revel the Commandant of the Regimental School at Arras. – Chatham : Lithographed at the Royal Engineer Establishment, 1851. – [6], 125 p. : ill., 8 plates ; 8° (22 cm).

Lithographed throughout from handwriting. – The plates drawn by Corporal Andrew Callaghan and Lance Corporal Edward Atkinson.

2.18 Military course of engineering at the Regimental School at Arras. : Rules for the practical course of study. : Course of sapping. / Translated from the original French copy presented to Colonel Sir Frederic Smith K.H. by Colonel Revel the Commandant of the Regimental School at Arras. – Chatham : Lithographed at the Royal Engineer Establishment, 1850. – [4], 123 p. : ill., 11 plates ; 8° (22 cm).

Lithographed throughout from handwriting. – The plates drawn by Lance Corporal Edward Atkinson and Private George Buchanan.

2.19 PASLEY, C.W. Exercise of the new decked pontoons, or double canoes, / invented by Lieut Colonel Pasley, R.E. – Chatham : Lithographed at the Establishment for Field Instruction, Royal Engineer Department, 1823. – [2], iii, [1], 70 p. : ill. ; 8° (22 cm).

DNB: Pasley, 9. – Lithographed throughout from handwriting. – Reverse of title-page carries the note 'Papers and Plans Lithographed at this Establishment for the use of the Corps are not to be published, or used as materials for Publication.'.

2.20 PASLEY, C.W. Exercise of the new decked pontoons, or double canoes, / invented by Lieut Colonel C.W. Pasley. – Chatham : Lithographed at the Establishment for Field Instruction Royal Engineer Department, 1827. – [2], 54 p. : ill. ; 8° (22 cm).

Lithographed throughout from handwriting. – Preface signed by Pasley and dated 7 July 1827. – It carries the note 'Papers and Plans lithographed at this Establishment for the use of the Corps, are not to be published, or used as materials for Publication.'.

2.21 PASLEY, C.W. Key Nº.1 of the universal telegraph adapted to the principle of Rear Admiral Sir Home Popham's Telegraphic Vocabulary / by Lieut Colonel Pasley R.E. – Chatham : Lithographed

at the Establishment for Field Instruction, Royal Engineer Department, 1823. – 8 p. : ill. ; 8° (19 cm).

Lithographed throughout from handwriting. – Page 7 is signed by Pasley and dated 9 Mar. 1823. – Page 8 carries the note 'Papers and Plans lithographed at the Establishment for the use of the Corps, are not to be published, or used as materials for publication.'.

2.22 PASLEY, C.W. Memoranda on the construction of batteries in the field. – Chatham : Lithographed at the Establishment for Field Instruction, Royal Engineer Department, 1827. – [2], viii, 101 p. : ill. ; 8° (21 cm).

Lithographed throughout from handwriting. – Preface signed by Pasley and dated 7 Apr. 1827. – Reverse of title-page carries the note 'Papers and Plans lithographed at the Establishment for the use of the Corps are not to be published, or used as materials for Publication.'. – Military insignia on the title-page.

2.23 PASLEY, C.W. Observations on nocturnal signals in general with a simple method of converting Lieut Colonel Pasley's two armed telegraph into a universal telegraph for day and night signals. / [by C.W. Pasley]. – Chatham : Lithographed at the Establishment for Field Instruction Royal Engineer Department, 1823. – [2], ii, 53 p. : ill. ; 8° (22 cm).

DNB: Pasley, 8. – Lithographed throughout from handwriting. – Introduction signed by Pasley and dated 20 Jan. 1823. – Reverse of title-page carries the note 'Papers and Plans Lithographed at the Establishment for the use of the Corps are not to be published, or used as materials for publication.'.

2.24 PASLEY, C.W. Observations on the propriety and practicability of simplifying the weights, measures & money, used in this country, without materially altering the present standards, / by C.W. Pasley. . . . – [Chatham : Lithographed for Private use at the Establishment for Field Instruction], 1831, – [2], 87 p. ; 8° (22 cm).

Lithographed throughout from handwriting. – The statement of publication is on the reverse of the title-page. – In his preface to the second, letterpress, edition of 1834 Pasley wrote (p.iii) 'I embodied my ideas in the form of a small pamphlet, of which 24 copies were lithographed for private circulation . . .'.

2.25 PASLEY, C.W. Practical rules for making telegraph signals, with a description of the two-armed telegraph, / invented in 1804 by Lieut.-Colonel Pasley. – Chatham, 1822. – 8°.

DNB: Pasley, 5. – Not traced. – The above descrip-

tion is taken from DNB, which also states that the item was lithographed. – It is reasonable to assume that it was printed at Chatham and has a similar imprint to other Chatham items of the 1820s.

2.26 PASLEY, C.W. Rules for blasting with gunpowder, in rock and masonry. – Chatham : Lithographed at the Establishment for Field Instruction Royal Engineer Department, 1826. – [2], iv, 59 p. : ill. ; 8⁰ (21 cm).
Lithographed throughout from handwriting. – Preface is signed by Pasley and dated 7 Dec. 1826. – Reverse of title-page carries the note 'Papers and Plans lithographed at the Establishment for the use of the Corps are not to be published, or used as materials for publication.'.

2.27 PASLEY, C.W. Rules for escalading works of fortification not having palisaded covered ways. / [by C.W. Pasley]. – Third edition. – Chatham : Lithographed at the Establishment for Field Instruction Royal Engineer Department, 1822. – [4], 25, [3] p. : ill. ; 8⁰ (22 cm).
DNB: Pasley, 4. – Lithographed throughout from handwriting. – Note on reverse of title-page, signed by Pasley and dated 30 Sept. 1822, reveals that the second edition (not traced) was also lithographed.

2.28 PASLEY, C.W. Rules for the practice of military mining, in any soil excepting rock. – Chatham : Lithographed at the Establishment for Field Instruction, Royal Engineer Department, 1824. – [2], 100 p. : ill. ; 8⁰ (22 cm).
Lithographed throughout from handwriting. – Preface is signed by Pasley and dated 16 June 1824. – Reverse of title-page carries the note 'Papers and Plans Lithographed at this Establishment for the use of the Corps are not to be published or used as materials for Publication.'. – At least two copies end at p.92.

2.29 PASLEY, C.W. Statement of an experiment for ascertaining whether a stockade could be breached by the bags of powder. – Chatham : Lithographed at the Royal Engineer Establishᵗ., 1840. – [7] p. : ill., 1 folding plate ; 8⁰ (22 cm).
Lithographed throughout from handwriting. – Signed by Pasley on final page. – Supplementary title-page reads 'Experiment on a stockade, Chatham, 1840'.

2.30 PONSONBY, (Colonel). An abridgement of Colonel Arentschildt's instructions to officers and non commissioned officers of Light Cavalry / By The Honorable Lieut: Colonel Ponsonby, of the

12ᵗʰ. Light Dragoons : Printed at Freneda in 1813. – Chatham : Lithographed at the Royal Engineer Establishment, under the direction of Colonel Sir Frederic Smith . . . , April 1848. – 15 p. ; 8⁰ (21 cm).
Lithographed throughout from handwriting. – The word 'Copy' is printed lithographically at the head of the title-page. – The pagination includes two otherwise blank pages. – The single copy inspected is severely trimmed and has lost some of its page numbers.

2.31 Rules for commencing parallels & approaches in a siege including those to be executed by the Flying Sap. – Chatham : Lithographed at the Establishment for Field Instruction; Royal Engineer Department, 1823. – [2], 15 p. : ill. ; 8⁰ (22 cm).
Lithographed throughout from handwriting. – Reverse of title-page carries the note 'Papers and Plans Lithographed at this Establishment for the use of the Corps, are not to be published; or used as materials for Publication.'.

2.32 Rules for executing the regular sap, whether single or double. – Chatham : Lithographed at the Establishment for Field Instruction Royal Engineer Department, 1825. – [2], 46 p. : ill. ; 8⁰ (22 cm).
Lithographed throughout from handwriting. – Reverse of title-page carries the note 'Papers and Plans lithographed at the Establishment for the use of the Corps are not to be published or used as materials for publication.'.

2.33 Rules for levelling, boning, and taking sections, for the use of the Regimental Schools. – Chatham : Lithographed at the Establishment for Field Instruction, Royal Engineer Department, 1823. – [2], 20 p. : ill. ; 8⁰ (22 cm).
Lithographed throughout from handwriting. – Reverse of title-page carries the note 'Papers and Plans Lithographed at the Establishment for the use of the Corps are not to be published, or used as materials for publication.'.

2.34 Rules for making fascines and gabions. – Chatham : Lithographed at the Establishment for Field Instruction, Royal Engineer Department, 1823. – [2], 30 p. : ill. ; 8⁰ (22 cm).
Lithographed throughout from handwriting. – Reverse of title-page carries the note 'Papers and Plans lithographed at this Establishment for the use of the Corps, are not to be published, or used as materials for publication.'.

2.35 Rules for tracing, and executing the parallels, and approaches, in a siege. – Chatham : Lithographed at the Establishment for Field Instruction Royal Engineer Department, 1826. – [2], 32p. : ill. ; 8º (22 cm).

Lithographed throughout from handwriting. – Reverse of title-page carries the note 'Papers and Plans lithographed at [this] Establishment for the use of the Corps are not to be published, or used as materials for publication.'.

2.36 Siege operations and mining practice. / S.M.E. Chatham. – [S.l. : s.n.], 1877. – [2], 30 leaves, printed on rectos only : ill., 27 plates ; 4º (33 cm).

Lithographed from handwriting, apart from p.9–12 which are printed letterpress and pasted down. – The statement of responsibility is at the head of the title-page. – The first leaf states that the report was made to Sir John Stokes, the Commandant of the School of Military Engineering, by Lieut: Colonel J. P. Maquay R.E. Instructor in Field Fortification. – The first 5 plates are lithographed, the remaining 22 are photographs mounted on to leaves printed with lithographed captions.

2.37 A simple practical treatise on field fortification for the use of the Regimental Schools of the Royal Sappers & Miners. – Chatham : Lithographed at the Establishment for Field Instruction Royal Engineer Department, 1823. – [4], 39p. : ill. ; 8º (22 cm).

Lithographed throughout from handwriting. – Reverse of title-page carries the note 'Papers and Plans lithographed at this Establishment for the use of the Corps are not to be published or used as materials for publication.'.

2.38 Tables of the weight of malleable, and cast iron calculated for the purpose of facilitating the estimating of smith's and founder's work connected with the architectural course. – Chatham : Lithographed at the Royal Engineer Establishment, 1841. – 16p. ; 8º (22 cm).

Lithographed throughout from handwriting. – Consists of title-page and 15 pages of tables.

2.39 [Tables: headed 'Refractions']. – [S.l. : s.n., s.d.]. – 8p. ; 8º (22 cm).

Lithographed throughout from handwriting. – Consists entirely of tables. – Bound up with other items of the Royal Engineer Department (of the 1820s and 1840s) in the Royal Engineer Corps Library, Chatham.

Metz

École d'Application de l'Artillerie et du
Génie [École Royale d'Artillerie et du Génie]

With the exception of 3.5, 3.18, 3.21–3.25, 3.43, the
descriptions below relate to a single set of items
bound up in nine volumes.

3.1 ARDANT, Paul-Joseph. Cours de construc-
tions. / Par Le Capitaine du Génie Ardant. ; 1ère
partie. – Metz : Ecole d'Application de l'Artillerie et
du Génie, Octobre 1840. – xvi, 411 p. : ill. ; 4°
(22 cm).

Lithographed throughout, the text handwritten. –
Bound up with 3.2 in a volume lettered 'Ardant.
École de Metz : Cours de construction 1'.

3.2 ARDANT, Paul-Joseph. Cours de construc-
tions. : Leçons sur l'architecture des bâtimens
militaires. – [Metz : Ecole d'Application de l'Artil-
lerie et du Génie, c. 1840]. – 336 p. : ill. ; 4° (22 cm).

Lithographed throughout, the text handwritten. –
No title-page. – The title and name of publisher are
taken from p.1. – Bound up with 3.1 in a volume
lettered 'Ardant : École de Metz : Cours de construc-
tion 1', and appears to be part two of this publica-
tion.

3.3 ARDANT, Paul-Joseph. Cours de construc-
tions. : 3ème partie. : Leçons sur la résistance des
matériaux et la stabilité des constructions. – [Metz :
Ecole d'Application de l'Artillerie et du Génie],
Juillet 1840. – xii, 177 p. : ill. ; 4° (22 cm).

Lithographed throughout, the text handwritten. –
Bound up with 3.4 in a volume lettered 'Ardant :
École de Metz : Cours de construction 2'.

3.4 ARDANT, Paul-Joseph. Cours de construc-
tions. : 4e partie. : Leçons préparatoires au projet de
construction hydraulique. – [Metz : Ecole d'Applica-
tion de l'Artillerie et du Génie], Mars 1840. – xviii,
385 p. : ill. ; 4° (22 cm).

Lithographed throughout, the text handwritten. –
Bound up with 3.3 in a volume lettered 'Ardant :
École de Metz : Cours de construction 2'.

3.5 BOILEAU. Notes pour servir à l'établisse-
ment des usines militaires. – [Metz : Lithographie
de l'Ecole d'Application, c. 1835]. – [4], 62 p. : ill. ; 4°.

Not seen. – Listed in Paul Breman Ltd, Catalogue
six, *Military architecture and engineering*, London,
June 1970, no.3.

3.6 Commission formée par ordre du Ministre de
la Guerre, en date du 29 Mai 1833, pour l'etablisse-
ment des principes du tir. : Premier et second rap-
ports. : 1834. / Ecole d'Artillerie de Metz. – [Metz]:
Lithog. de l'Ecole d'Application de l'Artillerie et du
Génie, Juillet 1835. – [2], 1–112, [2], 113–216 p. + 10
fold-out plates; 2° (34 cm).

Lithographed throughout, the text handwritten. –
The statement of responsibility is at the head of the
title-page. – Tables in text. – Bound up with 3.27 in
a volume lettered 'Piobert : École de Metz : Cours
d'artillerie 2'. – Page numbers 115 and 122 trans-
posed.

3.7 COURS DE TOPOGRAPHIE. Canevas
topographique d'un lever de fortification de peu
d'étendue. – [Metz]: Ecole d'Application de l'Arte.
et du Génie, [c. 1835–41]. – [1], 1–11, [2], 12–62, [3],
63–143, [3], 144–218, [1] p. + 2 folding plates : ill. ;
2° (34 cm).

Lithographed throughout, the text handwritten. –
The statement of responsibility is taken from p.1.
– Tables in text. – Bound up with 3.8 & 3.9 in a
volume lettered 'École de Metz : Cours de topo-
graphie 1'. – Traces of original blue-paper wrappers
still visible.

3.8 COURS DE TOPOGRAPHIE. Cours élemen-
taire de la pratique des levers topographiques. –
[Metz] : Ecole d'Application de l'Arte. et du Génie,
[c. 1835–41]. – 29 p. : ill. ; 2° (34 cm).

Lithographed throughout, the text handwritten. –
No title-page. – The title and name of publisher
are taken from p.1. – Bound up with 3.7 & 3.9 in a

volume lettered 'École de Metz : Cours de topographie 1'. – Traces of original blue-paper wrappers still visible.

3.9 COURS DE TOPOGRAPHIE. Cours de topographie pratique. : 2ᵉ. partie. : Elémens de la pratique de l'art des levers et du nivellement. – [Metz] : Ecole d'Application de l'Artillerie et du Génie, [*c.* 1835–41]. – 71 p. + 6 fold-out plates ; 2° (34 cm).

Lithographed throughout, the text handwritten. – No title-page. – The title and name of publisher are taken from p. 1. – Bound up with 3.7 & 3.8 in a volume lettered 'École de Metz : Cours de topographie 1'. – Traces of original blue-paper wrappers still visible.

3.10 COURS DE TOPOGRAPHIE. Notions sur la vérification et l'usage des instrumens employés en topographie. : Notions générales. – [Metz] : Ecole d'Application de l'Artillerie et du Génie, [*c.* 1835–41]. – 44 p. : ill. ; 4° (22 cm).

Lithographed throughout, the text handwritten. – No title-page. – The title and name of publisher are taken from p. 1. – Bound up with 3.11–3.14 in a volume lettered 'École de Metz : Cours de topographie 2'.

3.11 COURS DE TOPOGRAPHIE. 3ᵉ leçon. : Lever à la planchette. – [Metz : Ecole de Metz, *c.* 1835–41. – 12 p. ; 4° (22 cm).

Lithographed throughout from handwriting. – No title-page. – Bound up with 3.10, 3.12–3.14 in a volume lettered 'École de Metz : Cours de topographie 2'.

3.12 COURS DE TOPOGRAPHIE. 4ᵉ et 5ᵉ. leçons. : Lever à la boussole. : Théorie de la boussole et de son usage. – [Metz : Ecole de Metz, *c.* 1835–41]. – 72 p. : ill. ; 4° (22 cm).

Lithographed throughout, the text handwritten. – No title-page. – Bound up with 3.10–3.11, 3.13–3.14 in a volume lettered 'École de Metz : Cours de topographie 2'.

3.13 COURS DE TOPOGRAPHIE. 6ᵉ. leçon. : Nivellement. – [Metz : Ecole de Metz, *c.* 1835 –41]. – 41 p. + 1 plate : ill. ; 4° (22 cm).

Lithographed throughout, the text handwritten. – No title-page. – Bound up with 3.10–3.12, 3.14 in a volume lettered 'École de Metz : Cours de topographie 2'. – Paginated 73–88, [2], 89–113.

3.14 COURS DE TOPOGRAPHIE. 7ᵉ leçon. : Lever des sections horizontales. – [Metz : École de Metz, *c.* 1835–41]. – 11 p. : ill. ; 4° (22 cm).

Lithographed throughout, the text handwritten. – No title-page. – Bound up with 3.10–3.13 in a volume lettered 'École de Metz : Cours de topographie 2'. – Paginated 114–124.

3.15 FRANÇAIS, J.-F. : COURS D'ART MILITAIRE. Précis du cours d'art militaire. – [Metz] : Ecole d'Application de l'Artᵉ. et du Génie, [*c.* 1835–41]. – 60 p. ; 2° (34 cm).

Lithographed throughout, the text handwritten. – No title-page. – The title and name of publisher are taken from p. 1. – Tables in text. – Bound up with 3.16–3.17, 3.20 in a volume lettered 'Français : École de Metz : Cours d'art militaire et de géodèsie'.

3.16 FRANÇAIS, J.-F. : COURS D'ART MILITAIRE. Stratègie. – [Metz] : Ecole d'Application de l'Artᵉ et du Génie, [*c.* 1835–41]. – 35 p. ; 2° (34 cm).

Lithographed throughout from handwriting. – No title-page. – The title and name of publisher are taken from p. 1. – Bound up with 3.15, 3.17, 3.20 in a volume lettered 'Français : École de Metz : Cours d'art militaire et de géodèsie'.

3.17 FRANÇAIS, J.-F. : COURS D'ART MILITAIRE. Tactique. – [Metz] : Ecole d'Application de l'Artᵉ et du Génie, [*c.* 1835–41]. – 18 p. : ill. ; 2° (34 cm).

Lithographed throughout, the text handwritten. – No title-page. – The title and name of publisher are taken from p. 1. – Bound up with 3.15–3.16, 3.20 in a volume lettered 'Français : École de Metz : Cours d'art militaire et de géodèsie'.

3.18 FRANÇAIS, J.-F. Précis des leçons du cours de topographie militaire, à l'usage des élèves de l'Ecole Royale de l'Artillerie et du Génie. / Par J. F. Français, professeur. – à Metz: Litho: de l'Ecole Royale de l'Art: et du Génie, 1824. – [2], 27 p. + 1 fold-out plate. – 2° (34 cm).

Lithographed throughout, the text handwritten. – Title-page lettered 'Pierron', the plate lettered 'Burnier, Lieut: d'Artᵢᵉ'. – The text on laid paper with watermark 'JD' and two back to back c-shaped curves in outline and interlocking; the plate on wove paper with watermark 'D & C Blauw Puves'. – Page 1 is signed A. – Bound in plain, blue-stained wrappers.

3.19 Géologie. (5 leçons). – [Metz : Ecole de Metz, *c.* 1835–40]. – 12 p. ; 4° (21 cm).

Lithographed throughout from handwriting. – No title-page. – The title is taken from p.1. – Bound up with 3.36–3.42, 3.44–3.45 in a volume lettered 'École de Metz : Programme des divers cours de l'Ecole d'Applica [sic]'.

3.20 GOSSELIN, T. Cours de géodèsie de feu Mr. Français, professé [sic] à l'Ecole d'Application de l'Artillerie et du Génie / par Théo. Gosselin, Capitaine du Génie. – A Metz : Lithographie de l'Ecole d'Application, Novembre 1834. – [4], 189, [2]p. + 6 fold-out plates ; 2° (34 cm).

Lithographed throughout, the text handwritten. – Tables in text. – Bound up with 3.15–3.17 in a volume lettered 'Francais : École de Metz : Cours d'art militaire et de géodésie'. – The title-page appears to be by the letterer of 3.24. – Traces of original blue-paper wrappers still visible.

3.21 Leçons sur le lever de batiment. – [Metz] : Ecole Royale de l'Artillerie et du Génie, [*c.* 1824]. – [2], 25, [1]p. + 1 fold-out plate. – 2° (35 cm). – Sig: π^2 A–B^6 [C]2.

Lithographed throughout, the text handwritten. – The statement of responsibility is taken from p.1. – Evidence for the date is a close similarity with 3.18. – Some retouching and corrections in ordinary ink, especially on p.11 and p.12. – The text on laid paper with watermark 'Colombier' and two back to back c-shaped curves in outline; the plate on laid paper with watermark 'Annonay'. – Bound in plain, blue-stained wrappers. – First and last leaves pasted down as end papers, and not counted in the statement of pagination.

3.22 MUNIER & RODOLPHE. Cours de pyrotechnie militaire. – Metz : [Ecole d'Application de l'Artillerie et du Génie], 1844. – 29, [3], 472 p. ; 2°.

Not seen. – Listed in Paul Breman Ltd, Catalogue six, *Military architecture and engineering*, London, June 1970, no.12, where it is described as a set of lecture notes lithographed for the Ecole d'Application de l'Artillerie et du Génie in various hands, and with manuscript additions by T.-J.Rodolphe.

3.23 PERSY, N. Cours de balistique, à l'usage des élèves de l'Ecole Royale d'Artillerie et du Génie. – 2me edition. – Metz, 1827.

Not seen. – Described in the *National Union Catalog* as lithographed.

3.24 PERSY, N. Cours de stabilité des constructions, à l'usage des élèves de l'Ecole d'Application de l'Artillerie et du Génie. / Par N. Persy, professeur. – 4ème edition. – A Metz : Lithographie de l'Ecole d'Application, Juillet 1834. – [1], 231 p. : ill. ; 34 cm.

Lithographed throughout, the text handwritten. – Tables in text. – The title-page appears to be by the letterer of 3.20. – Traces of original blue-paper wrappers still visible. – A second edition (École Royale de l'Artillerie et du Génie, 1827) is described in the *National Union Catalog* as lithographed.

3.25 PERSY, N. Notions élémentaires sur les formes des bouches à feu et sur les systèmes d'artillerie à l'usage des élèves de l'Ecole Royale de l'Artillerie et du Génie. / Par N. Persy, professeur. – A Metz : Lithographie de l'Ecole Royale de l'Artillerie et du Génie, [*c.* 1824]. – [2], 63 p. + 1 fold-out table and 4 fold-out plates. – 2° (34 cm).

Lithographed throughout, the text handwritten. – Evidence for the date is a close similarity with 3.18, including the same owner's inscription. – Title-page lettered 'Pierron litho.'; three plates 'Burnier Lieut. d'Artillerie' (or similar); one plate 'Gacon Lieutt. d'Artillerie'. – The text on a combination of wove paper (with watermark showing two back to back c-shaped curves in outline and interlocking) and laid paper (with watermark 'Colombier' and two back to back c-shaped curves in outline, not interlocking). – The fold-out table on laid paper with watermark 'J Henriet / Medan'. – Bound in plain, blue-stained wrappers. – The *National Union Catalog* lists an American edition, lithographed at the Military Academy, West Point, 1836.

3.26 PIOBERT, Guillaume. Cours d'artillerie. : Partie théorique. / Par G. Piobert, Capitaine d'Artillerie. ; Rédigée d'après les cahiers et les leçons du professeur en 1835. Par M. M. Didion et de Saulcy, Capitaines d'Artillerie. – [Metz] : Lithog. de l'Ecole d'Application de l'Artillerie et du Génie, Avril 1841. – [2], liii, [1], 362, 7 p. : ill. ; 4° (22 cm).

Lithographed throughout, the text handwritten. – Binding lettered 'Piobert : École de Metz : Cours d'artillerie 1'.

3.27 PIOBERT, Guillaume. Cours d'artillerie : Projet de bouches à feu. : Sommaire des leçons sur le projet de bouches à feu. : Projectile. – [Metz] : Ecole d'Application de l'Artrie et du Génie, [*c.* 1835–41]. – 1–4, [5], 8–12 p. + 3 leaves of folding tables ; 2° (34 cm).

Lithographed throughout, the text handwritten. – No title-page. – The title and name of publisher are taken from p.1. – Tables in text. – Bound up with 3.6 in a volume lettered 'Piobert : École de Metz : Cours d'artillerie 2'.

3.28 PONCELET, Jean-Victor. Cours de mécanique appliquée aux machines. : Premiere section. : Considerations générales sur les machines en mouvemt. – [Metz] : Ecole d'Application de l'Arte. et du Génie, [c. 1839]. – 43 p. ; 2° (34 cm).

Lithographed throughout from handwriting. – No title-page. – The title and name of publisher are taken from p.1. – Bound up with 3.29–3.35 in a volume lettered 'Poncelet : École de Metz : Cours de mécanique'. – Traces of original blue-paper wrappers still visible.

3.29 PONCELET, Jean-Victor. Cours de mécanique appliquée aux machines. : 2ème section. : Des principaux moyens de régulariser l'action des forces sur les machines, et d'assurer l'uniformité du mouvement. – [Metz] : Ecole d'Application de l'Arte. et du Génie, [c. 1839]. – 122 p. : ill. ; 2° (34 cm).

Lithographed throughout, the text handwritten. – No title-page. – The title and name of publisher are taken from p.1. – Bound up with 3.28, 3.30–3.35 in a volume lettered 'Poncelet : École de Metz : Cours de mécanique'.

3.30 PONCELET, Jean-Victor. Cours de mécanique appliquée aux machines. : 3ème section. : Calcul des résistances passives dans les pièces à mouvement constant et soumises à des actions sensiblement invariables. – [Metz] : Ecole d'Application de l'Arte. et du Génie, [c. 1839]. – 120 p. : ill. ; 2° (34 cm).

Lithographed throughout, the text handwritten. – No title-page. – The title and name of publisher are taken from p.1. – Tables in text. – Bound up with 3.28–3.29, 3.31–3.35 in a volume lettered 'Poncelet : École de Metz : Cours de mécanique'. – Traces of original blue-paper wrappers still visible.

3.31 PONCELET, Jean-Victor. Du frottement des engrenages. – [Metz] : Ecole d'Application de l'Artillerie et du Génie, [c. 1839]. – 11 p. : ill. ; 2° (34 cm).

Lithographed throughout, the text handwritten. – No title-page. – The title and name of publisher are taken from p.1. – Bound up with 3.28–3.30, 3.32–3.35 in a volume lettered 'Poncelet : École de Metz : Cours de mécanique', and may therefore be part 4 of this series.

3.32 PONCELET, Jean-Victor. Cours de mécanique appliquée aux machines. : 5ème section. : Influence des changemens brusques de la vitesse. – [Metz] : Ecole d'Application de l'Artillerie et du Génie, [c. 1839]. – 50 p. : ill. ; 2° (34 cm).

Lithographed throughout, the text handwritten. – No title-page. – The title and name of publisher are taken from p.1. – Bound up with 3.28–3.31, 3.33–3.35 in a volume lettered 'Poncelet : École de Metz : Cours de mécanique'. – Traces of original blue-paper wrappers still visible.

3.33 PONCELET, Jean-Victor. Leçons préparatoires au lever d'usines. : 6ème section. : Du mouvement permanent et de l'écoulement des fluides. – [Metz] : Ecole d'Application de l'Arte. et du Génie, [c. 1839]. – 80 p. : ill. ; 2° (34 cm).

Lithographed throughout, the text handwritten. – No title-page. – The title and name of publisher are taken from p.1. – Tables in text. – Bound up with 3.28–3.32, 3.34–3.35 in a volume lettered 'Poncelet : École de Metz : Cours de mécanique'.

3.34 PONCELET, Jean-Victor. Cours de mécanique appliquée aux machines. : 7ème section. : Des principaux moteurs et récepteurs. – [Metz] : Ecole d'Application de l'Artillerie et du Génie, [c. 1839]. – 108 p. : ill. ; 2° (34 cm).

Lithographed throughout, the text handwritten. – No title-page. – The title and name of publisher are taken from p.1. – Tables in text. – Bound up with 3.28–3.33, 3.35 in a volume lettered 'Poncelet : École de Metz : Cours de mécanique'. – Traces of original blue-paper wrappers still visible.

3.35 PONCELET, Jean-Victor. Cours de mécanique appliquée aux machines : Section VIII. : Des ponts-levis. – [Metz] : Ecole d'Application de l'Artrie et du Génie, [c. 1839]. – 47 p. + 1 folding plate : ill. ; 2° (34 cm).

Lithographed throughout, the text handwritten. – No title-page. – The title and name of publisher are taken from p.1. – Bound up with 3.28–3.34 in a volume lettered 'Poncelet : École de Metz : Cours de mécanique'. – The folding plate is dated 'Janv. 1839'.

3.36 Programme du lever de bâtiment. – [Metz] : Ecole d'Application de l'Artillerie et du Génie, [c. 1840]. – 6, [2] p. ; 2° (34 cm).

Lithographed throughout from handwriting. – No title-page. – The title and name of publisher are taken from p.1. – Page 6 is signed Radoult and dated 'Metz, le 20 Mars 1840'. – Bound up with 3.19, 3.37–3.42, 3.44–3.45.

3.37 Programme du lever à la boussole. – [Metz] : Ecole d'application de l'Artillerie et du Génie, [*c.* 1841]. – 6, [2] p. ; 2° (34 cm.).

Lithographed throughout from handwriting. – No title-page. – The title and name of publisher are taken from p.1. – Page 6 is dated 'Metz, le 26 Avril 1841'. – Bound up with 3.19, 3.36, 3.38–3.42, 3.44–3.45.

3.38 Programme du lever de fortification à la planchette (et des mines pour les élèves du génie). – [Metz] : Ecole d'Application de l'Artillerie et du Génie, [*c.* 1841]. – 9 p. ; 2° (34 cm).

Lithographed throughout from handwriting. – No title-page. – The title and name of publisher are taken from p.1. – Page 9 is dated 'Metz, le 15 Avril 1841'. – Bound up with 3.19, 3.36– 3.37, 3.39–3.42, 3.44–3.45.

3.39 Programme du lever d'usines ou de machines. – [Metz] : Ecole d'Application de l'Artillerie et du Génie, [*c.* 1835–41]. – 6, [2] p. ; 2° (34 cm).

Lithographed throughout from handwriting. – No title-page. – The title and name of publisher are taken from p.1. – Signed by Radoult on p.6. – Bound up with 3.19, 3.36–3.38, 3.40–3.42, 3.44–3.45.

3.40 Programme du 1er lever à vue (lever militaire). – [Metz] : Ecole d'Application de l'Artillerie et du Génie, [*c.* 1834]. – [6] p. ; 2° (34 cm).

Lithographed throughout from handwriting. – No title-page. – The title and name of publisher are taken from p.1. – Signed P. Bergere and Bon. Pelletier. – Includes a 2 p. supplement signed P. Bergere and Bon. Pelletier and dated 'Metz, le 4 Septembre 1834'. – Bound up with 3.19, 3.36–3.39, 3.41–3.42, 3.44–3.45.

3.41 Programme du projet de bâtiment militaire. – [Metz] : Ecole d'Application de l'Artillerie et du Génie, [*c.* 1840]. – 5 p. ; 2° (34 cm).

Lithographed throughout from handwriting. – No title-page. – The title and name of publisher are taken from p.1. – Page 5 is signed by Radoult and dated 'Metz, le 1er Août 1840'. – Bound up with 3.19, 3.36–3.40, 3.42, 3.44–3.45.

3.42 Programme du projet de construction hydraulique. – [Metz] : Ecole d'Application de l'Artillerie et du Génie, [*c.* 1835–41]. – [4] p. ; 2° (34 cm).

Lithographed throughout from handwriting. – No title-page. – The title and name of publisher are taken from p.1. – Signed Comte d'Anthoüard and

P. Bergere and dated 'Paris, le 18 Mars 1830', though this is unlikely to be the date of the publication. – Bound up with 3.19, 3.36–3.41, 3.44–3.45.

3.43 Programmes pour l'enseignement de la fortification permanente, de l'attaque et de la défense des places. / Ecole d'Application de l'Artille. et du Génie. – Metz : Lithog. de l'Ecole d'Application de l'Artillerie et du Génie, Juin 1841. – 308 p. in various pagings (when the sequences are 84, 62, 101, 61 p.) + 10 fold-out plates ; 4° (22 cm).

Lithographed throughout, the text handwritten. – The statement of responsibility is at the head of the title-page. – Bears holograph paragraph signed 'GA' on p.84 of the first pagination.

3.44 Projet de fortification passagère. : Programme des dessins. – [Metz] : Ecole d'Application de l'Arte. et du Génie, [*c.* 1838]. – 4 p. ; 2° (34 cm).

Lithographed throughout from handwriting. – No title-page. – The title and name of publisher are taken from p.1. – Page 4 signed by Radoult and dated 'Metz, le 25 Mai 1838'. – Bound up with 3.19, 3.36–3.42, 3.45.

3.45 Projet de fortification passagère. : Programme de l'exécution du travail sur le terrain. – [Metz] : Ecole d'Application de l'Arte. et du Génie, [*c.* 1838]. – [4] p. ; 2° (34 cm).

Lithographed throughout from handwriting. – No title-page. – The title and name of publisher are taken from p.1. – Bound up with 3.19, 3.36–3.42, 3.44.

Phillipps

The antiquarian publications of Sir Thomas
Phillipps of Middle Hill, Broadway

4.1 Cartularium Monasterii de Winchcombe in
Com. Glouc. / abbreviatum per Joh. Prynne, Arm. /
Impensis Dni. Thomæ Phillipps, Bar^ti. – [Broadway] :
Ex Lithographia Medio-Montana, 1854. – [2], 227 p.
(numbered to 225) ; 2° (33 cm).

Fenwick, 8; Kraus, 121; Sotheby, 92. – Litho-
graphed from handwriting, with letterpress title-
page which includes an intaglio-printed vignette of
Broadway Tower (Turris Lativiensis). – Printed on
blue paper, wove and laid. – Verso of p.79 blank,
p.80 a recto and not numbered, p.91a included
between p.91 & 92 so as to return to odd numbers
on rectos.

4.2 Chronicon Abbatiae S.Nicholai, de Exonia. /
Impensis Dni. T. Phillipps, Bart. – [Broadway] : Ex
Lithographia Medio-Montana, [c. 1853–54]. – [2],
22 p. ; 2° (33 cm).

Fenwick, 5; Kraus, 79; Lowndes (App.), 236;
Sotheby, 88. – Lithographed from handwriting, with
letterpress title-page. – The text printed on blue laid
paper with the watermark 'Kent 1853', the title-page
on white paper.

4.3 DU-MOULIN, Louis. A short and true
account of the several advances the Church of
England hath made towards Rome . . . 1680. / By
Dr. Du-Moulin, sometime History Professor of
Oxford. – [Broadway : Middle Hill Press, c. 1860]. –
24 p. ; 4° (24 cm).

Fenwick, 113 (4); Kraus, 21. – Lithographed
throughout from handwriting. – Printed on unwater-
marked white wove paper. – Printed by S. H. Cowell
in Ipswich (see Wakeman, p.37, for an account dated
Aug. 1860).

4.4 Excerpta ex registris parochialibus, in Com.
Gloucester, &c. – [Broadway] : Ex Lithographia
Medio-Montana, 1854. – [2], 62 p. in various
pagings ; 2° (33 cm).

Fenwick, 12; Kraus, 122; Lowndes (App.), 236;
Sotheby, 94. – Lithographed from handwriting, with

letterpress title-page. – Printed mainly on blue
paper, wove and laid, the latter with the watermark
'Kent 1853', with 3 leaves of white paper.

4.5 Excerpta ex registris parochialibus, in Com.
Gloucester, &c. – [Broadway] : Ex Lithographia
Medio-Montana, 1854. – [2], 101 p. in various
pagings ; 2° (35 cm).

Fenwick, 11; Kraus, 123; Sotheby, 93. – Litho-
graphed from handwriting, with letterpress title-
page. – Printed mainly on blue paper, wove and laid,
the latter with the watermark 'Kent 1853', with 3
leaves of white paper. – Includes all of 4.4, with
other matter added.

4.6 FERRERS, Elizabeth, Countess of. Assignatio
dotis Elizabethæ Comitissæ de Ferrers, Anno 29
H. VI. – [Broadway: Middle Hill Press], 1855
([London and Broadway] : Ex Zincographia Appelana
et Typographia Medio-Montana). – [2], 7 p. ; 2°
(34 cm).

Fenwick, 80; Kraus, 100; Lowndes (App.), 236. –
From the Phillipps MS 13998. – Lithographed from
handwriting, with letterpress title-page. – Printed
on unwatermarked blue wove paper. – Printed by
Appel in London (see Wakeman, p.35–36).

4.7 Heralds visitation disclaimers / Impensis Dni.
Thomæ Phillipps, Bar^ti. – [Broadway : Middle Hill
Press], 1854 ([London] : Ex Zincographia Appelana).
– [2], 76 p. ; 2° (34 cm).

Fenwick, 54; Kraus, 312; Sotheby, 96. – Litho-
graphed from Phillipps's own handwriting, with
letterpress title-page. – Printed on unwatermarked
blue wove paper. – Printed by Appel in London (see
Wakeman, p.30, for an account dated 27 May 1852,
and also p.39).

4.8 Index to the Pedes Finium for Wiltshire, 1 Geo
1. to 11 Geo. 2. / Impensis Dni. Thomæ Phillipps,
Bar^ti. – [Broadway : Middle Hill Press], 1853
([London] : Ex Zincographia Appelana). – [2], 74,
60 p. ; 2° (35 cm).

Fenwick, 35; Kraus, 367, 368; Sotheby, 85. –
Lithographed from handwriting, with letterpress
title-page in red and black. – A variant title-page
exists. – Printed on unwatermarked blue wove
paper. – Printed by Appel in London (*see* Wakeman,
p.35, for an account dated 2 Aug. 1854).

4.9 Index to the Pedes Finium for Worcestershire. /
Impensis Dni. Thomæ Phillipps, Bar^ti. – [Broadway :
Middle Hill Press], 1853 ([London] : Ex Zincographia
Appelana). – [2], 434 p. ; 2° (35 cm).

Fenwick, 48; Kraus, 390, 391; Lowndes (App.),
235; Sotheby, 87. – Lithographed from handwriting,
with letterpress title-page in red and black. –
A variant title-page exists. – Printed on unwater-
marked blue wove paper. – Printed by Appel in
London (*see* Wakeman, p.31–32).

4.10 Index Pedum Finium pro Com. Glouc. temp.
George I. / Impensis Dni. Thomæ Phillipps, Bart. –
[Broadway] : Ex Lithographia, Medio-Montana
[*c.* 1854]. – [2], 115 p. ; 2° (35 cm).

Fenwick, 13; Kraus, 127; Lowndes (App.), 236;
Sotheby, 89. – Lithographed from handwriting, with
letterpress title-page. – The text printed on unwater-
marked blue paper, the title-page on white paper. –
Printed by Appel in London (*see* Wakeman, p.35, for
an account dated 2 Aug. 1854).

4.11 Visitations of Berkshire, 1565. 1623. 1664. /
Cura Dni. Thomæ Phillipps, Bart. Autographa. –
[Broadway] : Typis Medio-Montanis, circa 1840 [sic].
– [2], 42 p. ; 2° (40 cm).

Fenwick, 1; Kraus, 47, 47a; Lowndes (App.), 231;
Sotheby, 64–66. – Lithographed genealogies in
Phillipps's own handwriting, with letterpress title-
page. – Pages 37–38 are missing from all recorded
copies. – Printed on unwatermarked white paper.

4.12 The Wallop Latch. – [Broadway] : Ex Litho-
graphia, Medio-Montana, [*c.* 1854]. – [18] p. ; 2°
(34 cm).

Fenwick, 122; Kraus, 339; Lowndes (App.), 235;
Sotheby, 154. – Lithographed from handwriting,
with letterpress title-page. – Printed on blue laid
paper with the watermark 'Salmon 1854', the title-
page on white paper. – An account of psychic
phenomena observed in Nether Wallop, 1754–60,
signed by witnesses.

4.13 Wiltes : Rotulus Hildebrandi de Londonia et
Johannis de Harnham – [Broadway : Middle Hill
Press, *c.* 1853]. – 45 p. ; 2° (35 cm).

Fenwick, 36; Kraus, 379; Lowndes (App.), 236;
Sotheby, 90. – No title-page, the title is taken
from p.1, where it appears in an abbreviated form.
– Lithographed throughout from handwriting. –
Printed on unwatermarked blue wove paper. – The
item is Subsidy Roll 7 Edward III. – Printed by Appel
in London (*see* Wakeman, p.31, for an account dated
9 June 1853).

4.14 Wiltshire pipe rolls temp. Henrici 2.
Ann. 5.6.7.8.9.10, & 12 to 25. A.D. 1159. ad 1179. /
Impensis Dni. Thomæ Phillipps, Bar^ti. – [Broadway :
Middle Hill Press], 1853 ([London] : Ex Zincographia
Appelana). – [2], 131 p. in various pagings ; 2° (35 cm).

Fenwick, 32; Kraus, 375; Lowndes (App.), 235;
Sotheby, 86. – Lithographed from handwriting, with
letterpress title-page in red and black. – A variant
title-page exists. – Printed on blue paper, wove and
laid, the latter with the watermark 'CA 1852' or 'E
Towgood 1853'. – Printed by Appel in London (*see*
Wakeman, p.32–33, for an account dated 12 Sept.
1853).

Pitman

The phonographic publications of Sir Isaac Pitman.

The starting point for this catalogue was the list of works written on transfer paper by Isaac Pitman which was published in A. Baker, *The life of Sir Isaac Pitman* (London, 1913) p.371–373. Additional items were added to it after working on the Pitman Collection of Bath University Library and in the Carlton Shorthand Collection of the University of London Library. Wherever possible, items have been checked against entries for them in the major shorthand catalogues of K. Brown & D. C. Haskell, *The Shorthand Collection in the New York Public Library* (New York, 1935) and J. Westby-Gibson, *The bibliography of shorthand* (London and Bath, 1887). Unfortunately, neither of these publications can be used to identify all lithographed items; Brown & Haskell do not state whether items are lithographed, and Westby-Gibson does not do so consistently.

All the entries listed below are given in traditional orthography even when the original was printed in phonetic form.

5.1 BIBLE. The Holy Bible, containing the Old and New Testaments : translated out of the original tongues . . . – London : Fred. Pitman, Phonetic Depot ; Bath : Isaac Pitman, Phonetic Institution, 1867. – [2], 811, [1]p. : 21 cm. – Sig: π^1 1–101^4 10^2.
 Baker, p.372; Brown & Haskell, p.434; Westby-Gibson, p.162. – Lithographed throughout. – Title-page, book and chapter headings, running heads, folios, and signatures transferred from type, the text written in two columns within single-line borders. – Listed by Baker as produced from Isaac Pitman's lithographic transfers. – In the corresponding style of phonography. – Published as a supplement to the *Phonetic Journal*. – From sheet 53 an additional series of signatures is printed in parallel (1–53, 2–54, 3–55 etc). – Westby-Gibson records further Pitman editions of the Bible (1871, 1872) though Baker states that the edition begun in 1872 was never completed and remained unpublished.

5.2 BIBLE. The Holy Bible . . . Lithographed in the easy reporting style of phonography . . . Authorised version. – London : Isaac Pitman & Sons ; Bath : Phonetic Institute, 1890. – [2], 808 p. ; 22 cm. – Sig: π^1 1–50^8 51^4.
 Brown & Haskell, p.434. – Lithographed throughout. – Title-page, book and chapter headings, running heads, folios, and signatures transferred from type, the text written in two columns within single-line borders.

5.3 BIBLE. The Holy Bible . . . Lithographed in the corresponding style of phonography . . . Authorised version. – London : Isaac Pitman & Sons ; Bath : Phonetic Institute, 1891. – [2], 808 p. ; 22 cm. – Sig: π^1 1–50^8 51^4.
 Brown & Haskell, p.434. – Lithographed throughout, apart from letterpress title-page. – Book and chapter headings, running heads, folios, and signatures transferred from type, the text written in two columns within single-line borders.

5.4 BIBLE. The Holy Bible . . . Authorised version. Lithographed in the easy reporting style of Pitman's shorthand. – London : Sir Isaac Pitman & Sons, Ltd. ; Bath : Phonetic Institute, [191?]. – [4], 800 p. ; 23 cm. – Sig: π^2 1–50^8.
 Brown & Haskell, p.434. – The 'Twentieth century edition'. – Lithographed throughout, apart from the title-page, contents page, and part-title to the Old Testament, all of which are printed letterpress. – Book and chapter headings, running heads, folios, signatures, and the part-title to the New Testament transferred from type, the text written in two columns within single-line borders.

5.5 BIBLE: NEW TESTAMENT. The New Testament of our Lord and Saviour Jesus Christ: / In phonetic short hand. – London : Fred. Pitman, 1849. – [2], 286 p. ; 13 cm. – Sig: π^1 1–17^8 18^7.
 Baker, p.371; Brown & Haskell, p.434; Westby-

Gibson, p.166. – Title-page in phonetic form. – Lithographed throughout. – Written in the corresponding style of phonography in two columns within single-line borders. – Listed by Baker as produced from Isaac Pitman's lithographic transfers. – Decorative title-page signed by William Fisher. – A further impression, with a slightly altered imprint, dated 1850. – Published separately and also with the *Book of Psalms* (5.11).

5.6 BIBLE: NEW TESTAMENT. The New Testament of our Lord and Saviour Jesus Christ. / In phonetic shorthand. – London : Fred Pitman, Phonetic Depot ; Bath : Isaac Pitman, Phonetic Insttn. ; Glasgow : White, 1853. – [4], 380 p. ; 16 cm. – Sig: π^2 1–23^8 24^6.

Baker, p.371; Brown & Haskell, p.434; Westby-Gibson, p.166. – Lithographed throughout. – Written within single-line borders.

5.7 BIBLE: NEW TESTAMENT. The New Testament of our Lord and Saviour Jesus Christ. / In phonetic shorthand. – London : Fred. Pitman ; Bath : Isaac Pitman, Phonetic Institute, 1865. – [2], 360 p. ; 13 cm. – Sig: π^1 1–45^4.

Baker, p.371; Brown & Haskell, p.434; Westby-Gibson, p.166. – Title-page in phonetic form. – Lithographed throughout, apart from letterpress title-page and its verso. – Headings, running heads, folios, and signatures transferred from type, the text written in two columns within single-line borders.

5.8 BIBLE: NEW TESTAMENT. The New Testament of our Lord and Saviour Jesus Christ. / In phonography. – London : F. Pitman, 1867. – [2], 496 p. ; 17 cm. – Sig: π^1 a–i^8 j^8 k–u^8 v^8 w^8 x–z^8 1–5^8.

Brown & Haskell, p.434. – Lithographed throughout, apart from letterpress title-page. – Headings, running heads, folios, and signatures transferred from type, the text written within single-line borders.

5.9 BIBLE: NEW TESTAMENT. The New Testament of Our Lord and Savior [sic] Jesus Christ ... Printed in the corresponding style of phonetic shorthand. – London : Fred. Pitman, Phonetic Depot ; Bath : Isaac Pitman, Phonetic Institute, 1872. – 166 p. ; 22 cm. – Sig: 1–20^4 21^3.

Brown & Haskell, p.434; Westby-Gibson, p.166. – Lithographed throughout. – Title-page, headings, running heads, folios, and signatures transferred from type, the text written in two columns within single-line borders.

5.10 BIBLE: PENTATEUCH. The Pentateuch, or five books of Moses, / Written in phonetic shorthand, in the various styles of the art, – learner's, business, corresponding, and reporting, – each opening of the book displaying one style. – London : Fred. Pitman ; Bath : Isaac Pitman, Phonetic Institute, [1865]. – [2], 157 p. ; 22 cm. – Sig: π^1 1–19^4 20^3.

Baker, p.372; Brown & Haskell, p.435; Westby-Gibson, p.166. – Title-page in phonetic form. – Lithographed throughout. – Title-page, phonetic key, headings, running heads, folios, and signatures transferred from type, the text written in two columns within single-line borders. – Listed by Baker as produced from Isaac Pitman's lithographic transfers.

5.11 BIBLE: PSALMS. The Book of Psalms / in phonetic short hand. – Fred Pitman, 1849. – [2], 64 p. ; 13 cm. – Sig: π^1 1–4^8.

Baker, p.371; Brown & Haskell, p.435; Westby-Gibson, p.163. – Title-page in phonetic form. – Lithographed throughout. – Written in two columns within single-line borders. – Listed by Baker as produced from Isaac Pitman's lithographic transfers. – Decorative title-page by William Fisher, signed in phonetic form. – Published separately and also with the *New Testament* (5.5). – An edition with the date 1848 is recorded by Brown & Haskell and Westby-Gibson.

5.12 BIBLE: PSALMS. The Book of Psalms. – London and Bath, 1853. – 143 p. – 8°.

Baker, p.371; Westby-Gibson, p.163. – Not seen. – Listed by Baker as produced from Isaac Pitman's lithographic transfers.

5.13 BOOK OF COMMON PRAYER. The Book of Common Prayer, and administration of the sacraments, and the rites and ceremonies of the Church of England. Together with the Psalter, or Psalms of David. / Lithographed in phonography, by T. A. Reed. – London : Pitman, 1853 ([London] : F. & H. Swan imp. Dalston). – 224 p. ; 16 cm + 4 p. catalogue. – Sig: 1–14^8.

Brown & Haskell, p.436; Westby-Gibson, p.162. – Lithographed throughout. – Title-page transferred from type, the text written in two columns within single-line borders. – The statement of printing is taken from p.224.

5.14 BOOK OF COMMON PRAYER. The Book of Common Prayer ... – London : Fred. Pitman ; Bath : Isaac Pitman, Phonetic Institute, 1867. – 250 p. [i.e. 1–208, 219–250] ; 16 cm. – Sig: 1–15^8.

Baker, p.372; Brown & Haskell, p.436; Westby-Gibson, p.162. – Lithographed throughout. – In the corresponding style of phonography. – Pages 209–218 are missing in the numeration. – Title-page, headings, running heads, folios, and signatures transferred from type, the text written in two columns within single-line borders.

5.15 BOOK OF COMMON PRAYER. The Book of Common Prayer . . . – Printed in shorthand. – London : Fred. Pitman ; Bath : Isaac Pitman, Phonetic Institute, 1869. – [600]p. ; 17 cm. – Sig: π^6 [1–2]8 3–36^8 37^6.

Lithographed throughout, apart from 12 p. of introductory letterpress matter. – Headings, running heads, and signatures transferred from type, the text written in two columns within single-line borders.

5.16 BOOK OF COMMON PRAYER. The Book of Common Prayer . . . Printed in an easy reporting style of phonography. – London : Fred. Pitman ; Bath : Isaac Pitman, 1871. – [2], 443 p. ; 11 cm. – Sig: π^1 1–27^8 28^6.

Brown & Haskell, p.436; Westby-Gibson, p.162. – Lithographed throughout. – Title-page, headings, running heads, folios, and signatures transferred from type, the text written within single-line borders.

5.17 BOOK OF COMMON PRAYER. The Book of Common Prayer . . . – London : F. Pitman, s.d. – [2], 312 p. ; 17 cm. – Sig: π^1 1–19^8 20^4.

Brown & Haskell, p.436. – Lithographed throughout, apart from the title-page which is letterpress. – Main headings transferred from type, other headings and text written in two columns within single-line borders. – Owner's inscription dated 1876 in copy seen. – Another undated edition, [2], 312 p., with many identical pages, but with a variant title-page and some pages re-written.

5.18 BUNYAN, John. The narrative only of the Pilgrim's progress, from this world to that which is to come. / By John Bunyan. – Printed in phonography. – London : Fred. Pitman ; Bath : Isaac Pitman, Phonetic Institute, 1871. – 84 p. ; 14 cm. – Sig: 1–5^8 6^2.

Baker, p.373; Brown & Haskell, p.437; Westby-Gibson, p.163. – Lithographed throughout. – Title-page, running heads, folios, and signatures transferred from type, the text written in two columns within single-line borders. – Listed by Baker as produced from Isaac Pitman's lithographic transfers.

BUTTERWORTH, James. *See* 1.48–1.54.

5.19 Debate on the Irish Church Bill in the House of Lords, 14th, 15th, 17th, and 18th June, 1869. – London : F. Pitman, Phonetic Depot ; Bath : Isaac Pitman, Phonetic Institution, 1869. – 172, [1]p. ; 17 cm. – Sig: 1–10^8 11^7.

Baker, p.372; Westby-Gibson, p.164. – Written in the reporting style of phonography. – Lithographed throughout. – Title-page, running heads, folios, and signatures transferred from type, the text written in two columns within single-line borders. – Listed by Baker as produced from Isaac Pitman's lithographic transfers, and with a letterpress key. – A second edition, 1871, is recorded by Westby-Gibson.

5.20 GOLDSMITH, Oliver. The Vicar of Wakefield, / by Oliver Goldsmith. – Printed in phonography. – London : F. Pitman, [1876]. – 160 p. ; 14 cm. – Sig: 1–5^{16}.

Brown & Haskell, p.439; Westby-Gibson, p.164. – Lithographed throughout. – Title-page and chapter numbers transferred from type, the text written in two columns within single-line borders. – The date is taken from Brown & Haskell.

5.21 GRAY, Anne Augusta. Laura; or, 'The only way to be happy, is to be useful' : and, Edward's dream ; or, Good for evil. / By Anne Augusta Gray. – London : F. Pitman ; Bath : Isaac Pitman, 1848. – 48 p.

Baker, p.371; Brown & Haskell, p.440; Westby-Gibson, p.164. – Not seen. – Title-page in phonetic form. – Written in the corresponding style of phonography. – Listed by Baker as produced from Isaac Pitman's lithographic transfers. – Variously described as 8° and 16°.

5.22 GRAY, Thomas. Elegy written in a country churchyard. / By Thomas Gray. – London : F. Pitman, [1866]. – 16 p. ; 16°.

Brown & Haskell, p.440; Westby-Gibson, p.164. – Not seen. – Written in the corresponding style of phonography with interlinear translations.

5.23 HART, John. Hart's orthography. 1569. Reprinted from a copy in the British Museum. – London : Fred. Pitman, Phonetic Depot, 1850. – [2], 78 p. ; 16 cm. – Sig: π^9 3–5^8 6^7.

Baker, p.371; Brown & Haskell, p.181, 478; Westby-Gibson, p.165. – Title-page transferred from type, the remainder written within single-line borders. – Listed by Baker as produced from Isaac Pitman's lithographic transfers.

5.24 HOLCOMBE, William Henry. The other life. / By W. H. Holcombe ... – Printed in phonography. – London : Fred. Pitman ; Bath : Isaac Pitman, 1871. – 158, [2]p. ; 14 cm. – Sig: 1–10⁸.

Brown & Haskell, p.440; Westby-Gibson, p.165. – Lithographed throughout. – Title-page, running heads, folios, and signatures transferred from type, the text written in two columns within single-line borders. – Referred to by Westby-Gibson as lithographed by Isaac Pitman.

5.25 HOLCOMBE, William Henry. The sexes here and hereafter / By W. H. Holcombe ... – Printed in phonography. – London : Fred. Pitman ; Bath : Isaac Pitman, 1871. – 154, [2]p. ; 15 cm. – Sig: 1⁶ 2–10⁸.

Baker, p.373; Brown & Haskell, p.440; Westby-Gibson, p.165. – Written in the corresponding style of phonography. – Lithographed throughout. – Title-page, running heads, folios, and signatures transferred from type, the text written in two columns within single-line borders. – Referred to by Westby-Gibson as lithographed by Isaac Pitman.

5.26 HUGHES, Thomas. Tom Brown's school days by an old boy. / [Thomas Hughes]. – London : Isaac Pitman & Sons ; Bath : Phonetic Institute, 1891. – 288 p. ; 17 cm. – Sig: 1–18⁸.

Brown & Haskell, p.441. – In the easy reporting style of phonography. – Lithographed throughout. – Title-page, headings, running heads, folios, and signatures transferred from type, the text written within single-line borders. – Title-page headed 'National Phonographic Library'.

5.27 Ipswich phono-press. – No. 1–17 (Aug. 1845 to Dec. 1846). – Bath : Isaac Pitman at the Phonographic Institution ; London : Phonetic Depot, 1846. – Monthly ; 22 cm.

Baker, p.376; Brown & Haskell, p.503. – Edited by John King to Dec. 1845, then by Isaac Pitman. – Referred to by Baker as written on transfer paper by Isaac Pitman. – Issues consist of 8 p. written within single-line borders.

5.28 JOHNSON, Samuel. The history of Rasselas, Prince of Abyssinia. / By Samuel Johnson ... – London : Fred. Pitman ; Bath : Isaac Pitman, Phonetic Institute, 1867. – 101 p. ; 16 cm. – Sig: 1–3⁸ 4a⁸ 4b⁸ 5a⁸ 5b³.

Baker, p.372; Brown & Haskell, p.441; Westby-Gibson, p.165. – Title-page in phonetic form. – Written in the reporting style of phonography. – Title-page, headings, folios, and signatures transferred from type, the text written within single-line

borders. – Listed by Baker as produced from Isaac Pitman's lithographic transfers.

5.29 LAMBE, William. Diet. / Extracts from Dr Lambe's 'Report on regimen in chronic diseases,' published in London, 1815 ; with a preface and notes by Edward Hare ... – London : F. Pitman, Phonetic Depot, Bath : Isaac Pitman, 1869. – 176 p. : ill. ; 16 cm. – Sig: 1–11⁸.

Baker, p.372; Brown & Haskell, p.441; Westby-Gibson, p.165. – Written in the corresponding style of phonography. – Lithographed throughout. – Title-page, running heads, folios, and signatures transferred from type, the text written within single-line borders. – Listed by Baker as produced from Isaac Pitman's lithographic transfers.

5.30 MACAULAY, Thomas Babbington. Biographies / by Lord Macaulay, contributed to the Encyclopaedia Britannica. With notes of his connection with Edinburgh, and extracts from his letters and speeches ... – London : Fred. Pitman ; Bath : Isaac Pitman, Phonetic Institute, 1868. – 199, [1], 126 p. ; 16 cm. – Sig: 1–12⁸ 13⁴ A–G⁸ H⁷.

Baker, p.372; Brown & Haskell, p.442; Westby-Gibson, p.165. – Title-page in phonetic form. – Title-page and introduction (16 p.) and entire second pagination printed letterpress, the remainder lithographed. – The lithographed parts written in the reporting style of phonography within single-line borders (and listed by Baker as produced from Isaac Pitman's lithographic transfers). – The letterpress imprint reads 'Printed by Isaac Pitman, Phonetic Institute, Parsonage Lane, Bath'.

5.31 MACAULAY, Thomas Babbington. Biographies / by Lord Macaulay, contributed to the Encyclopaedia Britannica. With notes of his connection with Edinburgh, and extracts from his letters and speeches ... – Second edition. – London : F. Pitman, Phonetic Depot ; Isaac Pitman, Phonetic Institute, 1870. – [4], 187 p. ; 15 cm. – Sig: π² 1–11⁸ 12⁶.

Baker, p.372; Brown & Haskell, p.442; Westby-Gibson, p.165. – Written in the reporting style of phonography. – Title-page and contents page letterpress. – Headings, running heads, folios, and signatures transferred from type, the text written within single-line borders. – Second edition of 5.30 without the key.

5.32 MACAULAY, Thomas Babbington. Critical and historical essays / contributed to the Edinburgh review by Lord Macaulay. – Printed in phonography. – London : Fred. Pitman, Phonetic Depot ; Bath : Issac Pitman, Phonetic Institute, 1870. – [4], 462, [1]p. ; 23 cm. – Sig: π^2 1–3^8 4–51^4 52–53^8.

Baker, p.373; Brown & Haskell, p.442; Westby-Gibson, p.165–166. – Letterpress title-page and contents page. – Headings, running heads, folios, and signatures transferred from type, the text written in two columns within single-line borders. – Listed by Baker as produced from Isaac Pitman's lithographic transfers.

5.33 MILTON, John. Paradise lost ; a poem in twelve books / by John Milton. – Lithographed in phonography. – London : Fred. Pitman ; Bath : Isaac Pitman, 1871. – 280 p. ; 14 cm. – Sig: 1–17^8 18^4.

Baker p.373; Brown & Haskell, p.442; Westby-Gibson, p.166. – Written in the corresponding style of phonography. – Lithographed throughout. – Title page, running heads, folios, and signatures transferred from type, the text written in two columns within single-line borders. – Listed by Baker as produced from Isaac Pitman's lithographic transfers.

5.34 MULOCK, Dinah Maria (Mrs Craik). John Halifax, gentleman. / By Miss Mulock. – Printed in phonography. By permission. – London : Fred. Pitman ; Bath : Isaac Pitman, 1871. – 2 vol. (248 p.) (264 p.) ; 14 cm. – Sig: (1–15^8 16^4) (1^4 2–17^8).

Brown & Haskell, p.437 (under Craik); Westby-Gibson, p.164 (under Craik). – Lithographed throughout. – The two title-pages, running heads, and folios transferred from type, the text written in two columns within single-line borders. – Westby-Gibson records that the lithographic writing was done by Isaac Pitman, though T. A. Reed, in *A Biography of Isaac Pitman* (London, 1890), p.113, states specifically that this and some other books were written out by J. R. Lloyd.

5.35 The Phonographic casket. Edited by James Granger. – Vol. 1 to vol. 3 no.4 (Jan. 1859 to April 1861). – London : Fred Pitman, 1859–61. – Monthly ; 16 cm.

Brown & Haskell, p.518; Westby-Gibson, p.157. – Issues of 16 p. written within single-line borders.

5.36 The Phonographic correspondent. Conducted by Isaac Pitman. – Vol. 1–15 (Jan. 1844 to 1858). – London : Fred Pitman, Phonetic Depot, 1844–58. – Monthly, ill. ; 22, 15 cm.

Baker, p.375; Brown & Haskell, p.497; Westby-Gibson, p.157. – Written in the corresponding style

of phonography. – The title varies between traditional and phonetic orthography, sometimes including and sometimes excluding the words 'and reporter'. – Originally published in London and Bath. – Printed in Bath by J. Hollway to Dec. 1846. – At first 8 p. an issue, 16 p. from Jan. 1845. – Written within single-line borders with illustrations on opening pages and elsewhere. – Some decorative title-pages and illustrations of the late 1840s and early 1850s signed William Fisher (sometimes in phonetic form). – The issue for June 1852 announced Fisher's death aged 24 years.

5.37 The Phonographic correspondent; a supplement to the Phonetic journal. – London : Fred. Pitman ; Bath : Isaac Pitman, Jan. to June 1871. – Weekly. – iv, 400 p. ; 14 cm. – Sig: π^2 1–25^8.

Baker, p.376; Brown & Haskell, p.522 (under *Pitman's journal*); Westby-Gibson, p.157. – Title in phonetic form. – Edited and lithographed by Isaac Pitman. – Issues of 16 p. – Title-page, index, headings, running heads, folios, and signatures transferred from type, the text written within single-line borders.

5.38 The Phonographic examiner and aspirants' journal. – Vol. 1–14 (Feb. 1853 to 1866). – London : Fred. Pitman / Fred. Pitman & Wm White, 1853–66. – Monthly ; 16, 17 cm.

Brown & Haskell, p.519; Westby-Gibson, p.157. – Written in the corresponding and reporting styles of phonography. – Originally edited by James Drake & William Murray, then by James Drake, later by Charles Gahagan. – Vol. 2–3 'Engraved on Stone' (vol. 3 by Henry Swan). – Vol. 1 printed by F. & H. Swan, 13 Liverpool Street. – Wrappers of the issue for Dec. 1855 state that in 1856 the journal 'will cease to be engraved, and the specimen of Phonetic printing will be discontinued'. – Issues of 16 p. in letterpress wrappers. – The text written within single-line borders, with some decorative material included. – Some pages written on dotted lines. – The apostrophe in the title is after the final s on the individual parts and before it on the annual title-pages.

5.39 The Phonographic herald & magazine of general & phonetic literature. Conducted by C. F. Pearson & Edwin Gardner. – No. 1–37 (Jan. 1860 to Jan. 1863). – London : Fred. Pitman, 1860–63. – Monthly ; 17 cm.

Brown & Haskell, p.519; Westby-Gibson, p.157. – Issues of 16 p. written within single-line borders.

5.40 The Phonographic journal. – Vol. 1–3 (Jan. 1842 to Dec. 1844). – Bath : Isaac Pitman ; London : Samuel Bagster and Sons, 1842–44. – Monthly ; 17, 23 cm.

Baker, p.374; Brown & Haskell, p.519; Westby-Gibson, p.158. – The format and number of pages per issue varies (vol.1, foolscap 8°, 8 p.; vol.2, crown 8°, 12 p. ; vol.3, demy 8°, 8 p.). – Originally printed by Bradshaw & Blacklock in Manchester, from Dec. 1842 by J. Hollway in Bath. – Pages written within either single-or double-line borders. – The first British phonographic journal and the first major use of lithography by Pitman. – *See also* T. A. Reed, *A Biography of Isaac Pitman* (London, 1890), p.34–36.

5.41 The Phonographic lecturer. – Vol. 1–16 (Jan. 1871 to 1886). – Edited by F. Pitman. – London : F. Pitman, 1871–86. – Monthly ; 17 cm.

Brown & Haskell, p.519; Westby-Gibson, p.158. – Written in the reporting style of phonography. – Issues of 32 p. written within single-line borders. – Issued in letterpress wrappers.

5.42 The Phonographic magazine. Edited by W. Hepworth Dixon. – No. 1–4 (May to Aug. 1844). – Bath : Isaac Pitman ; London : S. Bagster ; Manchester : J. Gillett, 1844. – Monthly ; 22 cm.

Westby-Gibson, p.158. – A window bill bound with the copy in Bath University Library describes the journal as 'A monthly serial, consisting of original papers on science and art, essays, tales, reviews, poetry . . .'. – Issues of 8 p. written within double-line borders.

5.43 The Phonographic magazine. Conducted by Isaac Pitman. – Jan. 1849 to Dec. 1851; May 1852 to April 1853. – London : Phonetic Depot, 1849–53. – Monthly ; 16 cm.

Baker, p.377; Brown & Haskell. p.497; Westby-Gibson, p.158. – Title in phonetic form. – Written in the reporting style at the rate of 100 words per minute. – Issues of 16 p. written within single-line borders. – The journal lasted under Pitman until Dec. 1851 and was revived in May 1852 by Charles Gahagan. – The new series printed by F. & H. Swan, 13 Liverpool Street.

5.44 The Phonographic observer and journal of the Phonographic Literary Society. Conducted by Edwin Gardner. – No. 1–43 (Jan. 1859 to June 1862). London : Fred. Pitman, 1859–62. – Monthly, ill. ; 17 cm.

Brown & Haskell, p.520; Westby-Gibson, p.159. – Issues of 16 p. written within single-line borders.

5.45 The Phonographic reporter. Conducted by Thomas Allen Reed. – Vol. 1–35 (Jan. 1849 to Dec. 1883). – London : Fred. Pitman, Phonetic Depot, 1849–83. – Monthly ; 15 cm.

Brown & Haskell, p.521; Westby-Gibson, p.159. – Absorbed the *Reporter's magazine* (1847–48). – Title in phonetic form between 1849 and 1851. – Written in the third or reporting style of phonography. – Issues of 16 p. written within single-line borders. – Reed was a close associate of Isaac Pitman and his earliest biographer. – In 1881 the journal was edited by Frederick Nightingale and in 1883 by M. T. Shanasy.

5.46 The Phonographic review. – Vol. 1–2 (1855–56). – London : Fred. Pitman and William White, 1855–56. – Quarterly, monthly ; 20, 16 cm.

Brown & Haskell, p.521; Westby-Gibson, p.159–160. – Edited by Charles Gahagan, then by Joseph Joyce. – Written in the reporting style of phonography, with a letterpress key. – Quarterly issues of 48 p., monthly in 1856, written within single-line borders. – Issued in letterpress wrappers.

5.47 The Phonographic review: a monthly journal of phonetic and general literature. – Vol. 1–3 (Jan. 1867 to Dec. 1869). – London : F. Pitman ; Glasgow : A. Steele & Co., 1867–69. – Monthly ; 16 cm.

Brown & Haskell, p.521; Westby-Gibson, p.160. – Printed in Glasgow by A. Steele & Co., Engravers and Lithographers. – Issues of 16 p. written within single-line borders.

5.48 The Phonographic star. – Vol. 1–12 (March 1844 to 1855?). – London : 1844–55. – Monthly, ill. ; 20, 16 cm.

Baker, p.376–377; Brown & Haskell, p.497; Westby-Gibson, p.160. – Title varies, mostly in phonetic form. – Vol. 1–3 edited by John Newby of the Friends' School, Ackworth, Wakefield; vol.4–8 by Isaac Pitman; vol.9–12 by Francis and Morris Brettell. – Originally published by C. Gilpin, afterwards by Isaac Pitman and F. Pitman. – Issues of 8 p. at the outset, increasing to 16 p. from Jan. 1847 (vol.4). – Baker includes the change in editorship and format in 1847 as a new series 'written in the first style of phonography'. – Pitman ceased to be editor with the issue for Dec. 1851 and announced the closure of the journal. – It was revived in May 1852 (vol.9) and is included by Westby-Gibson as a new series with the title *Phonographic star, or, pupils' reading book*. – Westby-Gibson claimed that it continued to 1857, and the Carlton Collection of the University of London Library has the issue for Dec. 1856. – Some numbers in 1853 printed by

F. & H. Swan, 13 Liverpool Street. – Some decorative title-pages and illustrations of the late 1840s and early 1850s signed William Fisher (sometimes in phonetic form).

5.49 PITMAN, Isaac. Exercises in phonography. / By Isaac Pitman. – London : Bagster & Sons ... sold also by the author ..., Bath, and by all booksellers, 1842. – 24 p. ; 12⁰.

Baker, p.364; Westby-Gibson, p.173. – Not seen. – Lithographed shorthand reading matter, different from 5.50.

5.50 PITMAN, Isaac. Exercises in phonography. / By Isaac Pitman. – London : Samuel Bagster & Sons ; Bath : Isaac Pitman, 1842. – Price 3*d*. – 8 p. ; 16 cm.

Baker, p.365; Westby-Gibson, p.173. – Lithographed shorthand reading matter, written within double-line borders, different from 5.49. – Letterpress wrappers.

5.51 PITMAN, Isaac. Exercises in phonography. – London and Bath : s.n., 1843. – Price 6*d*. – 24 p.

Baker, p.365; Westby-Gibson, p.173. – Not seen. – Lithographed shorthand reading matter.

5.52 PITMAN, Isaac. A history of shorthand. / By Isaac Pitman. – Written in phonography. – London : Fred. Pitman, Phonetic Depot, 1852. – [4], 167 p. ; 16 cm. – Sig: π^2 1–10⁸ 11⁴.

Baker, p.370; Brown & Haskell, p.11, 443; Westby-Gibson, p.178. – Lithographed throughout. – Written in shorthand within single-line borders. – Title-page lettered in imitation of type.

5.53 PITMAN, Isaac. A history of shorthand. / By Isaac Pitman. – Reprinted from the Phonotypic journal, 1847. – Second edition. – London : F. Pitman, 1868. – 192 p.

Baker, p.370; Brown & Haskell, p.11; Westby-Gibson, p.178. – Not seen. – Variously described as 8⁰ and 24⁰. – Written in the corresponding style of phonography.

5.54 PITMAN, Isaac. A phonographic dictionary of the English language ; containing all the most usual words to the number of twelve thousand / by Isaac Pitman ... forming a supplement to the Ipswich phono-press. – London : Isaac Pitman, Phonetic Depot ; Bath : Phonetic Institution, 1846. – [2], 132 p. ; 22 cm.

Baker, p.369; Brown & Haskell, p.332; Westby-Gibson, p.177. – Title-page in phonetic form. – Lithographed throughout, the title-page lettered in

imitation of type. – Issued in parts Aug. 1845 to Dec. 1846.

5.55 PITMAN, Isaac. A phonographic and pronouncing vocabulary of the English language. / By Isaac Pitman. – London : Fred. Pitman, Phonetic Depot, 1850. – iv, 295 p. ; 18 cm + 4 p. catalogue. – Sig: π^2 a–s⁷·⁹ t⁴.

Baker, p.369; Brown & Haskell, p.332; Westby-Gibson, p.177. – Alternate leaves of letterpress and lithography, which accounts for the eccentric signatures. – The main body of the book is quired in alternating 7's and 9's, the outer sheets alternating between lithography (e.g. Sig: a) and letterpress (e.g. Sig: b) ; all such gatherings have a letterpress single-ton. – The structure of the final gathering cannot be determined. – Both letterpress and lithographed pages surrounded by single-line borders. – A second edition with the same pagination, dated 1852, has the lithographed parts re-written and includes a letterpress catalogue dated Jan. 1854.

5.56 PITMAN, Isaac. A phonographic and pronouncing vocabulary of the English language. / By Isaac Pitman ... – Third edition. – London and Bath, 1867. – 336 p. ; 15 cm. – Sig: A–I⁸ J⁸ K–U⁸.

Baker, p.369; Brown & Haskell, p.332; Westby-Gibson, p.177. – Lithographed throughout. – Title-page, running heads, and signatures transferred from type, the remainder written in four columns within single-line borders.

5.57 PITMAN, Isaac. The phonographic reading-book, written in the third style. – Bath : I. Pitman ; London : Bagster & Sons, 1844. – 24 p.

Baker, p.371; Brown & Haskell, p.443; Westby-Gibson, p.177. – Not seen. – Listed by Baker as from Isaac Pitman's lithographic transfers. – Variously described as 8⁰ and 12⁰.

5.58 PITMAN, Isaac. The phonographic teacher, an essay on the best method of teaching Pitman's phonography. – London : F. Pitman, 1847. – 64 p. ; 8⁰.

Baker, p.371; Westby-Gibson, p.161. – Not seen. – Written in the corresponding style of phonography. – Listed by Baker as from Isaac Pitman's lithographic transfers. – Second (1853), third (1867), and fourth (1871) editions were also lithographed.

5.59 PITMAN, Isaac. The reporter's assistant, a key to the reading of the reporting style of phonography. / By Isaac Pitman. – London : F. Pitman, Phonetic Depot ; Bath : Isaac Pitman, Phonetic Institute, 1867. – 86 p. ; 16 cm. – Sig: 1–5⁸ 6³.

Baker, p.363; Brown & Haskell, p.326; Westby-

Gibson, p.178. – Lithographed throughout. – Title-page, running heads, folios, and signatures transferred from type, the text written in two columns within single-line borders. – Referred to by T. A. Reed, *A Biography of Isaac Pitman* (London, 1890), p.112–113.

5.60 The Precursor. – Bath, 7 Oct. 1844 to 22 Oct. 1846 (irregularly); London, June 1850 to Dec. 1853 (monthly). – 22 cm.

Baker, p.377; Brown & Haskell, p.523. – Originally issued by Isaac Pitman, primarily for the Phonetic Council. – Title in phonetic form. – Issues of 8 or 16 p. written within single-line borders.

5.61 RICHMOND, Legh. The dairyman's daughter / By the Rev. Legh Richmond . . . – London : Fred. Pitman ; Bath : Isaac Pitman, Phonetic Institute, 1867. – 96 p. ; 16 cm. – Sig: A–F⁸.

Baker, p.372; Brown & Haskell, p.445; Westby-Gibson, p.166–167. – Title-page in phonetic form. – Written in the corresponding style of phonography. – Title-page and folios transferred from type, the text written within single-line borders. – Listed by Baker as produced from Isaac Pitman's lithographic transfers. – Brown & Haskell and Westby-Gibson record a further edition of 1871.

5.62 SCOTT, Sir Walter. Ivanhoe : a romance. / By Sir Walter Scott, Bart. ; Phonographic edition. By Edward J. Nankivell . . . – London : Reporters' Magazine Office, [1886]. – 3 vol. ; 14 cm.

Westby-Gibson, p.167. – Only vol.2 (consisting of 332 p.) seen. – Lithographed throughout. – Title-page and running heads transferred from type, the text written within single-line borders. – The date is taken from Westby-Gibson.

5.63 SCOTT, Sir Walter. Waverley or 'tis sixty years since, / by Sir Walter Scott Bart. – Lithographed in phonetic shorthand. – London : F. Pitman ; Glasgow : A. Steele & Co., [c. 1868] (Glasgow : A. Steele & Co. Engravers and Lithographers). – [4], ii, 124 p. ; 17 cm. – Sig: π¹ 1–8⁸.

Westby-Gibson, p.167. – Lithographed throughout, including wrappers. – Crayon-drawn vignette on first title-page. – Written within single-line borders. – The date derives from references on the back wrappers to a new series of the *Phonographic Express*.

5.64 The Sermon on the Mount . . . / In phonography, written in an easy style for learners. – London : Isaac Pitman, Phonetic Depot ; Bath : Phonetic Institution, 1846. – 16 p. ; 14 cm.

Baker, p.371; Westby-Gibson, p.167. – Lithographed throughout. – Written within single-line borders. – Listed by Baker as produced from Isaac Pitman's lithographic transfers. – Blue-paper wrappers, printed letterpress. – Price 3*d*. – Publication details taken from the wrappers.

5.65 SWEDENBORG, Emanuel. Heaven and its wonders; from things heard and seen. / by Emanuel Swedenborg. ; translated by the Rev. Samuel Nobel. – Centenary edition, in shorthand. – London : Fred. Pitman ; Bath : Isaac Pitman, Phonetic Institute, 1872. – xlviii, 272 p. ; 14 cm. – Sig: A–C⁸ 1–17⁸.

Baker, p.373; Brown & Haskell, p.446; Westby-Gibson, p.167. – Title-page in phonetic form. – Written in the corresponding style of phonography. – Title-page, running heads, folios, and signatures transferred from type, the text written within single-line borders. – Listed by Baker as produced from Isaac Pitman's lithographic transfers.

5.66 SWIFT, Jonathan. Gulliver's travels into several remote regions of the world. / by Dean Swift. – Printed in phonography. – London : Fred. Pitman ; Bath : Isaac Pitman, Phonetic Institute, 1871. – [4], 284 p. ; 14 cm. – Sig: π² 1–17⁸, 18⁶.

Brown & Haskell, p.447; Westby-Gibson, p.167. – Title-page, contents list, headings, running heads, folios, and signatures transferred from type, the text written within single-line borders. – Referred to by Westby-Gibson as lithographed by Isaac Pitman.

Locations

Locations of items described in the catalogue.
Where more than one copy has been seen in the
same collection the number of copies is shown
in parentheses

Bibliography

Abbey, J.R., *Life in England in aquatint and litho-graphy 1770–1860*. London, 1953.

Abbey, J.R., *Scenery of Great Britain and Ireland in aquatint and lithography 1770–1860*. London, 1952.

Abbey, J.R., *Travel in aquatint and lithography 1770–1860*. 2 vol. London, 1956, 1957.

Abraham, W., *Lithography in India: being a few practical hints for the Indian amateur*. Bombay, 1864.

Altick, R.D., *The English common reader: a social history of the mass reading public 1800–1900*. Chicago, 1957.

Asser, E.I., 'Procédé pour obtenir des positifs photo-graphiques sur papier, à l'encre d'imprimerie ou à l'encre lithographique', *Bulletin de la Société française de Photographie*, vol. 5, 1859, pp. 260–263.

B., L.J.D. [L.J.Du Blar], *Coup-d'œil sur la litho-graphie*. Brussels, 1818.

Baker, A., *The life of Sir Isaac Pitman*. London, 1908 (2nd ed. 1913).

Ball, D., *Victorian publishers' bindings*. London, 1985.

[Bankes, H.], *Lithography; or, the art of taking impressions from drawings and writing made on stone*. London, 1816.

Barker, N., *The publications of the Roxburghe Club 1814–1962*. Cambridge, 1964.

Baudelaire, C., *The mirror of art: critical studies by Charles Baudelaire*, translated and edited by Jonathan Mayne. London, 1955.

Bibliofila, La, *Calligraphy 1535–1885: a collection of seventy-two writing-books and specimens from the Italian, French, Low Countries and Spanish Schools catalogued and described*. Milan, 1962.

Bigmore, E.C., and Wyman, C.W.H., *A bibliography of printing*. 3 vol. London, 1880–86.

Blake, N.F., *William Caxton: a bibliographical guide*. New York and London, 1985.

Bland, D., *A history of book illustration*. London, 1958 (2nd ed. 1969).

Blunt, W., *The art of botanical illustration*. London, 1950.

Boase, F., *Modern English biography*. 6 vol. Truro, 1892–1921 (reprinted, London, 1965).

Bouchot, H., *La Lithographie*. Paris, 1895.

Brégeaut, L.-R., *Nouveau manuel complet de l'imprimeur lithographe, augmented by Knecht and Desportes*. Paris, 1850.

Bridson, G., and Wakeman, G., *Printmaking & picture printing: a bibliographical guide to artistic & industrial techniques in Britain 1750–1900*. Oxford and Williamsburg, 1984.

Brown, K., and Haskell, D.C., *The Shorthand Collection in the New York Public Library*. New York, 1935.

Brunet, J.-C., *Manuel du libraire et de l'amateur de livres*. 6 vol. Paris, 1860–64.

Burch, R.M., *Colour printing and colour printers*. 2nd ed. London, 1910.

Butler, E.H., *The story of British shorthand*. London, 1951.

Chambers, D., 'Sir Thomas Phillipps and the Middle Hill Press', *Private Library*, 3rd series, vol. 1, no. 1, Spring 1978, pp. 3–38.

Cowtan, R., *Memories of the British Museum*. London, 1872.

Dall'Armi, G., 'Cenni sulla litografia', *Biblioteca italiana, ossia Giornale di Letteratura, Scienze ed Arti*, vol. 44, Rome 1826, pp. 295–300.

Dawson, W.R., and Uphill, E.P., *Who was who in Egyptology*. 2nd ed. London, 1972.

De la Motte, P.H., *On the various applications of anastatic printing and papyrography*. London, 1849.

Desportes, J., 'Autographie', *Le Lithographe*, vol. 2, 1839, pp. 78–94, 105–115, 136–145.

Desportes, J., 'Exposition de l'Industrie', *Le Litho-graphe*, vol. 2, 1839, pp. 193–204, 225–230, 262–268.

Desportes, J., *Manuel pratique du lithographe*. Paris, 1834 (2nd ed. 1840).

Desportes, J., 'Transport d'épreuves lithographiques', *Le Lithographe*, vol.1, 1838, pp.319–333.

Desportes, J., 'Transport de vieilles épreuves', *Le Lithographe*, vol.1, 1838, pp.29–30.

Deutsch, O.E., *Musikverlags Nummern*. Berlin, 1961.

De Vinne, T.L., *Modern methods of book composition*. New York, 1904.

Diringer, D., *The alphabet*. 3rd ed., 2 vol. London, 1968.

Dobell, B., *Catalogue of books printed for private circulation*. London, 1906.

Doyen, C., *Trattato di litografia. Storico, teorico, pratico ed economico*. Turin, 1877.

Dunthorne, G., *Flower and fruit prints of the 18th and early 19th centuries*. London, 1938.

Dupont, P., *Essais pratiques d'imprimerie*. Paris, 1849.

Dussler, L., *Die Incunabeln der deutschen Lithographie (1796–1821)*. Berlin, 1925.

Engelmann, G., *Manuel du dessinateur lithographe*. Paris, 1822 (2nd ed. 1824; 3rd ed. 1830).

Engelmann, G., *Traité théorique et pratique de lithographie*. Mulhouse, 1835–40.

Fenwick, T.F. (Ed.), *The Middle Hill Press: a short catalogue of some of Sir Thomas Phillipps' privately printed works*. London, 1886.

Fielding, T.H., *The art of engraving, with the various modes of operation*. London, 1841 (2nd ed. 1844).

Foreign Review and Continental Miscellany, vol.4, no.7, 1829, pp.41–58.

Fortier, G., *La Photolithographie: son origine, ses procédés, ses applications*. Paris, 1876.

Friedman, J.M., *Colour printing in England 1486–1870*. New Haven, 1978.

Friedrich, F., *Bamberg und die frühe Lithographie*. Bamberg, 1978.

Gaskell, P., *A new introduction to bibliography*. Oxford, 1972.

Gernsheim, H. and A., *The history of photography*. London, 1955.

Gilmour, P. (Ed.), *Lasting impressions*. London, 1988.

Godfrey, R.T., *Printmaking in Britain: a general history from its beginnings to the present day*. Oxford, 1978.

Gold, J.J., 'The battle of the shorthand books, 1635–1800', *Publishing History*, no.15, 1984, pp.5–29.

Gombrich, E., *Art and illusion*. London and New York, 1960.

Gordon, C.H., *Forgotten scripts: the story of their decipherment*. London, 1968 (2nd ed., Harmondsworth, 1971).

Gray, B., *The English print*. London, 1937.

Gray, N., *Nineteenth century ornamented typefaces*. London, 1976 (originally published as *XIXth century ornamented types and title pages*, London, 1938).

Halkett, S., and Laing, J., *Dictionary of anonymous and pseudonymous English literature*. New ed., 8 vol. Edinburgh and London, 1926–56.

Hallam, E.M., *Domesday Book through nine centuries*. London, 1986.

Hallam, H.A.N., 'Lamport Hall revisited', *Book Collector*, Winter 1967, pp.439–449.

Hammann, J.-M.-H., *Des Arts graphiques*. Geneva and Paris, 1857.

Hansard, T.C., *Typographia*. London, 1825.

Harris, E., 'Experimental graphic processes in England 1800–59', *Journal of the Printing Historical Society*, no.4, pp.33–86, no.5, 1969, pp.41–80, no.6, 1970, pp. 53–89.

Head, F., *The Royal Engineer*. London, 1869.

Heal, A., *The English writing-masters and their copy books 1570–1800*. London, 1931 (reprinted, Hildesheim, 1962).

Hédou, J., *La Lithographie à Rouen*. Rouen, 1877.

Herluison, H., 'Les Débuts de la lithographie à Orléans', *La Réunion des Sociétés des Beaux-Arts des Départements*, Orleans, 1902, pp.75–87.

Hopkinson, C., *A bibliography of the musical and literary works of Hector Berlioz*. 2nd ed., Tunbridge Wells, 1980.

Houbloup, L., *Théorie lithographique*. Paris, 1825 (2nd ed. 1828).

Hullmandel, C.J., *The art of drawing on stone*. London, 1824 (2nd ed. 1833; 3rd ed. 1835).

Humphries, C., and Smith, W.C., *Music publishing in the British Isles*. London, 1954 (2nd ed., with supplement, Oxford, 1970).

Institute of Chartered Accountants in England and Wales, *Historical accounting literature: a catalogue of the collection of early works on book-keeping and accounting in the Library of the Institute of Chartered Accountants in England and Wales*. London, 1975.

Ivins, W.M., *Prints and visual communication*. London, 1953.

Jackson, H. (Ed.), *The complete nonsense of Edward Lear*. London, 1947.

James, H., 'The practical details of photo-zincography, as applied at the Ordnance Survey Office, Southampton', *British Journal of Photography*, 1 Sept. 1860, pp.249–251.

Jeffreys, A. E., *Michael Faraday: a list of his lectures and published writings*. London, 1960.

Johnson, W. McAllister, *French lithography: the Restoration Salons 1817–1824*. Kingston, Ontario, 1977.

Jones, H. B., *The life and letters of Faraday*. 2 vol. London, 1870.

Kampmann, C., *Die Literatur der Lithographie von 1798–1898*. Vienna, 1899.

Kann, E., *Die Geschichte der Lithographie*. Vienna, 1904.

Knecht, *Nouveau manuel complet du dessinateur et de l'imprimeur lithographe*. Paris, 1867.

Kraus, H. P., *A catalogue of publications printed at the Middle Hill Press 1819–1872*. New York, 1972.

Krummel, D. W., *Guide for dating early published music: a manual of bibliographical practices*. New Jersey, Kassel, Basel, Tours, London, 1974.

Kunzle, D., '*Mr. Lambkin*: Cruikshank's strike for independence', in R. L. Patten (Ed.), *George Cruikshank: a revaluation*. Princeton, 1974.

Lang, L., *Godefroy Engelmann imprimeur lithographe: les incunables 1814–1817*. Colmar, 1977.

Lang, L., and Bersier, J. E., *La Lithographie en France*. 3 vol. Mulhouse, 1946–52.

Legros, L. A., and Grant, J. C., *Typographical printing-surfaces*. London, 1916.

Leitch, J. (Ed.), *Miscellaneous works of the late Thomas Young*. 3 vol. London, 1855.

Lemercier, A., *La Lithographie française de 1796 à 1896 et les arts qui s'y rattachent*. Paris, c. 1898.

Lescure, M.-F.-A. de, *Les Autographes et le gout des autographes en France et à l'étranger*. Paris, 1865.

Levis, H. C., *A descriptive bibliography of the most important books in the English language relating to the art & history of engraving and the collecting of prints*. London, 1912.

Library of the Fine Arts, 'History and process of lithography', vol. 1, no. 1, Feb. 1831, pp. 44–58; 'A view of the present state of lithography in England', vol. 1, no. 3, Apr. 1831, pp. 201–216.

Le Lithographe, journal des artistes et des imprimeurs. 6 vol. Paris and Rotterdam, 1838–48.

Lorilleux, C., et Cie., *Traité de lithographie*. Paris, 1889.

Lowndes, W. T., *The bibliographer's manual of English literature*, revised by H. G. Bohn. 4 vol. London, 1864.

M...r, L., 'Dessins et écritures à la plume', *Le Lithographe*, vol. 2, 1839, pp. 339–342.

M...r, L., 'Dessins et écritures sur pierre', *Le Lithographe*, vol. 3, 1842, pp. 11–27.

McLean, R., *Victorian book design and colour printing*. London, 1963 (2nd ed., enlarged and revised, 1972).

Martin, J., *A bibliographical catalogue of books privately printed*. London, 1834 (2nd ed. 1854).

Masters, B., *Georgiana: Duchess of Devonshire*. London, 1981.

Matthäus, W., *Johann André: Musikverlag zu Offenbach am Main*. Tutzing, 1973.

Mettenleiter, X., *Grundzüge der Lithographie*. Mainz, 1818.

Michalik, R., 'Zur Frühzeit der Lithographie: der Privilegienstreit in Wien', *Archiv für Geschichte des Buchwesens*, vol. 8, 1966, col. 391–404.

Mosley, J., 'English vernacular: a study in traditional letter forms', *Motif*, no. 11, Winter 1963–64, pp. 3–55.

Mosley, J., 'The nymph and the grot: the revival of the sanserif letter', *Typographica*, no. 12, Dec. 1965, pp. 2–19.

Muir, P., *Victorian illustrated books*. London, 1971 (revised impression, 1985).

Mumford, I., 'Lithography, photography and photozincography in English map production before 1870', *Cartographic Journal*, vol. 9, no. 1, June 1972, pp. 30–36.

Munby, A. N. L., *The cult of the autograph letter in England*. London, 1962.

Munby, A. N. L., *Phillipps studies*. 5 vol. Cambridge, 1951–60.

Muzerelle, D., *Vocabulaire codicologique*. Paris, 1985.

Myers, R., 'George Isaac Frederick Tupper, facsimilist, "whose ability in this description of work is beyond praise" (1820–1911)', *Transactions of the Cambridge Bibliographical Society*, vol. 7, no. 2, 1978, pp. 113–134.

Myers, R., 'William Blades's debt to Henry Bradshaw and G. I. F. Tupper in his Caxton studies: a further look at unpublished documents', *Library*, 5th series, vol. 32, 1978, pp. 265–283.

Napper, D., 'Looking for an artist', *Deesider*, no. 84, Oct. 1971, pp. 24–25.

New Grove dictionary of music and musicians, The, 20 vol. London, 1980.

Nineteenth century short title catalogue, Series II, phase I: 1816–70. Newcastle-upon-Tyne, 1986–.

Noakes, V., *Edward Lear 1812–1888*. Royal Academy of Arts, exhibition catalogue, London, 1985.

Oeuvres complètes de Rodolphe Toepffer, vol. 10, Caricatures. Geneva, 1944.

Ordonnance et réglemens concernant l'École d'Application de l'Artillerie et du Génie. Metz, 1831.

Osborne Collection of early children's books, The, 2 vol. Toronto, 1958, 1975.

Ozzola, L., *La Litografia italiana dal 1805 al 1870.* Rome, 1923.

Pantazzi, S., 'A versatile Victorian designer: his designs for book covers – John Leighton, 1822–1912', *Connoisseur,* Apr. 1963, pp.262–273.

[Patent Office], *Abridgments of specifications relating to printing.* London, 1859 (reprinted by the Printing Historical Society, 1969).

Pennell, J., and E. R., *Lithography and lithographers, some chapters in the history of the art.* London, 1898 (2nd ed. 1915).

Peslouan, C.-L. de,'L'Art du livre illustré au XVIIIe siècle', *Arts et Métiers graphiques,* no.24, July 1931, pp.304–306.

Plant, M., *The English book trade: an economic history of the making and sale of books.* London, 1939 (2nd ed. 1965).

Pole, W., *The life of Sir William Siemens.* London, 1888.

Pope, M., *The story of decipherment from Egyptian hieroglyphic to Linear B.* London, 1975.

Porzio, D. (Ed.), *La Litografia: duecento anni di storia, arte e tecnica.* Milan, 1982 (French trans. 1983; English trans. 1983).

'Printing and piracy – new discovery', *Athenaeum,* no.736, 4 Dec. 1841, p.932.

Public Record Office, *Domesday re-bound.* London, 1954.

Ratcliff, E. C., *The booke of common prayer of the Churche of England: its making and revisions.* London, 1949.

Reed, T. A., *A biography of Isaac Pitman.* London, 1890.

Reid, A., 'Ralph Chubb, the unknown', *Private Library,* 3rd series, vol.3, no.3, Autumn 1970, pp.141–156; vol.3, no.4, Winter 1970, pp.193–213.

Richmond, W. D., *The grammar of lithography.* London, 1878.

Rosen, J., 'The printed photograph and the logic of progress in nineteenth-century France', *Art Journal,* Winter 1987, pp.305–311.

Sartori, C., *Dizionario degli editori musicale italiani.* Florence, 1958.

Saunders, F., *The author's printing and publishing assistant.* 2nd ed., London, 1839 (3rd ed. 1840).

Sayce, R. A., 'Compositorial practices and the localisation of printed books, 1530–1800', *Library,* 5th series, vol.21, March 1966, pp.1–45.

Schaaf, L., 'Anna Atkins' Cyanotypes: an experiment in photographic publishing', *History of Photography,* vol.6, no.2, April 1982, pp.151–172.

Schmid, H., 'Falter & Sohn: ein Münchner Musikverlag des 19. Jahrhunderts', *Mitteilungsblatt der Gesellschaft für Bayerische Musikgeschichte e. V.,* no.6, June 1973, pp.108–116.

Schmidl, C., *Dizionario universale dei musicisti.* Milan, 1937.

Schwerdt, C. F. G. R., *Hunting hawking shooting illustrated in a catalogue of books manuscripts prints and drawings collected by C. F. G. R. Schwerdt.* 4 vol. London, 1928.

Scott, A. de C., *On photo-zincography and other photographic processes employed at the Ordnance Survey Office, Southampton.* London, 1862.

Senefelder, A., *Vollständiges Lehrbuch der Steindruckerey.* 2 vol. Munich and Vienna, 1818 (English trans., *A complete course of lithography,* London, 1819; French trans., *L'Art de la lithographie,* Paris 1819; English trans. by J. W. Muller of the Munich edition of 1821, *The invention of lithography,* New York, 1911).

Singer, H. W., and Strang, W., *Etching, engraving and the other methods of printing pictures.* London, 1897.

Singer, S. W., *Researches into the history of playing cards.* London, 1816.

Smitskamp, R., 'Typographia hieroglyphica', *Quaerendo,* vol.9, no.4, Autumn 1979, pp.309–336.

Sotheby & Co. (Hodgson's Rooms), *Catalogue of printed books comprising publications of the Middle Hill Press from the celebrated collection formed by Sir Thomas Phillipps.* London, 1969.

Stadtmuseum, Offenbach, *Die Andrés.* Exhibition catalogue, Offenbach, 1974.

Stoyle, F. W., 'Michael Faraday and Anastatic Printing', *British Ink Maker,* Nov. 1965, pp.46–51.

Stuart, D. M., *Dearest Bess: the life and times of Lady Elizabeth Foster.* London, 1955.

Suzannet, A. de, *Catalogue des manuscrits livres imprimés et lettres autographes composant la Bibliothèque de La Petite Chardière: Oeuvres de Rodolphe Töpffer.* Lausanne, 1943.

Todd, W. B., *A directory of printers and others in allied trades London and vicinity 1800–1840.* London, 1972.

Tudot, E., *Description de tous les moyens de dessiner sur pierre.* Paris, 1833.

Turner, Dawson, *Guide to the historian, the biographer, the antiquary, the man of literary curiosity, and the collector of autographs, towards the verification of manuscripts, by reference to engraved fac-similes of handwriting.* Yarmouth, 1848.

Twyman, M., 'The art of drawing on stone', *Penrose Annual*, vol.64, 1971, pp.97–124.

Twyman, M., 'The beginnings of lithographic book production', *Nineteenth Century Short Title Catalogue Newsletter*, no.5, May 1988, pp.[4–11].

Twyman, M., 'Charles Joseph Hullmandel: lithographic printer extraordinary', in P. Gilmour (Ed.), *Lasting impressions*, London, 1988, pp.42–90, 362–367.

Twyman, M., *A directory of London lithographic printers 1800–1850.* London, 1976.

Twyman, M. (Ed.), *Henry Bankes's treatise on lithography*, reprinted from the 1813 and 1816 editions with an introduction and notes. London, 1976.

Twyman, M., 'The lithographic hand press 1796–1850', *Journal of the Printing Historical Society*, no.3, 1967, pp.3–50.

Twyman, M., 'Lithographic stone and the printing trade in the nineteenth century', *Journal of the Printing Historical Society*, no.8, 1972, pp.1–41.

Twyman, M., *Lithography 1800–1850: the techniques of drawing on stone in England and France and their application in works of topography.* London, 1970.

Twyman, M., *Printing 1770–1970: an illustrated history of its development and uses in England.* London, 1970.

Twyman, M., *Rudolph Ackermann and lithography.* Reading, 1983.

Twyman, M., 'Thomas Barker's lithographic stones', *Journal of the Printing Historical Society*, no.12, 1977/78, pp.1–32.

Twyman, M., 'The tinted lithograph', *Journal of the Printing Historical Society*, no.1, 1965, pp.39–56.

'Typolithographie' [report of J.-J. Delalande], *Le Lithographe*, vol.2, 1839, pp.177–191, 205–220, 234–254, 274–287, 300–316.

'Typolithographie: description du procédé', *Le Lithographe*, vol.2, 1839, pp.343–347.

Verein Schweizerischer Lithographiebesitzer, *Die Lithographie in der Schweiz und die verwandten Techniken Tiefdruck Lichtdruck Chemigraphie.* Bern, 1944.

Wagner, C., *Alois Senefelder, sein Leben und Wirken: ein Beitrag zur Geschichte der Lithographie.* Leipzig, 1914 (2nd ed. 1943).

Wakeman, G., 'Anastatic printing for Sir Thomas Phillipps', *Journal of the Printing Historical Society*, no.5, 1969, pp.24–40.

Wakeman, G., *Victorian book illustration.* Newton Abbot, 1973.

Wakeman, G., and Bridson, G. D. R., *A guide to nineteenth century colour printers.* Loughborough, 1975.

Warren, C., 'An Alpine bibliographical curiosity', *Alpine Journal*, vol.89, 1984, pp.141–144.

[Waterlow & Sons], *Every man his own printer; or, lithography made easy.* 2nd ed., London, 1859.

Weber, W., *Saxa loquuntur: Geschichte der Lithographie.* Heidelberg and Berlin, 1961 (English trans., *A history of lithography*, London, 1966).

Westby-Gibson, J., *The bibliography of shorthand.* London and Bath, 1887.

Williams, W. S., 'On lithography', *Transactions of the Society for the Encouragement of Arts, Manufactures, and Commerce.* London, 1847–48, pp.226–250.

Winkler, R. A., *Die Frühzeit der deutschen Lithographie: Katalog der Bilddrucke von 1796–1821.* Munich, 1975.

Zanetti, E., 'L'Editoria musicale a Roma nel secolo XIX: avvio di una ricerca', *Nuova Rivista Musicale*, vol.18, 1984, pp.191–199.

Index

References to illustrations are in square brackets.
References to items in the catalogue are in ranging numerals.